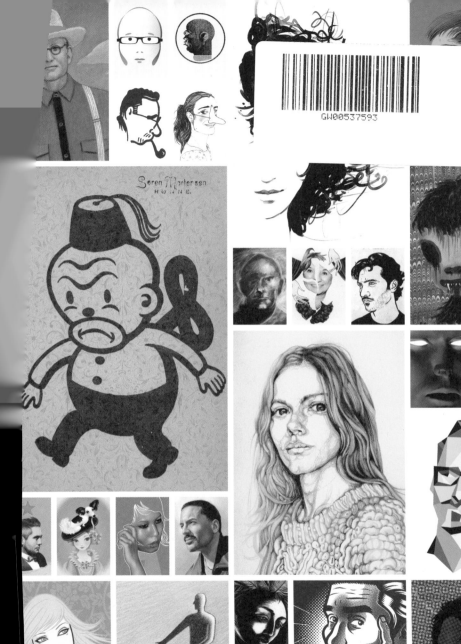

Søren Mortensen
R Ø N N E.

GW00537593

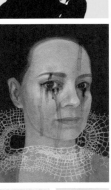

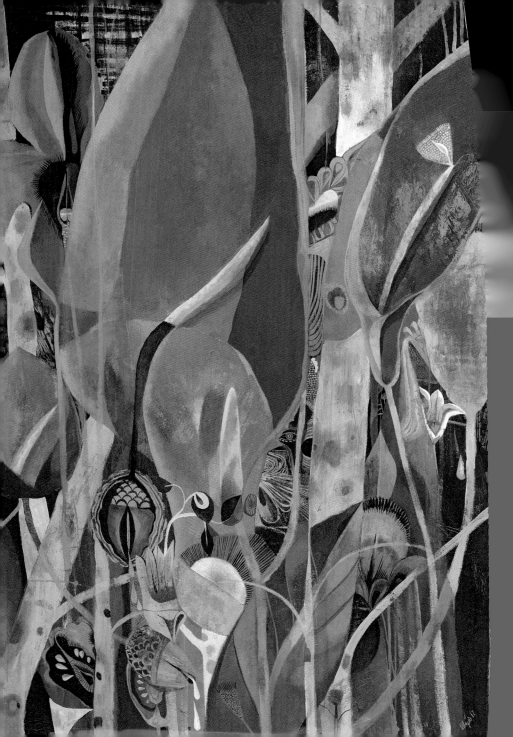

STEVEN HELLER
& JULIUS WIEDEMANN

100
ILLUSTRATORS

TASCHEN
Bibliotheca Universalis

CONTENTS

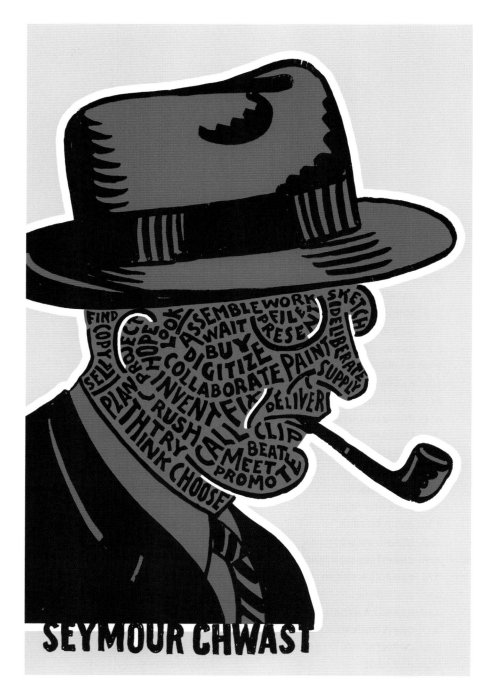

SEYMOUR CHWAST

BEST OF THE BEST

by Steven Heller

Choosing 100 international illustrators from over 600 who were featured in the previous four volumes of *Illustration Now!* together with the special "Portraits" and "Fashion" editions was always destined to be difficult work (and result in a lot of second-guessing and hurt feelings, no doubt). Yet, when asked, I eagerly accepted the challenge on one condition: that the editors of this new volume, Julius Wiedemann and Daniel Siciliano Bretas, whittle down the number of candidates to around 175 before passing them on to me for my final Solomonic judgment. Eliminating only 75 made the process somehow seem more *humane* than the wholesale slaughter of over 500 fine illustrators. But even that number was a struggle.

The original selections for the *Illustration Now!* volumes were based on each individual illustrator's gravity of reputation, body of assignments and quality of work.

Veteran illustrators (having 30 or more years in the field), including Seymour Chwast, Paul Davis, Marshall Arisman and Brad Holland, for example, who earned significant reputations for producing rule-busting art during their careers, were granted the *Illustration Now!* laurel. Their work, incidentally, has to stand up to the tests of time and continue to be relevant today, reflecting both past and present achievements. No one can dispute the fact that each of them has continued throughout their lifetimes to evolve into exemplary editorial artists.

Artists, as a rule — the good ones at any rate — don't get old in the creatively degenerative sense that sports figures and some actors do. As visual artists mature, we may presume that their work evolves in either nuanced ways or by major leaps. For some, like the illustrator, author and painter Maira Kalman, the work always feels young because her impressionism is not tied to a particular trend or fashion. It derives entirely from, and therefore expresses, an intimate personal sensibility. In determining who is included in this 100, every attempt has been made to separate out the illustrators whose work is stylistically following the herd.

Of course, there is an inherent problem in any selection of 100 and this in particular: not all the world's truly eminent illustrators accepted Wiedemann's invitation to contribute to any of these volumes — disturbingly absent are Milton Glaser, Edward Sorel, James McMullan and Sue Coe among significant others, leaving the book with an unexplained hole in illustration history. Then again, if they were all present, some of the younger illustrators might have lost their place among the worthy — and that would have been an error too.

What's more, *Illustration Now!* is not a history book. It is as much a showcase for young artists hopefully on the rise as it is for those who have previously risen. The word "Now" is not ambiguous. It means today, recent and contemporary. So, in addition to the revered veterans, these books have done their best to highlight scores of talented

neophytes, currently making bold individual marks. This old and young grouping shows two ends of the spectrum, but there is a large bridge of current, shall we say, middle-aged illustrators on whose shoulders some of the neophytes stand and whose approaches and personas accurately define the state of the art. They are the core of the *Illustration Now!* series—among them, Istvan Banyai, Gary Baseman, Mirko Ilić, Anita Kunz, Christoph Niemann, and more—and have perfected eclectic methods and styles that serve as models for today's illustrators and current practice. Without them there can be no *Illustration Now!* or ever.

Nonetheless, these three factions are not distinguished in the book but rather they are mixed together in the overall collage that is illustration. And that's not all…

In addition, pervasive throughout all the *Illustration Now!* books are a wide variety of styles, mannerisms and approaches. In fact, among the most notable illustrative characteristics *now*adays is the range of technical and conceptual methods, from retro to techno, and expressive to objective with various hybrids in between. Illustrators were selected for both style and concept. Likewise, it was essential that differing illustration formats be totally represented—from graphic novel right through to advertising. Certain genres were also in the spotlight—the "Portrait" book, which some of the artists in this volume were drawn from, was Wiedemann's response to the extreme number of

stylized portraits and witty caricatures produced by artists selected for the first four volumes (this and the special companion edition devoted to "Fashion" reveals another popular category of contemporary illustration). Most of all, illustrators were scrutinized for what each individually contributes to current practice—those eclectic quirks that make illustration such a decidedly accessible popular art.

For *100 Illustrators*, the fundamental selection criteria are the same, but the illustrator's contribution to the field carries more weight. The 100 selected here may not include all the most important or influential illustrators of the past decade, but those who are among this number are quantifiably players in editorial, advertising, book, information and technical illustration.

Another governing criterion is how *Illustration Now!* shall be seen and critiqued by artists today and historians tomorrow. So there is an intentional balance between the three categories of illustrator noted above. The eminences fill a dozen or more spreads. The up-and-comers (we hope) fill an equal number. That bridge (or middle-aged) group logically consumes the largest amount of space.

The last is a carnival of conceptual activity: Billie Jean's street-smart hip-hop expressionism, Zohar Lazar's hyper-frenetic brutism, Jeremyville's skateboard exoticism. All this is punctuated by Jean-Philippe Delhomme's refreshingly eloquent impres-

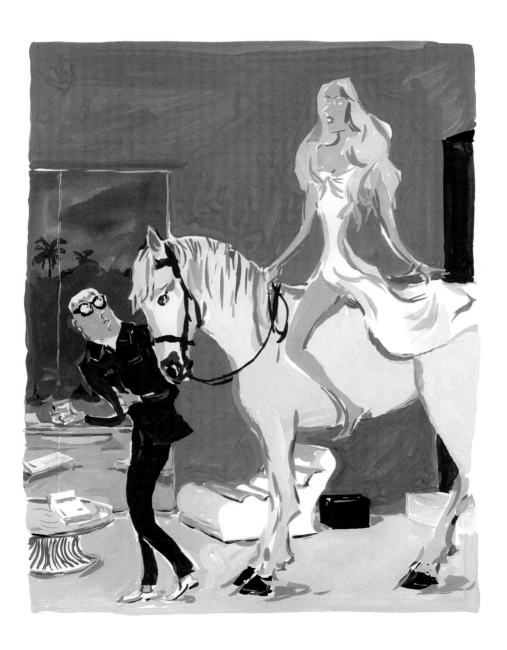

A Dog in Rome, 2012
Maira Kalman, Shiseido,
gouache on paper

sionist tableaux and Dave Calver's pastel romanticism. As disparate and jarring as they are, the images and styles somehow fit together hand in glove in the way that art works.

100 is a nice round number. It is a milestone, a sign of achievement. The collected *Illustration Now!* series is a record of how illustration, in an age when critics predict the "end of print" and, in fact, many traditional outlets for illustration have dried up, has triumphed over the doomsayers. Even I continually predicted that every edition would be its last—and here we are, illustration has rarely been in a healthier state of art.

Steven Heller is the co-chair of the School of Visual Arts MFA Designer as Author Program. For 33 years he was an art director for *The New York Times*, and currently writes the "Visuals" column for *The New York Times Book Review*. He is the author of 120 books on graphic design, illustration and satiric art.

In the same park I saw this dog. He could care less if I cried or not. Isn't that just like a dog, which is just one of the GREAT things about dogs.

DIE ALLERBESTEN

von Steven Heller

Die Aufgabe, ganze 100 Illustratoren aus den über 600 internationalen Grafikkünstlern auszuwählen, die in den vier bislang erschienenen *Illustration Now!*-Bänden vorgestellt wurden sowie in den zwei Sonderbänden, die sich der Porträtkunst sowie der Modeillustration widmeten, musste nolens volens heikel sein, um nicht zu sagen schwierig (und würde zweifellos mit sehr viel Besserwisserei quittiert werden und noch mehr gekränkte Gefühle hervorrufen). Doch als das Ansinnen an mich herangetragen wurde, sagte ich sofort zu, unter einer Voraussetzung: dass die Herausgeber dieses neuen Bandes, Julius Wiedemann und Daniel Siciliano Bretas, die Zahl der Kandidaten auf rund 175 reduzierten, ehe sie diese meinem abschließenden salomonischen Urteil zuführten. Nur 75 auszujurieren erschien mir irgendwie menschlicher, als ein Gemetzel an über 500 herausragenden Illustratoren zu veranstalten. Aber selbst diese Zahl zu erreichen war ein mühsames Unterfangen.

Die ursprüngliche Auswahl für die *Illustration Now!*-Bände beruhte auf dem Ansehen des jeweiligen Illustrators, dem Umfang und der Art seines Auftragswerks sowie der Qualität seiner Arbeiten.

Altgedienten Illustratoren (die auf 30 oder mehr Jahre Erfahrung zurückblicken), etwa Seymour Chwast, Paul Davis, Marshall Arisman und Brad Holland, die im Lauf ihrer Karriere durch bahnbrechende Kunst von sich reden machten, wurde der Lorbeerkranz von *Illustration Now!* zuerkannt. Ihr Werk überdauert alle Zeiten und Moden und ist heute noch relevant, es reflektiert vergangene und gegenwärtige Leistungen. Unbestritten ist, dass sie sich alle ihr Leben lang weiterentwickelten und zum Inbegriff des Grafikkünstlers wurden.

Im Großen und Ganzen vollzieht sich der Alterungsprozess bei Künstlern – zumindest bei den guten – nicht kreativ-degenerativ, wie es etwa bei Sportlern und einigen Schauspielern der Fall ist. Beim Reiferwerden entwickelt sich das Werk bildender Künstler entweder in winzigen Schritten oder aber in großen Sprüngen fort. Bei einigen, etwa der Illustratorin, Schriftstellerin und Malerin Maira Kalman, wirkt das Werk immer jung, denn ihr Impressionismus folgt keinem bestimmten Trend, keiner Mode, sondern entsteht aus einer intimen, persönlichen Empfänglichkeit heraus, und eben die bringen ihre Arbeiten zum Ausdruck. Bei der Auswahl der hier vertretenen 100 wurde große Mühe darauf verwendet, Illustratoren auszuschließen, deren Werk stilistisch der Masse folgt.

Es gibt ein Problem, das einer jeden Auswahl von 100 innewohnt, und dieser Zusammenstellung insbesondere: Nicht alle wirklich herausragenden Illustratoren entsprachen Wiedemanns Bitte, einen Beitrag für den einen oder anderen Band zu leisten. So fehlen, um nur einige Großmeister

zu nennen, Milton Glaser, Edward Sorel, James McMullan und Sue Coe, was dem Buch eine fast unverzeihliche Lücke in der Geschichte der Illustration beschert. Andererseits, wären sie alle vertreten, hätten einige der jüngeren Illustratoren keinen Platz unter den Erwählten gefunden, und auch das wäre nicht richtig gewesen.

Zudem ist *Illustration Now!* kein Geschichtsbuch, sondern vielmehr ein Schaukasten für Nachwuchskünstler, deren Stern hoffentlich im Aufgehen begriffen ist, sowie für die bereits aufgegangenen Sterne. Das Wort „Now" ist unzweideutig, es bedeutet „heute, kürzlich, zeitgenössisch". So war es uns bei allen Bänden ein Anliegen, neben den verehrten Altgedienten auch zahlreiche begabte Newcomer zu präsentieren, die gerade einfallsreiche individuelle Zeichen setzten. Die „alte" und die „junge" Garde bilden die zwei Enden des Spektrums, dazwischen spannt sich die sehr große Brücke gegenwärtiger Illustratoren mehr oder minder mittleren Alters, auf deren Schultern einige Novizen stehen und deren Vorgehensweisen und Persönlichkeiten den gegenwärtigen Stand der Dinge definieren. Sie bilden das Herzstück der *Illustration Now!*-Reihe – unter anderem Istvan Banyai, Gary Baseman, Mirko Ilić, Anita Kunz und Christoph Niemann – und haben eklektische Methoden und Stile perfektioniert, die Vorbildfunktion für heutige Illustratoren und die gegenwärtige Praxis haben. Ohne sie könnte es keine einzige *Illustration Now!* geben.

Allerdings wird im Buch nicht zwischen diesen drei Fraktionen unterschieden, vielmehr werden sie, wie es sich für eine Illustration gehört, zu einer bunten Collage vermischt. Und das ist nicht alles …

Alle *Illustration Now*-Bände zeichnen sich zudem durch eine große Bandbreite an Stilen, Eigenheiten und Herangehensweisen aus. Zu den bemerkenswertesten Facetten der Illustration gehört heute die erstaunliche Palette technischer und konzeptueller Methoden, von Retro bis Techno, von expressiv bis objektiv und diversen Hybridformen. Auswahlkriterien waren sowohl Stil als auch Konzept des Illustrators. Wichtig war überdies, dass die verschiedenen Formate der Illustration vertreten waren, von der Graphic Novel bis zur Werbung. Auch bestimmte Genres wurden schlaglichtartig beleuchtet; mit dem Sonderband zur Porträtkunst, dem einige hier vorgestellte Illustratoren entnommen sind, reagierte Wiedemann auf die große Anzahl stilisierter Porträts und geistreicher Karikaturen aus der Feder von Künstlern, die in den ersten vier *Illustration Now!*-Bänden präsentiert wurden (der hier vorliegende Band sowie ein weiterer der Mode gewidmeter Sonderband verdeutlichen zwei zusätzliche Bereiche der heutigen Illustration). Vor allem aber wurde unter die Lupe genommen, welchen Beitrag jeder einzelne Illustrator zur gegenwärtigen Praxis leistet – die eklektischen Grillen und Marotten, denen die Illustration ihren Status als nah- und begreifbare populäre Kunst überhaupt verdankt.

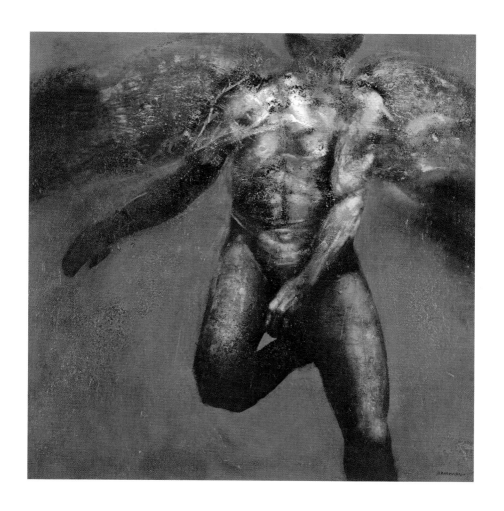

STAY FREE FOREVER.

THIS HAS BEEN A JEREMYVILLE
COMMUNITY SERVICE ANNOUNCEMENT.

Bei *100 Illustrators* waren die grundlegenden Auswahlkriterien dieselben, nur hatte der Beitrag des betreffenden Zeichners zum Genre mehr Gewicht. Zu den hier ausgewählten 100 gehören vielleicht nicht alle der bedeutendsten und einflussreichsten Grafikkünstler des vergangenen Jahrzehnts, doch alle, die aufgenommen wurden, sind quantifizierbare Größen in der Illustration für Zeitschriften, Werbung, Bücher sowie für Informations- und technische Zwecke.

Ein weiteres wesentliches Kriterium war, wie die heutige Illustration von zeitgenössischen Künstlern und künftigen Kunsthistorikern betrachtet und kritisiert werden würde. Das erklärt die bewusste Ausgewogenheit zwischen den drei oben erwähnten Künstlergruppen. Die Großmeister füllen ein Dutzend oder etwas mehr Doppelseiten, ebenso wie die (hoffentlich) aufsteigenden Sterne. Die Brückengruppe mittleren Alters nimmt verständlicherweise den meisten Platz ein.

Und sie bietet eine kunterbunte Mischung konzeptueller Umtriebigkeit: Billie Jeans pfiffiger Hip-Hop-Expressionismus, Zohar Lazars hyperfrenetische Erbarmungslosigkeit, Jeremyvilles Skateboard-Exotizismus. Periodisch durchbrochen werden sie durch Jean-Philippe Delhommes erfrischend vielsagendes impressionistisches Tableaux und Dave Calvers pastellfarbene Romantik. So unterschiedlich und auch gegensätzlich die Illustrationen sein mögen, die Darstellungen und Stile passen zusammen auf genau die Art, in der diese Kunstform funktioniert.

100 ist eine schöne, runde Zahl. Ein Meilenstein, ein Sinnbild des Vollbrachten. Die gesammelte *Illustration Now!*-Serie dient dem Beweis, dass die Illustration in einer Zeit, in der Kritiker das „Ende des gedruckten Wortes" prophezeien und in der Tat viele herkömmliche Anwendungsbereiche des Mediums untergegangen sind, über die Unkenrufer triumphiert hat. Selbst ich habe immer wieder orakelt, jeder Band wäre der letzte – und jetzt? So quicklebendig wie heute war die Illustration in ihrer Kunstgeschichte selten.

Steven Heller ist Kovorsitzender des Studiengangs „School of Visual Arts MFA Designer as Author". Er war 33 Jahre lang Artdirector der *New York Times*, schreibt die Kolumne „Visuals" für die *New York Times Book Review* und ist Autor von 120 Büchern über Grafikdesign, Illustration und politische Karikatur.

LA CRÈME DE LA CRÈME

par Steven Heller

Choisir 100 illustrateurs internationaux parmi les plus de 600 qui sont apparus dans les quatre volumes précédents d'*Illustration Now!* et dans l'édition spéciale « Portraits » et « Fashion » ne pouvait manquer d'être une tâche difficile (et de causer beaucoup de contestations et de blessures d'amour-propre, sans aucun doute). Pourtant, lorsque l'on m'a chargé de cette délicate mission, j'ai accepté avec plaisir, à une condition : que les directeurs de publication de ce nouveau volume, Julius Wiedemann et Daniel Siciliano Bretas, réduisent le nombre de candidats à 175 avant de les soumettre à mon jugement de Salomon. Le fait d'éliminer seulement 75 personnes faisait paraître ce processus plus *humain*, d'une certaine façon, que le massacre systématique de plus de 500 excellents illustrateurs. Mais même ce chiffre m'a posé problème.

Les sélections originales des différents volumes d'*Illustration Now!* étaient basées sur la réputation de chaque illustrateur, son carnet de commandes et la qualité de son travail.

Des vétérans de l'illustration (possédant 30 ans d'expérience ou plus dans le domaine), notamment Seymour Chwast, Paul Davis, Marshall Arisman et Brad Holland, par exemple, qui se sont forgé de solides réputations pour leur travail iconoclaste, ont reçu le sceau d'*Illustration Now!*. Leur travail doit par ailleurs résister à l'épreuve du temps et rester d'actualité, et refléter des réussites passées et présentes. Personne

ne peut contester le fait qu'ils ont tous continué d'évoluer tout au long de leur carrière pour devenir de magnifiques artistes de presse.

Les artistes, en règle générale, et en tout cas les bons artistes, ne vieillissent pas dans le sens d'une dégénérescence, comme les sportifs ou certains acteurs. Au fur et à mesure que les artistes visuels prennent de l'âge, on peut s'attendre à voir leur travail évoluer par touches subtiles ou par grands bonds. Pour certains, comme l'illustratrice, auteure et peintre Maira Kalman, le travail donne toujours une impression de fraîcheur, et dans son cas c'est parce que son impressionnisme n'est ancré dans aucune tendance ou mode en particulier. Il est entièrement dérivé d'une sensibilité personnelle intime, qu'il sert à exprimer. Pour décider qui appartient aux 100 élus, j'ai vraiment essayé d'éliminer les illustra-teurs dont le travail n'était pas assez original sur le plan stylistique.

Bien entendu, toute sélection de 100 éléments comporte un problème inhérent, et celui-ci en particulier : l'invitation de Wiedemann à participer à cette collection n'a pas forcément été acceptée par tous les grands illustrateurs – Milton Glaser, Edward Sorel, James McMullan et Sue Coe, entre autres importants exemples, laissent par leur absence criante un trou inexpliqué dans l'histoire de l'illustration. D'un autre côté, s'ils avaient tous répondu présents, certains des illustrateurs les plus jeunes auraient pu

p. 18 Spring, 2000
Dave Calver, American Showcase,
cover, colored pencil, marker and
acrylic

Frida & Diego, 2008
Paul Davis, Centennial of Diego
Rivera, poster, acrylic on canvas

perdre leur place, et cela aurait aussi été une erreur.

Et de toute façon, *Illustration Now!* n'est pas un livre d'histoire. C'est une vitrine pour les jeunes artistes que l'on veut voir monter, ainsi que pour ceux qui sont déjà tout en haut. Le mot « Now » n'est pas ambigu. Il fait référence à aujourd'hui, à l'histoire récente et au contemporain. Alors, outre les vétérans vénérés, ces livres ont tenté de mettre en valeur des dizaines de néophytes talentueux, qui ouvrent actuellement de nouvelles voies personnelles et pleines d'audace. Cette réunion des jeunes et des anciens montre les deux extrémités du spectre, mais il y a entre les deux un vaste groupe d'illustrateurs d'âge moyen, sur les épaules desquels une partie des néophytes se sont hissés, et dont les démarches et les personnages définissent très exactement ce qui se fait de mieux dans le secteur. Ils sont au cœur de la série *Illustration Now!* – Istvan Banyai, Gary Baseman, Mirko Ilić, Anita Kunz, Christoph Niemann, entre autres – et ont perfectionné les méthodes et styles éclectiques qui servent de modèle aux illustrateurs actuels. Sans eux, il ne saurait y avoir d'*Illustration Now!*, ni aujourd'hui ni demain.

Néanmoins, ces trois catégories ne sont pas séparées dans le livre, elles sont mélangées dans le grand collage qu'est l'illustration. Et ce n'est pas tout ...

De plus, un vaste éventail de styles, maniérismes et approches se font connaître tout au long des livres de la série *Now*. De fait, parmi les caractéristiques illustratives les plus notables actuellement, on trouve toute la gamme des méthodes techniques et conceptuelles, du rétro au techno, et de l'expressif à l'objectif, avec différents hybrides au milieu. Les illustrateurs ont été sélectionnés sur des critères de style et de concept. De même, il était essentiel de représenter tous les différents formats de l'illustration : depuis la bande dessinée contemporaine jusqu'à la publicité. Certains genres ont été mis en vedette – le livre sur les portraits, dont proviennent certains des artistes de ce volume, était la réponse de Wiedemann au nombre extrême de portraits stylisés et spirituels qu'avaient faits les artistes sélectionnés pour les quatre premiers volumes (l'édition spéciale consacrée à l'illustration de mode révèle une autre catégorie populaire de l'illustration contemporaine). Mais surtout, les illustrateurs ont été examinés sur ce que chacun apporte individuellement à la pratique actuelle – ces particularités éclectiques qui font de l'illustration un art populaire si résolument accessible.

Pour *100 Illustrators*, les critères de sélection fondamentaux restent identiques, mais la contribution de l'illustrateur à son domaine a plus d'importance. Les illustrateurs sélectionnés ici ne comprennent peut-être pas tous les plus importants de la dernière décennie, mais ce sont tous des acteurs de poids dans l'illustration de presse, de publicité, d'édition, d'information et de technique.

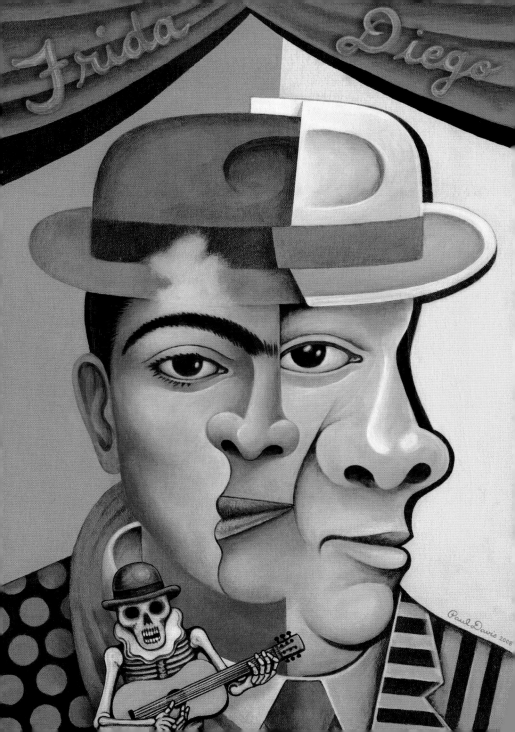

The Three Graces, 2010
Anita Kunz, Vita magazine,
Montreal, acrylic

pp. 24/25 The Birth of the
Domesticated, 2012
Gary Baseman, personal work,
Vicious, Antonio Colombo Arte
Contemporanea, Milan, exhibition,
acrylic on canvas

Un autre critère principal est la façon dont l'illustration actuelle doit être vue et analysée par les artistes d'aujourd'hui et les historiens de demain. Il existe donc un équilibre intentionnel entre les trois catégories d'illustrateurs mentionnées plus haut. Les éminences remplissent une bonne douzaine de doubles pages. Les étoiles montantes (ou du moins nous l'espérons) représentent un volume égal. Et le groupe du milieu occupe logiquement la majeure partie de l'espace.

Le dernier volume de la série est un festival d'activité conceptuelle : l'expressionnisme hip-hop urbain de Billie Jean, le brutisme hyperfrénétique de Zohar Lazar, l'exotisme sur skateboard de Jeremyville. Tout cela ponctué par le tableau impressionniste à l'éloquence rafraîchissante de Jean-Philippe Delhomme et le romantisme pastel de Dave Calver. Aussi disparates et discordants qu'ils puissent être, les images et les styles trouvent la façon de s'accorder les uns aux autres, comme cela arrive souvent lorsqu'il s'agit d'art.

100 est un beau chiffre bien rond. C'est un jalon, un signe de réussite. La série *Illustration Now!* montre comment l'illustration, à une époque où les critiques prédisent « la fin de l'imprimé » et où de nombreux supports traditionnels de l'illustration ont disparu, a triomphé malgré les prophètes de malheur. Moi-même, j'ai sans cesse prédit que chaque volume de cette série serait le dernier, et nous voici aujourd'hui encore une fois, l'illustration a rarement connu une santé aussi éclatante.

Steven Heller est coprésident de la filière « School of Visual Arts MFA Designer as Author ». Directeur artistique du *New York Times* pendant 33 ans, rédacteur de la colonne « Visuals » de la *New York Times Book Review*, il est en outre l'auteur de 120 livres sur le graphisme, l'illustration et la caricature politique.

Jorge Alderete

1971 born in Caleta Olivia, Argentina
Lives and works in Mexico City
www.jorgealderete.com

"My relationship with 'the portrait'
changes substantially for me
when the portrayed person ceases to be
an unknown person, and becomes someone
in my immediate surroundings."

Deus Ex: Human
Revolution, 2011
Upper Playground + Square
Enix, exhibition poster,
hand-drawn and digital

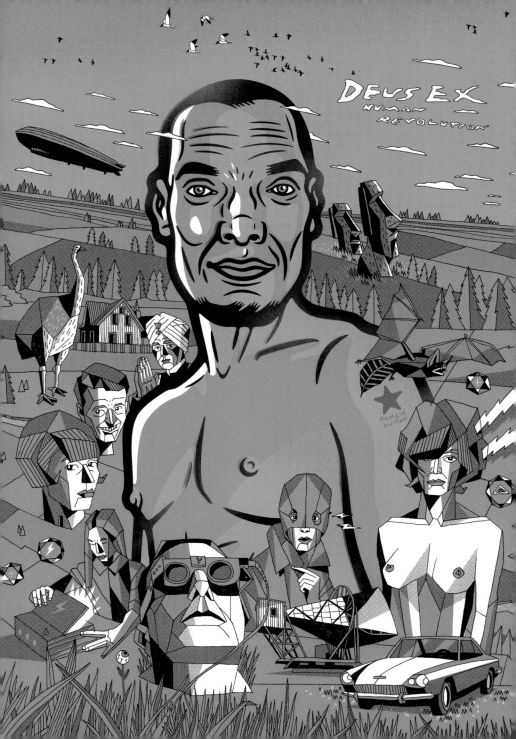

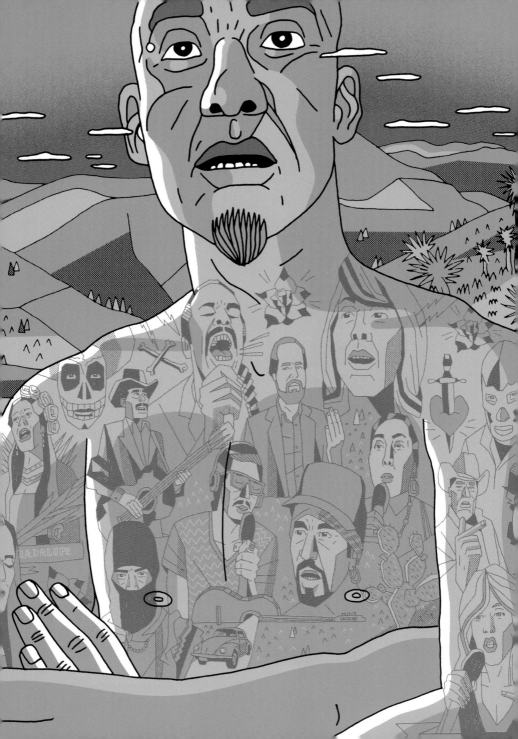

Jorge Alderete's stark graphic aesthetic, wedding comic books to a circus-like sensationalism, makes his portraits feel at once old and new. He refers to himself as a "pop illustrator, who uses trash culture, '50s science-fiction films, wrestling and surf-music imagery in [his] psychotronic illustrations, animations and comics." A graduate of the School of Fine Arts in the Universidad Nacional de La Plata, Argentina, as a Designer in Visual Communication, he is also co-owner of the independent record label Isotonic Records, for which he has designed album covers for bands from Argentina (Los Fabulosos Cadillacs), Mexico (Lost Acapulco, Twin Tones, Los Explosivos) and the USA (Los Straitjackets), among others.

Die ausgesprochen grafische Ästhetik Jorge Alderetes, in der sich Comic-Stil und zirkusartiger Sensationalismus miteinander verbinden, lässt seine Porträts alt und neu zugleich erscheinen. Er selbst bezeichnet sich als „Pop-Illustrator, der in psychotronischen Animationen, Illustrationen und Comics mit Trash-Kultur, Science-Fiction-Filmen der 1950er-Jahre, Wrestling und Bildelementen der Surf Music arbeitet". Der Künstler wurde an der argentinischen Universidad Nacional de La Plata zum Designer in Visual Communication ausgebildet und ist Mitinhaber des unabhängigen Labels Isotonic Records, für das er Albumcover entwarf, unter anderem für Bands aus Argentinien (Los Fabulosos Cadillacs), Mexiko (Lost Acapulco, Twin Tones, Los Explosivos) und den USA (Los Straitjackets).

L'esthétique très graphique de Jorge Alderete, qui marie la bande dessinée à un sensationnalisme de piste aux étoiles, donne à ses portraits un air ancien et neuf à la fois. Il se qualifie d'«illustrateur pop, qui utilise la culture trash, les films de science fiction des années 1950 et l'imagerie de la lutte et de la musique de surfeurs dans [ses] illustrations, animations et BD psychotroniques». Designer en communication audiovisuelle diplômé de l'École des Beaux-arts de l'Université nationale de La Plata, en Argentine, il est aussi copropriétaire du label indépendant Isotonic Records, et a créé des couvertures d'album pour des groupes argentins (Los Fabulosos Cadillacs), mexicains (Lost Acapulco, Twin Tones, Los Explosivos) et américains (Los Straitjackets), entre autres.

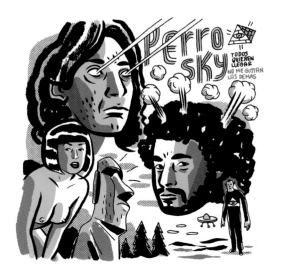

Hecho en Mexico, 2012
Lynn Fainchtein, poster
proposal, hand-drawn and
digital

Perrosky, 2012
Algo Records, 7-inch
vinyl sleeve, hand-drawn
and digital

SELECTED EXHIBITIONS — 2016, *Subte, solo show, Estación Bellas Artes, Mexico City //* **2012**, *Otro Yo, solo show, Acapulco 13, Mexico DF //* **2011**, *Piñatarama, group show, Museum of Modern Art, Mexico City //* **2010**, *Draw, group show, Museo de la Ciudad, Mexico City //* **2010**, *La Gráfica del Dr. Alderete, solo show, Faro de Oriente, Mexico City //* **2009**, *Yo Soy Un Don Nadie, solo show, Hollywood in Cambodia, Buenos Aires*

SELECTED PUBLICATIONS — 2016, *Illustration Now! Portraits, TASCHEN, Germany //* **2012**, *Surf Graphics, Korero Books, UK //* **2012**, *Mexican Graphics, Korero Books, UK //* **2012**, *Otro Yo, Ediciones Acapulco, Mexico //* **2012**, *Sonorama, La Caja de Cerillos, Mexico //* **2010**, *The Day of the Dead, Korero Books, UK //* **2008**, *I Am a Nobody, Black Cat Bones, France*

La Mano de Dios,
portrait of Diego Armando
Maradona, 2010
Football Heroes, book,
digital

Los Fabulosos Cadillacs,
2008
Sony BMG, CD cover,
digital

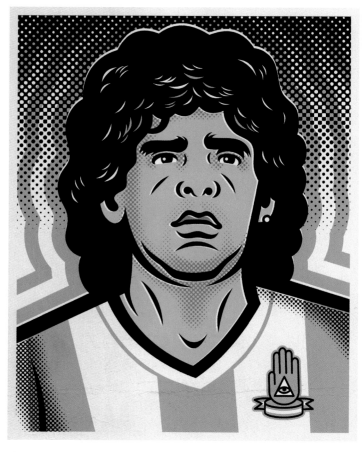

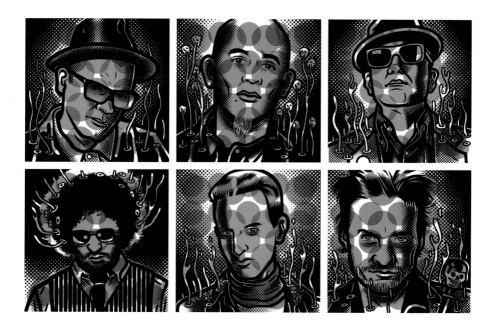

A committed entrepreneur, Alderete opened Kong in 2006, Mexico's first design store and gallery, and from 2006 to 2010 was curator of the Terraza space in the Spanish Cultural Center in Mexico. With his wife Clarisa Moura Alderete, he opened the Vertigo Gallery in 2009, focusing on design and illustration. His 2008 book, *I Am a Nobody*, was issued by the French publisher Black Cat Bones, and he is currently general editor for the London-based publisher Korero Books, where he edited *The Day of The Dead* (2010) and *Mexican Graphics* (2012).

Alderete ist ein vielseitiger Unternehmer: So eröffnete er 2006 Kong, Mexikos erste Design-Boutique und Galerie, und von 2006 bis 2010 kuratierte er das Espacio Terraza am Centro Cultural de España in Mexiko. Zusammen mit seiner Frau Clarisa Moura Alderete eröffnete er 2009 die auf Zeichnungen und Illustrationen spezialisierte Galería Vértigo. 2008 erschien im französischen Verlag Black Cat Bones sein Buch *I am a Nobody*. Zurzeit arbeitet er als General Editor für den Londoner Verlag Korero Books, wo er *The Day of The Dead* (2010) und *Mexican Graphics* (2012) herausgebracht hat.

Homme d'affaires actif, Alderete a ouvert Kong en 2006, le premier magasin et galerie de design de Mexico, et de 2006 à 2010 il a été commissaire de l'espace Terraza du Centre culturel espagnol de Mexico. En 2009, il a ouvert avec sa femme Clarisa Moura Alderete la galerie Vertigo, spécialisée dans le design et l'illustration. Son livre *I am a Nobody* a été publié en 2008 par la maison d'édition française Black Cat Bones, et il est actuellement éditeur en chef pour la maison d'édition londonienne Korero Books, où il a publié *The Day of The Dead* (2010) et *Mexican Graphics* (2012).

Jorge Arévalo

1968 born in Madrid
Lives and works in Madrid
www.jorgearevalo.com

"When I manage it, my portraits
become very personal and the character portrayed
picks up many of my own tastes."

Charlotte Casiraghi, 2012
Vanity Fair, hand-drawn
and digital

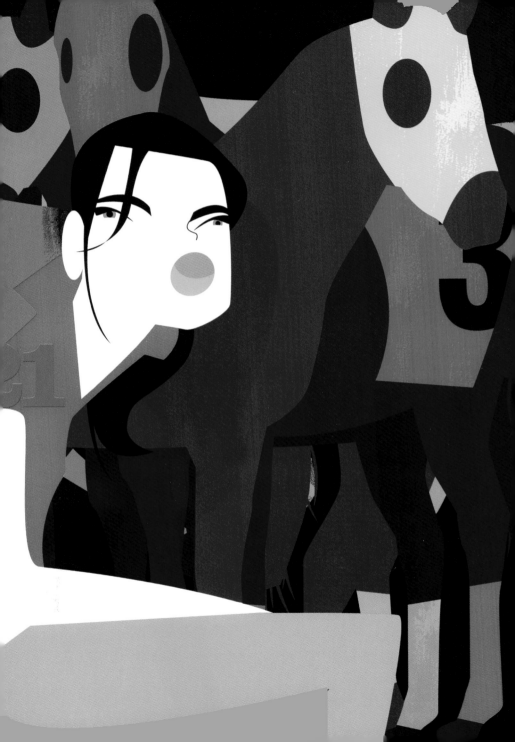

SELECTED EXHIBITIONS — *2012, Cherchez la femme, solo show, Cherchez la femme, Madrid // 2012, Custo Gallery, group show, Custo Shop, Madrid // 2011, Panta Rhei Illustrators, group show, Panta Rhei, Madrid // 2009, Bis & Cherchez la femme, group show, Fast Cool Gallery, Madrid*

SELECTED PUBLICATIONS — *2016, Illustration Now! Portraits, TASCHEN, Germany // 2015, Retratos, Promopress, Spain // 2010, The New Yorker, USA // 2010, Parade magazine, USA // 2007, Esquire, Spain // 2007, Vanity Fair, Spain // 2001, Rolling Stone, Spain*

Miles Davis, 2009
Vanity Fair, hand-drawn
and digital

Nat King Cole, 2009
Retratos 2, book, digital

Madonna & Lourdes, 2011
Vanity Fair, hand-drawn
and digital

Pleasing distortions and a bold color palette add kinetic excitement and pictorial intrigue to Jorge Arévalo's otherwise stationary compositions. Arévalo says that his interest in illustration comes from "the elegance of the line combined with the voluptuousness of the texture." Most of his work is in portraits, which he began doing for the Madrid-based newspaper *El Mundo*, where he tries to depict the subject in as minimalist a way as is possible. "I like to elaborate on some details while having large flat areas of color," he says.

Durch gefällige Verzerrungen und gewagte Farben verleiht Jorge Arévalo seinen ansonsten eher ruhigen Kompositionen Spannung und Zuspitzung. Arévalos Interesse für die Illustration speist sich nach eigenen Worten aus der „Eleganz der Linie, gepaart mit der Sinnlichkeit der Textur". Seit er für die Madrider Zeitung *El Mundo* arbeitet, zeichnet er hauptsächlich Porträts, wobei er versucht, seine Figuren so minimalistisch wie möglich darzustellen. „Es macht mir Spaß, Details herauszuarbeiten", sagt er, „und ich bevorzuge große Farbflächen."

Ses distorsions esthétiques et sa palette de couleurs audacieuse ajoutent du mouvement aux compositions par ailleurs plutôt statiques d'Arévalo. Selon lui, son intérêt pour l'illustration vient de « l'élégance de la ligne, combinée à la volupté de la texture ». La majeure partie de son travail est constituée de portraits. Il a commencé à en faire pour le journal madrilène *El Mundo*, où il essaie de représenter son sujet de la façon la plus minimaliste possible. « J'aime approfondir certains détails tout en gardant de grands aplats de couleur », déclare-t-il.

Jean Reno, 2012
Retratos, book, hand-drawn and digital

George Best, 2012
Personal work, book, hand-drawn and digital

Alexander McQueen, 2012
Vanity Fair, hand-drawn and digital

Marshall Arisman

1938 born in Jamestown
Lives and works in New York
www.marshallarisman.com

"I believe that personal vision can
be printed on a page or hung on a gallery wall.
Whatever form the image takes,
it is, in the end, good or bad art."

Lightrunner, 1990
School of Visual Arts,
poster in subway,
oil on canvas

"Spiritual" is a reasonable word to explain why Marshall Arisman's highly sophisticated primitive paintings jump off the canvas and into our consciousness and subconscious—they come not from the head but from a spiritual part of his psyche. Arisman's works are in the permanent collections of the Brooklyn Museum, the National Museum of American Art and the Smithsonian, as well as various private and corporate collections. He is Chair of the MFA program, Illustration as Visual Essay, at the School of Visual Arts in New York, and was the subject of a full-length documentary film directed by Tony Silver in 2002, *Facing the Audience: The Arts of Marshall Arisman*.

Mit dem Wort „spirituell" ließe sich wohl am ehesten erklären, wieso Marshall Arismans höchst subtile, ursprüngliche Gemälde von der Leinwand unmittelbar in unser Bewusstes und Unterbewusstes dringen – es sind keine Kopfgeburten, sondern sie kommen aus einem spirituellen Teil seiner Psyche. Arismans Bilder befinden sich sowohl in öffentlichen Einrichtungen wie dem Brooklyn Museum, dem National Museum of American Art und der Smithsonian Institution als auch in verschiedenen Sammlungen von Privatpersonen und Firmen. Er leitet das MFA-Programm (Master of Fine Arts) „Illustration as Visual Essay" an der School of Visual Arts in New York. Unter der Regie von Tony Silver erschien 2002 über ihn die abendfüllende Dokumentation *Facing the Audience: The Arts of Marshall Arisman*.

« Spirituel » est un terme raisonnable pour expliquer pourquoi les peintures primitives très sophistiquées de Marshall Arisman semblent bondir hors du cadre et plonger dans notre conscience et dans notre inconscient – elles ne proviennent pas de son esprit, mais d'une partie spirituelle de son psychisme. Les œuvres d'Arisman font partie des collections permanentes du Brooklyn Museum, du National Museum of American Art et du Smithsonian, ainsi que de nombreuses collections privées et d'entreprises. Il est président du programme MFA, Illustration as Visual Essay, à la School of Visual Arts à New York et a fait l'objet d'un long-métrage documentaire réalisé en 2002 par Tony Silver, *Facing the Audience: The Arts of Marshall Arisman*.

Last Tribe, 1996
Vision publishing,
oil on rag board

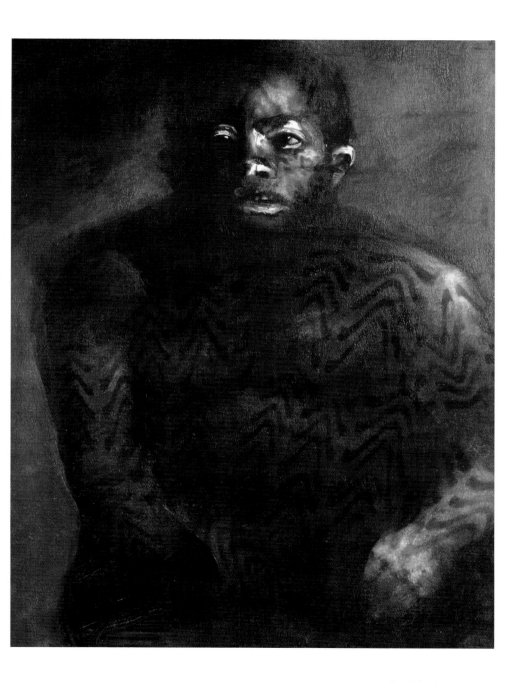

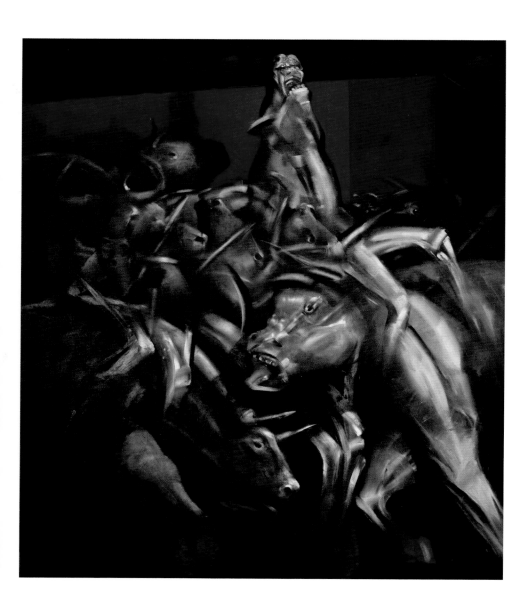

Last Tribe, 1990
Vision publishing,
oil on rag board

Shaman, 2012
John Rodby, CD cover,
drawing (etching) on
copper plate

His work has always emoted a sense of optimism in the face of apocalypse. He once said: "Horrific events captured in a photograph are not the same as when an artist paints them," referring to his tendency to depict darkness. "This has something to do with how we perceive time. The photograph represents a split second. The painting takes longer to complete. We look at the photograph, not the photographer. We look at the painting and wonder why someone painted it." Arisman's opus of opuses is the graphic novel *The Divine Elvis*, for which he spent two years painting monkeys, not run-of-the-mill monkeys, but sacred monkeys.

In seinem Werk waltet angesichts apokalyptischer Verhältnisse stets ein gewisser Optimismus. In Anspielung auf seine Neigung, Dunkelheit darzustellen, sagte er einmal: „Schreckliche Ereignisse, die fotografisch festgehalten werden, sind nicht dasselbe wie etwas vom Künstler Gemaltes. Das hat etwas damit zu tun, wie wir Zeit wahrnehmen. Die Fotografie repräsentiert den Bruchteil einer Sekunde. Das Gemälde entsteht langsamer. Wir betrachten die Fotografie, nicht den Fotografen. Wir betrachten das Bild und fragen uns, wieso es jemand gemalt hat." Arismans Opus magnum ist die Graphic Novel *The Divine Elvis*, für die er zwei Jahre lang Affen malte: keine Alltags-, sondern heilige Affen.

Son œuvre a toujours exprimé un sentiment d'optimisme face à l'apocalypse. Il a un jour déclaré : « Des événements horribles saisis par une photographie, ce n'est pas la même chose que lorsqu'un artiste les peint », en référence à sa tendance à la noirceur. « Cela a quelque chose à voir avec notre perception du temps. La photographie représente une fraction de seconde. La peinture nécessite un plus long temps de réalisation. On regarde la photographie, pas le photographe. On regarde la peinture et on se demande ce qui a motivé le peintre à la faire. » Le chef-d'œuvre d'Arisman est le roman graphique *The Divine Elvis*, pour lequel il a passé deux ans à peindre des singes sacrés.

SELECTED EXHIBITIONS — *2012*, Ayahuasca Cave, solo show, Sacred Gallery, New York // *2011*, Alternative Surfaces, solo show, Sacred Gallery, New York // *2004*, Arisman Retrospective, solo show, Visual Arts Museum, New York // *1999*, Sacred Monkeys, solo show, Guangdong Museum, Guangzhou // *1989*, Underground Images, group show, Cooper-Hewitt Museum, New York

SELECTED PUBLICATIONS — *2010*, The Divine Elvis, USA // *2008*, The Design Entrepreneur, Rockport Publishing, USA // *2004*, Juxtapoz magazine, USA // *1999*, Graphis magazine, USA // *1995*, Idea magazine, Japan // *1990*, Omni magazine, USA // *1980*, Time magazine, USA

American Psycho, 1990
Book jacket, oil on rag
board

Lisel Ashlock

1976 born in Walnut Creek
Lives and works in Brooklyn
www.liseljaneashlock.com

"Ashlock combines the surreal
floral art of Giuseppe Arcimboldo with the
Postimpressionism of Henri Rousseau."

Turn Right at Machu
Picchu, 2010
Penguin Books, book cover,
acrylic on birch panel

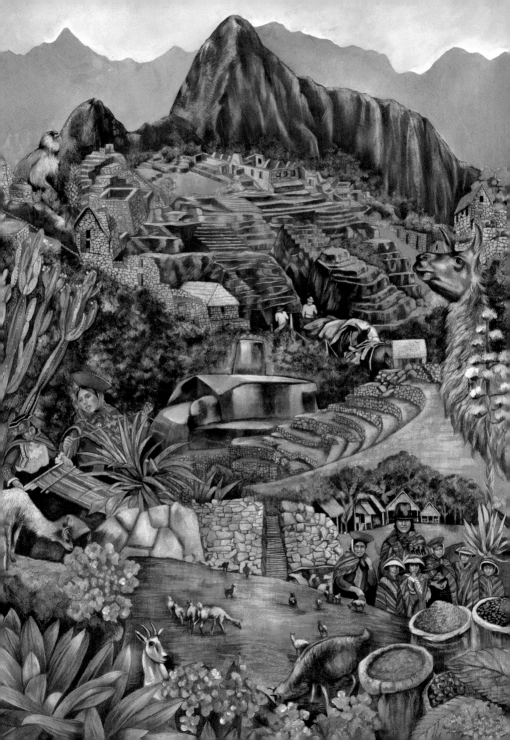

SELECTED PUBLICATIONS — *2016*, Illustration Now! Portraits, TASCHEN, Germany // *2015*, Do Unto Animals, Artisan, USA // *2014*, The New York Times, USA // *2012*, American Illustration, USA // *2011*, Illustrators Unlimited, Gestalten, Germany // *2010*, Communication Arts, Fresh section, USA // *2009*, Illusive, Gestalten, Germany

Portrait of Nico, 2005
Promotional, acrylic on
birch panel

Portrait of Jonathan
Galassi, 2012
Out magazine, acrylic
on birch panel

Lisel Ashlock 49

The fantastic magic of surrealism is all the more exquisite in the detailed representational tableaux that Lisel Jane Ashlock so delicately produces. She studied Illustration at California College of the Arts in San Francisco and in 2004 moved to New York City where she received her MFA at the School of Visual Arts in 2009. Working freelance as a designer and illustrator, her images have appeared in *CosmoGirl*, *Spin*, *Clamor* and ads for Sephora, and she has illustrated such well-known names as Sofia Coppola, Bob Dylan, Arcade Fire and Nico.

In den detailverliebten, gegenständlichen Tableaus, die Lisel Jane Ashlock mit großer Feinfühligkeit produziert, kommt die fantastische Magie des Surrealismus besonders exquisit zur Entfaltung. Sie studierte Illustration am California College of the Arts in San Francisco und ging 2004 nach New York, wo sie 2009 an der School of Visual Arts einen Master of Fine Arts erwarb. Die Bilder der freiberuflichen Designerin und Illustratorin erschienen in *CosmoGirl*, *Spin* und *Clamor*, außerdem gestaltete sie Anzeigen für Sephora und porträtierte so bekannte Personen und Gruppen wie Sofia Coppola, Bob Dylan, Arcade Fire oder Nico.

La magie fantastique du surréalisme est d'une délicatesse exquise dans les tableaux représentationnels ultra-détaillés de Lisa Jane Ashlock. Elle a étudié l'illustration au California College of the Arts de San Francisco, et en 2004 elle a déménagé à New York, où elle a reçu le MFA à la School of Visual Arts en 2009. Designer et illustratrice freelance, ses images ont été publiées dans *CosmoGirl*, *Spin*, *Clamor* ainsi que dans des publicités pour Sephora, et elle a illustré pour des noms de l'envergure de Sofia Coppola, Bob Dylan, Arcade Fire et Nico.

Transformation Cards
Left to right: King of
Spades, Four of Clubs,
Jack of Diamonds, 2012
Stranger & Stranger,
advertising, acrylic on
birch panel

Moby Dick, 2010
Table Talk magazine,
acrylic on birch panel

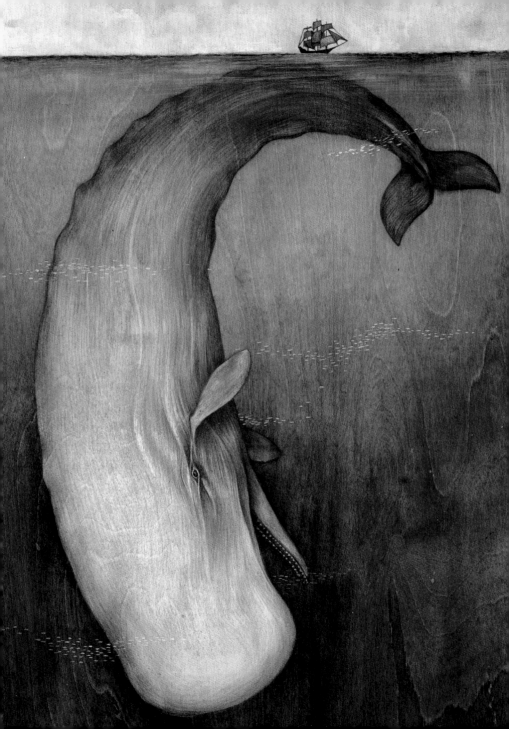

Istvan Banyai

1949 born in Budapest
Lives and works in New York and in Lakeville
www.ist-one.com

"An organic combination
of turn-of-the-century Viennese retro,
interjected with American pop, some European
absurdity added for flavor,
served on a cartoon-style color palette …
no social realism added."

The End of Print, 2009
The Atlantic Monthly,
cover for Fiction, pencil
and digital

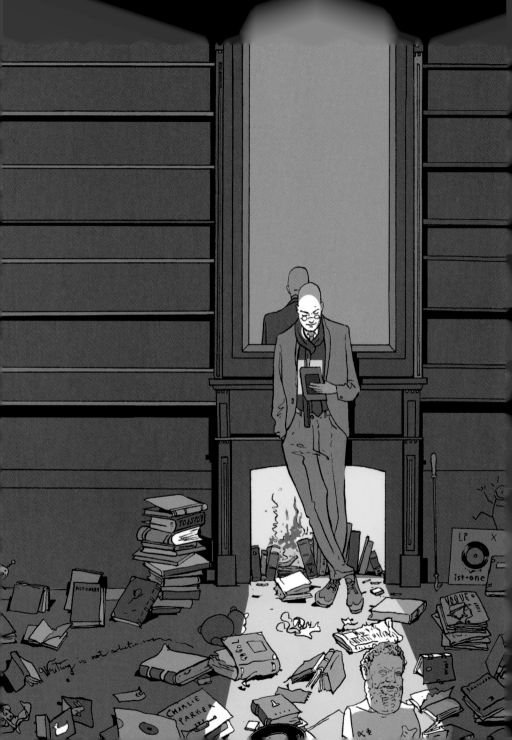

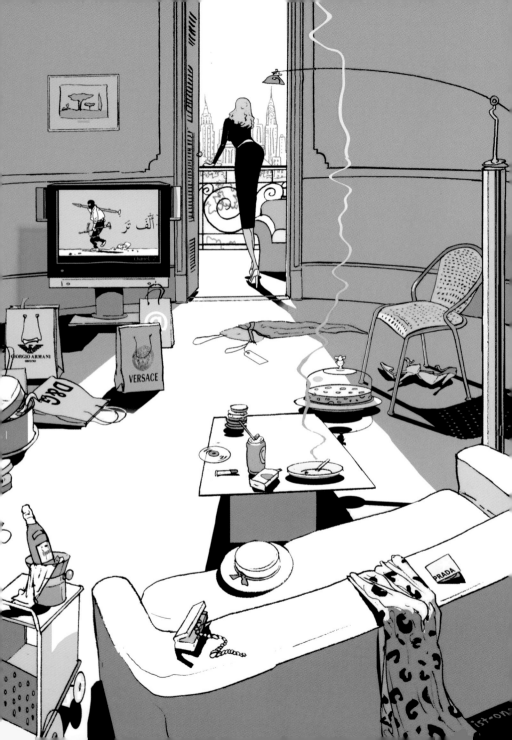

After the failed Hungarian uprising in 1956, when the occupying Soviet forces tightly shut the Iron Curtain again and proceeded to suck the life out of the nation's creative arts, replacing it with dreary Communist visual propaganda, for many Hungarians it felt as though art had been neutralized. Others, like Banyai, saw it as an opportunity to rebel against convention and revel in countless alternatives. In the 1980s he made a trial visit to New York with his portfolio and was to find that his work was perfect for the intellectual needs of *The New York Times* Op-Ed page, Week in Review and other sections that used "conceptual illustration" and "graphic commentary."

Als die sowjetische Besatzungsmacht nach dem gescheiterten Ungarn-Aufstand von 1956 den Eisernen Vorhang wieder fest verschlossen hatte und sich daranmachte, das künstlerische Leben des Landes zu ersticken und sein kreatives Potenzial durch trostlose kommunistische Propaganda zu ersetzen, hatten viele Ungarn das Gefühl, die Kunst wäre neutralisiert worden. Andere, wie Banyai, sahen es dagegen als Gelegenheit, gegen Konventionen aufzubegehren und zahllose Alternativen zu entwickeln. In den 1980er-Jahren reiste er mit seiner Mappe probehalber nach New York und stellte fest, dass seine Arbeiten genau dem intellektuellen Format bestimmter Teile der *New York Times* entsprachen – etwa der Op-Ed Page, der Week in Review und anderen, die mit „conceptual illustration" und „graphic commentary" arbeiteten.

Après l'échec de l'insurrection hongroise en 1956, lorsque les forces d'occupation soviétiques refermèrent le Rideau de fer et se mirent à éradiquer toute trace de vie dans les arts créatifs de la nation en imposant la grisaille de la propagande communiste, de nombreux Hongrois pensèrent que l'art avait été neutralisé. Mais d'autres, comme Banyai, y virent l'occasion de se rebeller contre les conventions et de se délecter des innombrables alternatives. Dans les années 1980, il fit une visite d'essai à New York avec son portfolio, et put constater que son travail convenait parfaitement aux besoins intellectuels de la colonne d'opinion du *New York Times*, Week in Review, ainsi que des autres sections qui utilisaient « l'illustration conceptuelle » et le « commentaire graphique ».

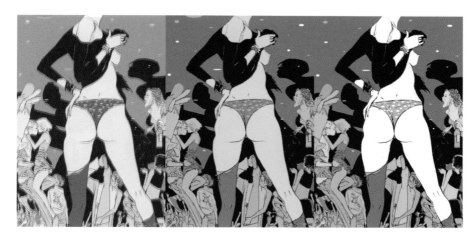

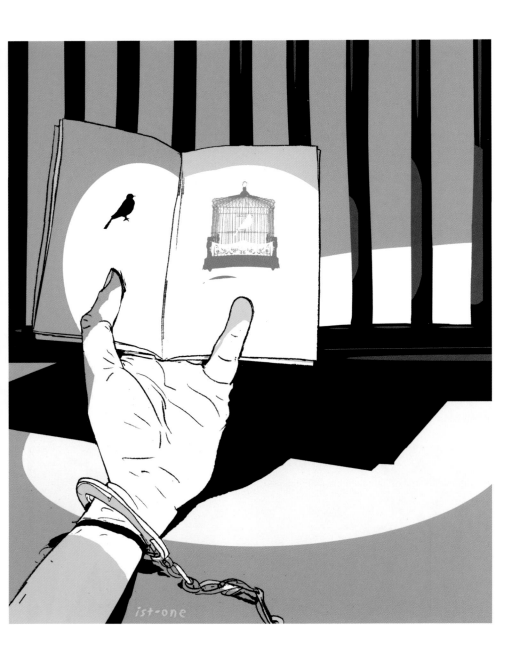

p. 54 The First Casualty
of War Is Truth, 2004
Anti-war poster, pencil
and digital

p. 55 Skins, 2011
The New Yorker, TV show,
pencil and digital

I'm Just a Bird in a Cage,
2005
The New York Times
Magazine, pencil
and digital

Art Collector, Finito,
Ist-One, 2004
GQ magazine, pencil
and digital

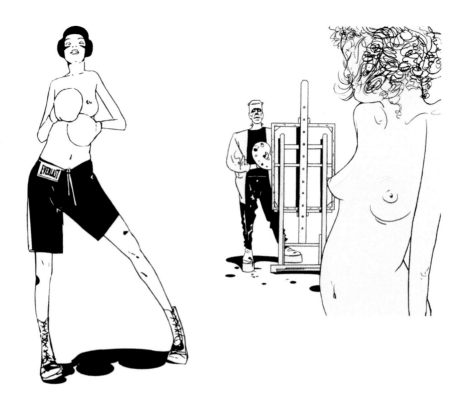

Rather than follow other artists' leads (or censors' decrees), Banyai asserts: "I can only see what makes sense to me. If I am lucky to have that, immediately a picture comes to mind. Now I just have to draw it." If his mind and body are in sync, as they usually are, he conjures an image that, he says, gets as close to that imaginary thing as possible. "It is all imitation, a semiotic game… [that] also works as therapy and—keeps me out of jail!"

Banyai hält sich nicht an die Vorbilder anderer Künstler (oder an die Vorgaben einer Zensur). „Ich kann nur sehen", sagt er, „was mir einleuchtet. Wenn das klappt, dann entsteht auch sofort ein Bild in meinem Kopf und ich brauche es nur noch zu zeichnen." Wenn sein Kopf und sein Körper in Einklang sind – was normalerweise der Fall ist –, beschwört er ein Bild, das nach seinen eigenen Worten so nah wie möglich an jenes imaginäre Ding herankommt. „Es ist alles Imitation, ein semiotisches Spiel… das auch als Therapie funktioniert und – mir den Knast erspart!"

Plutôt que de suivre le chemin tracé par les autres artistes (ou les décisions des censeurs), Banyai affirme : « Je ne peux voir que ce qui a du sens pour moi. Si j'ai la chance d'avoir cela, une image me vient à l'esprit immédiatement. Après, il ne me reste plus qu'à la dessiner. » Si son esprit et son corps sont en phase, il obtient une image qui, dit-il, est aussi proche que possible de cette chose imaginaire. « C'est de l'imitation, un jeu sémiotique… [qui] fonctionne aussi comme une thérapie, et m'évite de finir en prison ! »

SELECTED EXHIBITIONS — *2013*, Norman Rockwell Museum, solo show, Stockbridge // *2005*, Gödör, solo show, Budapest // *1988*, Immigrant Illustrators, group show, New York // *1980*, (Le fou parle) with Topor, group show, Paris // *1976*, Helicon Gallery, solo show, Budapest

SELECTED PUBLICATIONS — *2008*, Re-zoom, Paw Prints, USA // *2005*, Illustration Now! 1, TASCHEN, Germany // *2005*, 3x3 magazine, cover story, USA // *2001*, Minus Equals Plus, Abrams, USA // American Illustration, USA, every year since *1995* // *1995*, Zoom, Viking, USA

Boxer, 2010
Personal work, ink
on paper

The Joy of Sex, 2009
The New Yorker, pencil
and digital

Justin Bartlett

1977 born in San Diego
Lives and works in San Diego
www.vberkvlt.com

"Inspired by religious and theological
conflicts, environmental decay, and man's
inhumanity—embrace visual hell!!!"

Dead Since Birth, 2012
Personal work, ink

Macabre in the extreme, the work of Justin Bartlett, aka The Black Ink Warlock, uses eerie black and white, with a touch of blood-red, that recalls earlier masters of the horrible from Symbolist and Surrealist visionaries and, he says, "applies boundless visual style to depictions of the arcane." Bartlett's portfolio, representing clients of various kinds, reveals an illustrative language often derived from the occult, where theology and religion often meet in strife. His mastery of visual representations of various exponents of different genres of extreme music also extends to collaborations with visual and sound artist Stephen O'Malley of Sunn O))), as well as film, including Los Angeles-based SA Studios Global.

In seinem äußerst makabren Werk arbeitet Justin Bartlett, alias The Black Ink Warlock, mit gespenstischem Schwarz-Weiß und einem Hauch von Blutrot, das an frühere Meister des Schreckens aus der visionären Tradition der Symbolisten und Surrealisten erinnert und das, so Bartlett, „eine unendliche Vielfalt visueller Stile verwendet, um das Geheimnisvolle darzustellen". Bartletts Portfolio repräsentiert sehr unterschiedliche Kunden und offenbart eine illustrative Sprache, die sich vielfach aus dem Okkulten speist, wo Theologie und Religion gegeneinander kämpfen. Seine Meisterschaft in der visuellen Darstellung verschiedener Exponenten unterschiedlicher Genres extremer Musik zeigt sich auch in der Zusammenarbeit mit dem Bild- und Sound-Künster Stephen O'Malley von Sunn O))) oder bei Filmprojekten, etwa für die SA Studios Global in LA.

World Demise, 2007
Adbusters Norway,
magazine and poster, Art
Direction: Halvor Bodin,
pen and ink

Filth Rations, 2010
Trap Them, Southern
Lord Records, album
artwork, ink

Macabre à l'extrême, l'œuvre de Justin Bartlett, surnommé The Black Ink Warlock (Le Sorcier de l'encre noire), emploie un noir et blanc sinistre avec une touche de rouge sang qui rappelle les premiers maîtres de l'horrible des visionnaires symbolistes et surréalistes et, selon lui, «applique un style visuel sans limite à des représentations de l'impénétrable». Le portfolio de Bartlett comprend des clients très divers, et révèle un langage illustratif souvent dérivé de l'occulte, où la théologie et la religion entrent souvent en conflit. Sa maîtrise des représentations visuelles de différents genres de musique extrême s'étend aussi à des collaborations avec l'artiste visuel et sonore Stephen O'Malley du groupe Sunn O))) ainsi qu'au film, avec notamment SA Studios Global à Los Angeles.

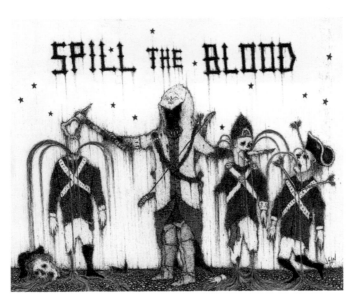

The Crystal World, 2010
Locrian, Utech Records,
album artwork, ink and
digital

Spill the Blood, 2012
Ubisoft/SA Studios Global,
poster and website, ink

SELECTED EXHIBITIONS — *2012*, *Invocation, group show, Meltdown, Hollywood //* ***2012****, Life and Death in Black and White, group show, Loren Naji Studio Gallery, Cleveland //* ***2010****, Corpse Corps: Urban Legends, group show, Signal Gallery, Brooklyn //* ***2010****, Dark Nature, group show, Poppy Sebire Gallery, London //* ***2008****, Catalyst, group show, FIFTY24SF Gallery, San Francisco*

SELECTED PUBLICATIONS — *2011*, *Out of Step magazine #3, Norway //* ***2011****, SOMA magazine #23, Brazil //* ***2009****, Illustration Now! 3, TASCHEN, Germany //* ***2009****, Terrorizer magazine #184, UK //* ***2009****, 3x3 Illustration Annual No. 5, USA*

Dead Raven Choir, 2008
Oaken Throne magazine,
pen and ink

Gary Baseman

1960 born in Los Angeles
Lives and works in Los Angeles
www.garybaseman.com

"I am a visual problem solver.
I find the essence of what needs to be
communicated and hit the viewer over the head
and smash his or her brain all over
the heart of my image."

Teacher's Pet, 2004
© Disney, acrylic on canvas

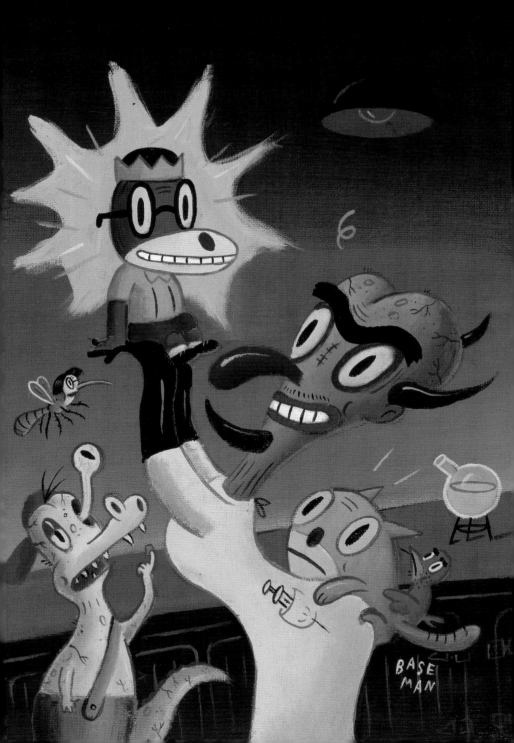

Boundaries routinely get pushed in Gary Baseman's comically dark cartoon representations of man and thing, as he reaches deep into his own psyche for these visual narratives. The most resonant virtue of Baseman's work is the way he adjusts his form and content to suit his time and place in life. His art, and maybe his life too, is a metaphorical candy-land replete with romping bug-eyed bunnies and bushy-tailed squirrels that reside in idyllic meadows filled with cone-headed homunculi (resembling KKK not-so-Grand Dragons), bulbous crawling babies, horned and fanged red devils, women with severed heads, and carloads of questionably prepubescent nymphets, among other surreal detritus.

In seinen komisch dunklen Cartoon-Darstellungen von Menschen und Dingen überschreitet Gary Baseman immer wieder Grenzen, indem er für diese visuellen Erzählungen tief in die eigene Psyche vordringt. Das Bemerkenswerteste an Basemans Werk ist die Art, wie er seine Formen und Inhalte jeweils orts- und zeitbezogen anpasst. Seine Kunst – und vielleicht auch sein Leben – ist ein metaphorisches Zuckerland, bevölkert von Häschen mit Glotzaugen und Eichhörnchen mit buschigem Schweif: Sie tummeln sich auf idyllischen Wiesen, umgeben von spitzköpfigen Homunkuli (die an etwas zu klein geratene Klansleute erinnern), herumkrabbelnden Knollenbabys, gehörnten roten Teufeln mit Reißzähnen, Frauen mit abgetrennten Köpfen, ganzen Waggonladungen voller präpubertierender Nymphchen und anderem surrealen Schutt.

Les représentations comiquement sombres de l'homme et des choses de Gary Baseman repoussent sans cesse les limites, car il puise au plus profond de son propre psychisme pour façonner ces récits visuels. La plus grande vertu du travail de Baseman, c'est la façon dont il adapte la forme et le contenu en fonction de sa propre situation. Son art, et peut-être aussi sa vie, est un paradis sucré où des lapins aux yeux comme des soucoupes et des écureuils aux queues foisonnantes s'ébattent dans des prairies idylliques remplies d'homoncules à tête conique (évoquant le KKK), de bébés bulbeux, de diables rouges cornus, de femmes sans tête et de brouettées de nymphettes possiblement prépubères, entre autres détritus surréels.

Bloody Smiles in Heaven,
2012
Personal work, acrylic
on canvas

Nightmare and the Cat,
2011
Album artwork, acrylic
on canvas

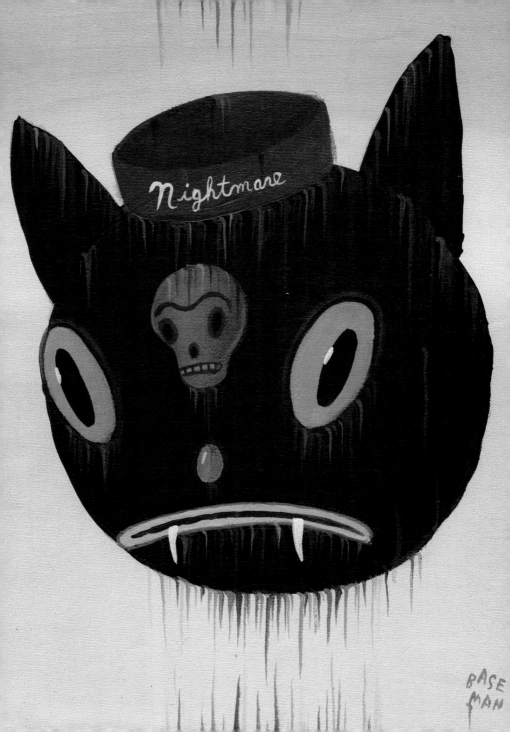

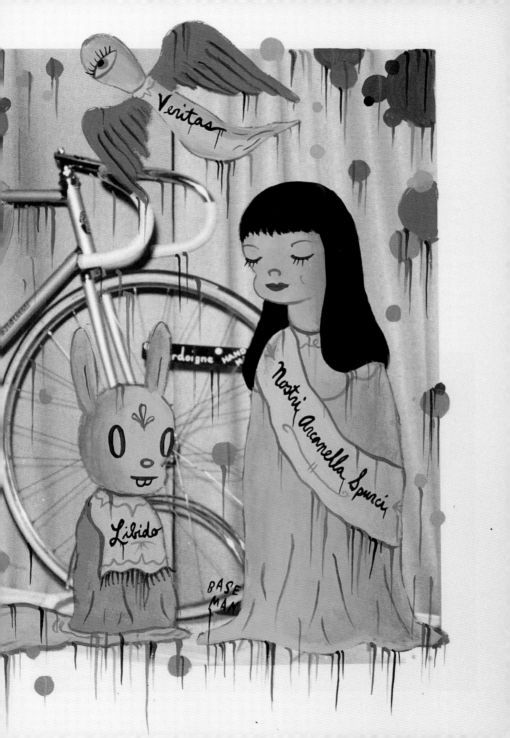

Baseman is expert at projecting illusions, and as an illustrator his work has appeared in such diverse realms as Target advertisements, *New Yorker* covers, table games and soda cans. But it is as a painter, printmaker, sculptor, or what some people call fine artist, that he has mostly explored the possibilities of narrative, through thematic exhibitions like "Vicious," "Walking Through Walls" and "The Sacrificing of the Cake," each a eulogy to childhood's demise.

Baseman versteht sich meisterhaft darauf, Illusionen zu projizieren, und hat als Illustrator in unterschiedlichsten Bereichen gearbeitet: von Anzeigen für Target und Cover-Abbildungen für den *New Yorker* bis hin zu Spieltischen und Soda-Dosen. Seine erzählerischen Möglichkeiten hat er jedoch am meisten in Malerei, Grafik und Plastik ausgelotet, beziehungsweise auf einem Gebiet, das manche Leute als „bildende Kunst" bezeichnen. Alle seine thematischen Ausstellungen wie „Vicious", „Walking Through Walls" und „The Sacrificing of the Cake" waren Elogen auf den Tod der Kindheit.

Baseman est expert en projection d'illusions, et en tant qu'illustrateur son travail a été vu dans des contextes aussi divers que des publicités pour Target, des couvertures du *New Yorker*, des jeux de société et des canettes de boisson. Mais c'est en tant que peintre, graveur et sculpteur qu'il a le plus exploré les possibilités de la narration, avec des expositions telles que «Vicious», «Walking Through Walls» et «The Sacrificing of the Cake», autant d'hommages à la défaite de l'enfance.

pp. **70**/**71** Untitled, 2010
Cinelli 2011 line, acrylic
on photographic paper

↙ Mystic Order of
the Cypress Park Beauty
Salon, 2011
Personal work, gallery
show Walking Through
Walls, Jonathan LeVine
Gallery, NY, acrylic
on canvas

The Luchador and the
Mermaid, 2011
Proximo Spirits, 1800
Tequila artist series bottle
design, acrylic on canvas

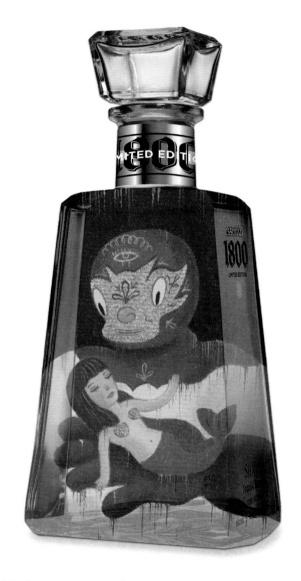

SELECTED EXHIBITIONS — *2016*, *My Eyes Are Bigger Than My Stomach, solo show, Drake One Fifty, Toronto* // *2014*, *The Door Is Always Open, solo show, MOCA, Taipei* // *2011*, *Walking Through Walls, solo show, Jonathan LeVine Gallery, New York* // *2009*, *La Noche de la Fusión, solo show, Corey Helford Gallery, Culver City, Los Angeles* // *2007*, *Hide and Seek in the Forest of ChouChou, solo show, Billy Shire Fine Arts, Los Angeles* // *2005*, *For the Love of Toby, solo show, Billy Shire Fine Arts, Los Angeles* // *1999*, *Dumb Luck, solo show, Mendenhall Gallery, Los Angeles*

SELECTED PUBLICATIONS — *2013*, *Gary Baseman: The Door is Always Open, Rizzoli, USA* // *2008*, *Dying of Thirst, Last Gasp, USA* // *2008*, *Knowledge Comes with Gas Release, Iguapop Gallery, Spain* // *2007*, *My Hunger for Venison, Baby Tattoo, USA* // *2004*, *Dumb Luck: The Art of Gary Baseman, Chronicle Books, USA*

Billie Jean

2002 founded in London
Located in London
www.billiejean.co.uk

"I take a petticoat tail shortbread from
my biscuit barrel and dunk it in my coffee.
After the wet shortbread flops into my mouth,
I can then put pencil on paper."

All Roads Lead to the
Slaughterhouse, 2012
Personal work, ballpoint
pen and digital

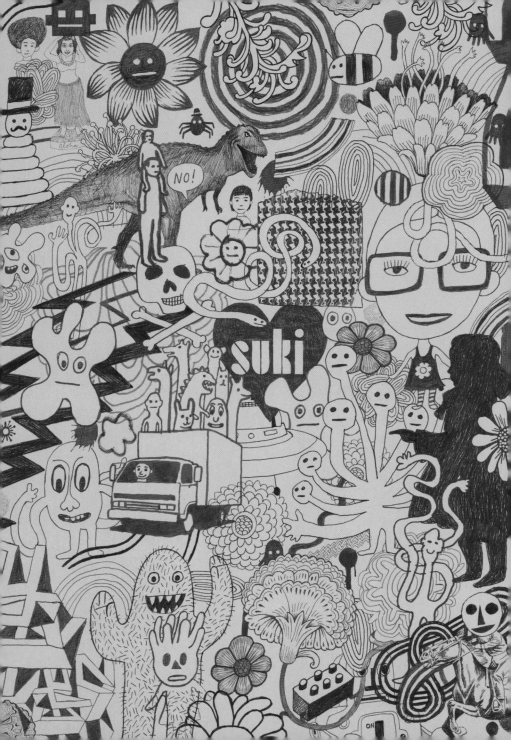

SELECTED EXHIBITIONS — 2011, Biro, group show, *The White Gallery, Milan* // 2010, *Design Less,* group show, Ofr. Galerie, Paris // 2010, *Fax-Ex Machina,* group show, KK Outlet, London // 2004, *Ballpoint,* group show, Pentagram, London // 2004, *Common Ground,* group show, National Art Gallery, Kuala Lumpur

SELECTED PUBLICATIONS — 2013, *Just Draw It!, Barron's, USA* // 2012, *The Fundamentals of Illustration, AVA, UK* // 2011, *Typography Sketchbooks,* Princeton Architectual Press, USA // 2010, *The Picture Book,* Laurence King, UK // 2009, *What Is Illustration?,* Rotovision, UK

← If I could do anything tomorrow, I would spend more time with Suki, 2007 If you could do anything tomorrow, what would it be? Issue 2, ballpoint pen and digital

↗ Tiny Sticks, 2007 Tiny Sticks Records, sleeve design, brush, ink and digital

→ Chic, 2004 Native Weapon magazine, watercolor, ink and digital

The world as seen by Billie Jean is utilitarian yet garnished with graphic absurdities, where odd juxtapositions cause the otherwise common objects of his consumer culture vision to proliferate in abundance. Yes, he is not a she, but a he whose real name is Samantha: "Samantha is a rather butch boy's name in Sri Lanka, where my parents come from," he says. "Truth is stranger than fiction!" Billie Jean's first illustration published in *The Sunday Times* appeared when he was only 16 years old. His handwork is clearly predominant, although some of it is obviously colored or retouched on screen.

Die Welt, wie Billie Jean sie sieht, ist zweckbestimmt, aber doch mit grafischen Absurditäten garniert, in denen ein merkwürdiges Nebeneinander eigentlich banaler Objekte der Konsumkultur für die Entfaltung von wahrem Überfluss sorgt. Nein, er ist keine Frau, sondern ein Mann, der in Wirklichkeit Samantha heißt: „In Sri Lanka, der Heimat meiner Eltern, ist Samantha ein richtiger Jungenname", sagt er. „Die Wahrheit ist seltsamer als die Fiktion!" Seine erste Illustration veröffentlichte Billie Jean bereits als Sechzehnjähriger in der *Sunday Times*. Seine handwerkliche Technik lässt sich deutlich erkennen, obwohl manches auch eindeutig am Bildschirm koloriert oder retuschiert wurde.

Vu à travers les yeux de Billie Jean, le monde est utilitaire, et regorge pourtant d'absurdités graphiques. Des juxtapositions étranges font proliférer les objets courants de sa vision de la culture de la consommation. Non, il n'est pas une femme, mais bien un homme dont le vrai nom est Samantha : « Samantha est un nom de garçon plutôt viril au Sri Lanka, d'où viennent mes parents, explique-t-il. La vérité dépasse la fiction ! » Lorsque sa première illustration a été publiée dans *The Sunday Times*, Billie Jean n'avait que 16 ans. La majeure partie de son travail est dessinée à la main, mais certaines images sont manifestement colorées ou retouchées à l'écran.

Design Less, 2010
DDB Paris, exhibition,
Creative Direction: Tashi
Bharucha, modeling clay,
acrylic, ballpoint pen,
photography and digital

Nike Air Max Lebron VII,
Artist Series, 2009
Nike, Creative Direction:
Michael Spoljaric, acrylic

Guy Billout

1941 born in Decize, France
Lives and works in Fairfield, Connecticut
www.guybillout.com

"What I consider my best work, is mostly illustrations for which I am granted total freedom, like the series I do for the Atlantic Monthly, and for the stories I write and illustrate for children's books. Yet, I remain 'addicted' to impossible deadlines, and stories deemed impossible to illustrate by art directors."

Midnight, 2011
Finyear, cover, digital
magazine, hand-drawn
and digital

SELECTED EXHIBITIONS — *2012*, Des Equilibres, solo show, Galerie Petits Papiers, Paris // *2012*, Three Perspectives, group show, Dedee Shattuck Gallery, Westport // *2006*, D'île en île, solo show, Centre Culturel, Decize // *2003*, Un dessinateur nivernais à New York, solo show, Palais Ducal, Nevers

SELECTED PUBLICATIONS — *2014*, The Frog Who Wanted To See The Sea, Creative Editions, USA // *2013*, Finyear magazine, France // *2013*, Penguin Books, UK // *2012*, The Atlantic, USA // *2011*, The New York Times, USA // *2011*, The New Yorker, USA

Island, 2012
The Atlantic magazine,
hand-drawn and digital

Fortissimo, 2011
The Atlantic magazine,
hand-drawn and digital

Night Patrol, 2012
The Atlantic magazine,
hand-drawn and digital

Like Tintin's creator, the great Hergé, Guy Billout recreates the precise outlines of the real world as set in the improbability of a dreamscape. Never scary but always mysterious, his dislocations are truths waiting to be discovered. He calls this the "Divine Surprise," when something unexpected occurs and one says, "My God, where is that coming from?" Billout worked in advertising after completing his schooling in art in Beaune, France, then in 1969 moved to New York where he made his name upon getting his work published in *New York* magazine, and found a fan in its Design Director and co-founder, Milton Glaser.

Wie Tintins Schöpfer, der große Hergé, skizziert auch Guy Billout sehr präzise die Umrisse einer realen Welt, die als Kulisse einer unwirklichen Traumlandschaft dient. Seine nie unheimlichen, aber immer geheimnisvollen Verlagerungen sind Wahrheiten, die nur darauf warten, entdeckt zu werden. Er nennt es die „göttliche Überraschung", wenn etwas Unerwartetes eintritt und man sich fragt: „Mein Gott, wo kommt das denn her?" Nach seinem Kunststudium in Beaune arbeitete Billout in der Werbebranche und ging 1969 nach New York. Mit seinen Illustrationen in der Zeitschrift *New York*, deren Design Director und Mitbegründer Milton Glaser zu einem Fan von ihm wurde, machte er sich einen Namen.

Tout comme le créateur de Tintin, le grand Hergé, Guy Billout recrée les contours précis du monde réel dans des mondes oniriques. Jamais menaçantes mais toujours mystérieuses, ses décompositions sont des vérités qui attendent d'être découvertes. Il appelle cela la « divine surprise », lorsque quelque chose d'inattendu survient, et que l'on se dit : « D'où cela peut-il bien sortir ? » Après ses études artistiques à Beaune, en France, Billout travailla dans la publicité. Puis, en 1969, il partit à New York, où la publication de son travail dans le magazine *New York* l'aida à se faire un nom. Il y trouva aussi un fan dans la personne du directeur du design et cofondateur du magazine, Milton Glaser.

Civil Engineering, 2001
The Atlantic Monthly,
watercolor and airbrush

Fortitude, 1990
The Atlantic Monthly,
watercolor and airbrush

Tim Biskup

1967 born in Santa Monica
Lives and works in La Cañada
www.timbiskup.com

"Most of my work is personal and/
or allegorical. I occasionally do illustration work,
but focus mainly on the fine art world,
showing in galleries and museums."

The Golden Chord
of Time, 2009
Personal work, cel-vinyl
acrylic on panel

Pingala, 2006
Personal work, gouache
in paper

Doom Loop #19, 2012
Personal work, graphite
and cel-vinyl acrylic on
paper

pp. 90/91 Golden Plague,
2004
Personal work, cel-vinyl
acrylic and gold leaf
on panel

Tim Biskup's painterly style is a contemporary mash-up of Cubist, Expressionist and Impressionist tendencies with a sprinkling of references from popular culture spicing up the stew. Biskup belongs to a "league" of contemporary artists—painters, toy designers and object-makers—concerned with pushing boundaries and mediums while dipping into the entrepreneurial world. Leaving Otis College in 1988 after two years, he followed his own muse and found technical tutoring as an illustrator, animator and graphic designer, his aesthetic clearly developing from roots that run deep into both punk and Disney.

Tim Biskups Malstil ist ein moderner Verschnitt aus kubistischen, expressionistischen und impressionistischen Tendenzen, hie und da durchsetzt von Zitaten der Popkultur, die dem Ganzen die nötige Würze verleihen. Biskup gehört zu einer „Liga" zeitgenössischer Künstler – Maler, Spielzeug- und Objektdesigner –, die gerne grenzüberschreitend arbeiten, zwischen den Medien hin- und herpendeln und gelegentlich auch für Unternehmen tätig werden. Nach zwei Jahren am Otis College, das er 1988 verließ, folgte er lieber seiner eigenen Muse und entwickelte seine Technik als Illustrator, Animator und Grafikdesigner weiter aus. Daraus entstand eine Ästhetik, die eindeutig ebenso vom Punk wie von Disney beeinflusst ist.

Le style de Tim Biskup est une fusion contemporaine de tendances cubistes, expression-nistes et impressionnistes avec une pincée de références de la culture populaire pour épicer le tout. Biskup appartient à une « ligue » d'artiste contemporains – peintres, créateurs de jouets et d'objets – qui veulent tester les limites et les techniques tout en explorant l'aspect commercial. Il a quitté l'Otis College en 1988, après deux années d'études pour suivre sa propre inspiration, et a trouvé des cours particuliers d'illustration, d'animation et de graphisme. Son esthétique s'est clairement développée à partir de racines qui plongent aussi profondément dans le punk que dans Disney.

SELECTED EXHIBITIONS — 2015, Space Madness, solo show, Kong Art Space, Hong Kong *// 2015*, A Step Felt In Full, group show, Slow Culture, Los Angeles *// 2013*, CHARGE, solo show, Martha Otero Gallery, Los Angeles *// 2012*, Excavation, solo show, Antonio Colombo Gallery, Milan *// 2011*, Former State, solo show, THIS Gallery, Los Angeles *// 2009*, The Mystic Chords of Memory, solo show, Iguapop Gallery, Barcelona

SELECTED PUBLICATIONS — 2010, Prepare For Pictopia, Pictoplasma, Germany *// 2008*, The Artist in You, Baby Tattoo Books, USA *// 2007*, Illustration Now! 2, TASCHEN, Germany *// 2007*, The Upset, Gestalten, Germany *// 2006*, American Cyclops, Iguapop, Spain

Cathie Bleck

1956 born in Waukegan
Lives and works in Cleveland
www.cathiebleck.com

"I record and observe nature's sensory
detail in inks and clay in a medium
which has an affinity with wood engraving,
illustrating opposing forces."

In Awe, 2010
Personal work, Aqua
Wynwood, exhibition,
Art Basel Miami Beach,
Curation: Mark Murphy,
ink, gold leaf and
handmade paint on clay

Scratchboard work can either be stiff or fluid, but Cathie Bleck's flowing lines and stark graphics achieve both aesthetics in one perfect marriage—a combination of Beardsley and Blake, her work is lyrical and lovely. Working in scratchboard as well as kaolin clayboard, her drawings are painstakingly cut through inks and handmade pigments, revealing the white of the kaolin clay beneath. It is a dark medium that demands the balancing of negative space. Concept is important, and through the exploration of symbolic narrative imagery, Bleck says, "I speak to relationships that are intrinsic, permeating through human experience. I rely on intense contrasts of tone and imagery to form dualities of interconnectedness."

Scratchboard-Technik kann steif oder flüssig sein, aber in Cathie Blecks fließenden Linien und starrer Grafik verbinden sich beide Arten von Ästhetik auf perfekte Weise: Ihr Werk – eine Kombination aus Beardsley und Blake – ist lyrisch und wunderschön. In ihren Scratchboard- und Clayboard-Zeichnungen arbeitet sie sehr sorgfältig mit Tuschen und handgemachten Pigmenten, hinter denen das Weiß des Kaolin-Tons zum Vorschein kommt. Es ist ein dunkles Medium, das die ausgewogene Behandlung von negativen Räumen erfordert. Wichtig ist das Konzept, und beim Ausloten einer symbolischen, narrativen Bildsprache findet Bleck „zu inneren Beziehungen, die die menschliche Erfahrung durchdringen. Ich arbeite mit starken Kontrasten von Farbtiefe und Bildlichkeit, um Dualitäten der Vernetzung zu gestalten."

Le travail sur carte à gratter peut être rigide ou fluide, mais les lignes coulées et le graphisme marqué de Cathie Bleck s'allient pour marier les deux esthétiques – une combinaison de Beardsley et de Blake, lyrique et charmante. Ses dessins sur carte à gratter ou sur panneau de kaolin sont méticuleusement gravés à travers des couches d'encres et de pigments faits à la main pour révéler le fond en kaolin. C'est un support foncé qui exige d'équilibrer l'espace négatif. Le concept est important, et en explorant l'imagerie narrative symbolique, explique Bleck, «je parle à des relations qui sont intrinsèques, qui imprègnent l'expérience humaine. J'ai recours à des contrastes intenses de ton et d'imagerie pour créer des dualités interconnectées».

Deer, 2013
US Post Office, postage
stamp, ink on scratchboard

New Feathers, 2013
Personal work, ink and
handmade paint on
clayboard

Rethinking Deforestation,
2006
The New York Times,
ink on scratchboard

Cathie Bleck 95

SELECTED EXHIBITIONS — 2015,
Avance, Firecat Projects, Chicago //
2013, frAGILITY: Works on Papyrus,
Packer Schopf Gallery, Chicago // 2009,
Undercurrents, Billy Shire Fine Arts,
Los Angeles // 2008, Becoming Human:
New Works, solo show, Butler Institute of
American Art, Youngstown, Ohio // 2008,
Mid-Career Retrospective, New Britain
Museum of American Art, New Britain //
2006, Open Spaces, solo show, I Space
Gallery, Chicago

SELECTED PUBLICATIONS — 2015,
Hi Fructose magazine, USA // 2012,
Juxtapoz magazine, August issue,
USA // 2009, Illustration Now! 3,
TASCHEN, Germany // 2007, Scratching
the Surface, Time Out Chicago, August
issue, USA // 2005, 3x3 magazine,
volume 2, number 1, USA // 1999,
Communication Arts magazine,
September issue, USA

Moon Lady, 2008
Good Earth Tea, packaging,
ink on scratchboard

Mother Nature's
Son Two, 2006
Open Spaces, artist's
monograph, cover, ink
on scratchboard

Nature's Myth, 2007
US State Department,
poster for the 2007
US Earth Day, ink on
clayboard panel

Jörg Block

1974 born in Siegburg, Germany
Lives and works in Hamburg
www.joergblock.de

"Illustration plays with associations.
I find the contrast between the prosaic
allure of vector graphics and hidden
meanings very exciting."

Forschung 1, 2012
Hamburg University of
Applied Sciences, annual
report, digital

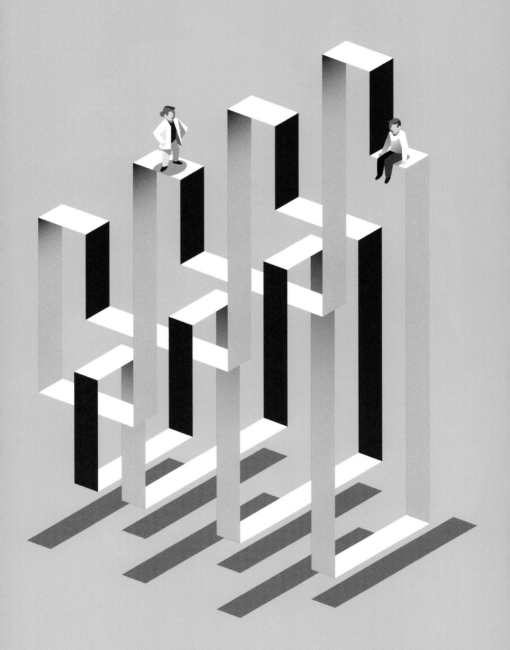

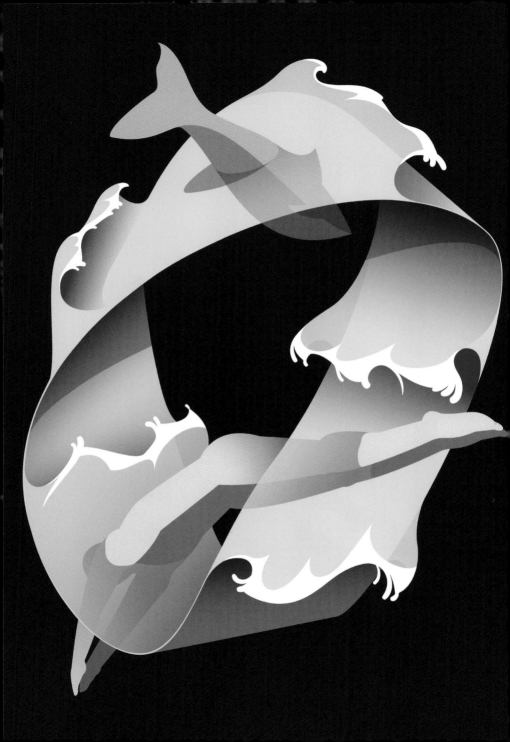

Although his works are soft like natural cotton and their concepts are likewise deceptively innocent, Jörg Block's illustration is by no means designed to soothe, but rather to spark the senses and stimulate comprehension. Block worked several years as a graphic designer in e-business companies, handling print and corporate, as well as web and screen design. He then moved on to study illustration at the Hamburg University of Applied Sciences, concentrating initially on artistic basics and painting. His special interest is creating illustrations that comment on editorial content in an idiosyncratic and pointed way.

Obwohl seine Bilder so weich sind wie natürliche Baumwolle und man ihre Konzepte für harmlos halten könnte, will Jörg Blocks Illustration alles andere als beschwichtigen, sondern vielmehr die Sinne schärfen und zu Verständnis anregen. Block arbeitete mehrere Jahre als Grafikdesigner im E-Business und kreierte Drucksachen und das Corporate Design von Firmen sowie Web- und Screen-Designs. Anschließend studierte er Illustrationsdesign an der Hamburger Hochschule für Angewandte Wissenschaften (HAW Hamburg), wo er sich zunächst auf künstlerische Grundlagen und Malerei konzentrierte. Besonders gerne macht er Illustrationen, die redaktionelle Inhalte auf ganz eigene und zugespitzte Weise kommentieren.

Bien qu'elles soient douces comme du coton et que leurs concepts soient d'une innocence trompeuse, les illustrations de Jörg Block n'ont certainement pas pour but de calmer les sens, mais au contraire de les éveiller et de stimuler la compréhension. Block a travaillé plusieurs années en tant que graphiste dans des entreprises de commerce électronique, où il s'occupait de la charte graphique, de l'identité d'entreprise et de la conception web. Puis il a étudié l'illustration à l'École supérieure des sciences appliquées de Hambourg, où il s'est d'abord concentré sur les bases de l'art et la peinture. Il aime particulièrement créer des illustrations qui expriment un commentaire sur un contenu rédactionnel de façon personnelle et pointue.

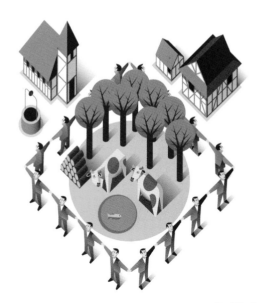

Meer 1, 2010
Personal work, poster,
digital

Allmende 1, 2012
Rotary magazine, digital

He was winner of the 2007 Adobe Design Achievement Award for Digital Illustration, and the following year produced image work for the *Forschungskalender der HAW Hamburg*, a research calendar for Hamburg University of Applied Sciences where he had studied. "I used striking, funny, or droll images to inspire spontaneous interest in the featured research subjects," he said, and indeed research and drawing are equally important to Block, who delves into his themes deeply and then creates all his forms digitally using the rectangle and ellipse shapes, pencil tools, or by combining shapes with Pathfinder. The results speak for themselves.

2007 gewann er den Adobe Design Achievement Award in der Kategorie „Digitale Illustration", und im Jahr darauf produzierte er Bilder für den *Forschungskalender der HAW Hamburg*. „Ich verwendete überraschende, witzige oder komische Bilder, um ein spontanes Interesse für den jeweiligen Forschungsgegenstand zu wecken", so Block, für den Forschung und Zeichnung in der Tat gleichermaßen wichtig sind: Zunächt vertieft er sich in die Themen, um dann seine rechteckigen und elliptischen Formen zu entwickeln, die er mithilfe digitaler Zeichenwerkzeuge kreiert oder mit Pathfinder kombiniert. Die Resultate sprechen für sich selbst.

Il a remporté le prix Adobe design Achievement d'illustration numérique en 2007, et l'année suivante il a illustré le *Forschungskalender der HAW Hamburg*, le calendrier de la recherche de l'Université des sciences appliquées de Hambourg, où il a fait ses études. « J'ai utilisé des images frappantes ou drôles pour susciter un intérêt spontané pour les sujets de recherche présentés », a-t-il expliqué, et il est vrai que la recherche et le dessin ont la même importance pour Block, qui aime plonger dans ses sujets et créer toutes ses formes numériquement à partir de rectangles et d'ellipses, d'outils stylo ou en combinant les formes avec Pathfinder. Les résultats se passent de commentaires.

SELECTED EXHIBITIONS — 2010, Red Dot Design Award, winners' exhibition, Germany // *2009*, Adobe Design Achievement Award, winners' exhibition, China // *2008*, Bologna Illustrators Exhibition, group show, Italy // *2008*, Red Dot Design Award: Communication, winners' exhibition, Germany // *2007*, Adobe Design Achievement Award, winners' exhibition, San Francisco

SELECTED PUBLICATIONS — 2016, Hightech Hack: Modern Technologies – Explained And Illustrated, Gestalten, Germany // *2012*, Deutschlandkarte, 102 neue Wahrheiten, Knaur Taschenbuch, Germany // *2011*, Illustration Now! 4, TASCHEN, Germany // *2009*, Deutschlandkarte: 101 unbekannte Wahrheiten, Knaur Taschenbuch, Germany

Moving On 1, 2012
Raiffeisen Centrobank
AG, annual report,
Art Direction: Brainds,
Vienna, digital

Forschung 2, 2012
Hamburg University of
Applied Sciences, annual
report, digital

Julia Breckenreid

1970 born in Kitchener
Lives and works in Toronto
www.breckenreid.com

"I specialize in editorial, got myself
a gold medal for it. Secondly, I'm an educator
and illustration community activist."

Lipreading, 2013
Stanford magazine,
acrylic, paper and digital

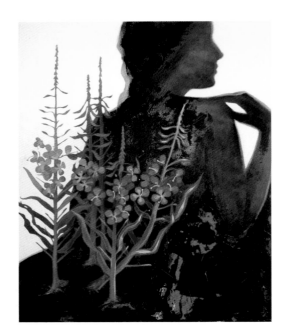

SELECTED EXHIBITIONS — 2013, Society of Illustrators 55, group show, New York // *2012*, Fall Classic, group show, SMASH Gallery, Toronto // *2010*, Society of Illustrators 52, group show, New York // *2009*, Cut to the Drummer, group show, Steam Whistle Gallery, Toronto // *2005*, Boy's Club, group show, Receiver Gallery, San Francisco

SELECTED PUBLICATIONS — 2016, O Magazine, USA // *2013*, Society of Illustrators 55, USA // *2011*, Communication Arts, USA // *2010*, Society of Illustrators 52, USA // *2009*, American Illustration 28, USA // *2008*, 3x3 ProShow, USA

The Winter Vault:
Fire Weed, 2012
Personal work,
acrylic on wood panel

Tissue Donor, 2012
The New York Times,
acrylic on paper

Alcoholism, 2010
The Washington Post,
acrylic, paper and digital

Impressions of sadness and expressions of solitude appear to flood Julia Breckenreid's paintings, which can at times be wistful, at other times confrontational—but always full of impact. Breckenreid graduated from art school in 1998, and in common with the inspired conceptual illustrators known from her native Toronto she keeps a laser focus on her career: "I'm an illustrator: conceptual, intuitive and versatile," she asserts. Her illustrations have gained recognition from several awards annuals and associations, including a gold medal in 2010 from the Society of Illustrators. Her clients include *The New York Times*, *The Washington Post*, *The Globe and Mail*, Chronicle Books, Penguin Canada, Soapbox and Anderson DDB.

Julia Breckenreids Gemälde strahlen etwas Trauriges und Einsames aus, gelegentlich können sie schwermütig sein, dann wieder angriffslustig – immer aber entfalten sie eine große Wirkung. Seit Abschluss ihres Kunststudiums 1998 konzentriert sie sich wie die anderen inspirierten themenzentrierten Illustratoren ihrer Heimatstadt Toronto ganz auf ihre berufliche Entwicklung: „Ich bin Illustratorin: konzeptuell, intuitiv und vielseitig", erklärt sie. Ihre Illustrationen wurden mehrfach ausgezeichnet, unter anderem gewann sie 2010 eine Goldmedaille der Society of Illustrators. Zu ihren Auftraggebern gehören die *New York Times*, die *Washington Post*, die *Globe and Mail*, Chronicle Books, Penguin Canada, Soapbox und Anderson DDB.

Les peintures de Julia Breckenreid semblent inondées de tristesse et de solitude, parfois teintées de mélancolie, parfois de confrontation, mais toujours pleines d'impact. Breckenreid a obtenu son diplôme de l'école d'art en 1998, et à l'instar des illustrateurs conceptuels inspirés qu'elle a connus dans sa ville natale de Toronto, elle a des idées précises sur sa carrière : « Je suis une illustratrice : conceptuelle, intuitive et polyvalente », affirme-t-elle. Ses illustrations ont été saluées par plusieurs récompenses annuelles et associations, notamment une médaille d'or de la Society of Illustrators en 2010. Elle compte parmi ses clients le *New York Times*, le *Washington Post*, le *Globe and Mail*, Chronicle Books, Penguin Canada, Soapbox et Anderson DDB.

Pink Horse, 2013
Personal work, Society of
Illustrators 55, American
Illustration 31, acrylic,
paper and digital

Lady Bird, 2012
Personal work,
acrylic on wood panel

Steve Brodner

1954 born in Brooklyn
Lives and works in New York
www.stevebrodner.com

"Illustration is about storytelling.
If done well it is compelling,
beautiful and unforgettable."

Hillary et al., 2008
Newsweek, watercolor

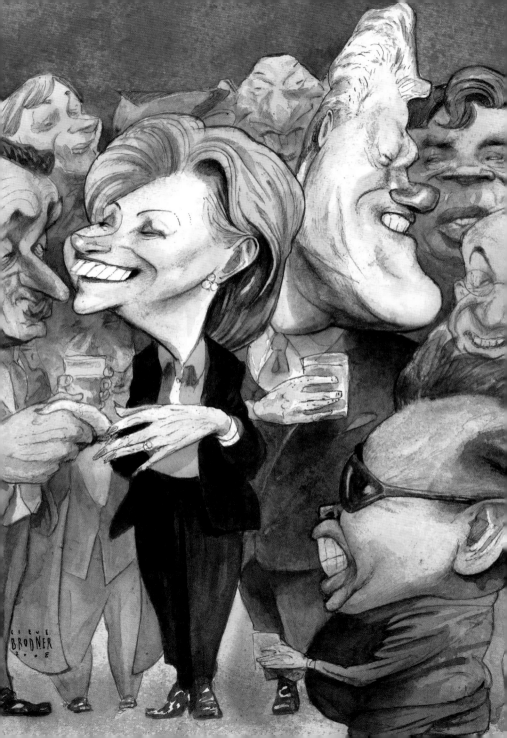

Achieving the perfect caricature demands a skillful ability with gesture, which is Steve Brodner's claim to mastery. Capturing facial tics is his talent, but defining his subject's expressive tics is his magic. Brodner is a satirical illustrator known for stunning likenesses and savage representations; being blessed with an incredible cast of characters, for many years (and several Presidential administrations) it has been like shooting fish in the proverbial barrel. Which isn't to say he takes mere potshots, since Brodner is one of the best of what might be called the "second generation" of American graphic commentators—the first being David Levine, Ed Sorel, Jules Feiffer and Robert Grossman.

Die perfekte Karikatur erfordert eine hohe Auffassungsgabe für Gestik und Mimik, und genau das macht Steve Brodners Meisterschaft aus. Er besitzt ein Talent, Gesichtszüge einzufangen, aber seine wahre Magie besteht darin, die individuellen Ticks seiner Personen herauszuarbeiten. Brodner ist ein satirischer Illustrator und dafür bekannt, seine Modelle mit umwerfender Ähnlichkeit, aber verrissen zu porträtieren. Er verfügt über ein unglaubliches Figurenrepertoire, und viele Jahre lang (und über mehrere US-Administrationen hinweg) bewegte er sich praktisch außer Konkurrenz. Was nicht heißen soll, er habe es leicht. Vielmehr ist Brodner ein typischer Vertreter der „zweiten Generation" amerikanischer Politkarikaturisten – die ersten waren David Levine, Ed Sorel, Jules Feiffer und Robert Grossman.

Arriver à la caricature parfaite demande une compréhension experte du geste, et c'est de là que vient tout l'art de Steve Brodner. Capter les tics du visage est son talent, mais définir les tics d'expression de ses sujets relève du don de magie. Brodner est un illustrateur satirique connu pour ses portraits incroyablement ressemblants et incisifs. Il a eu la chance de travailler sur une magnifique galerie de sujets, et pendant de nombreuses années (et plusieurs administrations présidentielles), ça a été carton sur carton. Ce qui ne veut pas dire qu'il se contente de coups faciles, car Brodner et l'un des plus éminents représentants de ce que l'on peut appeler la « deuxième génération » des commentateurs graphiques américains, la première étant composée de David Levine, Ed Sorel, Jules Feiffer et Robert Grossman.

SELECTED EXHIBITIONS — 2013, Society of Illustrators 55, group show, New York // 2011, Being American, group show, Visual Arts Gallery, New York // 2008, Artists Against the War, group show, Society of Illustrators, New York // 2008, Raw Nerve! The Political Art of Steve Brodner, solo show, Norman Rockwell Museum, Stockbridge

Self-Eating Elephant, 2012
Mother Jones magazine,
watercolor

pp. 114/**15** Steve Jobs/
Beatles, 2007
Fortune magazine,
watercolor

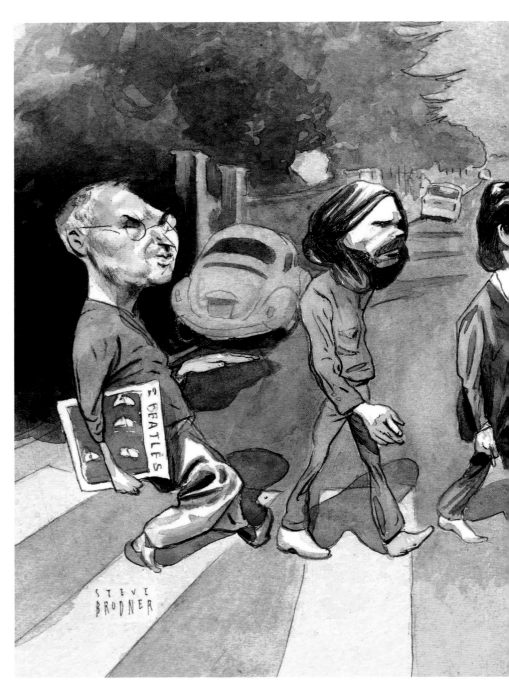

STEVE
BRODNER

Brodner has covered eight national political conventions for *Esquire*, *The Progressive*, *Village Voice* and other publications. For *The New Yorker* he covered Oliver North and the 1994 Virginia Senate race, the Pat Buchanan Presidential campaign, the Million Man March and an advance story on the Democratic Convention in Chicago, 1996. He is currently editor of *The Nation*'s cartoon feature, Comix Nation. He still contributes regularly to *The New Yorker* and during the 2008 Presidential campaign produced a video about his work. The same year, an exhibition of his political art was mounted at the Norman Rockwell Museum in Stockbridge, Massachusetts. And he continues to fight power with his pen.

Für den *Esquire*, *Progressive*, *Village Voice* und andere Medien begleitete Brodner acht Parteitage mit dem Zeichenstift. Im Auftrag des *New Yorker* illustrierte er Oliver North 1994 bei seiner Kandidatur für den Senat von Virginia, Pat Buchanans Präsidentschaftskampagne, den «Million Man March» sowie einen Vorabbericht über den Parteitag der Demokraten in Chicago von 1996. Zurzeit verantwortet er die Cartoon-Seiten von *The Nation*, Comix Nation. Er veröffentlicht nach wie vor regelmäßig im *New Yorker*, und anlässlich des Präsidentschafts- wahlkampfes 2008 produzierte er ein Video über seine Arbeit. Im selben Jahr stellte das Norman Rockwell Museum in Stockbridge, Massachusetts, seine politischen Karikaturen aus. Und noch immer stellt er sich dem Kampf mit dem Zeichenstift gegen die Mächtigen.

Brodner a couvert huit conventions politiques nationales pour *Esquire*, *Progressive*, *Village Voice* et d'autres publications. Pour le *New Yorker* il a couvert Oliver North et la campagne pour le poste de sénateur en Virginie en 1994, la campagne présidentielle de Pat Buchanan, la «Million Man March», et un reportage sur la Convention du Parti démocrate à Chicago en 1996. Il est actuellement responsable du dessin politique de *The Nation*, Comix Nation. Il collabore toujours régulièrement avec le *New Yorker*, et lors de la campagne présidentielle de 2008, il a produit une vidéo à propos de son travail. La même année, une exposition de ses dessins politiques a été montée au Norman Rockwell Museum de Stockbridge dans le Massachussets. Et il continue de combattre le pouvoir avec son crayon.

Paul Ryan, 2012
The Washington Post,
watercolor

Frank Ocean, 2012
Personal work, watercolor

Nigel Buchanan

1958 born in Gore, New Zealand
Lives and works in Sydney
www.nigelbuchanan.com

"Satire and humor makes
the ideal choice for me."

Gaddafi, 2011
The Week magazine,
cover, digital

Comic nuance comes through in even the straightest of Nigel Buchanan's illustrations, all of which are distinguished by his ability to capture the most descriptive pose—whether animal, mineral or vegetable. Buchanan notes that after rejecting architectural studies he found his calling with illustration and design. He works in a big warehouse with other illustrators, "where artwork is pumped out by the yard," he says. His own process, however, is not so facile: "I approach my work with a starting point of intense observation and develop a sketch through the foggy filter of my inaccurate memory of that observation."

Selbst in den geradlinigsten Illustrationen Nigel Buchanans ist das komische Element noch präsent, wenn auch nur in Nuancen. Alle Arbeiten zeichnen sich aus durch sein Vermögen, die markanteste Pose einzufangen, sei das Sujet tierisch, anorganisch oder pflanzlich. Nach einem abgebrochenen Architekturstudium fühlte sich Buchanan zur Illustration und zum Design hingezogen. Heute arbeitet er mit anderen Kollegen in einem großen Speicherhaus, wo, wie er sagt, „Grafik wie Meterware produziert wird". Sein Arbeitsprozess ist allerdings nicht ganz so mühelos: „Mein Ausgangspunkt ist die genaue Beobachtung, dann entsteht durch den unscharfen Filter meiner vagen Erinnerung eine Skizze."

Même les illustrations les plus sérieuses de Nigel Buchanan laissent transparaître sa veine comique, et elles se distinguent toutes par sa capacité à saisir la pose la plus descriptive – que le sujet soit animal, minéral ou végétal. C'est après avoir interrompu ses études d'architecture que Buchanan a trouvé sa vocation dans l'illustration et le design. Il travaille dans un grand entrepôt avec d'autres illustrateurs, « où l'on produit de l'art au kilomètre », dit-il. Son propre processus n'est cependant pas si évident : « Pour mon travail, je pars d'une observation intense et je développe un croquis à travers le filtre brumeux de mon souvenir imprécis de cette observation. »

Team, 2010
Plansponsor, digital

Boxers, 2012
Plansponsor Europe
magazine, digital

Buchanan's foremost influences include Miroslav Sasek, whose *This Is Paris* and other travel books for children introduced him to the loose yet expressive aspects of illustration. "With hindsight," Buchanan said in a recent interview, "I can appreciate the intense observation of Sasek as he drew, but mostly how his reinterpretation of what he saw shaped the image." With clients that include MTV, *The Wall Street Journal*, *The New York Times*, *Time*, and the *Radio Times* in the UK, Buchanan has been visible on the international stage.

Als wesentlichen Einfluss nennt Buchanan Miroslav Sasek, der ihm mit seinen Reise-büchern für Kinder, allen voran *Paris*, einen lockeren und zugleich ausdrucksstarken Illustrationsstil nahebrachte. „Rückblickend", so Buchanan kürzlich in einem Interview, „erkenne ich Saseks intensive Beobachtungsgabe beim Zeichnen, aber vor allem, wie seine Neuinterpretation des Gesehenen das Bild formte." Durch seine Auftraggeber, zu denen MTV, das *Wall Street Journal*, die *New York Times*, *Time* und die britische *Radio Times* gehören, ist Buchanan auch international bekannt.

Parmi les grandes influences de Buchanan, Miroslav Sasek, dont *This Is Paris* et d'autres carnets de voyage lui ont fait découvrir la liberté et l'expressivité de l'illustration. « Rétros-pectivement, a déclaré Buchanan dans un entretien récent, je peux apprécier l'observation intense de Sasek dans ses dessins, mais surtout la façon dont sa réinterprétation de ce qu'il avait vu déterminait l'image. » Avec des clients de l'envergure de MTV, le *Wall Street Journal*, *New York Times*, *Time* et le *Radio Times* au Royaume-Uni, Buchanan est bien visible sur la scène internationale.

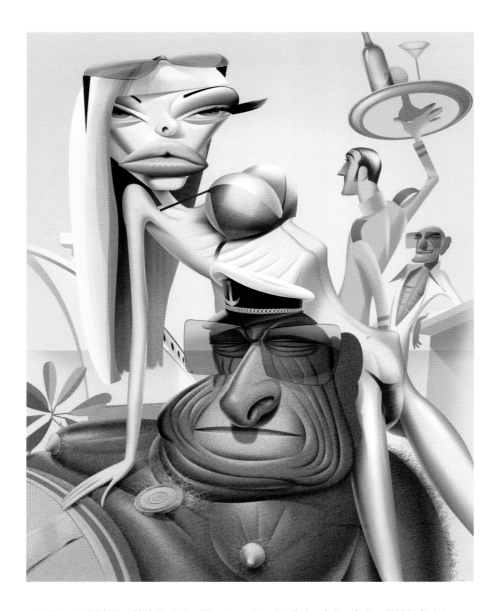

SELECTED EXHIBITIONS — 2013, Illustrators Show, group show, East Sydney Gallery, Sydney // *2011*, Society of Illustrators, group show, Gallery Nucleus, Los Angeles // *2009 to 2012*, Society of Illustrators, group show, New York

SELECTED PUBLICATIONS — 2014, Society of Illustrators Annual 57, USA // *2012*, Communication Arts Illustration Annual 53, USA // *2012*, New Illustrators File, Artbox, Japan // *2011*, Illustration Now! 4, TASCHEN, Germany // *2011*, Society of Illustrators, New York // *2009*, 3x3 magazine, USA

Bikini, 2004
BRW magazine,
pencil and digital

Velo 1 & 2, 2013
Personal work, ongoing
series of different cyclists
on local cycle track, digital

Dylan, 2011
The Week magazine,
cover, digital

Daniel Bueno

1974 born in São Paulo
Lives and works in São Paulo
www.buenozine.com.br

"Somehow, when I'm making a drawing,
I have the sensation that I'm an architect:
making a plan that will be followed
in the rest of the process, as its
construction takes on form."

Untitled, 2008
Stripburger magazine,
Slovenia, acrylic, collage
and digital

An illustrator in many styles is not always the most marketable, but Daniel Bueno is more than *bueno* when making each of these different approaches his own. An illustrator and a comics artist, his work involves geometric shapes, textures, graphic ambiguity and illusion, fantasy and the grotesque. "The characters are usually a reflection of the theme and situations of the illustrations," he explains. He is also a polymath who writes articles for magazines and teaches in workshops and on illustration courses.

In vielen Stilen zu Hause zu sein, ist für einen Illustrator nicht unbedingt ein verkaufs-förderndes Merkmal, doch Daniel Bueno ist mehr als nur *bueno* in seiner Aneignung der verschiedenen Ausdrucksweisen. In seinen Arbeiten als Illustrator und Comic-Zeichner verbindet er geometrische Figuren, Texturen, grafische Mehrdeutigkeit und Illusion sowie Fantasy und das Groteske. „Die Gestalten spiegeln meist das Thema und die Situation der Illustration wider", erklärt er. Als Multitalent schreibt er auch für Zeitschriften und unterrichtet bei Workshops und Seminaren für Illustratoren.

Un illustrateur qui jongle entre différents styles n'est pas toujours facile à vendre, mais Daniel Bueno est plus que *bueno* pour faire siennes chacune de ces différentes approches. Illustrateur et auteur de bandes dessinées, son travail tourne autour des formes géométriques, des textures, de l'ambiguïté graphique et de l'illusion, du fantastique et du grotesque. «Les personnages sont généralement un reflet du thème et des situations des illustrations», explique-t-il. Il est également un homme éclectique qui écrit des articles pour des magazines et enseigne dans des ateliers et des cours d'illustration.

MacIntel: They Are Coming, 2006
Macmania magazine, cover illustration, acrylic, collage and digital

Shopping Time, 2010
Stripburger, comic magazine, back cover, Editing: Gasper Rus, acrylic, collage and digital

Bueno graduated in Architecture and Urbanism from the University of São Paulo in 2001, and his degree thesis on Saul Steinberg celebrated one of his illustration heroes. His comic strips have appeared in *Ragu*, *Front* (both Brazil), *Stripburger* (Slovenia), *Suda Mery K* (Argentina/France), among others, and in total he has contributed to more than fifty magazine titles, newspapers (such as *Folha de S. Paulo*) and book publishers (like Cosac Naify and Companhia das Letras). Two of his illustrated books have won the Jabuti Prize, *Um Garoto chamado Roberto* and *O Melhor Time do Mundo*, while *A Janela de Esquina do Meu Primo* received an honorable mention at the Bologna Children's Book Fair (2011).

Bueno studierte Architektur und Stadtplanung an der Universität São Paulo, in seiner Abschlussarbeit aus dem Jahr 2001 beschäftigte er sich mit einem seiner Vorbilder in der Illustration: Saul Steinberg. Seine Comics erscheinen unter anderem in *Ragu* und *Front* (beide Brasilien), *Stripburger* (Slowenien) und *Suda Mery K* (Argentinien/Frankreich), insgesamt lieferte er Beiträge für über fünfzig Zeitschriften, Zeitungen (etwa *Folha de S. Paulo*) und Buchverlage (zum Beispiel Cosac Naify und Companhia das Letras). Zwei von ihm illustrierte Bücher wurden mit dem Jabuti-Preis ausgezeichnet – *Um Garoto chamado Roberto* und *O Melhor Time do Mundo*. Der Titel *A Janela de Esquina do Meu Primo* wurde 2011 bei der Kinderbuchmesse in Bologna mit einer lobenden Erwähnung gewürdigt.

Bueno a obtenu son diplôme d'architecture et urbanisme de l'Université de São Paulo en 2001, et sa thèse sur Saul Steinberg était un hommage à l'un de ses héros de l'illustration. Ses bandes dessinées ont été publiées dans *Ragu*, *Front* (Brésil), *Stripburger* (Slovénie), *Suda Mery K* (Argentine/France), entre autres, et au total il a participé à plus de cinquante magazines, journaux (comme *Folha de S. Paulo*) et maisons d'édition (comme Cosac Naify et Companhia das Letras). Deux de ses livres illustrés ont remporté le prix Jabuti, *Um Garoto chamado Roberto* et *O Melhor Time do Mundo*, tandis que *A Janela de Esquina do Meu Primo* a reçu une mention honorable au Salon des livres pour enfants de Bologne (2011).

Hungarian Party, 2011
Symposion magazine,
Editing: Sirbik Attila,
acrylic, collage and digital

My Cousin's Corner
Window, 2010
Cosac Naify, book, Graphic
Design: Maria Carolina
Sampaio and Paulo André
Chagas, digital

Brujeria, 2009
Göoo magazine, acrylic,
collage and digital

SELECTED EXHIBITIONS — 2012, AIAP: Latin American Illustration, group show, Angel Orensanz Foundation, New York // **2012**, Charivari, group show, SESC São Carlos, Brazil // **2012**, Ilustrarte, group show, Museu da Eletricidade, Lisbon // **2011**, Linhas de Histórias, group show, SESC Belenzinho, São Paulo // **2011**, Society of Illustrators 53, group show, New York

SELECTED PUBLICATIONS — 2015, 3x3 Annual, 3x3 magazine, USA // **2011**, Illustration Now! Portraits, TASCHEN, Germany // **2011**, 3x3 Annual, 3x3 magazine, USA // **2010**, 200 Best Illustrators Worldwide, Lürzer's Archive, Austria // **2008**, ILL08, 3x3 Directory, USA // **2008**, Revista Ilustrar no. 6, Brazil

John Jay Cabuay

1974 born in Manila
Lives and works in New York
www.johnjayart.com

"My illustrations are about
celebrating the art of draftsmanship
mixed with the complexity
of a saturated color palette and
the idealism of printmaking."

The Courtyard, 2012
Personal work, pencil
and digital

The art and craft of drawing reality in an uninhibited way is sometimes at odds with John Jay Cabuay's more fantastical images, yet this apparent dichotomy is an essential part of the artist's persona. Cabuay studied for a BFA from New York's Fashion Institute of Technology, and this may account for a certain veneer in his work—it isn't pure fashion illustration though, and has featured on book covers, magazines and in advertisements right across the world. Furthermore, his work projects powerfully in its poster-like scale and composition. Cabuay currently teaches illustration at the Fashion Institute of Technology and Parsons School of Design.

Die griffige Kunst, Realität unbefangen abzubilden, mag mit den fantastischeren Bildern John Jay Cabuays bisweilen in Konflikt stehen, doch ist diese scheinbare Dichotomie integraler Bestandteil seiner Künstlerpersönlichkeit. Cabuay studierte Kunst am Fashion Institute of Technology in New York, was vielleicht den eleganten Schliff seiner Zeichnungen erklärt. Allerdings macht er mitnichten reine Modeillustration, seine Grafiken sind weltweit auf Buchcovern, in Zeitschriften und als Werbung erschienen. Darüber hinaus haben seine Werke durch den Maßstab und die Komposition, die an Plakate erinnern, eine sehr kraftvolle Wirkung. Cabuay unterrichtet gegenwärtig Illustration am Fashion Institute of Technology sowie an der Parsons School of Design.

L'art et la manière de dessiner la réalité sans inhibitions entre parfois en dissonance avec les images plus fantasmagoriques de John Jay Cabuay, et pourtant cette dichotomie apparente est une part essentielle de son identité d'artiste. Cabuay a étudié pour obtenir un diplôme des beaux-arts au Fashion Institute of Technology de New York, ce qui peut expliquer l'apparence lisse de son travail. Ce n'est pourtant pas de la pure illustration de mode, et il a été publié sur des couvertures de livres, dans des magazines et des publicités dans le monde entier. De plus, l'échelle et la composition, typiques des affiches, donnent à son travail une forte projection. Cabuay enseigne actuellement l'illustration au Fashion Institute of Technology et à la Parsons School of Design.

Mr. White, 2012
Personal work, pencil
and digital

Pigeons, 2012
Personal work, pencil

SELECTED EXHIBITIONS — *2014*, *Moby Dick Exhibition, group show, Puebla // **2012**, ISM: 10, group show, Grand Central Art Center, Santa Ana, California // **2011**, Fashion Illustration: Visual Poetry, group show, Gallery Hanahou, New York // **2010**, A Labor of Line, group show, Gallery Nucleus, Alhambra, California // **2009**, Bellaciao, group show, Galerie Arludik, Paris // **2000**, Society of Illustrators 42, group show, New York*

SELECTED PUBLICATIONS — *2016*, *The Washington Post newspaper, USA // **2016**, New York Observer newspaper, USA // **2011**, Illustration Now! 4, TASCHEN, Germany // **2010**, Advanced Fashion Drawing, Laurence King, UK // **2008**, Big Book of Illustration Ideas 2, Harper Design, USA // **2007**, Big Book of Fashion Illustration, Batsford, UK*

Falls, 2011
Personal work, pencil
and digital

Niigata Girl, 2012
Personal work, private
commission, pencil and
digital

pp. 136/37 The Adarna
Bird, 2013
Personal work, children's
book, pencil and digital

Brian Cairns

1965 born in Paisley, UK
Lives and works in Glasgow
www.briancairns.com

"I adopt an intuitive approach
that explores a variety of ways
to communicate an idea."

Banana Ticker Tape, 2012
Tom Brown Art + Design,
thinkMoney magazine, ink
and digital

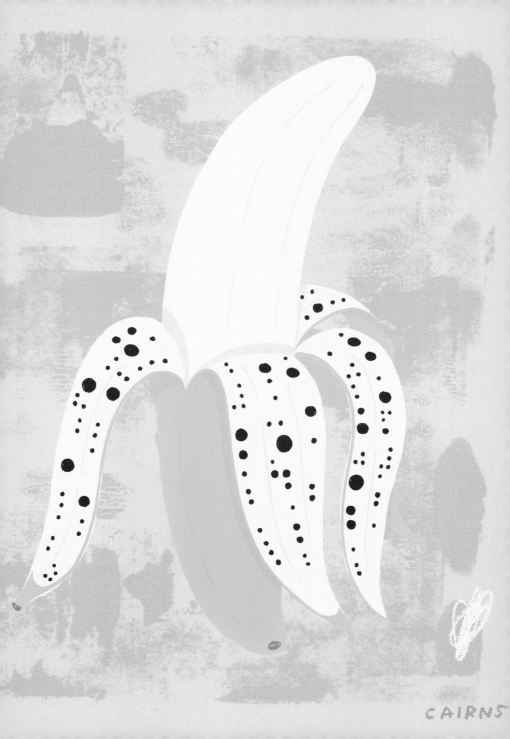

CAIRNS

Simplicity and dislocation are the means Brian Cairns employs to unsettle the common-place, at the same time enhancing the extraordinary in his admirable drawings. Making a lot out of little makes the ordinary into something monumental. Cairns is head and Creative Director of the Brian Cairns Studio in Glasgow's Merchant City. He studied graphic design at the Glasgow School of Art prior to specializing in illustration and, he says, "a love of all things typographic continues to be evident in my work from hand-drawn text to traditional print media such as letterpress and silk screen."

Schlichtheit und Entfremdung sind Brian Cairns' Mittel, um das Alltägliche zu unterwandern, gleichzeitig überhöht er in seinen famosen Zeichnungen das Außergewöhnliche. Wer aus wenigem viel macht, verwandelt das Normale in etwas Großartiges. Cairns ist Direktor und Künstlerischer Leiter des Brian Cairns Studio in Merchant City von Glasgow. Ehe er sich auf Illustration spezialisierte, studierte er Grafik an der Glasgow School of Art. Heute sagt er: „Eine Schwäche für das Typografische lässt sich in meinen Arbeiten nicht leugnen, vom handgeschriebenen Text bis hin zu traditionellen Druckverfahren wie Hoch- oder Siebdruck."

La simplicité et la rupture logique sont les moyens que Brian Cairns emploie dans ses admirables dessins pour déranger les lieux communs tout en soulignant l'extraordinaire. En faisant beaucoup avec peu, l'ordinaire devient monumental. Cairns est président et directeur de la création du Brian Cairns Studio à Merchant City, à Glasgow. Il a étudié le graphisme à la Glasgow School of Art avant de se spécialiser dans l'illustration et, dit-il, «l'amour de tout ce qui touche à la typographie est toujours évident dans mon travail, des textes dessinés à la main jusqu'aux techniques traditionnelles telles que l'impression typographe et la sérigraphie».

SELECTED PUBLICATIONS — 2012, Typographic Sketchbooks, Thames & Hudson, USA/UK // *2007*, Illustration Now! 2, TASCHEN, Germany // *2006*, Handwritten: Expressive Lettering in the Digital Age, Thames & Hudson, UK // *2006*, Touch This: Graphic Design That Feels Good, Rockport, UK // *2004*, Clin D'Oeil: A New Look at Modern Illustration, BIS Publishers BV, Taiwan

←← Colonoscopy, 2012
Todd Albertson Design/
AARP, ink and digital

← Factory Emissions, 2011
Tom Brown Art + Design,
thinkMoney magazine, ink,
wood and digital

Breaking the Rules,
2012
Personal work, ink and
digital

Ideas Generator, 2011
Personal work, ink and
digital

Twitter Gossip, 2012
Personal work, ink and
digital

Euro Bomber, 2012
The Observer, ink and
digital

Dave Calver

1954 born in Rochester
Lives and works in Palm Springs
www.davecalver.com

"I hope people see elegance and humor
in all my work."

Tura with Mask, 2012
M Modern Gallery, colored
pencil, marker, gouache
and varnish

The Headless Smoker,
2004
Personal work, colored
pencil, marker and acrylic

Commuters, 2007
NYC Mass Transit, poster,
NYC, Society of Illustrators
49, colored pencil, marker
and gouache

Light seems to bounce off Dave Calver's pastel masterpieces, and yet he captures the luminosity with ease, allowing for a tonality that is at once subtle and dramatic, and creating compositions that are alluring to a fault. A graduate of Rhode Island School of Design, his iconic snow-people have been used for years to promote the Lincoln Center's annual Winter's Eve event. Subway commuters in New York have also had their uncomfortable rides lightened by the intricate whimsy in Calver's three posters for the Metropolitan Transportation Authority—each an oasis of beauty in a crowded train.

Bei Dave Calvers pastellfarbenen Meisterwerken hat man den Eindruck, sie reflektierten das Licht, und dieses Strahlen fängt er mit unglaublich leichter Hand ein. Dadurch gelingt ihm nicht nur ein Farbspiel, das subtil und dramatisch zugleich ist, er schafft auch Kompositionen von bezwingendem Reiz. Die Schneemenschen des ehemaligen Studenten der Rhode Island School of Design, mit denen jahrelang die alljährliche Veranstaltung Winter's Eve des Lincoln Center beworben wurde, sind zu Kultfiguren geworden. Und die kunstvollen, launigen Spielereien der drei Plakate, die Calver für die Metropolitan Transportation Authority entwarf, haben Heerscharen von Fahrgästen der New Yorker U-Bahn von der Unbequemlichkeit in den überfüllten Waggons abgelenkt, schließlich ist jedes Poster eine Oase der Schönheit.

La lumière semble rebondir contre les chefs-d'œuvre au pastel de Dave Calver, et pourtant il capte la luminosité avec une grande facilité, et crée un ton à la fois subtil et spectaculaire, et des compositions séduisantes presque à l'excès. Il est diplômé de la Rhode Island School of Design, et ses célèbres personnages en neige servent depuis des années à la promotion de l'événement annuel du Lincoln Center pour l'arrivée de l'hiver. Les usagers du métro new-yorkais voient aussi leurs trajets inconfortables égayés par trois affiches à la fantaisie délicate que Calver a réalisées pour la Metropolitan Transportation Authority. Ce sont des oasis de beauté dans les wagons surchargés.

SELECTED EXHIBITIONS — *2014, Dave Calver, solo show, Speakeasy Art Gallery, Boonton, New Jersey // 2013, Recent Work, solo show, Spazio Orlandi Gallery, Milan // 2012, Tell Me A Story, Now!, group show, Rockland Center for the Arts, Nyack, New York // 2011, Parades, Poesie & Pathos, solo show, M Modern Gallery, Palm Springs // 2008, Sideshow, group show, Robert Berman Gallery, Los Angeles // 1986, American Pop Culture Images, group show, Laforet Museum, Tokyo*

SELECTED PUBLICATIONS — *2010, Communication Arts Annual, Coyne & Blanchard, USA // 2009, Illustration Now! 3, TASCHEN, Germany // 2008, Society of Illustrators 49, USA // 1996, Illustration: America, Rockport, USA // 1991, The Art of Mickey Mouse, Hyperion, USA*

Cecilia Carlstedt

1977 born in Stockholm
Lives and works in Stockholm
www.ceciliacarlstedt.com

"I love to experiment with
contrasts and textures and
strive for the unexpected
when I work."

Night Drawing, 2010
Personal work, exhibition,
ink and digital

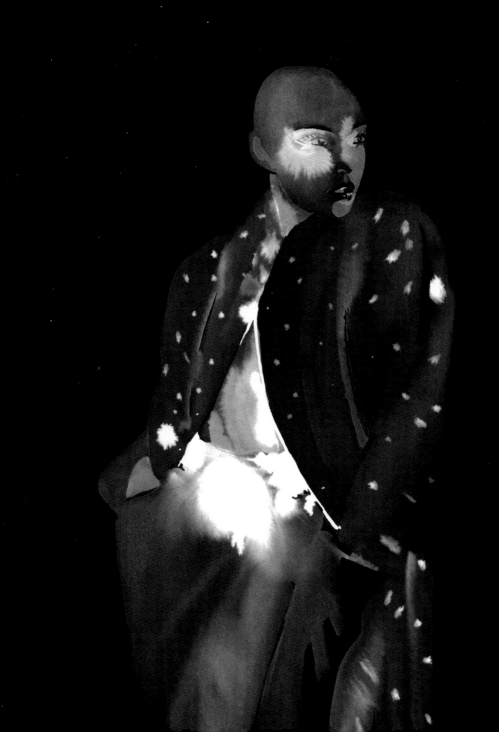

Making truly stylish fashion illustration is more difficult than any other commercial art, but Cecilia Carlstedt has the knack of creating sex appeal from just a few well-placed watercolors—and that is what fashion illustration is all about. Drawing and painting has been Carlstedt's medium of expression from an early age and after studying the History of Art at Stockholm University she took a BA in Graphic Design and Image Making at the London College of Communication with an exchange semester at the Fashion Institute of Technology in New York. She has illustrated for clients such as H&M, La Perla, Swarovski, Martini Gold, *Elle*, *Vogue* and *The New York Times*.

Wirklich stilsichere Modeillustration stellt unter den kommerziellen Kunstgattungen die größte Herausforderung dar, doch Cecilia Carlstedt besitzt die Gabe, mit ein paar wohlerwogenen Aquarelltupfern Sexappeal zu beschwören – und genau darum geht es in diesem Metier. Zeichnen und Malen sind für Carlstedt schon seit frühesten Jahren das bevorzugte Ausdrucksmittel. Im Anschluss an ein Kunstgeschichtsstudium in Stockholm machte sie am London College of Communication einen Bachelor in Grafik und Image Making, wofür sie ein Gastsemester am Fashion Institute of Technology in New York verbrachte. Zu ihren Kunden gehören unter anderem H&M, La Perla, Swarovski, Martini Gold, *Elle*, *Vogue* und die *New York Times*.

Faire de l'illustration de mode vraiment stylée est plus difficile que n'importe quel autre type d'art commercial, mais Cecilia Carlstedt a le don de créer du sex-appeal en quelques touches d'aquarelle bien placées – et c'est bien cela, l'essence de l'illustration de mode. Le dessin et la peinture sont les moyens d'expression de Carlstedt depuis l'enfance, et après ses études en histoire de l'art à l'Université de Stockholm, elle a obtenu une licence en graphisme et création d'image au London College of Communication, avec un semestre d'échange au Fashion Institute of Technology à New York. Elle a fait des illustrations pour H&M, La Perla, Swarovski, Martini Gold, *Elle*, *Vogue* et le *New York Times*.

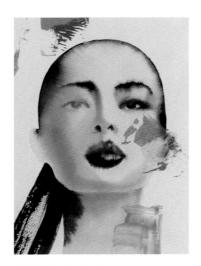

Zang Ziyi, 2010
Flaunt magazine, cover,
ink, acrylic and digital

Untitled, 2012
Personal work, ink and
collage on paper and
digital

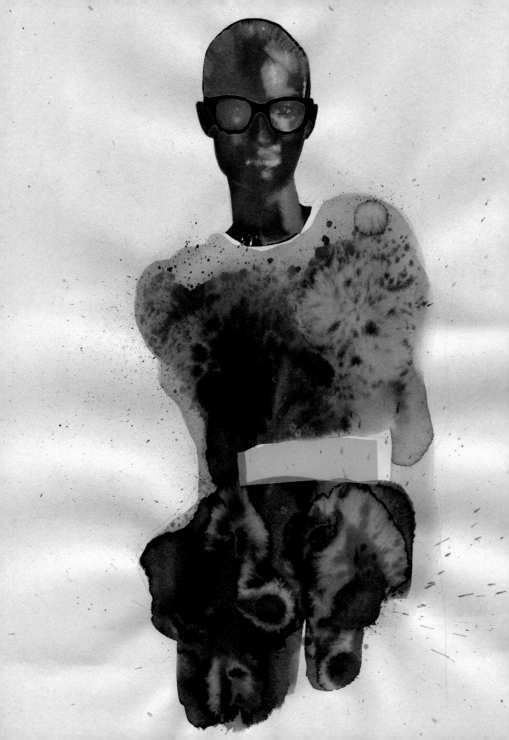

SELECTED EXHIBITIONS — *2016, Drawing on Style, group show, London // **2015**, New Nordic Fashion Illustration VOL 2, group show, Tallinn // **2012**, New Nordic Fashion Illustration, group show, Design Museum, Helsinki // **2011**, Fashion Illustration: Visual Poetry, group show, Gallery Hanahou, New York*

SELECTED PUBLICATIONS — *2016, Harper's Bazaar magazine, The Netherlands // **2012**, Dash magazine, UK // **2012**, Flaunt magazine, USA // **2012**, The Lab magazine, Canada // **2010**, Fashion Drawing, AVA Publishing, UK // **2010**, The New Age of Feminine Drawing, All Rights Reserved Publishing, USA*

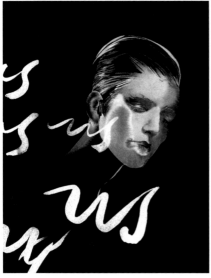

Untitled, 2010
Personal work, screen
printing

Night Drawing 02, 2010
Personal work, exhibition,
ink and digital

Untitled, 2009
Personal work, ink
and digital

André Carrilho

1974 born in Lisbon
Lives and works in Lisbon and in Macau
www.andrecarrilho.com

"I try to combine different graphic languages into one, choosing between pencil hand drawing, computer-generated effects and texture sampling. My goal is to create a visual vocabulary that is at the same time flexible and varied, while maintaining its cohesiveness."

AIDS in Old Age, 2008
Diário de Notícias
magazine, graphite on
paper and digital

Antonio Lobo Antunes,
2009
The New Yorker, graphite
on paper and digital

Edgar Allan Poe, 2009
The New Yorker, graphite
on paper and digital

p. 162 Steve Jobs, 2011
The New Yorker, graphite
on paper and digital

p. 163 Lena Dunham
vs Paul Ryan, 2012
Vanity Fair, graphite on
paper and digital

Elongating human features does not guarantee a successful caricature, unless an artist knows what to exaggerate and what not to. André Carrilho understands how to mold the head and body as though they were made of wet clay. As a designer, illustrator, cartoonist, animator and caricaturist, he has a critical perspective on his discipline: "Some caricaturists are not good illustrators (or good caricaturists for that matter), and good illustrators are very often not good caricaturists," he told the online magazine *Great Design*. "Caricature is peculiar in the sense that it has to look like the person you are portraying, there's no debating. It's a specific visual game, and everybody [...] has to get it."

Menschliche Gesichtszüge zu verlängern ist keine Garantie für eine gelungene Karikatur, wenn der Grafiker nicht genau weiß, welches Merkmal er hervorheben soll und welches nicht. André Carrilho aber versteht es, Kopf und Körper zu modellieren, als arbeite er mit feuchtem Ton. Als Designer, Illustrator, Cartoonist, Animator und Karikaturist steht er seiner Profession kritisch gegenüber: „Einige Karikaturisten sind keine guten Illustratoren (und, so nebenbei, auch keine guten Karikaturisten), und gute Illustratoren sind häufig keine guten Karikaturisten", sagte er der Online-Zeitschrift *Great Design*. „Die Karikatur ist etwas ganz Eigenes, sie muss wie die Person aussehen, die man zeichnet, daran führt kein Weg vorbei. Es ist ein ganz besonderes visuelles Spiel, und jeder [...] muss es auf Anhieb verstehen."

Il ne suffit pas d'étirer les traits de la figure humaine pour obtenir une caricature réussie, à moins que l'artiste ne sache précisément quels traits exagérer. André Carrilho sait travailler la tête et le corps comme s'ils étaient faits d'argile humide. En tant que designer, illustrateur, dessinateur humoristique, animateur et caricaturiste, il adopte un point de vue critique sur sa propre discipline : « Certains caricaturistes ne sont pas de bons illustrateurs (ni de bons caricaturistes, d'ailleurs), et les bons illustrateurs sont très souvent des caricaturistes médiocres », a-t-il déclaré au magazine en ligne Great Design. « La caricature est à part, dans le sens où il faut qu'elle ressemble au sujet, il n'y a pas de débat là-dessus. C'est un jeu visuel bien particulier, et tout le monde [...] doit pouvoir le comprendre. »

SELECTED EXHIBITIONS — 2013, Ilustra 33, group show, Lisbon // 2012, Boarding Pass, solo show, Portuguese Consulate, Maputo, Mozambique // 2012, Starting Point, solo show, Portuguese Bookstore, Macau // 2007, Frente & Verso, solo show, Diário de Notícias Gallery, Lisbon // 2006, Linha, Ponto & Vírgula, solo show, Casa de Camilo, Famalicão, Portugal // 2004, Caricatures and Comics, solo show, International Comics Festival, Amadora, Portugal

SELECTED PUBLICATIONS — 2014, A Máquina do Mundo (The World Machine), Portugal // 2012, Diário de Notícias, Portugal // 2012, Neue Zürcher Zeitung, Switzerland // 2012, The Independent, UK // 2012, The New Yorker, USA // 2012, Vanity Fair, USA

Martha Stewart vs
Tom Waits, 2012
Vanity Fair, unpublished,
graphite on paper and
digital

Intellectuals, 2006
Diário de Notícias
magazine, graphite on
paper and digital

Nicoletta Ceccoli

1973 born in the Republic of San Marino
Lives and works in the Republic of San Marino
www.nicolettaceccoli.com

"My illustrations play with contradictions.
They are whimsical, but also disturbing,
dreamlike and thought-provoking."

Bliss, 2010
Personal work, Jonathan
LeVine Gallery, New York,
acrylic on paper

The hauntingly innocent petite young girls painted with exacting care by Nicoletta Ceccoli seem always and forever on the verge of betraying their inner demons to their outer ones—the ones that are really threatening. Ceccoli studied cinema and animation at the State Institute of Art In Urbino (Italy) and in 2001 was awarded the Anderson Prize as the best children's book illustrator in Italy. She has illustrated many picture books, including the acclaimed *The Girl in the Castle Inside the Museum*, and in 2006 was awarded a Silver Medal by the Society of Illustrators in New York.

Bei den verstörend unschuldigen zierlichen Mädchen, die Nicoletta Ceccoli mit so großer Sorgfalt malt, hat man unweigerlich den Eindruck, als würden sie jeden Moment ihren inneren Dämon an den äußeren verraten – den, der die eigentliche Gefahr darstellt. Ceccoli studierte Film und Animation am Staatlichen Kunstinstitut in Urbino (Italien) und wurde 2001 mit dem Anderson-Preis als beste italienische Kinderbuch-Illustratorin ausgezeichnet. Sie illustrierte zahlreiche Bilderbücher, unter anderem das populäre *The Girl in the Castle Inside the Museum*, 2006 wurde ihr von der Society of Illustrators in New York die Silbermedaille verliehen.

Les petites filles à l'innocence fascinante que Nicolette Ceccoli peint avec un soin méticuleux semblent toujours sur le point de trahir leurs démons intérieurs pour se défendre des démons extérieurs, dont la menace est bien réelle. Ceccoli a étudié le cinéma et l'animation à l'Institut artistique national d'Urbino (Italie), et en 2001 elle a reçu le prix Anderson, qui récompense le meilleur illustrateur de livres pour enfants en Italie. Elle a illustré de nombreux livres d'images, notamment le très applaudi *The Girl in the Castle Inside the Museum*, et en 2006 elle a reçu la médaille d'argent de la Society of Illustrators de New York.

SELECTED EXHIBITIONS — *2012*, Eye Candy, solo show, AFA Gallery, New York // *2011*, Girls Don't Cry, solo show, Roq La Rue Gallery, Seattle // *2010*, Incubi Celesti, solo show, Dorothy Circus Gallery, Rome // *2009*, Babes in Toyland, solo show, CoproNason Gallery, Santa Monica // *2008*, By the Time You Are Real, solo show, Richard Goodall Gallery, Manchester

SELECTED PUBLICATIONS — *2010*, Beautiful Nightmares, Soleil, Paris // *2008*, The Girl in the Castle Inside the Museum, Random House, New York // *2007*, The Boo! Book, Simon and Schuster, USA // *2005*, Little Red Riding Hood, Barefoot Books, Bath // *2001*, Pinocchio, Mondadori, Italy

Cuddle – A Tribute
to Aaron Wiesenfeld, 2011
Personal work, acrylic
on paper

Teardrop Pearls, 2010
Personal work, Jonathan
LeVine Gallery, New York,
acrylic on paper

Ceccoli's 2008 exhibition of big-eyed nymph paintings, "By the Time You Are Real" (an appropriate title), featured a set of new images that were as mysterious as they were delight-fully imponderable. "I prefer to work on my personal artworks without a theme previously established," she told the webzine *Arrested Motion*. Among the abundant influences in Ceccoli's work she acknowledges Remedios Varo, Domenico Gnoli, Paolo Uccello, Stasys Eidrigevicius, Mark Ryden, Edward Gorey, Winsor McCay and Ray Caesar. Concerning the field of art and illustration she says, "Drawing is my love, my hobby, my job," and to complement that: "I think both personal art and applied illustration can enrich each other."

Ceccolis Gemäldeausstellung von großäugigen Nymphen im Jahr 2008 mit dem sehr passenden Titel „By the Time You Are Real" (in etwa „Wenn du schließlich echt bist") zeigte neuartige Bilder, die ebenso geheimnisvoll wie unergründlich sind. „Ich arbeite lieber an meinen eigenen Bildern, ohne vorgegebenes Thema", berichtete Ceccoli dem Webzine *Arrested Motion*. Zu den zahlreichen Inspiratoren ihrer Arbeit zählt sie Remedios Varo, Domenico Gnoli, Paolo Uccello, Stasys Eidrigevicius, Mark Ryden, Edward Gorey, Winsor McCay und Ray Caesar. Was Kunst und Illustration betrifft, sagt sie: „Zeichnen ist meine große Liebe, mein Hobby, meine Arbeit", und fügt hinzu: „Ich glaube, dass die persönliche Kunst und die angewandte Illustration sich gegenseitig bereichern können."

L'exposition de tableaux de nymphes aux grands yeux que Ceccoli a réalisée en 2008, « By the Time You Are Real » (« D'ici à ce que tu deviennes réalité », un titre approprié), se composait de nouvelles images aussi mystérieuses que délicieusement imprévisibles. « Je préfère travailler sur mes projets personnels sans thème prédéfini », a-t-elle déclaré au webzine *Arrested Motion*. Parmi ses nombreuses influences, elle cite Remedios Varo, Domenico Gnoli, Paolo Uccello, Stasys Eidrigevicius, Mark Ryden, Edward Gorey, Winsor McCay et Ray Caesar. En ce qui concerne le domaine de l'art et de l'illustration, elle déclare : « Dessiner est mon amour, ma passion, mon métier », et conclut ainsi : « Je pense que l'art personnel et l'illustration appliquée peuvent s'enrichir l'un l'autre ».

Just Dessert, 2011
Personal work, Jonathan
LeVine Gallery, New York,
acrylic on paper

Agata, 2007
Personal work, Richard
Goodall Gallery,
Manchester, acrylic
on paper

Seymour Chwast

1931 born in New York
Lives and works in New York
www.pushpininc.com

"I determine the style,
attitude and technique from the
material I am illustrating."

Diet?, 2001
The New Yorker, Editing:
Christine Curry, pen, ink
and digital

Sometimes Seymour Chwast's finished work looks like a rough sketch; at other times it has the appearance of precise schematics. The style ranges from childlike scrawls to complex paintings, but Chwast is a virtuoso with either pencil and brush, or burin and scissors, in fact, few artists are so versatile yet so consistent. His illustrations can be seen in magazines and children's books, and on posters, advertisements, book jackets, record covers and product packaging. In co-founding Push Pin Studios with Milton Glaser in 1954, he directly influenced two generations of international illustrators and designers, and indirectly inspired another two, to explore an eclectic range of stylistic and conceptual methods, with Chwast being closely involved in wedding typographic design to illustration.

Einige Arbeiten von Seymour Chwast sehen aus wie ein grober Entwurf, andere wirken wie präzise Schaltbilder. Sein Stil variiert von kindlichen Kritzeleien bis zu komplexen Gemälden, doch ist er unweigerlich virtuos, ob mit Bleistift und Pinsel oder Stichel und Schere. Letztlich sind nur wenige Künstler so vielseitig und beständig zugleich. Chwasts Illustrationen sind in Zeitschriften und Kinderbüchern zu sehen, auf Plakaten, in der Werbung, auf Buch-umschlägen, Plattenhüllen und Verpackungen. Als Mitbegründer der Push Pin Studios mit Milton Glaser im Jahr 1954 beeinflusste er unmittelbar zwei Generationen von Illustratoren und Grafikern weltweit und ermutigte zwei weitere, sich an einer großen Bandbreite von Stilen und Konzepten zu versuchen. Chwasts eigenes großes Anliegen ist die Verbindung von Typografiedesign mit Illustration.

Parfois, les illustrations terminées de Seymour Chwast ressemblent à une ébauche, parfois à un plan détaillé. Il pratique le gribouillage enfantin tout comme la peinture la plus aboutie, mais Chwast est un virtuose du crayon, du pinceau, du burin et des ciseaux. En fait, peu d'artistes sont aussi polyvalents tout en étant aussi constants. On peut voir ses illustrations dans des magazines et des livres pour enfants ainsi que sur des affiches, des publicités, des couvertures de livres, des jaquettes de disques et des emballages de produits. En cofondant Push Pin Studios avec Milton Glaser en 1954, il a directement influencé deux générations d'illustrateurs et de designers internationaux, et en a indirectement inspiré deux autres. Il est étroitement lié au mariage de la typographie et de l'illustration.

SELECTED EXHIBITIONS — 2013, Double Portrait, group show, Philadelphia Museum of Art, Philadelphia // 2012, Century of the Child, group show, Museum of Modern Art, New York // 2000, Seymour Chwast, solo show, Wilanów Poster Museum, Warsaw // 1982, Seymour Chwast, solo show, Gutenberg Museum, Mainz, Germany // 1970, Push Pin Style, group show, Musée des Arts Décoratifs, Paris

SELECTED PUBLICATIONS — 2012, Homer's Odyssey, Bloomsbury, USA // 2011, The Canterbury Tales, Bloomsbury, USA // 2010, Dante's Divine Comedy, Bloomsbury, USA // 2009, Seymour: The Obsessive Images of Seymour Chwast, Chronicle Books, USA // 1985, The Left-Handed Designer, Abrams, USA

Monkey Space Men, 2003
The Zak Company, poster,
pen, ink and digital

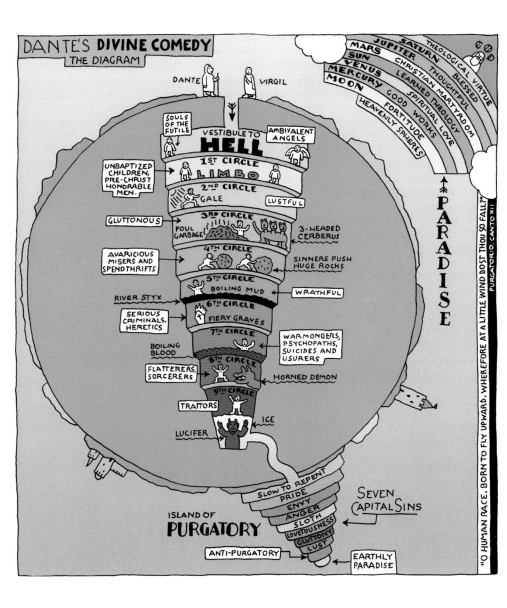

DANTE'S **DIVINE COMEDY**
THE DIAGRAM

DANTE · VIRGIL

SOULS OF THE FUTILE

VESTIBULE TO **HELL**

AMBIVALENT ANGELS

1ST CIRCLE
LIMBO

UNBAPTIZED CHILDREN, PRE-CHRIST HONORABLE MEN.

2ND CIRCLE
GALE · LUSTFUL

GLUTTONOUS

3RD CIRCLE
FOUL GARBAGE · 3-HEADED CERBERUS

4TH CIRCLE

AVARICIOUS MISERS AND SPENDTHRIFTS · SINNERS PUSH HUGE ROCKS

5TH CIRCLE
BOILING MUD

RIVER STYX · WRATHFUL

6TH CIRCLE
FIERY GRAVES

SERIOUS CRIMINALS, HERETICS

7TH CIRCLE

BOILING BLOOD · WARMONGERS, PSYCHOPATHS, SUICIDES AND USURERS

8TH CIRCLE

FLATTERERS, SORCERERS · HORNED DEMON

9TH CIRCLE

TRAITORS · ICE

LUCIFER

THEOLOGICAL VIRTUE
GOD
SATURN THOUGHTFUL
JUPITER BLESSED
MARS CHRISTIAN MARTYRDOM
SUN LEARNED THEOLOGY
VENUS SPIRITUAL LOVE
MERCURY GOOD WORKS
MOON FORTITUDE
(HEAVENLY SPHERES)

P A R A D I S E

PURGATORIO, CANTO XII

"O HUMAN RACE, BORN TO FLY UPWARD, WHEREFORE AT A LITTLE WIND DOST THOU SO FALL?"

SLOW TO REPENT
PRIDE
ENVY
ANGER
SLOTH
COVETOUSNESS
GLUTTONY
LUST

SEVEN CAPITAL SINS

ISLAND OF
PURGATORY

ANTI-PURGATORY

EARTHLY PARADISE

Dante's Divine
Comedy, 2001
The New York Times Book
Review, Art Direction:
Steven Heller, pen, ink
and digital

Double the Fun, 2006
The Nose, Push Pin Group,
acrylic on paper

Seymour Chwast 177

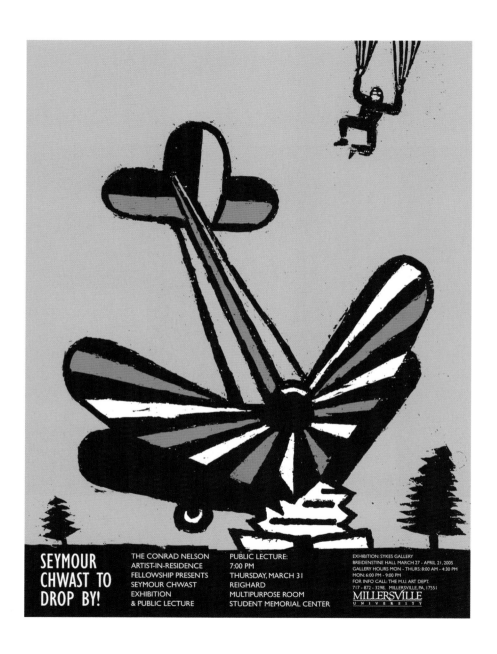

SEYMOUR CHWAST TO DROP BY!

THE CONRAD NELSON
ARTIST-IN-RESIDENCE
FELLOWSHIP PRESENTS
SEYMOUR CHWAST
EXHIBITION
& PUBLIC LECTURE

PUBLIC LECTURE:
7:00 PM
THURSDAY, MARCH 31
REIGHARD
MULTIPURPOSE ROOM
STUDENT MEMORIAL CENTER

EXHIBITION: SYKES GALLERY
BREIDENSTINE HALL MARCH 27 - APRIL 21, 2005
GALLERY HOURS MON - THURS: 8:00 AM - 4:30 PM
MON: 6:00 PM - 9:00 PM
FOR INFO CALL: THE M.U. ART DEPT.
717 - 872 - 3298, MILLERSVILLE, PA, 17551
MILLERSVILLE
UNIVERSITY

3000 Years of Hair

Seymour Chwast
to Drop By, 2004
Millersville University,
woodcut

Hair Timeline, 2006
The Nose 13, Push Pin
Group, pen, ink and digital

Joe Ciardiello

1953 born in Staten Island
Lives and works in Milford, New Jersey
www.joeciardiello.com

"I prefer to draw directly with pen
whenever possible. It is the most honest,
direct and spontaneous way for me to achieve the
expressiveness that I'm after."

Eric Clapton, 2003
Playboy magazine, Japan,
Art Direction: Tomoko
Kawaguchi, pen, ink
and watercolor

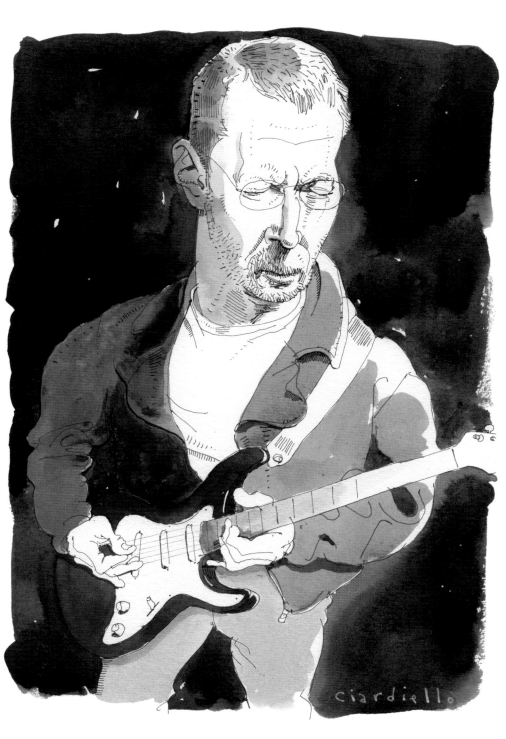

Emancipation: Evolution ...

"With Malice Toward None"

"Endless Forms Most Beautiful"

Shrewd

Depression

Free-Thinking

Anxiety

Thelonious Monk, 2009
The New York Times Book
Review, Art Direction:
Nicholas Blechman, pen
and ink

Lincoln and Darwin, 2009
Smithsonian magazine,
Art Direction: Maria
Keehan, pen, ink and
watercolor

Joe Ciardiello 183

Joe Ciardiello is the master of negative space, an artist for whom line frames mass, and the space between empty masses tells us where his visual stories appear. His line, to mix metaphors, is like the beat to his melody, and perhaps not surprisingly, Ciardiello is a drummer who plays regularly in a jazz band made up of illustrators. He attended the High School of Art and Design and gained a BFA at Parsons School of Design. In the course of his career he has worked for most of the major magazines and newspapers, book publishers and record companies, including *The New Yorker*, *Rolling Stone*, *Sports Illustrated*, *Time*, ESPN, Capitol Records and the Rock & Roll Hall of Fame. His portraits of authors are a fixture in *The New York Times Book Review*.

Joe Ciardiello ist der Meister des Negativraums, ein Künstler, für den ein Strich Masse begrenzt, und aus dem Raum zwischen den leeren Massen entstehen seine visuellen Geschichten. Sein Strich ist, um Metaphern zu vermischen, wie der Takt zu seiner Melodie, und es überrascht vielleicht nicht, Ciardiello spielt regelmäßig Schlagzeug mit einer aus Illustratoren zusammengesetzten Jazzband. Er besuchte die High School of Art and Design und verließ die Parsons School of Design mit einem Bachelor in bildender Kunst. Im Lauf seiner Karriere hat er für die meisten großen Magazine und Zeitungen, Verlage und Plattenlabels gearbeitet, unter anderem *New Yorker*, *Rolling Stone*, *Sports Illustrated*, *Time*, ESPN, Capitol Records und die Rock & Roll Hall of Fame. Seine Autorenporträts sind aus der *New York Times Book Review* nicht mehr wegzudenken.

Joe Ciardiello est le maître de l'espace négatif, un artiste pour lequel la ligne encadre le volume, et l'espace entre volumes vides nous dit où ses histoires visuelles apparaissent. La ligne est en quelque sorte le rythme de sa mélodie, et ce n'est pas étonnant, car Ciardiello joue régulièrement de la batterie dans un groupe de jazz composé d'illustrateurs musiciens. Il a étudié à la High School of Art and Design et a obtenu un diplôme en beaux-arts de la Parsons School of Design. Au cours de sa carrière, il a travaillé pour la plupart des grands magazines et journaux, maisons d'édition et de disques, notamment le *New Yorker*, *Rolling Stone*, *Sports Illustrated*, *Time*, ESPN, Capitol Records, et le Rock & Roll Hall of Fame. Ses portraits d'auteurs sont un grand classique des critiques de livres du *New York Times*.

SELECTED EXHIBITIONS — 2016, *52 Reasons to Love a Vet, group show, Hunterdon Art Museum, New Jersey //* 2012, *Collaborative Editions Project, group show, Printmaking Center of New Jersey, Branchburg //* 2010, *Earth: Fragile Planet, group show, Society of Illustrators, New York //* 2010, *Lines of Attack, group show, Nasher Museum of Art, Durham, North Carolina //* 1999, *Eye on America, group show, Norman Rockwell Museum, Stockbridge //* 1999, *Portraits in Blues, solo show, Society of Illustrators, New York*

SELECTED PUBLICATIONS — 2011, *Illustration Now! Portraits, TASCHEN, Germany //* 2005, *Illustration Now! 1, TASCHEN, Germany //* 2001, *The Illustrator in America, The Society of Illustrators, USA //* 2000, *Rolling Stone, The Illustrated Portraits, Chronicle Books, USA //* 1994, *Communication Arts, USA*

Michael Chabon, 2012
Mother Jones magazine,
Art Direction: Tim J. Luddy,
pen, ink and watercolor

Tavis Coburn

1975 born in London, Canada
Lives and works in Toronto
www.taviscoburn.com

"I feel like I'm an architect sometimes, building a visual structure out of individual elements, each having their own distinct voice yet combined together these elements create new meaning for themselves and their relationships to each other."

Marussia Motors B2, 2012
Marussia Motors,
showroom display and
poster, Art Direction: Max
Kalmykov, digital

Understanding Anxiety,
2002
Time magazine, cover,
unpublished, Art Direction:
Arthur Hochstein, acrylic,
digital and screen printing

The New Face of
Confidence, 2003
Inc. magazine, Art
Direction: Linda Koury,
acrylic, digital and screen
printing

pp. 190/91 Marussia F1
Team-Crew, 2012
Marussia F1 Team, outdoor
display and merchandise,
Art Direction: Paul
Andrews, digital

Drama and melodrama course through Tavis Coburn's brush, if not his veins. He captures action and power in ways reminiscent of the most imposing and resonant propaganda art. His agitprop style is inspired by 1940s comic-book art, the Russian avant-garde movement, and printed material from the '50s and '60s. He takes the old and makes it new. Coburn graduated from California's Art Center College of Design with a BFA in Illustration and subsequently found work in North America and Europe with *Time*, *Rolling Stone*, *GQ*, Nike and Universal Music, among others. Some of his works are available as prints, which imbues them with a curious timelessness.

Dramatik und Melodramatik fließen durch Tavis Coburns Pinsel, wenn nicht durch seine Adern. Seine Art, Aktion und Kraft darzustellen, erinnert an die beeindruckendste und schlag-kräftigste Propagandakunst. Sein Agitprop-Stil geht auf die Comic-Kunst der 1940er-Jahre zurück, auf die russische Avantgarde sowie auf Druckerzeugnisse der 50er- und 60er-Jahre. Er greift Altes auf und gestaltet es neu. Coburn besuchte das Art Center College of Design in Kalifornien, das er mit einem Bachelor in bildender Kunst verließ, und fand dann Arbeit in Nordamerika und Europa, unter anderem bei *Time*, *Rolling Stone*, *GQ*, Nike und Universal Music. Einige seiner Werke sind als Drucke erhältlich, ein Format, das ihnen eine erstaunliche Zeitlosigkeit verleiht.

Le drame et le mélodrame coulent dans les veines de Tavis Coburn. Sa façon de saisir l'action et le pouvoir évoquent l'art de propagande le plus imposant et le plus retentissant. Son style agitprop s'inspire des bandes dessinées des années 1940, du mouvement avant-gardiste russe et de documents des années 1950 et 1960. Il fait du neuf avec du vieux. Après avoir obtenu un diplôme d'illustration de l'Art Center College of Design de Californie, Coburn a trouvé du travail en Amérique du Nord et en Europe avec *Time, Rolling Stone, GQ*, Nike et Universal Music, entre autres. Certaines de ses œuvres sont disponibles sous forme de tirages artistiques, ce qui leur confère une curieuse intemporalité.

SELECTED EXHIBITIONS — 2015, Andy Warhol: Revisited, group show, Toronto // *2012*, UNO: The Art Show, group show, The Brickworks, Toronto // *2011*, American Illustration, group show, Angel Orensanz Foundation, New York // *2010*, Society of Illustrators 52, group show, New York // *2006*, Rumble Rumble, group show, Artlab, Toronto // *2004*, Picture Mechanics, group show, Exploding Head Gallery, Sacramento

SELECTED PUBLICATIONS — 2011, Illustration Now! Portraits, TASCHEN, Germany // *2011*, Illustrators Unlimited, Gestalten, Germany // *2005*, Illustration Now! 1, TASCHEN, Germany // *2000*, American Illustration, USA // *2000*, Rolling Stone, The Illustrated Portraits, Chronicle Books, USA

Josh Cochran

1979 born in Klammath Falls
Lives and works in Brooklyn
www.joshcochran.net

"My work creates unexpected
juxtapositions with obsessive attention to detail.
I get the most satisfaction from illustration
when I improvise and find myself
surprised with the outcome."

Collecting on a Budget,
2013
Collecting Art, Phaidon,
book, Art Direction: Julia
Hastings, pencil and digital

Sunday Morning, 2011
Charter Media, Art
Direction: Brian Watson for
Cactus, pencil and digital

100 Cars We Love, 2006
Esquire magazine, Russia,
pencil and digital

Blending wit and a contemporary graphic style, Josh Cochran has a versatile approach that is at once distinct within his portfolio and distinctive in the illustration world. His work marries realistic and cartoon-like elements with a quirky sense of humor, in a style that is visually light and conceptually strong. Despite this, Cochran is not a slave to his self-made fashions. "It's good to have a recognizable look," he said in a *Print* magazine interview. "It's even better if I can transcend it." He grew up in Taiwan as well as the USA, and started working as an illustrator immediately after graduating (with honors) from the Art Center College of Design.

Josh Cochran verbindet geistreichen Witz mit einem zeitgenössischen Grafikstil. In seinen Arbeiten vereinen sich realistische und cartoonartige Elemente mit einem schrägen Sinn für Humor, visuell ist der Stil leicht und konzeptionell aber packend. Dennoch ist Cochran mitnichten ein Sklave seiner selbstgeschaffenen Stile. „Es ist gut, einen erkennbaren Look zu haben", sagt er in einem Gespräch mit der Zeitschrift *Print*. „Noch besser ist es, wenn ich über ihn hinauswachsen kann." Er ist in Taiwan und den USA aufgewachsen und begann gleich nach seinem (mit Auszeichnung bestandenen) Abschluss am Art Center College of Design als Illustrator zu arbeiten.

Mêlant humour et style graphique contemporain, Josh Cochran a une approche polyvalente qui est à la fois diversifiée au sein de son portfolio et distinctive dans le monde de l'illustration. Son travail rassemble des éléments réalistes et de bande dessinée avec un sens de l'humour décalé, dans un style visuellement léger et conceptuellement solide. Mais Cochran n'en est pas esclave. « C'est bien d'avoir un look caractéristique », a-t-il déclaré dans un entretien accordé au magazine *Print*. « C'est encore mieux si je peux le transcender. » Il a grandi à Taïwan ainsi qu'aux États-Unis, et a commencé à travailler comme illustrateur immédiatement après l'obtention de son diplôme (avec mention) de l'Art Center College of Design.

SELECTED EXHIBITIONS — *2016, Get Nude. Get Drawn, group show, New York // 2013, TBD, solo show, University of the Arts, Philadelphia // 2011, Fresh StART, group show, McCall Family Foundation, Santa Monica // 2011, Nudes, group show, Artypes, Brooklyn // 2011, Travel, solo show, Rumkammerat, Copenhagen // 2010, Small Is Beautiful, group show, Murphy and Dine Gallery, New York*

SELECTED PUBLICATIONS — *2014, Inside and Out: New York, Big Picture Press, USA // 2012, The Where, the Why and the How, Chronicle Books, USA // 2011, Pulled, Princeton Architectural Press, USA // 2010, Graphic, Inside the Sketchbooks of the World's Greatest Graphic Designers, The Monacelle Press, USA // 2009, New Visual Artists, 20 Under 30, Print magazine, USA // 2008, Communication Arts, cover feature, USA*

Ever Since, 2012
The New Yorker, Author:
Donald Antrim, Art
Direction: Jordan Awan,
pencil and digital

Collecting Art (Guston),
2013
Collecting Art, Phaidon,
book, Art Direction: Julia
Hastings, pencil and digital

Brian Cronin

1958 born in Dublin
Lives and works in Brooklyn
www.briancronin.com

"I try and make the story
I'm illustrating a personal reaction
as much as I can within
the confines of the medium."

Knitters Vacation, 2012
The Yarn Whisperer,
Abrams, book, acrylic
on paper

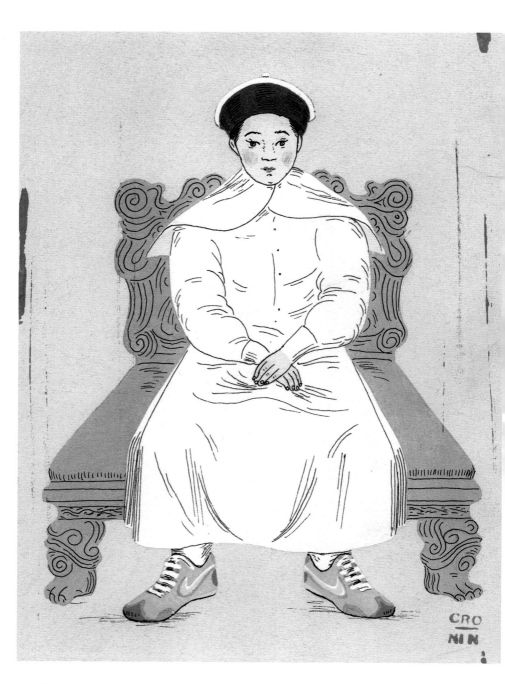

CRO
NIN

200

An expressive line is key to Brian Cronin's illustrative power and eye-catching appeal. His solid outline frames indelible representations of political, social and spiritual concerns, which both tease and deliver the goods. When he was younger Cronin worked for Milton Glaser, who said he "has blossomed into one of the best practitioners for design and illustration in the field." Over the years Cronin has developed an approach that is both personal and communicates to a mass audience. "I am always aware of the editorial process and the context in which my drawings appear," he noted.

Brian Cronins Stärke als Illustrator liegt im ausdrucksvollen Strich, und der macht auch seinen bezwingenden Charme aus. Mit kraftvollen Umrissen gestaltet Cronin denkwürdige Darstellungen politischer, gesellschaftlicher und spiritueller Fragen und spricht dabei spielerisch das Wesentliche an. In jungen Jahren arbeitete er für Milton Glaser, der von ihm sagt, er habe sich „zu einem der besten Praktiker von Grafik und Illustration in seinem Feld entwickelt." Im Lauf der Jahre hat Cronin zu einem sehr persönlichen Stil gefunden, der auch bei einem größeren Publikum ankommt. „Ich führe mir ständig den redaktionellen Ablauf vor Augen und den Kontext, in dem meine Zeichnungen erscheinen sollen", sagte er einmal.

L'expressivité du trait est la clé du pouvoir et de l'attrait des illustrations de Brian Cronin. Ses contours solides ceignent des représentations indélébiles d'ordre politique, social et spirituel, qui promettent et tiennent leurs promesses. Plus jeune, Cronin a travaillé pour Milton Glaser, qui a dit qu'il était « devenu l'un des meilleurs pour le design et l'illustration dans le secteur ». Au fil des années, Cronin s'est forgé une approche personnelle mais qui sait aussi s'adresser au grand public. « Je garde toujours à l'esprit le processus de communication et le contexte dans lequel mes dessins apparaissent », a-t-il déclaré.

Little Emperor, 2009
Psychology Today
magazine, acrylic on paper

Little Strangers, 2012
The New Yorker, acrylic
on paper

SELECTED EXHIBITIONS — *2013, The Art of Brian Cronin, solo show, The University of the Arts, Philadelphia //* *2008, Cronin: Twenty-Five Years and Change, solo show, Casa da Cerca, Centro de Arte Contemporânea, Almada, Portugal //* *2002, Hair Stories, group show, Adam Baumgold Gallery, New York //* *1998, Fat Face With Fork, retrospective 1985-1998, solo show, Irish Museum of Modern Art, Dublin //* *1985, The 688 Show, group show, The Belltable Arts Centre, Limerick, Ireland*

SELECTED PUBLICATIONS — *2016, The Lost House, Penguin Books, USA //* *2012, All the Art That's Fit to Print (And Some That Wasn't): Inside The New York Times Op-Ed Page, Columbia University Press, USA //* *2012, Big Time, The Legendary Style of Männer Vogue 1984-1989, Condé Nast, USA //* *2006, Handwritten: Expressive Lettering in the Digital Age, Thames & Hudson, UK //* *2003, Illustrated Men, GQ magazine, USA //* *2002, The Art of Brian Cronin, Circa magazine, Ireland*

Father's Day, 2013
Outside, acrylic on paper

Gents, 2012
Howler, acrylic on paper
and digital

Money from My Parents,
2013
More magazine, acrylic
on paper

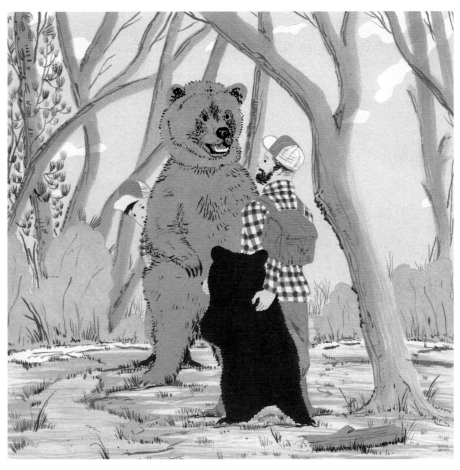

"Brian Cronin: Fat Face With Fork" was the artist's first exhibition in Ireland since starting his practice in 1983, and working freelance for *The Irish Times*. The show, in 1998, included some of Cronin's earliest illustrations, a number of commissioned works that had appeared in different publications, right up to recent non-commissioned large-scale drawings. His work often appears in such publications as *The Times* (London), *The New Yorker*, *The Los Angeles Times*, *The Wall Street Journal*, *Rolling Stone*, and countless others.

Seine Karriere begann 1983 mit einer freiberuflichen Tätigkeit für die *Irish Times*, 1998 fand unter dem Titel „Brian Cronin: Fat Face With Fork" seine erste Ausstellung in Irland statt. Dort waren einige seiner frühesten Illustrationen zu sehen, aber auch eine ganze Reihe von Auftragsarbeiten für verschiedene Printmedien und schließlich neue, großformatige freie Arbeiten. Cronins Illustrationen erscheinen häufig in Publikationen wie der *Times* (London), dem *New Yorker*, der *Los Angeles Times*, dem *Wall Street Journal*, *Rolling Stone* und vielen anderen.

« Brian Cronin: Fat Face with Fork » a été la première exposition de l'artiste en Irlande depuis ses débuts en 1983, et son travail en freelance pour *The Irish Times*. Réalisée en 1998, elle comprenait quelques-unes des premières illustrations de Cronin, des commandes pour différentes publications, ainsi que des dessins grand format récents, projets personnels. Son travail apparaît souvent dans des publications telles que le *Times* (Londres), le *New Yorker*, le *Los Angeles Times*, le *Wall Street Journal*, *Rolling Stone* et d'innombrables autres.

Paul Davis

1938 born in Centrahoma
Lives and works in New York
www.copyrightdavis.com

"I am most satisfied in my work when
I am able to convey some sense of the peculiar and
particular emotional qualities that I perceive
in daily life. Creating images often seems to me
a self-conscious pursuit. At the same time,
there is always the delicious possibility that
in the process of making a picture
something unexpected will occur."

King Lear, 2007
The Public Theater, acrylic

Changing styles to suit his mood, Paul Davis is best known for his theater posters, painted in a mysterious realist style and relying on light and dark to define the dramatic components of scene or face. By the early 1960s, Davis had in a relatively short time become one of the most prolific new illustrators, and his style had a staggering impact on the field. Yet by the late 1960s, during a period of personal success, he was no longer content simply to repeat his triumphs. He has typically enjoyed looking in new directions, and indeed change and surprise have been his trademark.

Paul Davis, der seinen Stil ganz nach Laune verändert, ist am besten bekannt für seine Theaterplakate. Sie sind in einem geheimnisvoll-realistischen Stil gehalten und fangen den dramatischen Gehalt einer Szene oder eines Gesichts vor allem durch das Spiel von Licht und Dunkelheit ein. Anfang der 1960er-Jahre galt Davis innerhalb relativ kurzer Zeit als einer der produktivsten neuen Illustratoren, und sein Stil hatte einen nachhaltigen Einfluss in der Branche. Doch Ende der 60er-Jahre, in einer Phase persönlicher Triumphe, genügte es ihm nicht mehr, seinen Erfolg immer nur zu wiederholen. So ist es typisch für ihn, neue Richtungen einzuschlagen und auf Veränderung und Überraschung zu setzen.

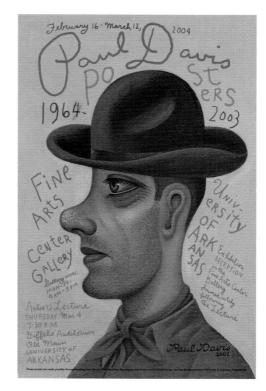

Merry Down, 2003
Merrydown Cider, poster,
acrylic on paper

Paul Davis Posters, 2003
University of Arkansas,
acrylic

Paul Davis change de style en fonction de son humeur, et est surtout connu pour ses affiches de théâtre, peintes dans un style réaliste mystérieux, où les contrastes de lumière définissent les composants dramatiques de la scène ou du visage. Au début des années 1960, Davis était devenu en relativement peu de temps l'un des nouveaux illustrateurs les plus prolifiques, et son style a eu une énorme influence. Pourtant, à la fin des années 1960, une période de réussite personnelle, il ne s'est plus contenté de répéter ses triomphes. Il a pris l'habitude de s'amuser à explorer de nouvelles directions, et le changement et la surprise sont effectivement devenus ses marques de fabrique.

SELECTED EXHIBITIONS — *2006*, I Manifesti di Paul Davis, solo show, Basilica Palladiana, Vicenza // *2005*, Paul Davis: Show People, solo show, Complesso Museale, Santa Maria della Scala, Siena // *1987*, Paul Davis Exhibition in Japan, solo show, Odakyu Grand Hall, Tokyo // *1977*, Paul Davis, solo show, Centre Georges Pompidou, Paris // *1975*, Paul Davis Exhibition, solo show, Museum of Modern Art, Kyoto

SELECTED PUBLICATIONS — *2007*, I Manifesti di Paul Davis, Nuages, Italy // *2005*, Paul Davis: Show People, Nuages, Italy // *1987*, Paul Davis Exhibition in Japan, The Mainichi Newspapers, Japan // *1985*, Paul Davis: Faces, Friendly Press, USA // *1975*, Paul Davis, Museum of Modern Art, Kamakura, Japan

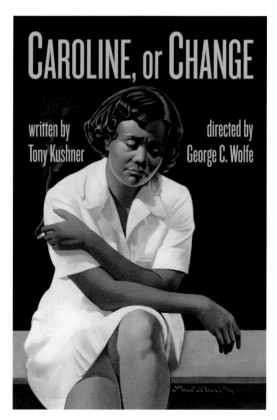

Caroline, or Change, 2005
The Public Theater,
poster, acrylic

Teatro Odeon, 2006–2007
Teatro Comunale di
Lumezzane (Italy), acrylic

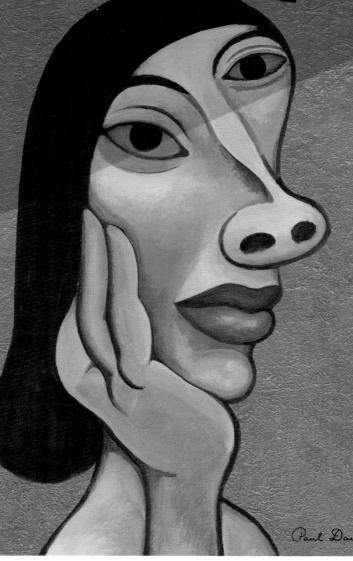

teatro Odeon
2006 2007

Paul Davis

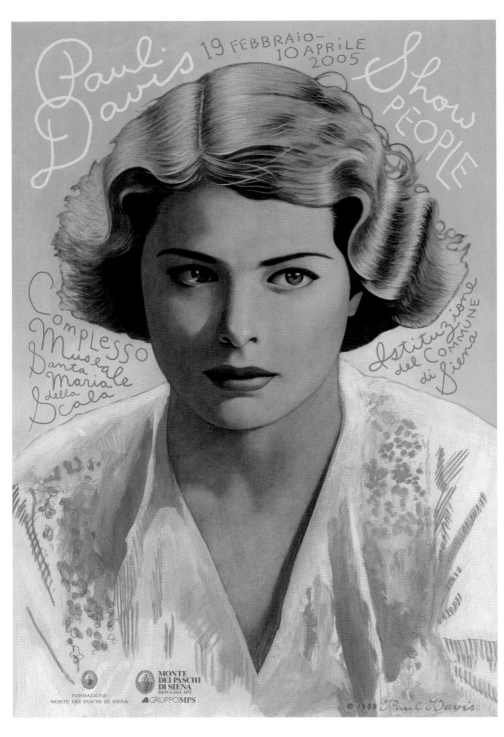

Davis was always interested in drawing, and at 15 took a job with a local illustrator, Dave Santee, doing odd jobs around the studio. After graduating at 17 he left Tulsa for New York. He was lucky, for at this time a revolution with a profound impact on the method and content of illustration was beginning at the Cartoonists and Illustrators School where he attended both day and night classes. From the Sixties to the present, he has contributed a number of paradigmatic approaches to the eclectic mix of American graphic art. "I don't feel like I've ever thrown anything away," Davis once said about these varied directions in illustration.

Davis hat sich immer schon fürs Zeichnen interessiert, und mit 15 begann er im Studio des Illustrators Dave Santee in Tulsa alle möglichen Arbeiten zu erledigen. Nachdem er mit 17 Jahren die Schule abgeschlossen hatte, ging er nach New York. Er hatte Glück, denn genau zu der Zeit begann in der Cartoonists and Illustrators School eine Revolution, die einen tiefgreifenden Einfluss auf die Methode und den Inhalt der Illustration haben sollte, und dort besuchte Davis sowohl Tages- als auch Abendkurse. Seit den 60er-Jahren hat er die eklektische Mischung der amerikanischen Grafik um eine ganze Reihe paradigmatischer Vorgehensweisen bereichert. „Ich habe nicht das Gefühl, dass ich mir jemals etwas habe entgehen lassen", sagte er einmal mit Blick auf diese unterschiedlichen Stilrichtungen der Illustration.

Davis a toujours été intéressé par le dessin, et à 15 ans il a fait un stage pour un illustrateur local, Dave Santee. À 17 ans, il a quitté Tulsa, direction New York. Il a eu de la chance, car à cette époque était en train de germer à la Cartoonists and Illustrators School une révolution sur les contenus et la méthode de l'illustration. Des sixties à aujourd'hui, il a été à l'origine de plusieurs approches paradigmatiques du mélange éclectique de l'art graphique américain. « Je n'ai pas l'impression d'avoir jamais jeté quoi que ce soit », a un jour remarqué Davis à propos de ces différentes directions dans l'illustration.

Paul Davis – Show People,
2006
Commune di Siena, poster,
acrylic on board

Grand Illusion, 2012
Rialto Pictures, poster,
acrylic on paper

Jean-Philippe Delhomme

1959 born in Paris
Lives and works in Paris
www.jphdelhomme.com

"Paintings in a semiabstract form,
yet accurately figurative,
with subjects ranging from fashion
and portraits, to a satirical
take on culture."

The Logs We Had Fedexed
from Montana Were 2
Inches Too Wide, 2011
Los Angeles Times
magazine, gouache

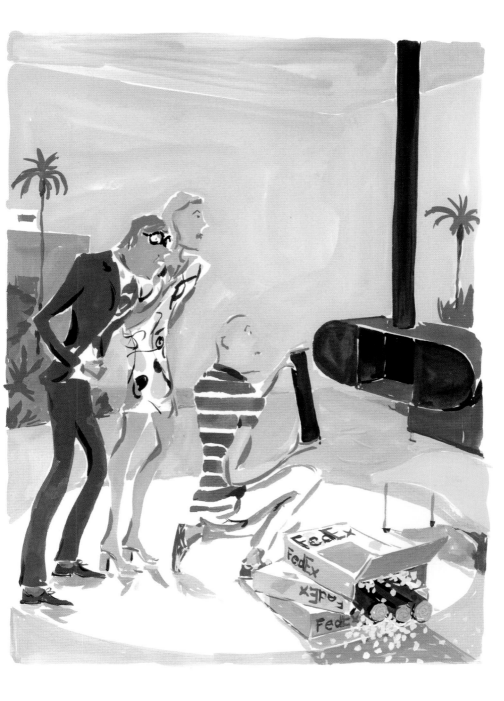

Fitting at threeASFOUR,
2010
Personal work, The
Unknown Hipster, book,
gouache

Opening at Gagosian, 2010
Personal work, The
Unknown Hipster, book,
gouache

Splotches of color define the impressionistic way Jean-Philippe Delhomme visually describes his fashionable cast of figures. Delhomme fancies himself a commentator and satirist, in the tradition of André François, Ronald Searle, and even back to Gillray and Rowlandson. He studied animation at the École nationale des Arts Décoratifs in Paris, graduating in 1985, and his first fashion illustrations were published in British *Vogue* with further work appearing soon after in publications including *Vogue Nippon*, *Vogue Paris*, and *House & Garden*.

Farbkleckse erzeugen den impressionistischen Look, den Jean-Philippe Delhomme seinen stilvoll modischen Figuren verleiht. Delhomme sieht sich als Kommentator und Satiriker in der Tradition eines André François und Ronald Searle bis zurück zu Gillray und Rowlandson. Bis 1985 studierte er Animation an der École nationale des Arts Décoratifs in Paris, seine ersten Modeillustrationen erschienen in der englischen *Vogue*, wenig später folgten Aufträge unter anderem für *Vogue Nippon*, *Vogue Paris* und *House & Garden*.

C'est avec des taches de couleur impressionnistes que Jean-Philippe Delhomme décrit visuellement ses personnages chics. Delhomme se considère comme un commentateur et un satiriste, dans la tradition d'André François et Ronald Searle, et même des anciens Gillray et Rowlandson. Il a étudié l'animation à l'École nationale des Arts Décoratifs de Paris, dont il est sorti en 1985, et ses premières illustrations de mode ont été publiées dans l'édition britannique de *Vogue*. Son travail est par la suite apparu dans *Vogue Nippon*, *Vogue Paris* et *House & Garden*.

Concerning his process, Delhomme said in an interview with Glenn O'Brien: "I usually end up hanging around places where I know I'm likely to spot a few characters with a bit of an attitude—outstanding looks, arrogant or funny behavior. [...] If I return without any potential subjects, I'm in serious trouble. But most of the time, I just sit at my table, and the so-called victims happen to be inside of me, like possible selves I refrained from being!" One of his most celebrated works is the series Polaroids de Jeunes Filles, created in 1987.

Was seinen Arbeitsablauf betrifft, erzählt Delhomme in einem Interview mit Glenn O'Brien: „Meist treibe ich mich an Orten herum, wo ich weiß, dass mir ein paar ausgefallene Typen über den Weg laufen – ein famoses Äußeres, ein arrogantes oder komisches Verhalten [...] Wenn ich ohne potenzielles Motiv zurückkomme, habe ich ein echtes Problem. Meist sitze ich dann an meinem Schreibtisch und stelle fest, dass das sogenannte Opfer in mir selbst steckt, wie ein mögliches Ego, das ich nicht sein wollte!" Besonders großes kritisches Lob erhielt Delhomme für die Serie Polaroids de Jeunes Filles aus dem Jahr 1987.

En ce qui concerne son processus, Delhomme a déclaré dans un entretien avec Glenn O'Brien : «En général, je me retrouve à fréquenter les endroits où je sais que je vais repérer des personnages qui ont de l'attitude – un look inhabituel, un comportement arrogant ou amusant. [...] Si je repars sans sujet potentiel, c'est un problème. Mais la plupart du temps, je me contente de rester assis à ma table, et les "victimes" sont en fait à l'intérieur de moi, comme des alter egos possibles que j'ai refoulés!» L'une de ses œuvres les plus célèbres est la série Polaroids de Jeunes Filles, réalisée en 1987.

SELECTED PUBLICATIONS — *2016*, New York Observer newspaper, USA // *2016*, Zeit magazine, Germany // *2013*, The Unknown Hipster Diaries, August Editions, USA // *2011*, How To Be a Man, by Glenn O'Brien, Rizzoli, USA // *2009*, The Cultivated Life, Rizzoli, USA // *2007*, Design Addicts, Thames & Hudson, UK // *2007*, Scènes de la vie parentale, Denoël, France

The Fashion Editors, 2011
W magazine, gouache

Vanessa Dell

1973 born in Surrey, UK
Lives and works in Surrey
www.vanessadell.com

"I quite like imperfection
so the people I paint whether they
are for straight portraits or imagined tend
to be a little awkward looking—I suppose
this gives them vulnerability."

Mark Zuckerberg, 2011
TASCHEN, pitch for book
cover, oil on paper

Likeness is essential for a portraitist, but Vanessa Dell's faces are more than mere copies of well-known expressions. With her preferred method of painting in oil on treated paper, mainly from photographs, she captures the essence of individuals by focusing primarily on the eyes and is happy to paint the "real" person underneath the proverbial mask. After studying at Wimbledon School of Art, then Kingston University, Dell specialized in illustration, people being her main subject alongside those parts of our everyday lives where humor, beauty or even ugliness can be found. Commissioned work has come from the BBC, Saatchi and Saatchi, Kiehls, *The Times*, *The New Yorker* and *Rolling Stone*.

Für einen Porträtisten gehört es zum Handwerkszeug, das Modell möglichst genau zu treffen, aber Vanessa Dell beschränkt sich keineswegs auf das Kopieren bekannter Gesichtszüge. Sie malt vorzugsweise in Öl auf behandeltem Papier, hauptsächlich nach fotografischen Vorlagen. So fängt sie individuelle Charaktere ein, wobei sie sich vor allem auf die Augen konzentriert, und es macht sie glücklich, die „wahre" Person hinter der sprichwörtlichen Maske zu malen. Nach ihrem Studium an der Wimbledon School of Art und der Kingston University spezialisierte sich Dell auf Illustration. Ihr Hauptthema sind Menschen, weiter solche Aspekte unseres Alltags, in denen Humor, Schönheit und sogar Hässlichkeit zu finden sind. Zu ihren Auftraggebern gehören die BBC, Saatchi & Saatchi, Kiehls, die *Times*, der *New Yorker* und *Rolling Stone*.

La ressemblance est essentielle pour les portraitistes, mais les visages de Vanessa Dell sont bien plus que de simples copies d'expressions reconnaissables. Avec sa méthode de prédilection, la peinture à l'huile sur papier traité, elle saisit l'essence de ses sujets en concentrant l'attention sur les yeux, et aime peindre la « vraie » personne derrière les apparences. Après ses études à la Wimbledon School of Art, puis à l'Université de Kingston, Dell s'est spécialisée dans l'illustration, et son sujet principal est la figure humaine, ainsi que les parties de nos vies quotidiennes où l'on peut trouver de l'humour, de la beauté ou même de la laideur. BBC, Saatchi and Saatchi, Kiehls, le *Times*, le *New Yorker* et *Rolling Stone* lui ont passé commande.

SELECTED PUBLICATIONS — *2016*, Slate magazine, USA // *2011*, Illustration Now! Portraits, TASCHEN, Germany // *2007*, 3x3 magazine, USA // *2005*, Illustration Now! 1, TASCHEN, Germany // *2004*, Contact 20, Elfande, UK

Grooming Part Three, 2003
Personal work, digital

Ramsgate Rooftops, 2002
Personal work, oil on paper

Audrey Hepburn, 2008
Annabelle magazine,
Switzerland, oil on paper

David Despau

1972 born in Madrid
Lives and works in Madrid
www.despau.com

"I am fascinated by faces,
drawing them realistically or simplifying
them almost to abstraction. Composition
and rhythm are fundamental
to an illustration."

Yorokobu, 2012
Yorokobu magazine, cover,
ballpoint pen, ink and
digital

Highly stylized yet still modest, the portraits of David Despau are exquisitely rendered in such a way that the personality of his subjects is magnificently photographic in its illusionistic exactitude. Despau discovered his passion for illustration while working as a creative director, having swiftly moved to Fine Arts (graduating with a degree in Design) after first studying Architecture. The contemporary quality of his work lies in the massive detailing offset by empty space—what is left out is as telling as what is so precisely put in. He believes the combination of typography and visual rhythm to be an important aspect of illustration.

Rachel Weisz, 2010
Personal work, ballpoint
pen, ink and digital

Ella, 2012
Personal work, ballpoint
pen, ink and digital

Die stark stilisierten, dabei zurückhaltenden Porträts von David Despau sind so exquisit in ihrer Machart, dass die Persönlichkeit der Dargestellten in ihrer illusionistischen Exaktheit auf großartig fotografische Weise zur Geltung kommt. Seine Leidenschaft für die Illustration entdeckte Despau während seiner Arbeit als Creative Director, nachdem er vom ursprüng-lichen Architektur- sehr schnell zum Kunststudium übergewechselt war (das er mit einem Diplom in Design absolvierte). Die zeitgenössische Qualität seines Werks liegt in den sehr detaillierten Leerräumen – was ausgelassen wird, ist genauso aufschlussreich wie das präzis Gezeichnete. Nach Despaus Auffassung ist die Kombination aus Typografie und visuellem Rhythmus ein wichtiger Aspekt der Illustration.

Très stylisés et pourtant modestes, les portraits de David Despau sont d'une exquise délicatesse. Leur exactitude illusionniste donne à la personnalité de ses sujets un magnifique rendu photographique. Despau a découvert sa passion pour l'illustration lorsqu'il travaillait comme directeur de la création. Il a tout d'abord étudié l'architecture, puis a passé un diplôme de design avant de se convertir aux beaux-arts. La qualité contemporaine de ses œuvres se situe dans l'énorme quantité de détails, et dans le contraste avec l'espace laissé vide – ce qui est omis est aussi révélateur que ce qui est dessiné avec tant de précision. Il pense que la combinaison de la typographie et du rythme visuel est un aspect essentiel de l'illustration.

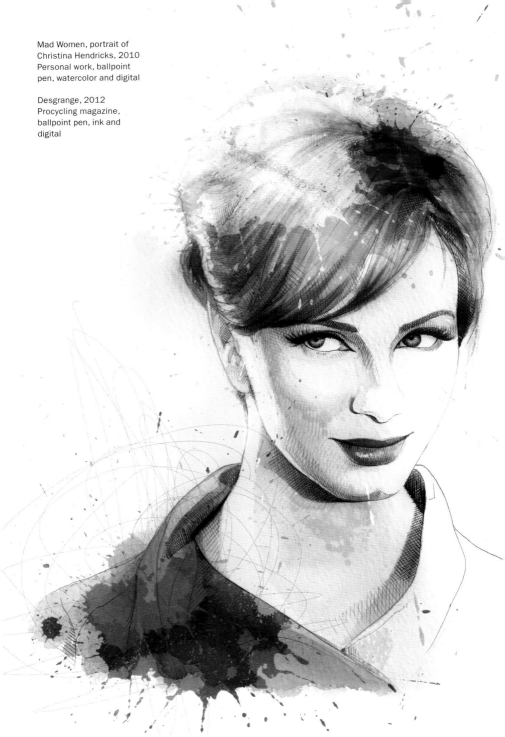

Mad Women, portrait of
Christina Hendricks, 2010
Personal work, ballpoint
pen, watercolor and digital

Desgrange, 2012
Procycling magazine,
ballpoint pen, ink and
digital

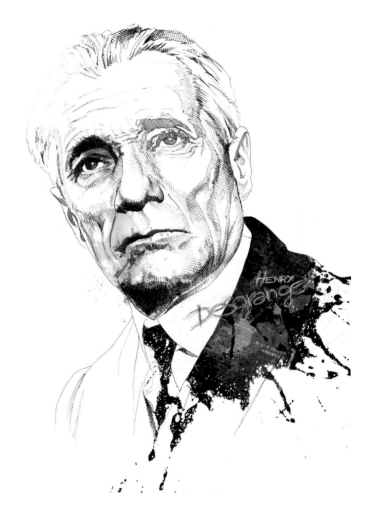

SELECTED EXHIBITIONS — 2012, *Darkness & Light, group show, DC'S Burbank Office, California //* **2010**, *75th DC Comics & MyFACE, group show, Palais de Tokyo, Paris*

SELECTED PUBLICATIONS — 2011, *Yorokobu, Brand & Roses, Spain //* **2010**, *Hair'em Scare'em, Gestalten, Germany //* **2010**, *Illusive 3, Gestalten, Germany //* **2010**, *The New Age of Feminine Drawing 2, All Rights Reserved Publishing, Hong Kong //* **2009**, *200 Best Illustrators Worldwide, Lürzer's Archive, Austria*

Peter Diamond

1981 born in Oxford
Lives and works in Vienna
www.peterdiamond.ca

"Visual short stories interrupted
at a point of climax. Bright colors forced into
dark schemes, detailing familiar things in
obscure circumstances."

Religion ohne Götter
(Religion without Gods),
2012
Hohe Luft magazine,
Picture Editor: Maja Metz,
ink and digital

There is a neo-Pre-Raphaelite patina to Peter Diamond's exquisite tableaux, though this is not to imply that they are at all replicas of the past. It should be noted as well that the accessible complexity in his work makes for a highly immersive group of illustrations. "I've been drawing pretty much non-stop since the first time someone put a crayon in my hand," he told the website Tangled Fingers, "and it became illustration when I started drawing posters for the punk rock shows a friend and I organized as teenagers. I would be a struggling musician if I weren't spending all my time as a struggling artist."

Peter Diamonds exquisite Tableaus haben etwas von einer neo-präraffelitischen Patina, was aber nicht heißen soll, dass es sich ausschließlich um Repliken der Vergangenheit handeln würde. Festzuhalten ist auch, dass die zugängliche Komplexität seiner Arbeit Illustrationen entstehen lässt, in die man gerne eintaucht. „Seitdem mir zum ersten Mal irgendjemand einen Buntstift in die Hand gedrückt hat, habe ich praktisch pausenlos gezeichnet", berichtet er auf der Website von Tangled Fingers, „und daraus wurden dann richtige Illustrationen. Ich begann damit, Poster für die Punkrock-Shows zu entwerfen, die ein Freund und ich als Teenager organisierten. Ich wäre ein hunger-leidender Musiker geworden, hätte ich mich nicht die ganze Zeit als hungerleidender Künstler herumgeschlagen."

Les superbes compositions de Peter Diamond ont une certaine patine néo-préraphaélite, mais cela ne signifie pas qu'elles soient toutes des répliques du passé. Il faut aussi remarquer que la complexité accessible de son travail crée des illustrations dans lesquelles on a envie de plonger. « J'ai dessiné plus ou moins sans interruption depuis la première fois que quelqu'un m'a mis un crayon dans la main », a-t-il déclaré au site web Tangled Fingers, « et c'est devenu de l'illustration lorsque j'ai commencé à dessiner des affiches pour les concerts punks qu'un ami organisait lorsque j'étais adolescent. Si je ne passais pas tout mon temps à être un artiste crève-la-faim, je serais un musicien crève-la-faim. »

Chasing the Cup, 2012
Personal work, ink and
digital

Aeon, 2012
Burden, vinyl record
sleeve, Design: Friedrich
Detering, ink and digital

How to Catch a Giant Hand,
2011
Zeixs, playing card, Art
Direction: Marc Wnuck
and Sahba Yadegar,
unpublished, ink and digital

SELECTED EXHIBITIONS — **2013**, *Illustrators 54: Advertising and Institutional, group show, Museum of American Illustration, New York* // **2012**, *Joseph Binder Award 2012, group show, DesignForum Vienna* // **2011**, *The Deeper We Fall, The Stronger We Stay, group show, Swoon Fine Art, Halifax* // **2009**, *The Devils I Know, solo show, Argyle Fine Art, Halifax* // **2009**, *An Eye For An Ear, solo show, Utility Gallery, Halifax*

SELECTED PUBLICATIONS — **2014**, *Little Nemo: Dream Another Dream, Locust Moon, USA* // **2012**, *Fantasy + Vol. 4, World's Most Imaginative Artworks, CYPI Press, UK/China* // **2012**, *Spectrum Fantastic Art Vol. 19, Underwood Books, USA* // **2011**, *Illustration Now! 4, TASCHEN, Germany* // **2011**, *Illustrators Unlimited, Gestalten, Germany* // **2011**, *Spectrum Fantastic Art Vol. 18, Underwood Books, USA*

The Secret History of Costaguana, 2011
The New York Times Sunday Book Review, Art Direction: Nicholas Blechman, ink and digital

Lifelines, 2011
Plansponsor magazine, ink and digital

Where We're From, 2012
Personal work, ink and digital

Christina Drejenstam

1977 born in Gothenburg
Lives and works in Stockholm
www.drejenstam.se

"My illustrations are modern
yet classical—they are both simplified and
rich in detail at the same time."

Untitled, 2012
Personal work, pen and
digital

eBoy

1998 founded in Berlin
Located in Berlin and in Vancouver
www.eboy.com

"The basic idea driving eBoy
is the embracement of the new possibilities
of emerging digital world."

MLK-Nike Game
Cover, 2012
Milk magazine, Hong
Kong, digital

It was inevitable that pixelation would become an artistic style, but eBoy does not use this primitive unit simply for irony. The group of pixel-pushers founded by Kai Vermehr, Steffen Sauerteig and Svend Smital has brilliantly made this method into a viable medium and code for the here and now. Their art is reminiscent of computer games of bygone years and the happy feelings of nostalgia that evokes, but there is more to it than that since eBoy aims to provide a "stage and a shared identity and a shelter from all the killers out there," as they say in their mission statement.

Es konnte nicht ausbleiben, dass das Pixeln zu einem künstlerischen Stilmittel werden würde, aber eBoy verwendet diese primitive Einheit nicht nur zur Ironisierung. Das von Kai Vermehr, Steffen Sauerteig und Svend Smital gegründete Pixler-Kollektiv hat diese Methode auf brillante Weise zu einem brauchbaren Medium und Code für das Hier und Jetzt gemacht. Die Kunst von eBoy erinnert an Computerspiele längst vergangener Zeiten und an die glücklichen Nostalgiegefühle, die sich mit ihnen verbinden, aber das ist nicht alles: Zum Leitbild der Gruppe gehört auch, „ein Podium, ein Zusammengehörigkeitsgefühl und eine Zuflucht vor all den Killern da draußen" zu schaffen.

Que la pixélisation devienne un style artistique, c'était inévitable. Mais eBoy n'utilise pas cette unité primaire par simple ironie. Ce groupe de pixélisateurs fondé par Kai Vermehr, Steffen Sauerteig et Svend Smital a brillamment converti cette méthode en technique et code viables pour notre présent. Leur art évoque les jeux vidéo d'antan et la douce nostalgie qui leur est associée, mais c'est aussi plus que cela, car eBoy cherche à créer « une scène, une identité partagée et un abri contre tous les assassins qui traînent », comme l'indique l'énoncé de mission du groupe.

Kero & Annie, 2012
Detroit Underground
Records, digital

2012/10/04, 2012
Personal work, digital,
eBoy's iPhone app The Grix

Finger Candy, 2012
Personal work, digital,
eBoy's iPhone app The Grix

With all three being fans of television, advertising and the ephemera of pop culture (not forgetting Lego), their art extends from simple portraits, vehicles and rampaging beasts, to cityscapes densely packed with isometric buildings and the myriad elements of modern life. Much of their work is illustration, but is increasingly becoming more entrepreneurial. "I would group toy design, pixel work and R&D into the category of 'creation,'" Vermehr told *Computer Arts* magazine. "I'd love to introduce more 3D concepts into our work [...] On the other hand, we all really enjoy a slow evolution of style and craftsmanship, based on quality."

Alle drei sind Fans des Fernsehens, der Werbung und der Kurzlebigkeit der Popkultur (nicht zu vergessen Lego), und ihre Kunst reicht von einfachen Porträts, Fahrzeugen und wütenden Bestien bis zu Stadtlandschaften, dicht vollgepackt mit isometrischen Gebäuden und Myriaden an Elementen des modernen Lebens. Ein Großteil ihrer Arbeit ist Illustration, richtet sich aber zunehmend auch auf den Unternehmensbereich. „Ich würde Spielzeug-Design, Pixel-Arbeit sowie F&E der Kategorie ‚Kreation' zuordnen", sagt Vermehr der Zeitschrift *Computer Arts*. „Ich würde gerne mehr mit 3D-Konzepten arbeiten [...] Anderer-seits sind wir sehr auf Qualität bedacht und finden es gut, uns stilistisch und handwerklich langsam zu entwickeln."

Les trois membres étant grands amateurs de télévision, de publicité et des succès éphémères de la culture populaire (sans oublier les Lego), leur art englobe les simples portraits, les véhicules et les bêtes déchaînées, mais aussi les paysages urbains saturés de bâtiments isométriques et des innombrables de la vie moderne. L'illustration est une grande partie de leur travail, mais le commercial prend une place croissante. « J'ai envie de regrouper la conception de jouets, la pixélisation et le travail de recherche et développement dans la catégorie "création" », a déclaré Vermehr au magazine *Computer Arts*. « J'aimerais beaucoup incorporer davantage de concepts 3D dans notre travail [...] D'un autre côté, nous aimons prendre notre temps pour faire évoluer notre style et notre savoir-faire, et privilégier la qualité. »

Chyrss Blink, 2012
Personal work, digital

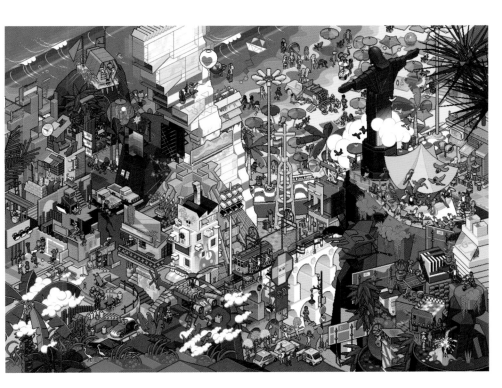

SELECTED EXHIBITIONS — *2009, eBoy LA, solo show, Concrete Hermit Gallery, London // 2009, eBoy, solo show, weloveasbaek, Copenhagen // 2004, Pixelesque, solo show, Maxalot, Barcelona // 2004, Superbroncobattle, solo show, Miunco, London // 2002, The Book and the Exhibition, solo show, Magma Clerkenwell, London*

SELECTED PUBLICATIONS — *2016, Süddeutsche Zeitung newspaper, Germany // 2008, eBoy Pixorama, eBoy, Germany // 2008, eBoy Schmock, Rojo, Spain // 2008, Small Studios, Hesign, China/Germany // 2003, Super, Thomas Bruggisser/Michel Fries, Switzerland // 2002, eBoy Hello, Laurence King, UK*

Rio, 2011
Personal work, digital

Daniel Egnéus

1972 born in Falköping, Sweden
Lives and works in Athens
www.danielegneus.com

"I see everyday life and art as one inseparable whole. My work is an expression of my colorful life in Athens and my daydreaming."

→ Elizabethan Giraffe
Woman, 2012
Personal work, ink and
watercolor on colored
paper and digital

pp. 250/51 The Rape
of Proserpina, 2013
Personal work,
ink and watercolor

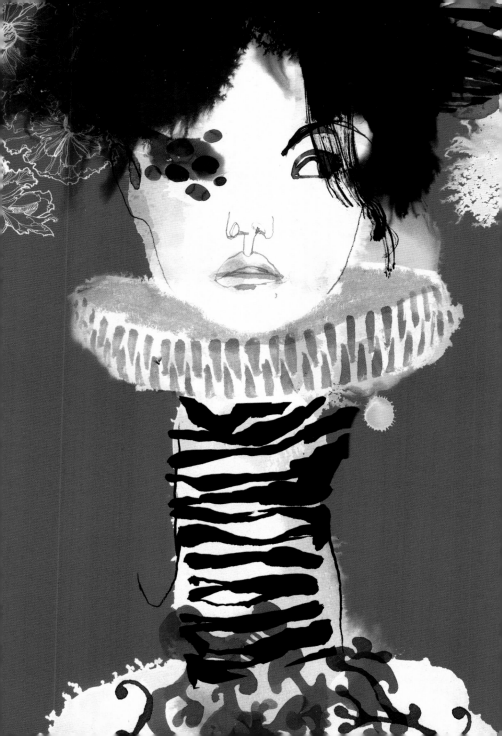

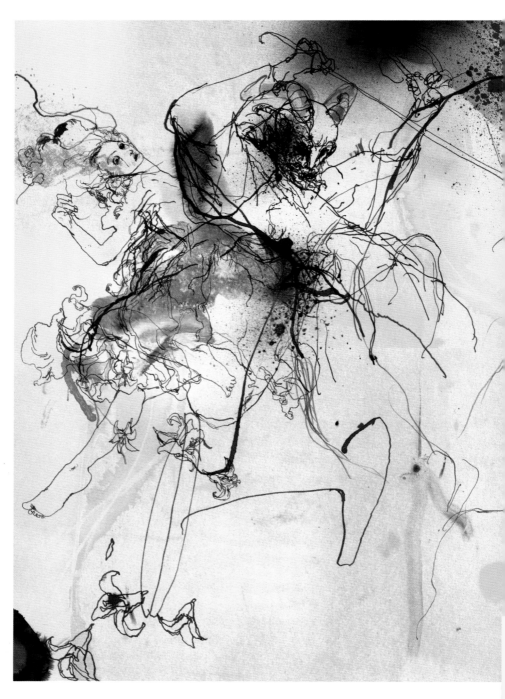

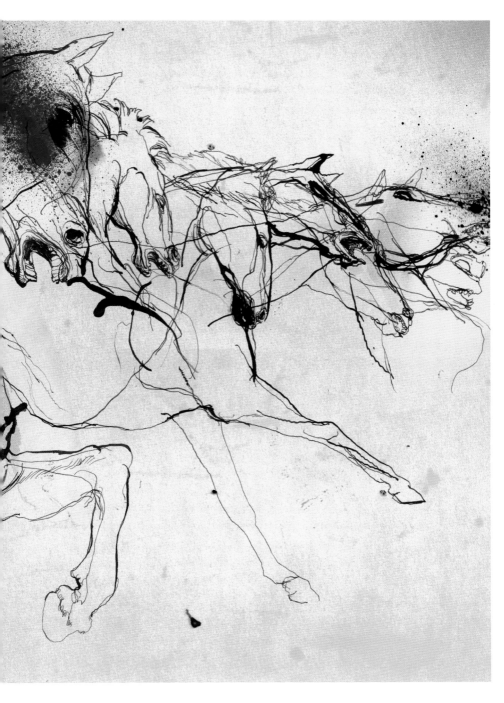

p. 254 Apartment in
Apollonos Street, 2012
Personal work, ink

p. 255 Pension
Money, 2013
Personal work, ink
on colored paper

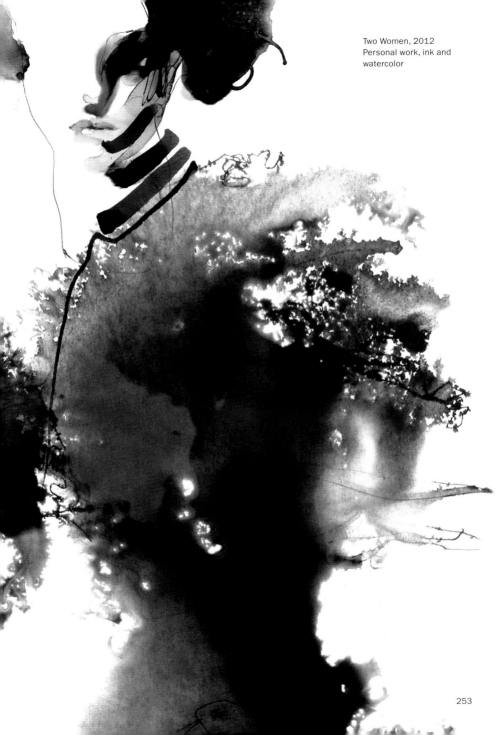

Two Women, 2012
Personal work, ink and
watercolor

253

To draw in pen and ink with such effortless fluidity as can be seen in the works of Daniel Egnéus is a dying (perhaps already dead) art. He masters a range of distortions and expressions with distinctive and compelling results, all done primarily in black and red. In order to become an illustrator (and quit a series of part-time jobs) he knocked on every door to try and sell his drawings. Then, with the Internet, everything became simpler—the work was out there in the world. "It is a part of me," he says about his passion for illustration.

So mühelos und fließend mit Stift und Tusche zu zeichnen, wie Daniel Egnéus es in seinen Arbeiten tut, ist eine aussterbende (vielleicht sogar schon ausgestorbene) Kunst. Er bringt eine Vielfalt an Verzerrungen und Ausdrucksweisen zu unverwechselbaren, überzeugenden Resultaten, in denen Rot und Schwarz vorherrschen. Um Illustrator zu werden (wofür er eine ganze Reihe von Teilzeitjobs aufgab), ging er überall Klinken putzen, um seine Zeichnungen an den Mann zu bringen. Mit dem Internet wurde dann alles einfacher – die Arbeit flog aus in die ganze Welt. „Sie ist ein Teil von mir", sagt er über seine Leidenschaft für die Illustration.

Dessiner au stylo et à l'encre avec autant d'aisance et de fluidité que dans les œuvres de Daniel Egnéus est un art en voie de disparition (et peut-être déjà disparu). Il maîtrise un vaste éventail de distorsions et d'expressions avec des résultats originaux et irrésistibles, toujours en rouge et noir. Pour devenir illustrateur (et quitter une série de jobs à temps partiel), il a frappé à toutes les portes. Puis, avec Internet, tout est devenu plus simple – il suffisait d'aller chercher le travail. « Cela fait partie de moi », dit-il à propos de sa passion pour l'illustration.

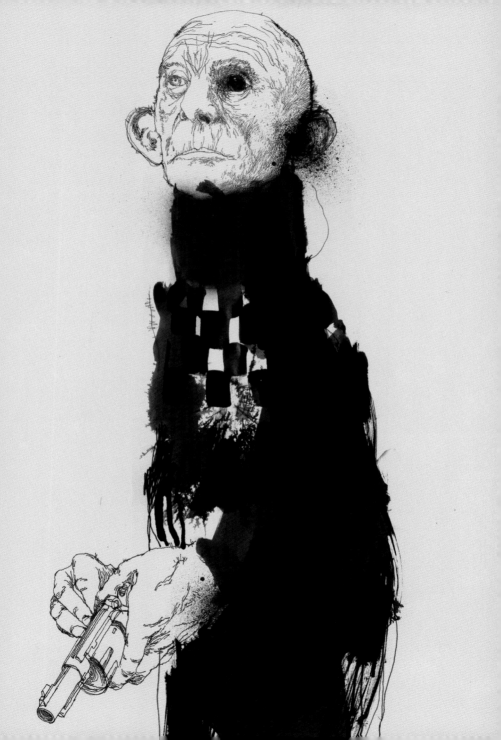

Catalina Estrada

1974 born in Medellín, Colombia
Lives and works in Barcelona
www.catalinaestrada.com

"My work consists of all the colors
and power of Latin-American folklore,
refined with a subtle touch of
European sophistication."

Bengala Tiger, 2011
Ministry of Tourism,
Government of India,
poster, digital

Incredible India

This is optical complexity raised to the level of virtuosity. Careful attention to symmetric detail gives Catalina Estrada's tableaux the shock and awe factor that can hold the eye for hours. This is not surprising since she admits in an interview, "I've always loved emotional images, so I guess I put lots of both emotion and color into every image I create." Having received a degree in Graphic Design, she moved to Spain to continue her studies in Fine Arts before returning to a style of illustration closer to her beginnings. "I developed my own graphic language and this allowed me to get more illustration commissions."

Hier begegnet uns optische Komplexität, die den Grad des Virtuosen erreicht. Die gründliche Konzentration auf symmetrische Details verleiht den Bildern Catalina Estradas jene überwältigende Schockwirkung, die den Blick stundenlang zu fesseln vermag. Das überrascht umso weniger, als sie selbst in einem Interview bekennt: „Ich habe schon immer emotionale Bilder gemocht, und vermutlich steckt deshalb in jedem meiner Bilder so viel Emotion und Farbe." Nach der Ausbildung zur Grafikdesignerin ging sie nach Spanien, um ihr Kunststudium fortzusetzen, ehe sie dann wieder zu einem illustrativen Stil zurückkehrte, der eher ihren Anfängen entspricht. „Ich entwickelte meine eigene zeichnerische Sprache, und dadurch bekam ich auch mehr Aufträge für Illustrationen."

La complexité optique élevée au niveau de la virtuosité. L'attention méticuleuse que Catalina Estrada porte à la symétrie des détails donne à ses tableaux un facteur de choc et d'émerveillement qui peut retenir le regard pendant des heures. Ce n'est pas surprenant, car elle reconnaît dans un entretien : « J'ai toujours aimé les images émotionnelles, alors je suppose que je mets beaucoup d'émotion et de couleur dans chaque image que je crée. » Après son diplôme de graphisme, elle est partie vivre en Espagne pour continuer ses études dans les beaux-arts avant de retourner à un style d'illustration plus proche de ses débuts. « J'ai développé mon propre langage graphique et cela m'a permis de recevoir plus de commandes d'illustration. »

OFFF Festival, 2012
Offf Festival, Barcelona,
book, digital

Peacock Girl & Tiger Boy,
2012
Monoblock, notebook
cover, digital

SELECTED EXHIBITIONS — *2012, Catalina Estrada, solo show, MAMM Museum of Modern Art, Medellín // 2012, Making Great Illustration, group show, The Peninsula Arts Gallery, Plymouth // 2009, Disarming Dreams, solo show, Iguapop Gallery, Barcelona // 2008, A Cabinet of Natural Curiosities, group show, Roq La Rue, Seattle // 2007, Sweet Company, group show, La Luz de Jesus, Los Angeles*

SELECTED PUBLICATIONS — *2016, Jungla Cósmetica, Plaza & Janés, Spain // 2012, Catalina Estrada, Making Great Illustration Book, UK // 2012, Catalina Estrada's Private Paradise, El País newspaper, Spain // 2012, El Colombiano newspaper, Colombia // 2012, Illustrated Girl, Architectural Digest magazine, Spain // 2010, Latino Gráfico, Gestalten, Germany*

When I Get Angry I'm
a Panther, 2011
Laboratorio del Espíritu,
scarves, notebooks
and mugs, digital

Fish and Guava, 2011
Laboratorio del Espíritu,
scarves, notebooks and
mugs, digital

Gianluca Folì

1978 born in Rome
Lives and works in Grottaferrata
www.gianlucafoli.com

"Feel all the mental
concentration preceding the creative
act which is palpable in the suspended
lines and big white spaces."

El Don Giovanni, 2011
ELI Edizioni, book cover,
Art Direction: Daniele
Garbuglia, watercolor, ink
and digital

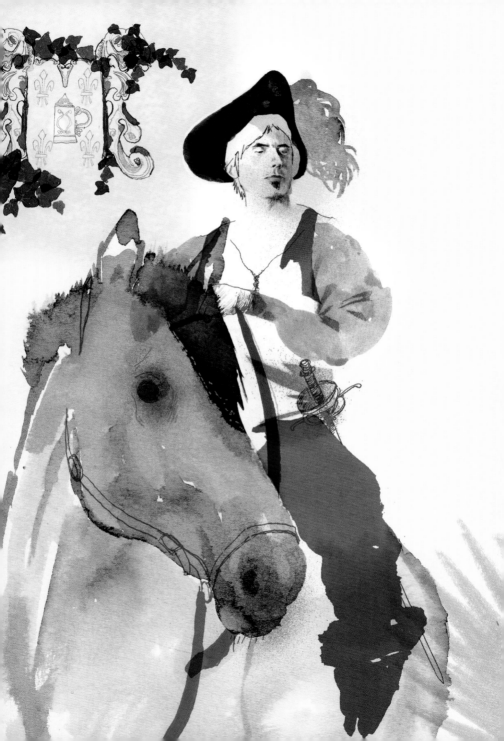

← → The Three
Musketeers, 2011
Teide Edition, book, Art
Direction: Anna Folquè,
watercolor, ink, spray
and digital

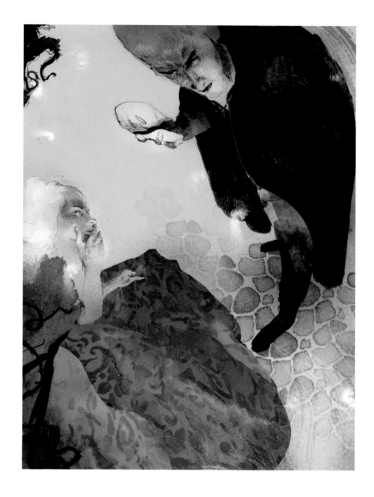

There is a soothing quality about the vignettes Gianluca Folì seems to manufacture without
the slightest effort on his part. Even so, there are illustrations here that are graphic *tours de
force*, while others emerge as engaging narratives. Some of what Folì calls decoration comes
across as remarkably dark conceptual ideas, but he doesn't shy away from the D-word either.
And then there are the children's books, which benefit from his sophisticated artistry and
obvious empathy. Folì says he has always loved drawing, and from his studio near the
vineyards of Castelli Romani, work flows out for such clients as Mondadori, Feltrinelli, Fendi,
The Wall Street Journal and various others.

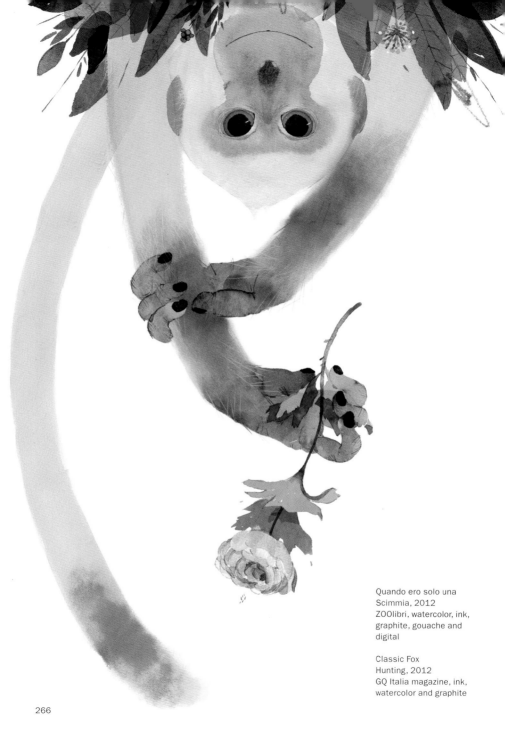

Quando ero solo una
Scimmia, 2012
ZOOlibri, watercolor, ink,
graphite, gouache and
digital

Classic Fox
Hunting, 2012
GQ Italia magazine, ink,
watercolor and graphite

Die scheinbare Mühelosigkeit in Gianluca Folìs Arbeiten verbreitet etwas Beruhigendes. Dennoch gibt es Illustrationen, die grafische Kraftakte sind, während andere wie fesselnde Geschichten auftreten. Aus dem, was Folì als Dekoration bezeichnet, lassen sich zum Teil bemerkenswert düstere Konzeptideen herauslesen, aber er schreckt auch vor dem Dokumentarischen nicht zurück. Und dann gibt es die Kinderbücher, denen seine raffinierte Technik und offensichtliche Empathie zugutekommt. Folì, der nach eigener Aussage schon immer gerne gezeichnet hat, produziert in seinem Atelier nahe der Weingärten der Castelli Romani Aufträge für Kunden wie Mondadori, Feltrinelli, Fendi, das *Wall Street Journal* und verschiedene andere.

Les images que Gianluca Folì semble exécuter sans le moindre effort ont une qualité réconfortante. Pourtant, certaines de ses illustrations sont de véritables tours de force graphiques, et d'autres racontent des histoires fascinantes. Une partie de ce que Folì qualifie de décoration se présente comme des idées conceptuelles remarquablement sombres. Et puis il y a les livres pour enfants, qui bénéficient de son talent artistique sophistiqué et de son évidente empathie. Folì dit qu'il a toujours aimé dessiner, et, depuis son studio non loin des vignes de Castelli Romani, il travaille pour des clients tels que Mondadori, Feltrinelli, Fendi, *The Wall Street Journal* et de nombreux autres.

SELECTED EXHIBITIONS — *2014*, Gianluca Folì + Philip Giordano – An Italian Dialogue, group show, Gallery Dazzle, Tokyo // *2012*, 50th Annual Illustration West Exhibition, group show, Gallery Nucleus, Los Angeles // *2010*, Bianco di Fondo, solo show, Rome // *2009*, CJ Picture Book Festival, group show, Hong Kong

SELECTED PUBLICATIONS — *2012*, SILA Annual 54, USA // *2011*, Illustration Now! 4, TASCHEN, Germany // *2011*, Taiwan Design Center #159, Design at the Edge, Taiwan // *2008*, DPI magazine, Taiwan // *2007*, 030 Illustrators, Hublab, Italy

Craig Frazier

1955 born in Merced
Lives and works in Mill Valley
www.craigfrazier.com

"Ideas are an essential ingredient
in creating an illustrated voice.
Without them, we have little foundation
in telling a story that will arrest anyone's
attention for more than a second."

Bubbledove, 2010
Saleforce.com, conference
materials, cut and digital

Magic Whitman, 2010
Realm Cellars, label for
wine bottle, cut and digital

Potholes, 2002
Peninsula Community
Foundation, cut and digital

Quill44, 2011
US Postal Service, postage
stamp, cut and digital

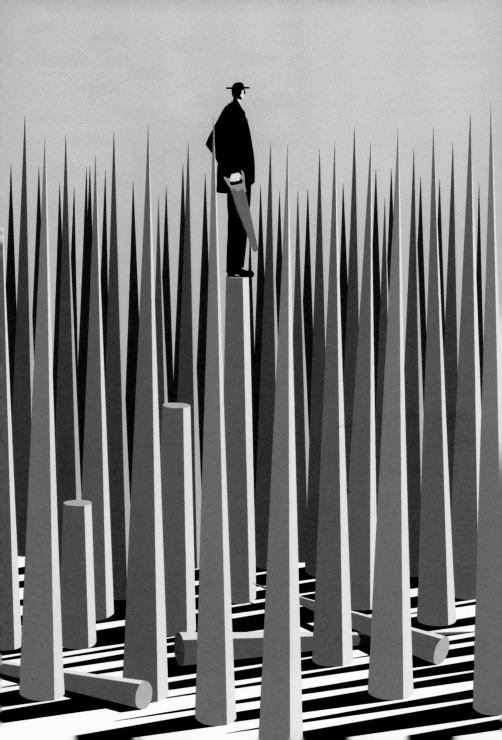

With a talent for economy of line and a penchant for wry comment, Craig Frazier has defined a genre of symbolic narrative that many have copied but few, as they say, have mastered as well as he has done. Frazier spent the first 18 years of his career as a graphic designer, working for Apple, Herman Miller, LucasArts, and others, before turning to illustration because, as he told *Graphis*, he "couldn't find the Craig." Finding his own voice was the key and so he has, it's even the title of his book, *The Illustrated Voice*. His style has an "everyman" aesthetic, but is decidedly not everybody's method.

Mit seinem Talent für sparsame Linienführung und seiner Neigung zu lakonischen Kommentaren hat Craig Frazier ein Genre symbolischer Erzählung definiert, das von vielen kopiert wurde, das aber nur wenige – eingestandenermaßen – so gut beherrschen wie er. Die ersten 18 Jahre seiner beruflichen Laufbahn arbeitete Frazier als Grafikdesigner, unter anderem für Apple, Herman Miller und LucasArts, um sich dann auf die Illustration zu verlegen, weil er „den Craig nicht finden konnte", wie er gegenüber *Graphis* äußerte. Das Entscheidende für ihn war, seine eigene Stimme zu finden, was ihm auch gelang – es ist sogar der Titel seines Buchs: *The Illustrated Voice*. Sein Stil hat eine Ästhetik, die jeder versteht, entspricht aber eindeutig nicht jedermanns Methode.

Avec un talent pour l'économie du trait et un penchant pour le commentaire narquois, Craig Frazier a défini un genre de narration symbolique qui a été beaucoup copié, mais que peu ont réussi à maîtriser aussi bien que lui. Frazier a passé les 18 premières années de sa carrière comme graphiste pour Apple, Herman Miller et LucasArts, entre autres, avant de se tourner vers l'illustration parce que, comme il l'a déclaré à *Graphis*, il n'arrivait pas à « trouver le Craig ». Trouver sa propre voix était la clé de tout, et c'est ce qu'il a fait, c'est même le titre de son livre, *The Illustrated Voice*. Son style a une esthétique très « Monsieur tout-le-monde », mais sa méthode est quant à elle résolument personnelle.

SELECTED EXHIBITIONS — 2015, *Drawing It Out, solo show, SCAD Atlanta // **2005**, The Graphic Imperative, group show, Bakalar Gallery, Boston*

SELECTED PUBLICATIONS — 2016, *Don't Be a Chump, MouseType Press, USA // **2005**, Illustration Now! 1, TASCHEN, Germany // **2003**, The Illustrated Voice, Graphis Press, USA // **2002**, Graphis magazine, USA // **2000**, Society of Illustrators 42, cover feature, USA // **1991**, Communication Arts, USA*

Spiked, 2012
Personal work, cut and
digital

ABC Tie, 2012
Blanchette Press, poster,
graphite and digital

Gez Fry

1978 born in Tokyo
Lives and works in London

"Gez Fry's work is comprised of digitally painted illustrations, sequential and concept art. Born in Tokyo, he has since lived in several countries, is fluent in French, Italian, Japanese, and of course, English. This varied upbringing, and his Japanese/British nationality, is reflected in the multicultural nature of his work."

Evisu, 2004
Evisu Shoes, advertising
campaign, digital

There is an old-time — well, early 20th-century — realism packed tightly into a new sense of narrative composition in Gez Fry's tableaux. A painter first, storyteller second, his work speaks on multiple levels. Thanks to a mash-up of Eastern and Western techniques resulting from his dual British and Japanese nationality, Fry has developed a unique computer-generated and hand-drawn manga style that is informed both by traditional Japanese woodblock prints and contemporary anime illustrations. His work fits squarely into the zeitgeist. The accomplished comic-book method in his images underscores the current obsession with storytelling among younger artists, and yet he is not completely tied to fashion, although his work may serve it well.

Ein altmodischer Realismus – nun ja, der des frühen 20. Jahrhunderts – verdichtet sich in Gez Frys Tableaus zu einer neuen Richtung der Erzählkomposition. In erster Linie Maler, in zweiter Geschichtenerzähler, spricht sein Werk auf vielen Ebenen. Durch die Verquickung östlicher und westlicher Techniken, die sich aus seiner britischen wie japanischen Nationalität erklärt, hat Fry einen einzigartigen, computergenerierten und handgemachten Manga-Stil entwickelt, der sowohl von traditionellen japanischen Holzschnitten als auch von heutigen Animes beeinflusst ist. Sein Werk passt zum Zeitgeist. Seine vollendete Comic-Methode unterstreicht die aktuelle Leidenschaft jüngerer Künstler am Geschichtenerzählen, dennoch ist er nicht ausschließlich auf diese Mode fixiert, obwohl sein Werk ihr durchaus nützlich sein mag.

Le sentiment de nouveauté qui émane de la composition narrative des tableaux de Gez Fry se nourrit d'un réalisme ancien (enfin, du début du XXᵉ siècle). D'abord peintre, et raconteur d'histoires ensuite, son travail communique sur plusieurs plans. Grâce à un mélange de techniques orientales et occidentales résultant de sa double nationalité britannique et japonaise, Fry a mis au point un style manga dessiné à la main mais généré par ordinateur qui prend ses racines dans les gravures sur bois japonaises traditionnelles et l'anime moderne. Son travail prend parfaitement sa place dans l'air du temps. Sa méthode « bande dessinée » très aboutie souligne l'obsession actuelle pour la narration chez les jeunes artistes, et pourtant il n'est pas complètement assujetti à la mode, bien que son travail sache la servir.

Ginza, 2006
Beacon Communications
KK, Montblanc, digital

Popplin, 2005
Firetrap, advertising
campaign, digital

There is more to Fry's technical and conceptual prowess than meets the eye. His line is confident and his imagery is layered, ready to be unpacked for its hidden meanings by the knowing viewer. Not your standard former art-school student, he has an MA in Modern and Medieval Languages from Cambridge, but such scholarship hasn't been an obstacle to finding clients such as Adidas, Nintendo, Adobe, Marvel, HarperCollins, or Industrial Light and Magic.

Hinter Frys technischem und konzeptuellem Können steckt mehr, als sich auf den ersten Blick erkennen lässt. Er verfügt über einen sicheren Strich und entfaltet eine vielschichtige Bildsprache, deren verborgene Bedeutungen sich dem wissenden Betrachter erschließen werden. Er ist nicht gerade das, was man sich unter einem normalen Kunststudenten vorstellt, sondern hat in Cambridge seinen Master of Arts in modernen und mittelalterlichen Sprachen gemacht, aber diese akademische Ausbildung hinderte ihn nicht, Auftraggeber wie Adidas, Nintendo, Adobe, Marvel, HarperCollins oder Industrial Light and Magic zu finden.

Les prouesses techniques et conceptuelles de Fry renferment des trésors cachés. Son trait est assuré et son langage visuel est profond, prêt à être décortiqué par l'observateur averti. Fry n'a pas un parcours classique d'études artistiques. Il détient une maîtrise en langues modernes et médiévales de Cambridge. Cela ne l'a pas empêché de trouver des clients tels qu'Adidas, Nintendo, Adobe, Marvel, HarperCollins ou Industrial Light and Magic.

Marvel Characters, 2007 Ukiyo-e, 2006
Marvel, digital Personal work, digital

Chris Gall

1961 born in Cleveland
Lives and works in Tucson
www.chrisgall.com

"The role of the illustrator is unique
within the arts, for an illustrator must
be equal parts craftsman, engineer, and visionary.
The greatest goal is that of a solution
that no one expects or foresees, but which arises from
the collaboration of creative minds."

Government Anti-Smoking
Campaign, 2004
Calendar, Design: Mark
Murphy, scratchboard
and digital

George Soros
as God, 2007
NRA, scratchboard
and digital

Light is the theme of Chris Gall's imagery—dark and light are orchestrated to give maximal impact to these decidedly detail-oriented illustrations of people and things. His style is also a throwback, with imagery taken from the heroic realism of the '30s and '40s, and indeed there is a high degree of admiration for the past albeit in a way that is rendered new through compositional skill and painterly prowess. Like so many artist-illustrators, Gall has been drawing as long as he can remember and recalls that when his teacher caught him drawing on his desk at school he was made to clean all the desks in the classroom.

Licht ist das große Thema in den Bildern von Chris Gall – Hell und Dunkel werden so orchestriert, dass sie diesen ausgesprochen detailorientierten Illustrationen von Menschen und Dingen maximale Wirkung verleihen. Stilistisch knüpft er an die Bildsprache des heroischen Realismus der 1930er- und 1940er-Jahre an. Tatsächlich ist bei Gall große Bewunderung für Vergangenes zu spüren, wenn auch durch kompositorisches Geschick und malerische Fähigkeiten neu übersetzt. Wie viele andere Illustrationskünstler hat auch Gall schon seit er denken kann gezeichnet: Aus Schülerzeiten ist ihm noch in Erinnerung, wie der Lehrer ihn beim Bekritzeln seines Pults erwischte und er daraufhin sämtliche Schulbänke des Klassenzimmers säubern musste.

La lumière est le thème des images de Chris Gall – l'obscurité et la clarté sont orchestrées pour maximiser l'impact de ces illustrations résolument détaillées de personnes et d'objets. Son style est également un retour en arrière, avec des éléments empruntés au réalisme héroïque des années 1930 et 1940. Il exprime en effet une grande admiration pour le passé, mais l'actualise grâce à son talent pour la composition et son savoir-faire de peintre. Comme tant d'autres d'artistes-illustrateurs, Gall a toujours dessiné, et il se souvient que lorsque son professeur l'a pris en train de dessiner sur son bureau à l'école, il l'a obligé à nettoyer tous les bureaux de la classe.

SELECTED EXHIBITIONS — 2012, Chris Gall: Please Don't Tell, solo show, ArtsEye Gallery, Tucson // *2009* to *2011*, Society of Illustrators, group show, New York // *2000*, Chris Gall: Tales and Yarns, solo show, ArtsEye Gallery, Tucson

SELECTED PUBLICATIONS — 2016, NanoBots, Hachette Book Group, USA // *2012*, Arizona Daily Star newspaper, USA // *2012*, Arizona Highways, Arizona Dept. of Transportation, USA // *2011* and *2012*, Communication Arts, USA // *2008*, SCBWI Bulletin, Society of Children's Book Writers/Illustrators, USA

Harvesting Natural
Gas, 2008
American Clean Skies
Foundation, scratchboard
and digital

Ai Weiwei, 2010
Huck magazine,
scratchboard and digital

The Blind Oceanographer,
2010
Popular Science,
scratchboard and digital

The inspiration to write more stories which "illustrated" his art came after he received a Young Writer's Award at the age of 13 from children's classroom magazine *Read*. Gall made the decision in college to become an illustrator for a living and since then his work has appeared in almost every publication in the US, including *The New York Times*, *The Washington Post*, *Time*, *Newsweek* and *Fortune*. He has held a professor's chair in Art at the University of Arizona and has won over 50 major awards for his work including from the Society of Illustrators and *Communication Arts* magazine.

Nachdem er als 13-Jähriger von der Jugendzeitschrift *Read* mit einem Young Writer's Award ausgezeichnet worden war, kam ihm die Idee, noch weitere Geschichten zur „Illustration" seiner Kunst zu schreiben. Auf dem College beschloss Gall, den Beruf des Illustrators zu ergreifen, und seitdem sind seine Arbeiten in fast allen amerikanischen Medien erschienen, unter anderem in der *New York Times*, der *Washington Post*, *Time*, *Newsweek* und *Fortune*. Er war Lehrbeauftragter für Kunst an der University of Arizona und hat über 50 bedeutende Auszeichnungen für sein Werk erhalten, unter anderem von der Society of Illustrators und dem Magazin *Communication Arts*.

L'idée d'écrire des histoires pour « illustrer » son art est venue après avoir reçu un prix décerné aux jeunes écrivains par le magazine pour écoliers *Read* à l'âge de 13 ans. C'est à l'université que Gall a décidé de gagner sa vie en tant qu'illustrateur, et son travail est depuis apparu dans presque toutes les publications américaines, notamment le *New York Times*, le *Washington Post*, *Time*, *Newsweek* et *Fortune*. Il a été professeur d'art à l'Université de l'Arizona, et a remporté plus de 50 prix prestigieux pour son travail, notamment de la Society of Illustrators et du magazine *Communication Arts*.

Carmen García Huerta

1975 born in Madrid
Lives and works in Madrid
www.cghuerta.com

"Basically I try to achieve
a harmonious mix between machine-
and handmade work."

Oysho, 2012
Oysho underwear, finalist
in the brand's illustration
contest, color pencil on
paper

Morrissey, 2009
Buffalo magazine,
hand-drawn

Woman as a Subject, 2013
It Fashion, web, color
pencil on paper

Adolfo Domínguez –
Ceylan Perfume, 2013
Avenue Illustrated
magazine, color pencil on
paper

SELECTED EXHIBITIONS — *2014*, *3 de 100, group show, Galería Ministerio de Asuntos Importantes, Madrid // 2010, ModaPan, group show, Pantocrator Gallery, Barcelona // 2009, Bellaciao, group show, Gallerie Artludik, Paris // 2009, Pandora's Box – BAC!, group show, CCCB Barcelona, Barcelona // 2003, My Work, solo show, Galería Standarte, Madrid*

SELECTED PUBLICATIONS — *2016, Vanidad magazine, Madrid // 2011, Illustration Now! Portraits, TASCHEN, Germany // 2010, The Beautiful: Illustrations for Fashion and Style, Gestalten, Germany // 2007, Fashion Unfolding, Victionary, Hong Kong // 2005, Fashion Illustration Now!, TASCHEN, Germany // 2005, It's a Matter of Illustration, Victionary, Hong Kong*

The signature moody palette of Carmen García Huerta's eloquently rendered studies separates her fashion work from most other purely stylistic renderings (including her own forays into glitter style). She also captures physical muscularity and material detail better than many of her peers. Her list of clients is impressive even in the fashion world, including international magazines such as *Vogue*, *Elle*, *Glamour* and *Cosmopolitan* among many others. Apart from commercial work, García Huerta has also been shown in several exhibitions around the world, and with her style somewhat reminiscent of Egon Schiele it is clear that she is a master of the human form and understands how best to manipulate light and solid mass to attain compelling expressions.

Die charakteristisch düstere Farbpalette infolge der versierten Studien von Carmen García Huerta hebt ihre Modeillustration von anderen, rein stilbetonten Darstellungen ab (einschließlich ihrer eigenen Ausflüge in die Glitzerwelt). Auch die Muskulatur eines Körpers und materielle Details fängt sie besser ein als viele ihrer Kollegen. Zur beindruckenden Liste ihrer Auftraggeber gehören internationale Fashion-Magazine wie *Vogue*, *Elle*, *Glamour*, *Cosmopolitan* und viele andere mehr. Neben ihrer kommerziellen Arbeit wurde García Huertas Schaffen vielfach weltweit ausgestellt. Mit ihrem an Egon Schiele gemahnenden Stil ist sie natürlich Meisterin im Umgang mit der menschlichen Form, mit Licht und Festkörpern und erreicht so fesselnde Ausdruckskraft.

La palette sombre, caractéristique des études éloquentes de Carmen García Huerta, sépare ses illustrations de mode de la plupart de ses autres travaux purement stylistiques (y compris ses incursions dans le style paillettes). Elle saisit également la musculature et les détails de texture mieux que beaucoup de ses pairs. Sa liste de clients est impressionnante même dans le monde de la mode, avec des magazines internationaux tels que *Vogue*, *Elle*, *Glamour* et *Cosmopolitan*, et de nombreux autres. Outre son travail commercial, García Huerta a également participé à plusieurs expositions à travers le monde. Son style a un lointain écho d'Egon Schiele, et il est évident qu'elle maîtrise la forme humaine et sait manipuler la lumière et la matière pour obtenir des expressions fascinantes.

Hypnosis Session, 2005
Hint magazine, Charles
Anastase Spring/Summer
2005, digital

I Love Rolls-Royces
Custo Barcelona, Spring/
Summer 2005, digital

Andreas Gefe

1966 born in Lucerne
Lives and works in Zurich
www.gefe.ch

"For an illustration I need the following:
1. confidence, 2. sufficient time for a good idea
in which at least one person occurs,
3. sufficient time for the realization,
4. music. When these conditions are met,
I try to paint a picture that I'd like to hang
on my own wall at home."

Heavy Metal, 2009
Fantoche, animation film
festival, poster, acrylic

Das Glück liegt auf der
Straße, 2010
Der Beobachter magazine,
cover, acrylic on cardboard

Langstraße, 2010
SonntagsZeitung,
newspaper article, acrylic

Im Tal, portrait of Theresa,
2009
Personal work, postcard,
acrylic

Whether depicting fantasy or real life, Andreas Gefe's drawings and paintings are emotively convincing. Dramatic in their composition and moody in their environment, they portray each figure in a way that is as real to the eye as it is enticing to the senses. Gefe's primary techniques are monotype, with computer-generated color, and acrylic, and his illustration work is perhaps best known from *Die Weltwoche*, *NZZ Folio* and *NZZ am Sonntag*. His work is expressively narrative, what he calls "objective," and representational in terms of style, with abstract caricatural qualities. In fact, the heads and faces of his figures are often disproportionately large because, he says, "I love faces."

Andreas Gefes Zeichnungen und Gemälde sind emotional immer überzeugend, egal ob sie Fiktives oder das reale Leben darstellen. Seine Figurenporträts, die jeweils dramatisch komponiert und in ein stimmungsvolles Ambiente eingebettet sind, wirken auf das Auge des Betrachters ganz real, während sie zugleich seine Sinne betören. Gefe, der hauptsächlich mit digital kolorierten Monotypien und Acryl arbeitet, veröffentlicht seine Illustrationen vor allem in Zeitungen wie *Die Weltwoche*, *NZZ Folio* und *NZZ am Sonntag*. Sein Werk ist auf ausdrucksvolle Weise erzählerisch – in seinen Worten „objektiv" – und im Stil gegenständlich, besitzt aber auch abstrakte Eigenschaften der Karikatur. Tatsächlich sind die Köpfe und Gesichter seiner Figuren oft unverhältnismäßig groß, was er damit erklärt, dass er „Gesichter liebt".

Qu'ils représentent un monde imaginaire ou la vraie vie, les dessins et tableaux d'Andreas Gefe possèdent une véritable éloquence émotionnelle. Théâtraux par leur composition et sombres par leurs décors, ils dépeignent chaque personnage avec autant de réalisme visuel que d'attrait sensuel. Ses techniques préférées sont le monotype, avec des couleurs générées par ordinateur, et l'acrylique. Ses illustrations sont apparues notamment dans *Die Weltwoche*, *NZZ Folio* et *NZZ am Sonntag*. Son travail est résolument narratif, ce qu'il appelle « objectif », et figuratif en termes de style, avec des caractéristiques caricaturales abstraites. En fait, les têtes et les visages de ses personnages sont souvent surdimensionnés car, dit-il, « j'adore les visages ».

Aire, 2012
SonntagsZeitung,
newspaper article, acrylic

Lady Snowblood, portrait
of Yuki Kashima, 2007
ETH Filmstelle, poster and
postcard, acrylic

Stéphane Goddard

1968 born in Chambéry, France
Lives and works in Paris
www.stephanegoddard.com

"I try to paint sensual, elegant and
modern pictures which are full of impact.
I want them to produce 'direct emotions.'
Emotion is a universal language."

Ray, 2013
Klay Paris, exhibition,
digital

Stéphane Goddard has created a distinctive vocabulary and a procedure for using both primitive and contemporary methods whereby he inextricably weds signs and symbols in a designed environment. For the last decade, Goddard has used only gouache for painting, though with some use of digital when finishing off. "Before I start painting I move around to relax myself," he says. "My sketches are very important [...] After those outlines I add colors directly to the page." He calls himself an "observer full of curiosity and mischief," and has been greatly influenced by American comic illustration, Francis Bacon and Velázquez, alongside filmmakers David Lynch and the Coen brothers.

Stéphane Goddard hat ein unverkennbares Vokabular und eine ganz persönliche Arbeitstechnik entwickelt: Durch die Verwendung primitiver als auch moderner Methoden kombiniert er Zeichen und Symbole auf kunstvolle Weise in einem durchgestalteten Ambiente. Seit zehn Jahren malt er ausschließlich in Gouache, mit digitalen Hilfsmitteln in der Endphase eines Werks. „Ehe ich mit dem Malen beginne, laufe ich zur Entspannung erst einmal herum", sagt er. „Meine Skizzen sind mir sehr wichtig [...] Nach diesen Vorzeichnungen füge ich die Farbe direkt auf dem Blatt hinzu." Goddard, der sich selbst als einen „Beobachter voller Neugier und Schalkhaftigkeit" bezeichnet, ist maßgeblich von amerikanischen Comics, von Francis Bacon und Velázquez beeinflusst, aber auch von Filmemachern wie David Lynch und den Coen-Brüdern.

Stéphane Goddard a créé un vocabulaire original et une procédure consistant à utiliser des méthodes primitives et contemporaines pour marier inextricablement les signes et les symboles dans un environnement sur mesure. Ces dix dernières années, Goddard n'a utilisé pour peindre que de la gouache, bien qu'il emploie la retouche numérique pour les finitions. « Avant de commencer à peindre, je bouge pour me détendre. Mes croquis sont très importants [...]. Après ces contours, j'ajoute la couleur directement sur la page. » Il se qualifie lui-même « d'observateur plein de curiosité et de malice », et a été très influencé par la bande dessinée américaine, Francis Bacon et Velázquez, ainsi que par les réalisateurs David Lynch et les frères Coen.

SELECTED EXHIBITIONS — *2016*, Blackfury, solo show, Arludik Gallery, Paris // *2012*, Icônes Assiégées, group show, Cité de la Mode et du design, Paris // *2011*, La ville dessinée, group show, Cité de l'architecture, Paris // *2009*, Qee exhibition, group show, Christie's & Colette Paris, Paris // *2004*, No Standard, solo show, Citadium et Stade de France, Fukuoka // *1988*, Sketches, solo show, Musée des Beaux-Arts, Lyon

SELECTED PUBLICATIONS — *2013*, Illustration, Genkosha, Japan // *2009*, Fifty Years of Contemporary Illustration, Laurence King, UK // *2008*, Fashion Wonderland, Victionary, Hong Kong // *2005*, New Fashion Illustration, Batsford, UK

Maki Drum, 2004
Citadium, exhibition,
acrylic and digital

Fire Blades, 2013
Black Rainbow magazine,
digital

Chanel Apes, 2012
Personal work, poster,
acrylic and digital

Sophie Griotto

1975 born in Alès, France
Lives and works in the South of France
www.sophiegriotto.com

"I like to define outlines by way
of empty space; I cook the material, the color
and look for the attitude
that will enable me to emphasize
a personality."

Slow Time, 2011
Zecabas, canvas bag, ink,
collage and graphics tablet

Capturing a mood—often a perky one—is essential to Sophie Griotto's approach. Whether a sunset or an interior, the color is precise, the composition focused, the rendering vivid. Similar vividness marks the works of those artists whose paths she has crossed spiritually: Matisse, the Nabis, Miró, Modigliani, as she told Ronnie Spirit in an interview. Griotto's work is indeed about capturing place and mood, and the feminine images in pencil and pastel crayon in her fashion illustrations are very much time markers for the present. "I love observing women in their daily routine, like when they are sitting on a chair or simply having a coffee."

Sophie Griottos wesentlicher Ansatz ist, eine bestimmte – oft kecke – Stimmung einzufangen. Ob Sonnenuntergang oder Interieur: Die Farbgebung ist präzise, die Komposition fokussiert und der Auftrag lebendig. Eine ähnliche Lebhaftigkeit zeichnet die Werke jener Künstler aus, deren Wege sie spirituell gekreuzt hat – Matisse, die Nabis, Miró, Modigliani –, wie sie in einem Interview mit Ronnie Spirit sagte. In Griottos Werk geht es tatsächlich darum, Ort und Stimmung einzufangen, und die weiblichen Figuren ihrer in Stift und Pastellkreide ausgeführten Fashion-Illustrationen sind Zeuginnen ihrer Zeit. „Ich beobachte Frauen gerne in ihrem Alltag, es gefällt mir, wenn sie in einem Sessel sitzen oder einfach nur Kaffee trinken."

Saisir une atmosphère – souvent légère – est essentiel dans la démarche de Sophie Griotto. Qu'il s'agisse d'un coucher de soleil ou d'un intérieur, la couleur est précise, la composition assurée, l'interprétation vivante. Un éclat comparable marque l'œuvre des artistes dont elle a croisé le chemin spirituel : Matisse, les Nabis, Miró et Modigliani, comme elle l'a dit lors d'un entretien accordé à Ronnie Spirit. Le travail de Griotto consiste effectivement à saisir le lieu et l'atmosphère, et ses illustrations de mode féminines réalisées au crayon et au pastel sont très contemporaines. « J'aime observer les femmes dans leur vie quotidienne, assises sur une chaise, ou simplement en train de boire un café. »

Pause café à Tokyo, 2009
Personal work, digigraphie,
ink, collage and graphics
tablet

New York Girl, 2008
Atelier Contemporain, ink,
collage and graphics tablet

SELECTED EXHIBITIONS — *2016*, Sophie Griotto, solo show, Untitled Factory, Paris // *2013*, Champions de l'Univers, solo show, Le Bon Marché, Paris // *2012*, Atelier Contemporain, group show, Les Galeries Lafayette, Paris

SELECTED PUBLICATIONS — *2013*, Illustration Now! Fashion, TASCHEN, Germany // *2009*, Advanced Creation, Oracom, France // *2009*, Illustration Now! 3, TASCHEN, Germany // *2007*, Fashionize 2, Happy Books, Italy

Vacances à Marrakech, 2011
Club Med, web and catalog, ink and graphics tablet

Parisiennes au café, 2012
Personal work, digigraphie, ink and graphics tablet

Olaf Hajek

1965 born in Rendsburg, Germany
Lives and works in Berlin
www.olafhajek.com

"My works are created with brush
and color only. I paint with acrylic on cardboard.
The texture and surface feel of the material
is very important and gives me a feeling
of satisfaction while working."

Hidden Girl, 2013
Strange Flowers,
Whatiftheworld gallery,
Cape Town, exhibition,
acrylic on wood

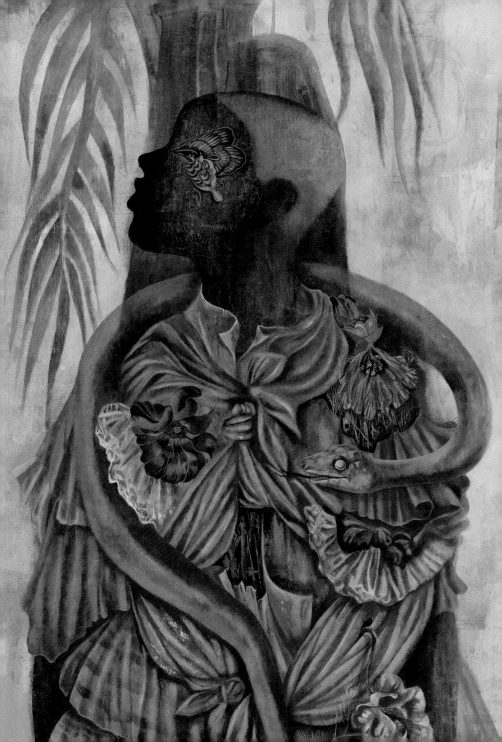

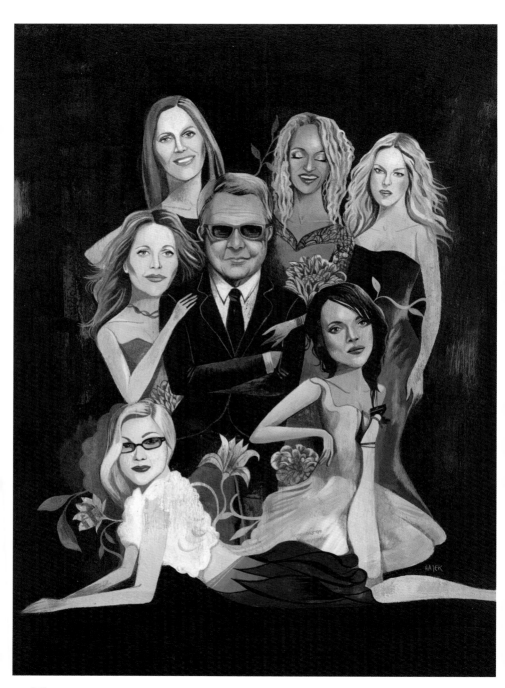

Sublime complexity is the baseline for Olaf Hajek's graphic gems, and yet each of his images is focused on a particular place—a target zone—where he wants the viewer's eye to land. Despite, or because of the engrossing detail, the viewer does whatever Hajek commands. Folk culture, mythology, religion, history and geography are all employed "to explore the opposition between imagination and reality within our culture," he says. His work reveals various traces of influences that range from Frida Kahlo or Botticelli or Arcimboldo to old Cuban advertising posters, and overall he might best be described as a magic realist on account of the hallucinatory quality of his work.

Olaf Hajeks grafische Juwelen zeichnen sich generell durch vollendete Komplexität aus, dabei ist jedes seiner Bilder auf einen bestimmten Ort – einen Zielpunkt – fokussiert, zu dem er den Blick des Betrachters hinlenken möchte. Trotz oder gerade wegen der fesselnden Details macht der Betrachter immer genau das, was Hajek von ihm erwartet. Volkskunst, Mythologie, Religion, Geschichte und Geografie, all das dient ihm dazu, „den Gegensatz zwischen Imagination und Realität innerhalb unserer Kultur zu ergründen", wie er sagt. In seinem Werk zeigen sich unterschiedliche Spuren und Einflüsse, sie reichen von Frida Kahlo, Botticelli oder Arcimboldo bis zu alten kubanischen Werbeplakaten. Angesichts des halluzinatorischen Charakters seines Werks ließe er sich insgesamt wohl am besten als magischer Realist bezeichnen.

Une complexité sublime se trouve à la base des joyaux graphiques d'Olaf Hajek, et pourtant chacune de ses images est structurée autour d'un point précis où il veut attirer le regard de l'observateur. Malgré le détail captivant, ou à cause de lui, l'observateur fait ce que Hajek exige. Culture populaire, mythologie, religion, histoire et géographie sont mises au service de l'exploration de « l'opposition entre imagination et réalité dans notre culture ». Son travail porte les traces d'influences diverses, Frida Kahlo et Botticelli ou Arcimboldo, ou encore les vieilles affiches publicitaires cubaines, et dans l'ensemble on peut le qualifier de réaliste magique, à cause de la nature hallucinatoire de ses images.

Charlie Haden and the Sophisticated Ladies, portrait of Charlie Haden with Norah Jones, Renée Fleming, Ruth Cameron, Melody Gardot, Diana Krall and Cassandra Wilson, 2010
Universal Music, Germany, press release, acrylic on cardboard

Broken Chair, 2004
Bloomberg Wealth Manager, acrylic on cardboard

pp. **314/15** Water, 2012 Bohem Press, book, acrylic on wood

Hajek designs his paintings to be as luscious as the mythic scenes and people they depict. His illustrations have appeared in major publications such as *The Wall Street Journal*, *The Financial Times*, *The New Yorker*, *GQ*, *Architectural Digest* and *Playboy*, as well as being used on stamps for the Royal Mail in the UK. The first monograph on his work, *Flowerhead*, was published in 2010 and abundantly reflects a career as bright and complex as the paintings he has created during that time.

In ihrer Machart sind Hajeks Gemälde ebenso sinnlich wie die mythischen Szenen und Figuren, die sie darstellen. Seine Illustrationen erschienen in wichtigen Medien wie dem *Wall Street Journal*, der *Financial Times*, dem *New Yorker*, *GQ*, *Architectural Digest* und *Playboy*, wurden aber auch als Briefmarkenmotive der britischen Royal Mail verwendet. Die erste Monografie zu seinem Werk, *Flowerhead* (2010), dokumentiert ausführlich eine Karriere, die ebenso brillant und komplex ist wie die Gemälde, die er in dieser Zeit schuf.

Les tableaux de Hajek sont aussi somptueux que les scènes et personnages mythiques qu'ils représentent. Ses illustrations sont apparues dans de grandes publications telles que le *Wall Street Journal*, le *Financial Times*, le *New Yorker*, *GQ*, *Architectural Digest* et *Playboy*, et ont été utilisées sur des timbres de la Poste royale du Royaume-Uni. La première monographie sur son œuvre, *Flowerhead* (2010), reflète une carrière aussi brillante et complexe que les tableaux qui la composent.

SELECTED EXHIBITIONS — *2016*, Jäger und Sammler, solo show, Anna Jill Lüpertz Gallery, Munich // *2013*, Strange Flowers, solo show, Whatiftheworld Gallery, Cape Town // *2012*, The King Has Lost His Crown, solo show, AJL Arts, Berlin // *2011*, Dark Clouds Are Gathering, solo show, Whatiftheworld Gallery, Cape Town

SELECTED PUBLICATIONS — *2013*, Black Antoinette: The Work of Olaf Hajek, Gestalten, Germany // *2012*, American Illustration 18 to 31, USA // *2010*, Flowerhead, The Work of Olaf Hajek, Gestalten, Germany // *2010*, 200 Best Illustrators Worldwide, Lürzer's Archive, Austria // *2005*, Illustration Now! 1, TASCHEN, Germany

Strange Flowers
(Still Life 1), 2013
Strange Flowers,
Whatiftheworld gallery,
Cape Town, exhibition,
acrylic on wood

I Travelled the World and
the 7 Seas, 2012
Strange Flowers,
Whatiftheworld gallery,
Cape Town, exhibition,
acrylic on wood

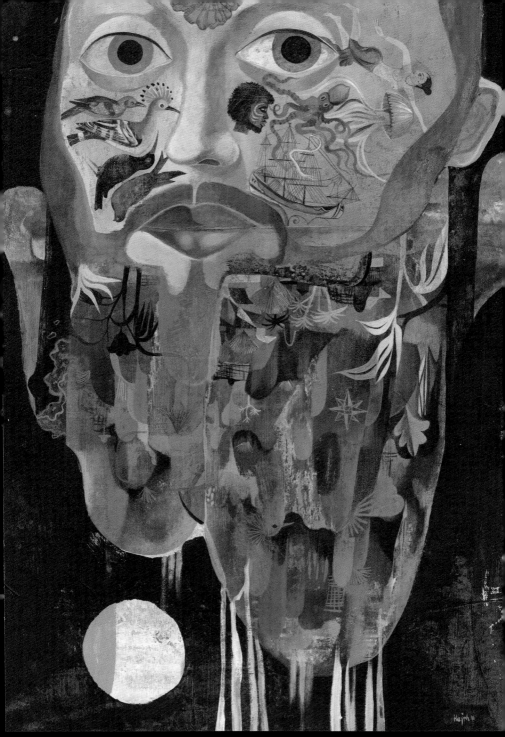

Tomer Hanuka

1974 born in Israel
Lives and works in New York and in Tel Aviv
www.thanuka.com

"As an illustrator I sometimes feel
I am an undercover agent of comics,
drawing frames of stories that never started
and will never end, but will
let the viewer, for a brief moment,
meet a few of those lost heroes."

From God's Mountain IV,
2010
The Divine, graphic novel,
personal work, mixed
media

There was a time when this kind of comic-book detail was rejected by serious, painterly illustrators, then Tomer Hanuka brought it back with a vengeance. He wants his audience to get deeply involved in his line. Hanuka calls his work "magic realism," referring to the dreamlike qualities he integrates into his frozen panels, and has previously described his fascination with comics to Garrick Webster in *Computer Arts*. In the late 1970s, Hanuka and his twin brother (also an illustrator) were surrounded by American comic books. "Comics are just so mysterious and majestic; an unreachable light in a faraway land."

Es gab eine Zeit, da wurden solche detailverliebten Comics von seriösen, malerisch arbeitenden Illustratoren abgelehnt, ehe Tomer Hanuka ihnen dann zu einer eindrucksvollen Renaissance verhalf. Er will das Publikum so ansprechen, dass es sich dem Sog seiner Bilder nicht entziehen kann. Hanuka definiert sein Werk als „magischen Realismus" – ein Verweis auf die traumartigen Elemente, die er in seine starren Gemälde miteinbezieht. In einem Interview mit Garrick Webster für das Magazin *Computer Arts* äußerte er, wie sehr ihn Comics faszinieren. In den späten 1970er-Jahren waren Hanuka und sein Zwillingsbruder (ebenfalls Illustrator) ständig von amerikanischen Comics umgeben. „Comics sind einfach so mysteriös und majestätisch wie ein unerreichbarer Lichtschein in einem fernen Land."

Il fut un temps où ce type de dessin détaillé dans le style de la bande dessinée était rejeté par les illustrateurs sérieux, qui se rapprochaient plus de la peinture, mais Tomer Hanuka l'a remis au goût du jour en grande pompe. Il veut que son public s'investisse profondément dans son trait. Hanuka qualifie son travail de « réalisme magique », en référence aux éléments oniriques qu'il intègre à ses panneaux figés, et a décrit à Garrick Webster sa fascination pour les bandes dessinées dans un entretien pour *Computer Arts*. À la fin des années 1970, Hanuka et son frère jumeau (également illustrateur) étaient entourés de bandes dessinées américaines. « Les bandes dessinées sont si mystérieuses et majestueuses ; une lumière hors d'atteinte dans un pays très lointain. »

←← Society of Illustrators Call for Entries, 2012 The Society of Illustrators, poster, Design: Anton Ioukhnovets, mixed media

←← Overkill, 2012 Gingko Press, book cover, Design: Anton Ioukhnovets, mixed media

← 300, 2012 Mondo, poster, screen printing

Perfect Storm, 2010 Personal work, Giclée print, mixed media

SELECTED EXHIBITIONS — *2015*, The Art of The Divine, group show, White Walls Gallery, San Francisco // *2011*, American Illustration, group show, Angel Orensanz Foundation, New York // *2011*, Blow-Up, group show, Society of Illustrators, New York // *2010*, Annual Juried Exhibition, group show, Society of Illustrators, New York

SELECTED PUBLICATIONS — *2016*, New Yorker magazine, USA // *2015*, The Divine, Roaring Brook Press, USA // *2012*, Overkill: The Art of Tomer Hanuka (monograph), Gingko Press, USA // *2011*, Elephant magazine, The Netherlands // *2010*, Computer Arts Projects magazine, UK // *2009*, IdN magazine, Hong Kong // *2008*, Juxtapoz, USA

From God's Mountain V, 2011
Personal work, concept work for The Divine, graphic novel, mixed media

Eternal Sunshine of the Spotless Mind, 2005
Entertainment Weekly magazine, mixed media

Fred Harper

1967 born in Erie
Lives and works in New York
www.fredharper.com

"My work includes elements
of machinery with animals,
humans, and buildings to create surreal
landscapes that cause the viewer
to wonder what this world is."

Patton Oswalt Family
Crest, 2011
Personal work, oil
and digital

Comic caricature demands that the distortion of a character's features is at the same time recognizable yet surprising. Fred Harper is adept at capturing the first and ensuring the second—combined with a healthy dose of wit. His images are painted to feel three-dimensional, making his caricatures like toys or dolls—one can almost feel their presence. Formerly an illustrator for Marvel and D.C. Comics, Harper nowadays supplies editorial illustrations and caricatures for *The New York Times*, *The Wall Street Journal*, *Village Voice* and *Sports Illustrated*. His medium of choice is gouache on Bristol but he's also skilled with oils, pencils and, of course, Photoshop.

Karikaturen müssen die Gesichtszüge einer Figur so verzerren, dass sie einerseits noch erkennbar bleiben, andererseits überraschen. Fred Harper versteht sich auf beides – und verfügt über eine gehörige Portion Witz. Seine Bilder wirken wie in 3D gemalt, was dem Betrachter das Gefühl gibt, seine Karikaturen seien Spielzeuge oder Puppen, ihre Präsenz ist förmlich mit Händen zu greifen. Harper arbeitete früher als Illustrator für Marvel und DC Comics und macht heute Textillustrationen für die *New York Times*, das *Wall Street Journal*, *Village Voice* und *Sports Illustrated*. Sein bevorzugtes Medium ist Gouache auf Bristolkarton, aber er ist auch versiert im Umgang mit Ölfarbe, Stiften und – natürlich – Photoshop.

Pour la caricature comique, il faut que la distorsion des traits du personnage soit à la fois reconnaissable et surprenante. Fred Harper excelle dans cet art, et sait y ajouter une bonne dose d'humour. Ses images sont peintes de façon à donner une impression tridimensionnelle, ce qui transforme ses caricatures en jouets ou en poupées – on arrive presque à sentir leur présence. Ancien illustrateur pour Marvel et D.C. Comics, Harper fournit aujourd'hui des illustrations et des caricatures au *New York Times*, *Wall Street Journal*, *Village Voice* et *Sports Illustrated*. Sa technique préférée est la gouache sur bristol, mais il est également un expert de la peinture à l'huile, des crayons et, bien sûr, de Photoshop.

SELECTED PUBLICATIONS — 2012, New York Observer newspaper, USA // **2012**, The Wall Street Journal newspaper, USA // **2012**, The Week magazine, USA

No Nukes!, 2010
Personal work, gouache
on paper

Last Year Occupied, 2011
New York Observer,
gouache on paper

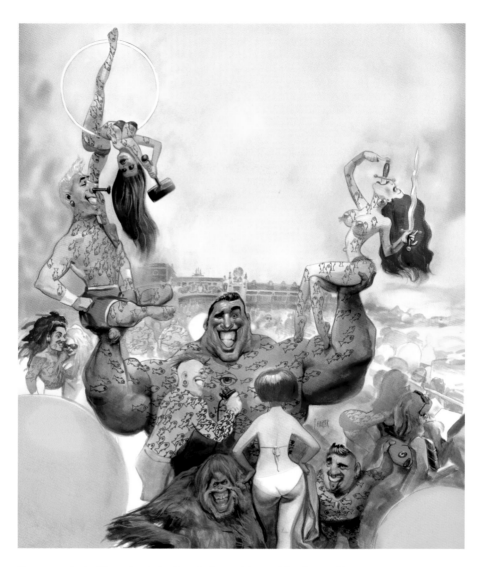

Harper graduated from the Columbus College of Art and Design and has now become immersed in the sights and sounds of the urban mecca. He told *Creep Machine* how he was smitten by the common streetscape: "Pipes that come out of a sidewalk with no apparent purpose. Wires painted over countless times. In the subway, layers of pipes and wires and dirt and tiles became a backdrop in my thoughts… the accumulation of all these things appeals to my aesthetic. People wait in front of tiles and pipes and wires and decay for the next train and I get inspired to paint."

Harper studierte am Columbus College of Art and Design und gibt sich heute ganz den optischen und akustischen Reizen der Großstadt hin. Der Zeitschrift *Creep Machine* erzählte er, was ihn an der alltäglichen Stadtlandschaft so faszinierte: „Rohre, die ohne erkennbaren Zweck aus dem Bürgersteig ragen. Drähte, die unzählige Male überpinselt wurden. In der U-Bahn haufenweise Röhren und Drähte, Schutt und Fliesen – das beflügelte meine Fantasie … Von all diesen Dingen in ihrer Massenhaftigkeit fühle ich mich ästhetisch angesprochen. Die Leute warten im Angesicht von Fliesen, Röhren, Drähten und Verfall auf den nächsten Zug, und mich regt das zum Malen an."

Harper est diplômé du Columbus College of Art and Design, et s'est maintenant immergé dans les lumières et les sons de la Mecque urbaine. Il a déclaré à *Creep Machine* qu'il était amoureux du paysage urbain ordinaire : « Les tuyaux qui sortent du trottoir sans raison apparente. Les câbles sur lesquels on a repeint mille fois. Dans le métro, les couches de tuyaux, câbles, poussière et carreaux sont devenues une toile de fond dans mes pensées … cette accumulation séduit mon sens de l'esthétique. Les gens attendent le train devant des carreaux, des tuyaux, des câbles et de la pourriture, et cela me donne envie de peindre. »

Vissionary Tattoo Festival, 2012
Poster, gouache and digital on paper

Marlon Brando Young Desire & Old Desire, 2012
Personal work, gouache on paper

Minni Havas

1983 born in Lahti, Finland
Lives and works in Helsinki
www.minnihavas.fi

"I draw detailed pictures
somewhere in the borderlands
of the real and the imaginary."

Untitled, 2011
New Nordic Fashion
Illustration Exhibition,
Concept: Anne Törnroos,
mixed media and digital

One of the jobs of the illustrator is to invent worlds that are inhabitable only through the magic of illustration. This is Minni Havas's talent. Her worlds involve style and fashion, and are created with enviable imagination. Havas studied Fashion Design at Helsinki's University of Art and Design, and the manner of drawing she has developed relies on a generous helping of natural light. Her photorealistic images of female characters derive from her father's airbrush art, the dominant style of the late '70s, and she absorbed this together with a curiously spiritual interest in the human form, including the shades of red and blue to be seen beneath human skin.

Die Aufgabe des Illustrators besteht unter anderem in der Erfindung von Welten, die nur durch die Magie des Bildes bewohnbar werden. Das ist Minni Havas' Talent. Ihre Welten, in denen es um Stil und Mode geht, erschafft sie sich mit beneidenswerter Fantasie. Havas studierte Fashion Design an der University of Art and Design in Helsinki und entwickelte eine Art des Zeichnens, bei der natürliches Licht eine entscheidende Rolle spielt. Ihre fotorealistischen Porträts weiblicher Figuren leiten sich vom Airbrush-Stil her, wie er in den späten 1970er-Jahren vorherrschte und auch von ihrem Vater praktiziert wurde. Neben dieser Technik hat sie ein merkwürdig spirituelles Interesse für die menschliche Form, etwa für die Rot- und Blauschattierungen, die unter der menschlichen Haut zu erkennen sind.

Untitled, 2011
New Nordic Fashion
Illustration Exhibition,
Concept: Anne Törnroos,
mixed media and digital

Twins, 2012
Personal work, watercolor
and digital

Untitled, 2012
Monki magazine,
hand-drawn, watercolor
and digital

Smoker, 2008
T-Bar, T-shirt print,
hand-drawn

L'une des missions de l'illustrateur est d'inventer des mondes que l'on ne peut habiter que grâce à la magie de l'illustration. C'est cela, le talent de Minni Havas. Ses mondes tournent autour du style et de la mode, et sont créés avec une imagination qui peut faire des envieux. Havas a étudié la création de mode à l'Université d'Art et de Design d'Helsinki, et le style qu'elle s'est forgé repose sur une généreuse ration de lumière naturelle. Ses images photoréalistes de personnages féminins sont dérivées des peintures au pistolet de son père, qui représentaient le style dominant des années 1970, et elle a absorbé en même temps que cela un intérêt curieusement spirituel pour la forme humaine, notamment les nuances de rouge et de bleu qui transparaissent sous la peau.

SELECTED EXHIBITIONS — *2012*, *I Want To Be First, group show, Kat Von D's Wonderland Gallery, Los Angeles* // *2012*, *Pekka of Finland, group show, Finnland-Institut, Berlin* // *2011*, *Graphic Designer of the Year, group show, Design Forum Finland, Helsinki* // *2011*, *Looking Up, group show, R21/Grafill, Oslo* // *2011*, *New Nordic Fashion Illustration, group show, The Rotermann Quarter, Tallinn*

SELECTED PUBLICATIONS — *2012*, *The Best of the Year 2011 (year book), Grafia, Finland* // *2011*, *Illustration Now! 4, TASCHEN, Germany* // *2010*, *The Beautiful: Illustrations for Fashion and Style, Gestalten, Germany*

Tony Healey

1959 born in Wales
Lives and works in London
www.th-illustration.co.uk

"There is a great tradition of pen
and ink illustration here in the UK.
I would like to think that my work follows
in the footsteps of that tradition,
albeit that nowadays the pen is made
by Wacom and there is no ink, only pixels."

Hendrix, 2011
Anna Goodson Illustration
Agency, pencil and digital

Every caricaturist must maintain total control of their subject—a single misplaced feature can destroy a likeness. For caricature to be successful the exaggeration of every slightest detail must be credible. Tony Healey, who specializes in portraits and caricature, is keenly aware that a lot depends on capturing particular expressions and this is the mark he aims for every time. After Swansea College of Art he moved to London where he worked freelance as an illustrator, initially for BBC Current Affairs. His work contains lots of detail, he says, "because I enjoy the process of drawing so much."

Jeder Karikaturist muss sein Modell total im Griff haben – ein einziger falsch gesetzter Strich kann ein ganzes Porträt zunichtemachen. Eine Karikatur wird nur dann gelingen, solange die Übertreibung selbst des kleinsten Details glaubwürdig bleibt. Tony Healey ist auf Porträts und Karikatur spezialisiert und weiß nur zu gut, wie sehr es darauf ankommt, einen typischen Gesichtsausdruck einzufangen, und genau das versucht er jedes Mal aufs Neue. Nach dem Studium am Swansea College of Art ging er nach London, wo er freiberuflich arbeitete, zunächst für das Current-Affairs-Team der BBC. „Ich zeichne wahnsinnig gern", sagt er – und das erklärt wohl auch die außerordentliche Detailfülle seiner Arbeiten.

Hooker, 2011
Personal work, pencil

Miles Davis, 2005
Personal work,
exhibition, pencil

Tout caricaturiste doit savoir maîtriser totalement son sujet – un seul trait du visage mal placé peut anéantir la ressemblance. Pour que la caricature soit réussie, l'exagération du moindre petit détail doit être crédible. Tony Healey, spécialisé dans les portraits et la caricature, sait parfaitement que certaines expressions portent le gros du fardeau, et ce sont ces repères-là qu'il vise à chaque fois. Après le Swansea College of Art, il est parti pour Londres, où il a travaillé comme illustrateur freelance, tout d'abord pour BBC Current Affairs. Ses dessins sont extrêmement détaillés parce qu'il prend « un énorme plaisir à dessiner ».

Healey has featured extensively in *The Times*, *The Observer*, *The Economist*, *The Daily Mirror* and *The Washington Post*, among others, and currently appears every week in the *Financial Times*. "I just draw," he says about becoming an illustrator. "I've been drawing since I can remember. I've never really given any thought as to what may have inspired me to start." He began taking his portfolio around after leaving college and found work immediately, "and haven't stopped since. I am still as excited by drawing now as I was when I started out."

Healey hat sehr viel für Zeitungen wie *Times*, *Observer*, *Economist*, *Daily Mirror*, *Washington Post* und andere gearbeitet; zurzeit erscheinen seine Karikaturen einmal wöchentlich in der *Financial Times*. „Ich zeichne einfach", sagt er, wenn man ihn fragt, wie er Illustrator geworden ist. „Ich zeichne, seit ich denken kann. Ich habe nie wirklich darüber nachgedacht, wie ich zum Zeichnen gekommen bin." Nach Abschluss des College zeigte er seine Mappe überall herum und fand sofort Arbeit, „und seitdem ging das immer so weiter. Zu zeichnen finde ich heute noch genauso spannend wie in meinen Anfängen".

Healey a beaucoup été publié dans le *Times*, l'*Observer*, l'*Economist*, le *Daily Mirror* et le *Washington Post*, entre autres, et apparaît actuellement chaque semaine dans le *Financial Times*. « Je me contente de dessiner », a-t-il répondu à une question sur son parcours. « J'ai toujours dessiné. Je n'ai jamais vraiment réfléchi à la raison qui m'a poussé à commencer. » Il a commencé à montrer son portfolio à droite et à gauche après l'université, et a trouvé du travail immédiatement, « et je n'ai pas arrêté depuis. Le dessin me passionne toujours autant maintenant qu'à mes débuts ».

SELECTED EXHIBITIONS — *2012*, Celebrating John Mortimer, solo show, Illustration Cupboard, London // *2012*, Images 36, group show, Somerset House, London // *2006*, Garrick/Milne Prize, group show, Christie's, London // *2006*, Sunday Times Watercolour Prize, group show, Mall Galleries, London // *2006*, Welsh Artist of the Year, group show, St David's Hall, Cardiff

SELECTED PUBLICATIONS — *2012*, Good Old Drawing, Haus Publishing, UK // *2012*, Images 36, Association of Illustrators, UK // *2011*, Images 35, Association of Illustrators, UK // *2010*, Images 34, Association of Illustrators, UK // *2009*, Illustration Now! 3, TASCHEN, Germany

Rafael Nadal, 2011
The Daily Telegraph,
Art Direction: Wayne Caba,
pencil and digital

Charley Patton, 2009
Personal work, Good Old
Drawing, book, 2012,
pencil

Antoine Helbert

1967 born in Colmar, France
Lives and works in Benfeld, France
www.antoine-helbert.com

"Looking around you provides an unlimited
source of inspiration. Past centuries and the present
offer me a cultural gold mine, extreme,
varied, diverse, rich... The tone is given,
the color is found, eclecticism..."

Marie-Antoinette, 2010
Personal work, hand-drawn
and digital

What still cannot be accomplished in film and video these days can be made in art. Antoine Helbert's illustration is a gateway into the imponderable fantasies that populate wild imaginations. It should thus come as no surprise that Helbert has painted scenery for the Opéra National du Rhin, the fantasy of Mozart's *Magic Flute* and the majesty of Bronzino's *Allegory of the Triumph of Venus* being totally visible in his own less monumental illustrative tableaux.

Was sich bis heute nicht in Film oder Video realisieren lässt, ist mit den Mitteln der Kunst möglich. Die Illustrationen Antoine Helberts eröffnen einen Zugang selbst zu den wildesten Fantasievorstellungen. Es dürfte also kaum überraschen, dass er Bühnenbilder für die Opéra National du Rhin gestaltet und in seinen eigenen, weniger monumentalen Tableaus die Fantasie von Mozarts *Zauberflöte* und die Erhabenheit von Bronzinos *Allegoria del trionfo di Venere* sehr sichtbar zum Ausdruck gebracht hat.

Ce que la photographie et la vidéo ne peuvent toujours pas accomplir de nos jours, l'art peut le faire. Les illustrations d'Antoine Helbert sont une porte qui s'ouvre sur les rêves imprévisibles qui peuplent les imaginations sauvages. Il ne faut donc pas s'étonner que Helbert ait peint des décors pour l'Opéra National du Rhin, la fantaisie de *La Flûte enchantée* de Mozart et la majesté de *l'Allégorie du triomphe de Vénus* de Bronzino étant parfaitement visibles dans ses tableaux illustratifs moins monumentaux.

Fashion's Men, 2008
Soon magazine,
hand-drawn and digital

Party Blondes Chantilly,
2013
Personal work, hand-drawn
and digital

Antoine Helbert 345

Helbert was chosen by the Orchestre Philharmonique de Strasbourg to produce 20 studies from the history of art for an advertising campaign, but the original works these details represented did not actually exist, and never have. His trope for work such as this is telling stories visually through fictional paintings and sculpture. A fascination for the Middle Ages in turn led to a passion for the Orientalism of the 19th century, which Helbert employed in painting backdrops for *Don Giovanni* and costumes for Handel's *Ariodante*.

Im Auftrag des Orchestre Philharmonique de Strasbourg produzierte er 20 Studien aus der Kunstgeschichte für eine Werbekampagne, doch die Originalwerke, die in diesen Detail-skizzen dargestellt sind, existieren überhaupt nicht und haben auch nie existiert. In solchen Arbeiten bedient er sich fiktionaler Gemälde und Plastiken für das visuelle Erzählen von Geschichten. Aus Helberts Mittelalter-Begeisterung resultierte wiederum eine Leidenschaft für den Orientalismus des 19. Jahrhunderts, den er in seine Bühnenbilder für *Don Giovanni* und die Kostüme für Händels *Ariodante* einfließen ließ.

L'Orchestre philharmonique de Strasbourg a choisi Helbert pour réaliser 20 études tirées de l'histoire de l'art pour une campagne de publicité, mais les œuvres originales que ces détails représentent n'ont jamais existé. Pour ce type de travail, il aime raconter des histoires visuelles à travers des peintures et sculptures fictives. Helbert a eu une fascination pour le Moyen Âge, qui s'est ensuite transformée en passion pour l'orientalisme, qu'il a exploitée pour peindre les décors de *Don Giovanni* et les costumes de *l'Ariodante* de Haendel.

SELECTED EXHIBITIONS — 2008, Constantinople ville oubliée, solo show, Ribeauvillé

SELECTED PUBLICATIONS — 2014, Le Journal d'Aéroports magazine, France // *2009*, Bellaciao, Michel Lagarde, Paris // *2007*, Citizen K International, France // *2007*, Illustration Now! 2, TASCHEN, Germany // *2007*, Soon magazine #7, France

Hommpaon, 2006
Personal work, hand-drawn
and digital

Femmecoq, 2006
Personal work, hand-drawn
and digital

John Hendrix

1976 born in St. Louis
Lives and works in St. Louis
www.johnhendrix.com

"I love to draw. My work is completely
about drawing. There is something beautiful
about the solitude of pen, paper, and a voice.
The joy of making images, to me,
is telling a small story. Not a lofty goal,
nor a unique one to be sure."

Legends of Rock 1950,
2011
Rolling Stone magazine,
pen, ink and acrylic

The Canary Lantern, 2012
Personal work, pen,
ink and acrylic

I Will Raise a Storm, 2003
Personal work, pen, ink
and acrylic washes

Expecto Patronum, 2011
Gallery Nucleus, The Art
of Harry Potter, exhibition,
pen, ink, acrylic and
colored pencil

Drawing on popular culture, John Hendrix creates a world through his illustrations that allows the impossible to become possible and indeed real—all with a flick of his startling pen-and-ink. A first commissioned illustration for *Village Voice* in 2001 led directly to hundreds of drawings for *The New York Times*, where Hendrix also worked as an art director for three years. However, he always wanted to make his career as an illustrator and leave art direction to others.

In seinen Illustrationen lässt John Hendrix mit leichtem Federstrich und unter Rückgriff auf Elemente der Popkultur eine Welt entstehen, in der das Unmögliche möglich, ja sogar real werden kann. Eine erste Illustration, die er 2001 für *Village Voice* machte, verschaffte ihm sofort Hunderte neuer Aufträge für die *New York Times*, bei der er auch drei Jahre lang als Artdirector tätig war. Doch Hendrix wollte immer Karriere als Illustrator machen und die konzeptionelle Arbeit lieber anderen überlassen.

John Hendrix s'inspire de la culture populaire pour créer à l'aide de ses illustrations un monde où l'impossible peut devenir possible, et même réel – tout cela d'un coup de son étonnant stylo à encre. Une première commande pour *Village Voice* en 2001 mena directement à des centaines de dessins pour le *New York Times*, où Hendrix a également occupé le poste de directeur artistique pendant trois ans. Cependant, il a toujours voulu faire carrière en tant qu'illustrateur, et laisser la direction artistique à d'autres.

Most recently, Hendrix has turned his attention to children's books. His first thus written was a story about John Brown, the antislavery radical and one of the catalysts of the American Civil War. "I first fell in love with John Brown as a visual subject," he recalls. "When I started reading about him, I also loved who he was and what he believed in. So, I made a list of all the images I wanted to include [...] and wrote the book around those ideas. Even though I wrote [it], I would never start with words. I am not a 'writer's writer'… but an artist who uses words to frame and create my own visual content."

Neuerdings beschäftigt sich Hendrix mit Kinderbüchern. Seine erste Veröffentlichung war eine Geschichte über den radikalen Abolitionisten John Brown, einen der Auslöser des Sezessionskriegs. „Zunächst sprach mich John Brown als visuelles Thema an", erinnert er sich. „Als ich dann über ihn zu lesen begann, entwickelte ich auch eine große Zuneigung zu dem Mann selbst und zu seinen Überzeugungen. Ich machte eine Liste all der Bilder, die ich in dem Buch unterbringen wollte [...], und diese Ideen wurden dann zum Fundament für meine Geschichte. Auch wenn ich das Buch selbst schrieb, begann ich doch nie mit dem Text. Ich bin ja kein blendendes Vorbild der Autorenzunft, aber ein Künstler, der Wörter als Rahmen für den eigenen visuellen Inhalt benutzt."

Plus récemment, Hendrix a porté son attention sur les livres pour enfants. Il a tout d'abord écrit une histoire sur John Brown, antiesclavagiste radical et l'un des instigateurs de la Guerre civile américaine. « Je suis tout d'abord tombé amoureux de John Brown en tant que sujet visuel. Lorsque j'ai commencé à me documenter sur lui, j'ai aussi aimé le personnage et ses opinions. Alors j'ai fait une liste de toutes les images que je voulais inclure [...] et j'ai écrit le livre autour de ces idées. Et bien que je l'aie écrit, je ne commencerais jamais par des mots. Je ne suis pas un écrivain qui aime écrire… mais un artiste qui utilise les mots pour encadrer et créer mon propre contenu visuel. »

Autopsy Lake, 2012
Norwegian Medical
Association magazine,
cover, pen, ink
and acrylic

Bells & Whistles, 2005
Plansponsor magazine,
pen, ink and acrylic
washes

SELECTED EXHIBITIONS — *2013*, Society of Illustrators 55, group show, Society of Illustrators, New York // *2012*, American Illustration 32, group show, American Illustration, New York // *2012*, Illustrated Type, group show, Gallery Nucleus, Los Angeles // *2012*, Original Art Show: Best Children's Books of 2012, group show, Society of Illustrators, New York // *2011*, The Art of Harry Potter, group show, Gallery Nucleus, Los Angeles

SELECTED PUBLICATIONS — *2016*, Miracle Man, Abrams Books, USA // *2015*, Drawing Is Magic: Discovering Yourself in a Sketchbook, Abrams Books, USA // *2010*, Communication Arts (feature profile), USA // *2009*, John Brown: His Fight for Freedom, Abrams Books for Young Readers, USA // *2009*, Sketchbooks, the Hidden Art of Designers, Illustrators & Creatives, Laurence King, UK // *2007*, Illustration Now! 2, TASCHEN, Germany // *2006*, Handwritten: Expressive Lettering in the Digital Age, Thames & Hudson, UK

Jody Hewgill

1988 born in Toronto
Lives and works in Toronto
www.jodyhewgill.com

"I don't confine myself to literal depiction because I like to employ a little magic realism in some of my pieces. The art of Frida Kahlo and Pablo Picasso have been great sources of inspiration."

David Bowie, 2004
Rolling Stone magazine,
acrylic on gessoed
ragboard

Surrealism can be a narrative tool and also a personal voice. Jody Hewgill combines surreal dislocation and crystalline realism, touched with a hint of fantasy, to achieve dramatic yet playful imagery that speaks of her concern with social conditions and human affairs. Hewgill has stated, "I am very inspired by the novels of Ian McEwan and literature that explores the darker side of the human condition. [...] My work often references Pre-Raphaelite masters, but it's also an amalgamation of [...] the whimsical, narrative or surreal, and incorporates elements of pop culture, ancient symbolism, and folklore. But whatever direction I decide to explore, I'm always intent on expressing the emotional content of the message through gesture."

Surrealismus kann Erzählmittel wie auch eine persönliche Ausdrucksweise sein. Jody Hewgill verbindet surreale Verfremdung und kristallklaren Realismus, gestreift von einem Hauch des Fantastischen, zu einer dramatischen und doch spielerischen Bilderwelt, die ihre gesellschaftlichen und zwischenmenschlichen Anliegen ausdrückt. „Ich lasse mich sehr von den Romanen Ian McEwans und von Literatur anregen, die die dunklen Seiten des Menschlichen beleuchtet [...] Meine Arbeit bezieht sich häufig auf präraffaelitische Meister, aber sie amalgamiert auch [...] das Launige, das Erzählerische oder Surreale und nimmt Elemente der Popkultur, überlieferter Symbolik und der Folklore auf. Aber welche Richtung ich auch gerade verfolge, ich versuche immer, den emotionalen Gehalt der Botschaft gestisch auszudrücken."

Le surréalisme peut être un outil de narration, ainsi qu'un ton personnel. Jody Hewgill combine la rupture surréaliste et un réalisme cristallin, avec une touche de fantastique, pour créer des images théâtrales mais ludiques qui parlent de sa préoccupation pour les conditions sociales et les questions humaines. Hewgill a déclaré : « Les romans d'Ian McEwan et la littérature qui explore le côté sombre de la condition humaine m'inspirent beaucoup. [...] Mon travail fait souvent référence aux maîtres préraphaélites, mais c'est aussi un amalgame de [...] fantaisie, de récit ou de surréel, et j'y incorpore des éléments de culture populaire, de symbolisme antique, et de folklore. Mais quelle que soit la direction que je décide d'explorer, j'essaie toujours d'exprimer le contenu émotionnel du message à travers le geste. »

SELECTED EXHIBITIONS — 2015, Before Midnight, group show, Museum of American Illustration, NY // 2011, Instinct(s), solo show, Richard C. Von Hess Gallery, Philadelphia // 2010, Fragile Earth, group show, Society of Illustrators, New York // 2010, Kaboom, group show, La Luz de Jesús, Los Angeles // 2007, Green, group show, Robert Berman Gallery, Santa Monica // 2006, Le Favolose Matite Colorate nel Mondo, group show, Villa Poniatowski, Rome

SELECTED PUBLICATIONS — 2011, The Essence of Contemporary Illustration, Gestalten, Germany // 2011, Illustration Now! Portraits, TASCHEN, Germany // 2008, Icons & Images: 50 Years of Illustration, Society of Illustrators, USA // 2006, 3x3 magazine, Vol. 3, issue #1 (feature article), USA // 1997, Communication Arts, Sept/Oct issue (feature article), USA

The Tree of Life, 2011
Entertainment Weekly
magazine, Creative
Direction: Amid Capeci, Art
Direction: Jennie Chang,
acrylic on wood panel

Shirley MacLaine, 2012
The Saturday Evening Post
magazine, cover, Art
Direction: Amanda Bixler,
acrylic on gessoed
ragboard

Wilco: The Whole Love,
2012
Personal work, Art
Direction: Joe Hutchinson
and Matt Cooley,
unpublished, acrylic on
gessoed ragboard

John Mayer "Born and
Raised," 2012
Rolling Stone magazine,
Art Direction: Steven
Charny, acrylic on wood
panel

Brad Holland

1943 born in Fremont
Lives and works in New York
www.bradholland.net

"My pictures are like book jackets
for stories I haven't written and
couldn't write because they're not stories
that can be told in words."

Prime Mover, 2004
Tor Books, acrylic on
Schoellerhammer board

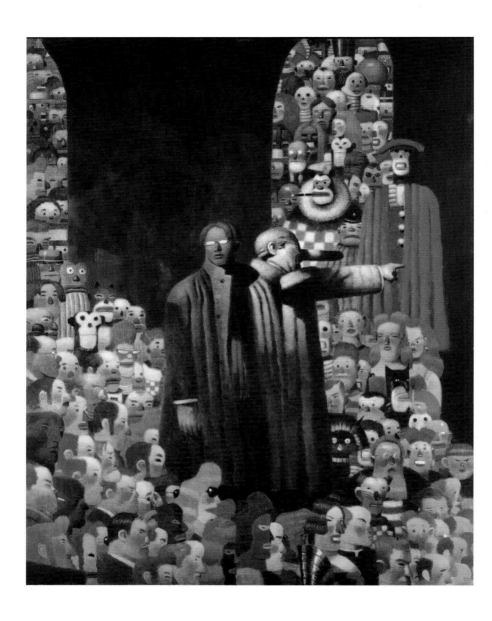

Carnival of Souls, 2006
Odeon Theater, Vienna,
Serapions Ensemble,
Direction: Erwin Piplits and
Ulrike Kaufmann, poster,
acrylic on masonite

Postmodern Thinkers,
2010
Personal work, pen
and ink on paper

I'm Not Me, 2011
Discover magazine,
acrylic on ragboard

Without Brad Holland's fervency and passion for mass art, illustration in general and American illustration specifically would not be as conceptually astute as it is today. Decades ago he altered the way art directors and illustrators perceived the art of illusion, and early in his career busted through the old verities—sentiment and romanticism—to replace them with ideas. In the beginning, Holland said, "I dropped off my portfolio. After that, work found me. I've never been good at self-promotion. I always thought the best way to promote yourself was to do the best job you could every day. But that's not a strategy. It's just my nature."

Ohne Brad Hollands glühende Leidenschaft für die Massenkunst hätte heute die Illustration nicht dasselbe scharfsinnige Konzept. Vor Jahrzehnten veränderte er die Auffassung von der Kunst der Illusion in den Köpfen von Artdirectors und Illustratoren, und sehr früh in seiner Laufbahn demontierte er lieb gewordene Grundsätze – Sentiment und Romantik – und ersetzte sie durch Ideen. Zu Anfang, sagte Holland, „ließ ich einfach meine Mappe liegen. Danach fanden die Aufträge mich. Ich war nie gut in Selbstvermarktung. Ich war immer der Auffassung, dass man sich am besten vermarktet, wenn man Tag für Tag seine Arbeit so gut wie möglich macht. Aber das ist keine Strategie. So bin ich einfach."

Sans la ferveur et la passion de Brad Holland pour l'art de masse, l'illustration en général et l'illustration américaine en particulier ne seraient pas aussi conceptuellement pointues qu'elles le sont aujourd'hui. Il y a quelques dizaines d'années, il a changé la perception que les directeurs artistiques et les illustrateurs avaient de l'art de l'illusion, et très tôt dans sa carrière il a fait voler en éclats les vieilles vérités – sentiment et romantisme – pour les remplacer par des idées. Au début, raconte Holland, «je déposais mon portfolio. Ensuite, c'est le travail qui m'a trouvé. Je n'ai jamais su me vendre. J'ai toujours pensé que la meilleure façon de me vendre, c'était de faire mon travail de mon mieux jour après jour. Mais ce n'est pas une stratégie, c'est juste dans ma nature».

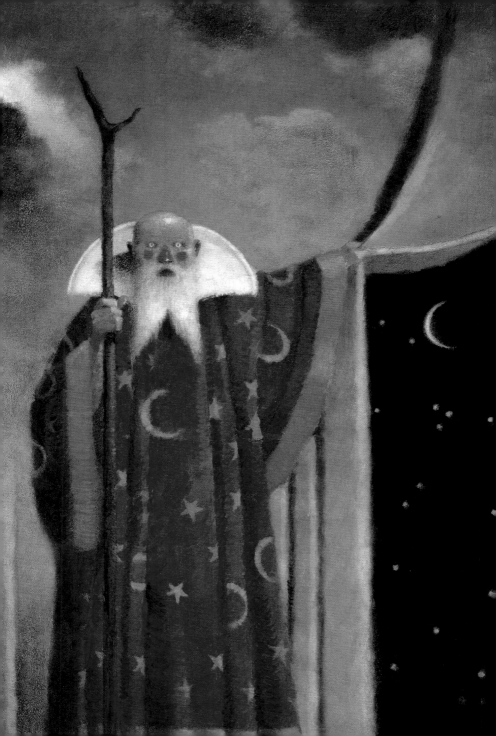

SELECTED EXHIBITIONS — *2006, Dark to Light, solo show, the Torino Atrium, Turin, Italy //* **1999**, *Brad Holland, solo show, Museum of American Illustration, New York //* **1999**, *Unreal, solo show, Musée des Beaux-Arts, Clermont-Ferrand //* **1990**, *Brad Holland, solo show, Mikkeli Art Museum, Mikkeli, Finland //* **1974**, *The Art of the Times, group show, Musée des Arts Décoratifs, Paris*

SELECTED PUBLICATIONS — *2011, Making Great Illustration, A. & C. Black, UK //* **2009**, *Brad Holland: Translating Words Into Illustrations, Graphis Design, USA //* **2006**, *Brad Holland, Dark to Light, Orecchio Acerbo, Italy //* **1986**, *Innovators of American Illustration, Van Nostrand Reinhold, USA //* **1977**, *Human Scandals, T. Y. Crowell, USA*

Carnival of Souls, 2006
Odeon Theater, Vienna,
Serapions Ensemble,
Direction: Erwin Piplits and
Ulrike Kaufmann, poster,
acrylic on masonite

A Perfect Match, 2010
Northwestern University,
Northwestern magazine,
acrylic on board

PaRaDiSo, 2013
The Odeon Theater,
Vienna, poster, acrylic on
masonite

Paul Hoppe

1976 born in Biskupiec, Poland
Lives and works in Brooklyn
www.paulhoppe.com

"Whether it's an editorial illustration,
a comic or a children's book,
I like telling stories with drawings,
and imagining locations
and atmosphere."

Ruins Girl, 2013
Personal work, ongoing
series The Invisible City,
postcard, ink on paper and
digital

Patrick Hruby

1981 born in Los Angeles
Lives and works in Los Angeles
www.patrickdrawsthings.com

"My work is about the celebration
of color and the precision of design.
I strive to achieve beauty through clean
shape and vibrant harmonies."

Playtime Paris Winter,
2012
Playtime Paris, digital

Forests and Water, 2012
The United Nations, digital

As a young boy, Patrick Hruby dreamed of "running away to join the circus and becoming a trapeze artist." Doesn't everyone? He grew up to study science subjects instead, before attending the Art Center College of Design in Pasadena where illustration became his true métier. Hruby's fascination with the geometry of nature is central to his drawings—and beautifully so. Being variously influenced by such artists and graphic designers as Mary Blair, Charley Harper and Paul Rand, he went on to develop his own neomodern approach. Vivid use of color, geometrical forms and humor coalesce into his utterly distinctive images.

Als kleiner Junge träumte Patrick Hruby davon, „durchzubrennen und Trapezkünstler im Zirkus zu werden". Tut das nicht jeder? Stattdessen studierte er später Naturwissenschaften, bevor er das Art Center College of Design in Pasadena besuchte, wo die Illustration zu seinem wahren Beruf wurde. Hrubys Faszination für die Geometrie der Natur ist in seinen Zeichnungen zentral – auf wunderschöne Weise. Unter den Einflüssen so verschieden-artiger Künstler und Gestalter wie Mary Blair, Charley Harper oder Paul Rand entwickelte er seinen eigenen neo-modernen Ansatz. Lebhafte Farben, geometrische Formen und Witz wirken in seinen ganz unverwechselbaren Bildern zusammen.

Petit garçon, Patrick Hruby rêvait de «fuguer pour entrer dans un cirque et devenir trapé-ziste». Comme tout le monde, non ? Mais il finit par faire des études scientifiques, avant d'entrer à l'Art Center College of Design de Pasadena, où l'illustration devint son vrai métier. La fascination de Hruby pour la géométrie de la nature est au cœur de ses dessins et de leur beauté. C'est à partir des influences diverses d'artistes et de graphistes tels que Mary Blair, Charley Harper et Paul Rand qu'il a développé sa propre démarche néomoderne. Ses images au style unique sont le résultat d'une utilisation très dynamique des couleurs, des formes géométriques et de l'humour.

Robot 3 & 1, 2011
Sappi Fine Paper, digital

Castle at Dimmer Ends, 2011
Personal work, digital and silk screen on paper

Mirko Ilić

1956 born in Bijeljina, Bosnia and Herzegovina
Lives and works in New York
www.mirkoilicillo.com

"Work Philosophy:
there must be any one of three things (if not all):
1. lots of money, 2. lots of freedom,
3. lots of time."

The Look of Love
(The Sexual Male Series)
1 of 2, 2008
Playboy magazine, Art
Direction: Rob Wilson,
digital

Designer and illustrator Mirko Ilić brings to his work—and therefore to his clients—an ethical rigor, of a higher standard than most, that permits him neither to repeat past successes nor succumb to low expectations. Ilić was self-taught and the only rules he learned were his own. Consequently, he works in an iconoclastic bubble. "Not that I have anything against taking classes," he has said, but when he began his career he decided what he wanted to do and then learned by trial and error.

While still in Europe, Ilić illustrated and produced posters, record covers and comics; after arriving in the US in 1986, he designed exquisite scratchboard illustrations, until the day his hand and mind could no longer scratch a line—he had become bored. Digital was just then beginning and Ilić leapt in head first. "I got my first computer in 1990," he said, and the techniques he developed with it are second nature now. Concepts not style are his signature, although his look is his own. Moreover, being an early adopter he recognizes both the possibilities and the shortcomings of certain programs. "I try to adjust myself to the medium and work with it."

Der Designer und Illustrator Mirko Ilić trägt an seine Arbeit – und damit an seine Auftraggeber – ein Ethos von selten zu findender Strenge heran, das ihm weder vergangene Erfolge zu wiederholen gestattet noch sich niedrigen Erwartungen zu fügen. Ilić ist Autodidakt, und die einzigen Regeln, die er gelernt hat, sind seine eigenen. So findet er sich in einer ikonoklastischen Blase. „Nicht, dass ich etwas gegen Unterricht hätte", sagt er, aber zu Beginn seiner Laufbahn entschied er sich, was er tun wollte, und lernte dann durch Probieren.

Als er noch in Europa lebte, entwarf und produzierte Ilić Poster, Plattencover und Comics. Nach seiner Ankunft in den USA 1986 schuf er ganz besondere Illustrationen in Kratz- und Schabetechnik, bis ihm eines Tages Hand und Geist verweigerten, noch eine Linie zu kratzen – ihm war langweilig geworden. Die Digitaltechnik stand damals am Anfang, und Ilić stürzte sich kopfüber hinein. „Ich bekam 1990 meinen ersten Computer", sagt er, und die Techniken, die er damit entwickelte, wurden ihm zur zweiten Natur. Das Begriffliche, nicht der Stil ist sein Kennzeichen, dabei behält er stets seinen eigenen Blick. Als jemand, der sich früh Computerprogramme zunutze machte, erkennt er überdies deren Möglichkeiten und Schwächen. „Ich versuche mich dem Medium anzupassen und mit ihm zu arbeiten."

Le designer et illustrateur Mirko Ilić apporte à son travail (et donc à ses clients) une rigueur éthique particulièrement stricte, qui ne l'autorise ni à répéter les succès du passé ni à succomber à la facilité. Ilić est autodidacte, et les seules règles qu'il a apprises sont les siennes. Il travaille donc dans une bulle iconoclaste. « Je n'ai rien contre le fait de prendre des cours », a-t-il déclaré. Mais lorsqu'il a commencé sa carrière, il a choisi ce qu'il voulait faire et a appris par tâtonnements.

Alors qu'il était encore en Europe, Ilić a illustré et créé des affiches, des couvertures de disques et des bandes dessinées ; après son arrivée aux États-Unis, en 1986, il a créé des illustrations sur carte à gratter d'une délicatesse infinie, jusqu'au jour où sa main et son esprit refusèrent de gratter – cela ne l'intéressait plus. Le numérique en était alors à ses balbutiements, et Ilić y plongea la tête la première. « J'ai eu mon premier ordinateur en 1990 », explique-t-il. Les techniques qu'il a mises au point avec cette première machine sont maintenant comme une seconde nature. C'est à ses concepts qu'on le reconnaît, et non à son style, bien qu'il possède une esthétique bien à lui. De plus, faisant partie des premiers utilisateurs, il reconnaît les possibilités mais aussi les limitations des programmes. « J'essaie de m'adapter au support et de travailler avec. »

p. 380 Tribes, 2008
Penguin, book cover, Art
Direction: Joseph Perez,
digital

Fixing Europe, 2011
Der Spiegel magazine,
cover, Art Direction: Stefan
Kiefer, digital

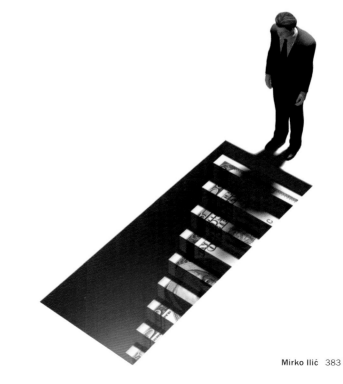

Data Trail, 2003
National Geographic
magazine, digital

All the Devils Are Here,
2010
Penguin, book cover, Art
Direction: Joseph Perez,
digital

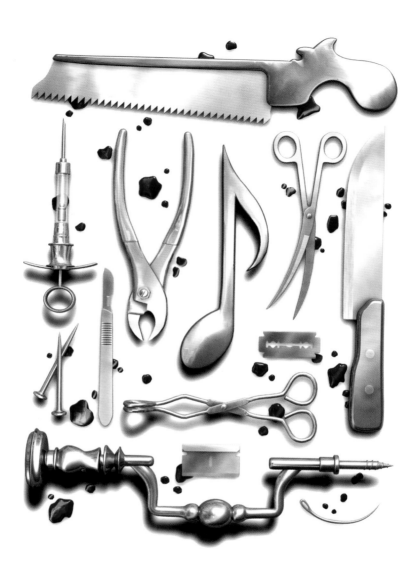

Halt—Before I Make You
Listen to Matchbox 20
Again, 2005
Best Life magazine, digital

The Flight of the
Spermatozoon, 2007
Mirko Ilić, Playboy
magazine, Art Direction:
Rob Wilson, digital

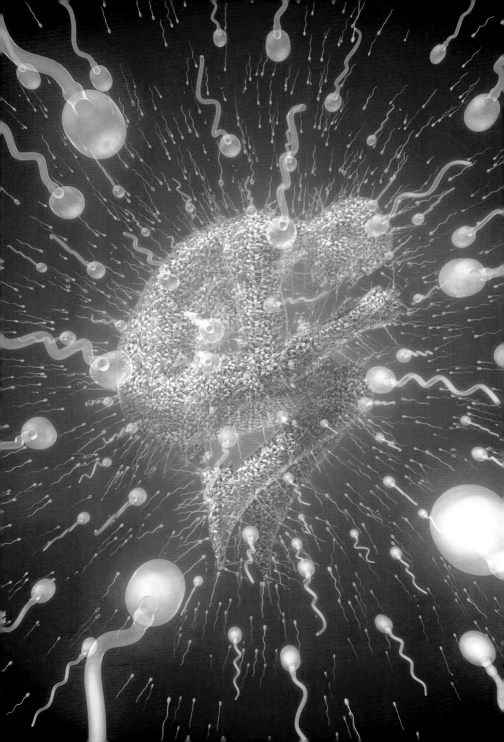

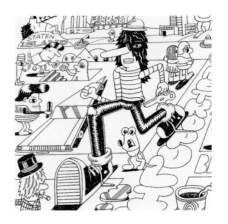

Jeremyville

1975 born in Sydney
Lives and works in Sydney and in New York
www.jeremyville.com

"To rescue drowning characters
from my stream of consciousness."

My Days in Bondi, 2011
Personal work, pen and
screen printing

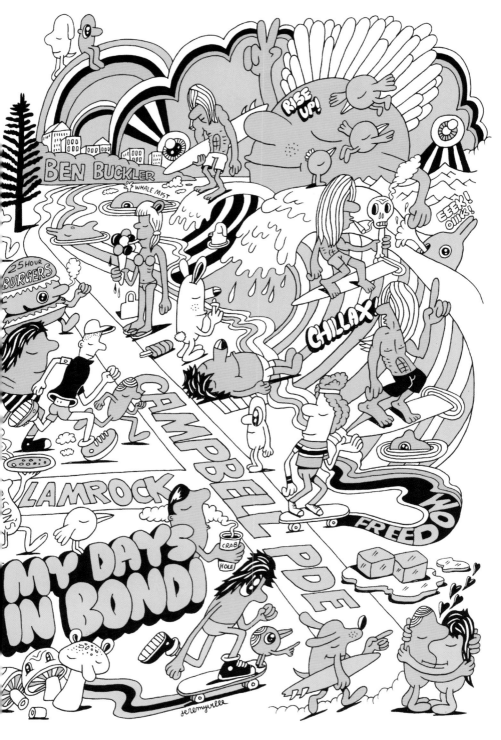

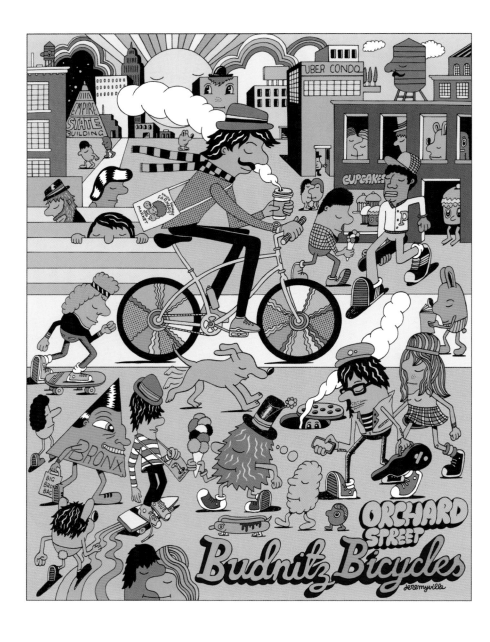

Orchard Street,
Lower East Side, 2012
Budnitz Bicycles, Owner:
Paul Budnitz, pen

Jeremyville is the ever-aspiring comics-loving kid's answer to art. His pictures are orgies of strange and joyful characters just waiting—perhaps impatiently—to be molded into plastic and turned into toys. The artist who styles himself as Jeremyville grew up near the beach and played long and hard with Lego, Smurfs and similar toys, while his library was filled with Tintin and Richard Scarry. When asked how he balances the personal and the commercial he replied: "I'm a very harsh critic of my work, so only when I feel something is really good does it leave my studio."

Jeremyville ist die Antwort der ständig hoffenden, comicverliebten Kids auf die Kunst. Seine Bilder sind Orgien seltsamer und fröhlicher Figuren die – vielleicht ungeduldig – nur darauf warten, in die Kunststoffpresse zu kommen und Spielzeug zu werden. Der Künstler, der sich zu Jeremyville stilisiert hat, wuchs nahe dem Strand auf und spielte lange und eifrig mit Lego, Schlümpfen und Ähnlichem, während Tintin und Richard Scarry aus dem Bücherschrank quollen. Gefragt, wie er Persönliches und Kommerzielles unter einen Hut bringe, antwortet er: „Ich bin ein sehr strenger Kritiker meiner eigenen Arbeit, deshalb geht nur etwas aus meinem Studio, das ich wirklich gut finde."

Jeremyville est un gamin mordu de bande dessinée, devenu artiste. Ses images sont des orgies de personnages étranges et enjoués qui n'attendent que d'être moulés dans du plastique et transformés en jouets. L'artiste qui a décidé de s'appeler Jeremyville a grandi près de la plage et a joué éperdument avec ses Lego, ses Schtroumpfs et compagnie, et sa bibliothèque était remplie d'albums de Tintin et de Richard Scarry. Lorsqu'on lui demande comment il équilibre l'aspect personnel et l'aspect commercial, il répond : « Je suis un critique très sévère de mon travail, et je ne laisse sortir de mon studio que les images que je considère comme très bonnes. »

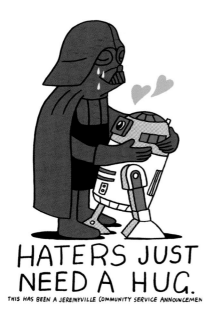

Haters Just Need a Hug, 2012
Personal work, pen and screen printing

p. 390 Converse Rubber Tracks Live, 2012 Converse USA, Music Hall of Williamsburg, New York, stage backdrop, pen

p. 391 Desolate Night, Hell's Kitchen, 2011 Personal work, pen and screen printing

Any format can be interesting and exciting to Jeremyville, as he states: "I don't limit myself to just one medium, like just apparel. I feel comfortable doing lots of things, sometimes at once! I also like trying new things, [...] this keeps me excited." To give examples, he has designed snowboards for Rossignol and a toy for Super Rad, both in the US, worked on animation for firms in Argentina and the UK, T-shirt designs for Graniph (Japan), a comicbook for a French publisher, and all while preparing for solo or group exhibitions in Paris and Rome.

Jedes Format kann für Jeremyville interessant und aufregend werden: „Ich beschränke mich nicht auf ein bestimmtes Medium, etwa nur Bekleidung. Ich fühle mich wohl dabei, eine Menge Dinge zu machen, manchmal alle zugleich! Ich probiere auch gern etwas Neues aus." So hat er zum Beispiel Snowboards für Rossignol und ein Spielzeug für Super Rad entworfen, an Trickfilmen für Firmen in Argentinien und Großbritannien gearbeitet, T-Shirts für Graniph (Japan) entworfen und ein Comicbuch für einen französischen Verlag gezeichnet – all das, während er gleichzeitig Einzel- und Gruppenausstellungen in Paris und Rom vorbereitete.

Tous les formats peuvent être intéressants pour Jeremyville : « Je ne me limite pas à un seul support, par exemple seulement les vêtements. Je me sens bien lorsque je fais beaucoup de choses différentes, parfois en même temps ! J'aime aussi essayer de nouvelles choses, [...] comme ça je ne m'ennuie jamais. » Par exemple, il a créé des snowboards pour Rossignol et un jouet pour Super Rad aux États-Unis, travaillé sur de l'animation pour des entreprises en Grande-Bretagne et en Argentine, créé des t-shirts pour Graniph (Japon) et une bande dessinée pour une maison d'édition française tout en préparant des expositions en groupe et en solo à Paris et à Rome.

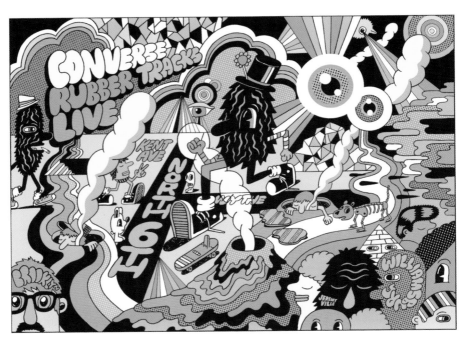

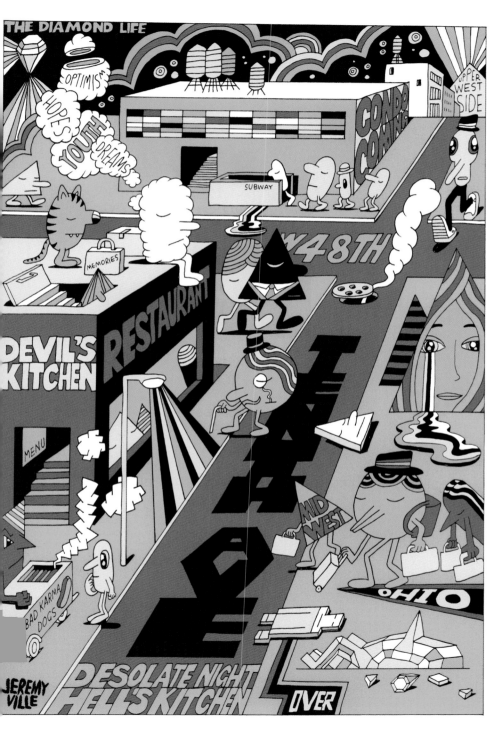

Kako

1975 born in São Paulo
Lives and works in São Paulo
www.kakofonia.com

"Keep mind, eyes, and hands busy."

O Japão Daqui, 2008
Editora Abril, poster and
postcard, digital

The collage-like drawings by Kako are girded with symbolic resonance and underscored by representational drawing virtuosity, also fitting well into the current zeitgeist for realism, illusionism and fabulism. From his teens he worked in many fields: "My first job was assistant camera in an advertising production company where I spent two years before getting into Fine Arts College. I dropped out a couple of years later to help an ex-teacher on his comic-book art classes [...] then was hired as a web designer. It was only in 2002 that I realized that I should quit my job and focus on illustration."

Die collageartigen Zeichnungen von Kako sind reich an symbolischem Widerhall, gepaart mit Virtuosität im gegenständlichen Zeichnen, und sie fügen sich gut in die herrschende Vorliebe für Realismus, Illusionismus und Fabulierkunst. Schon als Teenager hat er auf vielen unterschiedlichen Gebieten gearbeitet: „Meine erste Anstellung hatte ich als Kamera-assistent bei einer Werbefirma, wo ich zwei Jahre blieb, bevor ich an die Kunsthochschule ging. Das ließ ich ein paar Jahre später sausen, um einen früheren Lehrer bei seinen Kursen im Comiczeichnen zu unterstützen [...] danach wurde ich als Webdesigner engagiert. Erst 2002 ging mir auf, dass ich meinen Job aufgeben und mich aufs Illustrieren konzen-trieren sollte."

Les dessins-collages de Kako sont empreints d'une résonance symbolique et soulignés par la virtuosité du dessin figuratif, ce qui s'inscrit parfaitement dans la tendance actuelle au réalisme, à l'illusionnisme et au fabulisme. Depuis l'adolescence, il a travaillé dans de nombreux secteurs différents : « Pour mon premier job, j'ai été assistant caméraman dans une société de production de publicité, où j'ai passé deux ans avant d'entrer aux Beaux-Arts. J'ai arrêté mes études deux ans plus tard pour assister un ancien professeur dans ses classes de bande dessinée, [...] puis j'ai été embauché comme concepteur web. Ce n'est qu'en 2002 que j'ai réalisé que je devrais démissionner et me concentrer sur l'illustration. »

Boardwalk Empire, 2010
The Washington Post,
digital

Steelers Defense, 2011
ESPN magazine, digital

Kako works freelance for clients in advertising, publishing and editorial, and has received a Gold Lion at Cannes in 2008, Gold at El Ojo de Iberoamérica, and the award for Best Illustrator of 2007 at HQMix. From time to time he likes "to flirt with the comic-book world doing covers for unusual books or telling very very very very short stories," and at that point strange things can happen. Meanwhile, illustration gives him opportunities to engage in fashion, comic books and movies, as well as graphic and web design, but right now he is where "I've always wanted to be: everywhere at the same time."

Kako arbeitet freiberuflich für Kunden aus der Werbung, dem Verlags- und Zeitschriftenwesen und hat 2008 den Goldenen Löwen in Cannes gewonnen, Gold bei El Ojo de Iberoamérica und den Preis als bester Illustrator 2007 bei HQMix. Hin und wieder flirtet er „mit der Welt der Comic-Bücher", er gestaltet „Umschläge für Titel, die aus dem Rahmen fallen" oder erzählt „ganz, ganz, ganz, ganz kurze Geschichten", und wenn es dazu kommt, können unerwartete Dinge geschehen. Im Übrigen gibt ihm die Illustration Gelegenheit, sich in der Mode, beim Comic, im Film wie auch in der Grafik und im Webdesign zu betätigen, aber gegenwärtig ist er da, „wo ich immer sein wollte: überall zugleich".

Kako travaille en freelance pour des clients des secteurs de la publicité, de l'édition et de la presse, et a remporté un Lion d'or à Cannes en 2008, l'or à El Ojo de Iberoamérica, et le prix du meilleur illustrateur 2007 à HQMix. De temps en temps, il aime « flirter avec le monde de la bande dessinée en faisant des couvertures pour des livres qui sortent de l'ordinaire, ou raconter des histoires très très très très courtes », et alors d'étranges choses peuvent arriver. L'illustration lui donne l'occasion d'interagir avec la mode, les bandes dessinées et les films, ainsi que le design web et le graphisme, mais il se trouve actuellement « exactement là où j'ai toujours voulu être : partout en même temps ».

The Queen That Came
From the Sea 1 & 2, 2012
Escrita Fina Edições,
digital

SELECTED EXHIBITIONS — **2016**, DreamWorks Voltron Legendary Defender Art Showcase, group show, Hero Complex Gallery, Los Angeles // **2012**, Impredecible Gráfica Brasileña, group show, Feria Internacional del Libro, Bogotá // **2012**, Society of Illustrators 54, group show, New York // **2011**, IlustraBrazil!, group show, The Foundry Gallery, Shanghai // **2010**, New Illustrators File, group show, Art Box International Gallery, Tokyo // **2008**, Creative Art Session, group show, Kawasaki City Museum, Kawasaki

SELECTED PUBLICATIONS — **2012**, AI-AP Latin American Ilustración, Amilus, USA // **2012**, Illustrators Annual, Society of Illustrators, USA // **2012**, New Illustrators File, Art Box International, Japan // **2011**, Illustration Now! Portraits, TASCHEN, Germany // **2011**, 200 Best Illustrators Worldwide, Lürzer's Archive, Austria

The Minotaur, 2011
Editora Abril, digital

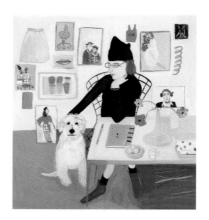

Maira Kalman

1949 born in Tel Aviv
Lives and works in New York
www.mairakalman.com

"My work is based on a lot of influences
beginning in my childhood.
Cartoons, TV serials, advertisements,
music, design, art and photography
from the '60s to now."

Lady With Face Net, 2000
The New York Times
Magazine, gouache on
paper

THESE Two Women were Friends of
the writer ROBERT WALSER
You could say he was BROKEN
Because he Ended Up in a mental
Institution, but his Books are Beautiful.

On the street I photograph a Flowery Sofa.

The Sisters, 2012
Shiseido, gouache on
paper

Flowered Sofa on
the Street, 2006
The New York Times online
Op-Ed, The Principles of
Uncertainty, Penguin, book,
gouache on paper

Elements of Style, 2005
The Elements of Style
Illustrated, Penguin, book,
Author: William Strunk and
E. B. White, gouache on
paper

Maira Kalman 401

Maira Kalman's beguilingly naïf approach has over the past two decades blossomed into a pictorial storytelling language of some virtuosity. Kalman's work is reportage, commentary and satire; she is an intrepid journalist, diarist and columnist, going where few illustrators dare. She takes on the roles of those she draws and illustrates, and works in more formats than there are words to describe them. Her *New York Times* column, "The Principles of Uncertainty," which later became a book, may also be an opera of some sort.

Maira Kalmans bestrickend naiver Ansatz ist in den letzten zwei Jahrzehnten zu einer virtuos gehandhabten Bildsprache des Erzählens erblüht. Ihre Arbeiten sind Reportage, Kommentar, Satire. Kalman ist eine unerschrockene Journalistin, Chronistin und Kolumnistin, die sich auf ein Terrain wagt, das wenige Illustratoren betreten. Sie nimmt die Rollen derjenigen ein, die sie zeichnet oder illustriert, und arbeitet in mehr Formaten, als sich mit Worten bezeichnen lässt. Ihre Kolumne „The Principles of Uncertainty" in der *New York Times*, die später in Buchform erschienen ist, ließe sich sogar als Oper bezeichnen.

Au cours des vingt dernières années, la charmante naïveté de la démarche de Maira Kalman s'est épanouie en un langage narratif visuel d'une grande habileté. La spécialité de Kalman, c'est le reportage, le commentaire et la satire. Elle est une intrépide journaliste, diariste et chroniqueuse, et va là où peu d'illustrateurs osent s'aventurer. Elle endosse les rôles de ceux qu'elle dessine et illustre, et travaille dans plus de formats qu'il n'existe de mots pour les décrire. Sa chronique dans le *New York Times*, « The Principles of Uncertainty », qui est devenue un livre, peut aussi être considérée comme une sorte d'opéra.

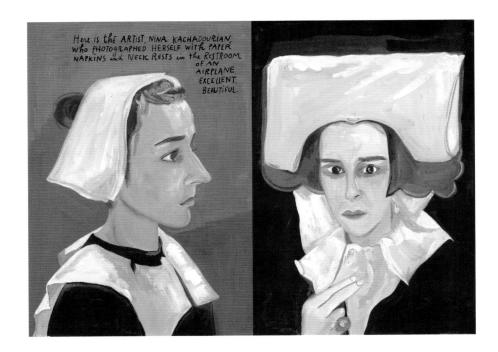

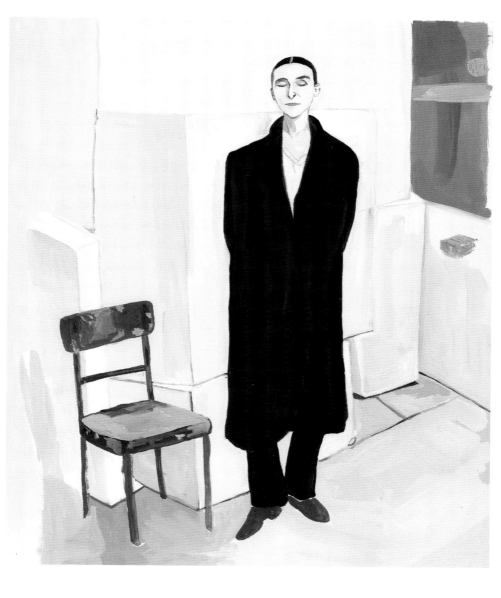

Nina Katchadourian, 2012
Shiseido, gouache on
paper

Pina Bausch, 2005
The Elements of Style
Illustrated, Penguin, book,
Author: William Strunk and
E. B. White, gouache on
paper

On Beauty

Broken and Unbroken

By Maira Kalman

I must tell you. My dreams have been disturbing (darkness, darkness), but I am still able to see and feel beauty. Everywhere.

Dread and delight at the same time.

That is the truth about being alive.

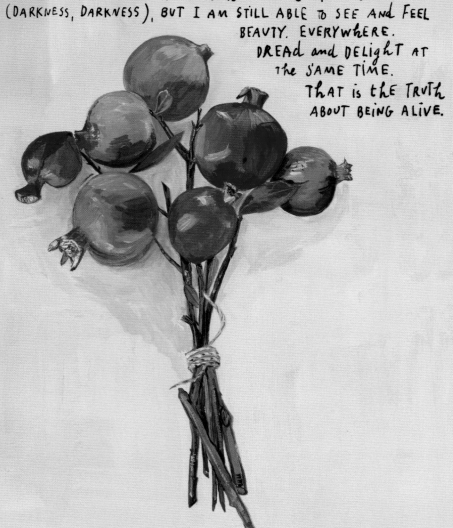

Kalman's work for an illustrated edition of Strunk & White's *Elements of Style* in 2005 might not at first appear a money-making project, even if the book is a recognized classic. After she chanced upon a copy while on holiday in Cape Cod, the bracing sea air gave breath to the idea. "It took a few years to convince the parties—the E. B. White estate, the publisher, and so on. But it was a great publishing success and I loved working on it with absolutely no one telling me what to do." She also has ideas for little movies and the like: "The point would be to get carried away with something."

Kalmans Arbeit an einer illustrierten Ausgabe von Strunk und Whites' *Elements of Style* aus dem Jahr 2005 hört sich zunächst nicht nach einem lukrativen Auftrag an, obwohl das Buch ein Klassiker ist. Sie stieß auf den Titel, als sie in Cape Cod Urlaub machte, und die frische Seeluft beflügelte die Idee. „Es dauerte ein paar Jahre, die Beteiligten zu überzeugen – die Nachlassverwalter E.B. Whites, den Verlag usw. Aber es wurde ein durchschlagender Erfolg, und die Arbeit daran machte großen Spaß, weil niemand sich einmischte." Sie hat auch Einfälle für Kurzfilme und Ähnliches. „Ich muss mich nur für etwas begeistern können."

Le travail de Kalman pour une édition illustrée d'*Elements of Style* de Strunk & White en 2005 ne ressemble peut-être pas au typique projet lucratif, mais le livre est un classique reconnu. Tombée par hasard sur le livre alors qu'elle était en vacances à Cape Cod, l'air marin vivifiant lui inspira l'idée. « Il m'a fallu quelques années pour convaincre les intéressés – les successeurs d'E.B. White, l'éditeur, etc. Mais ça a été un grand succès, et j'ai adoré pouvoir y travailler sans que personne ne me dise quoi faire. » Elle a également des idées pour des petits films et autres : « Ce qui compte, c'est de se plonger dans quelque chose. »

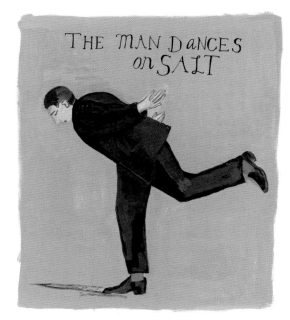

Pomegranates, 2012
Shiseido, gouache on
paper

The Man Dances on Salt,
2006
The New York Times online
Op-Ed, The Principles of
Uncertainty, Penguin, book,
gouache on paper

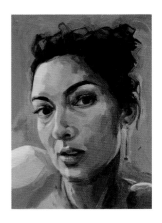

Karen Klassen

1977 born in High Level, Canada
Lives and works in Calgary
www.karenklassen.com

"My interest in portraiture and fashion,
and mixed media impacts on everything I do in art,
from how I choose subjects to ultimately
how I portray that image."

Poppy Crown, 2009
Market Mall / Zero Gravity,
acrylic and oil on paper

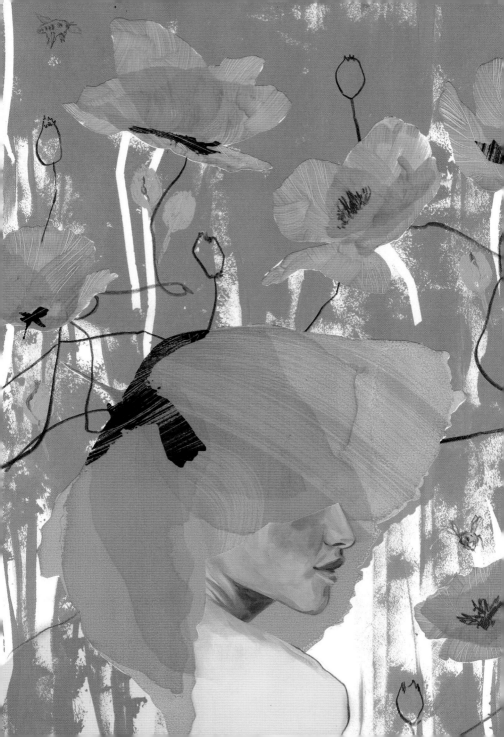

SELECTED EXHIBITIONS — *2012*, ISM Show, group show, Grand Central Art Center, Santa Ana // *2011*, Coax Me, group show, The Chalet, Glasgow // *2010*, A Labor of Line, group show, Nucleus Gallery, Los Angeles // *2008*, Know by Heart, group show, Element Eden, Toronto // *2007*, The Shatner Show, group show, Uppercase Gallery, Calgary

SELECTED PUBLICATIONS — *2012*, Communication Arts, USA // *2012*, 1000 Portrait Illustrations, Quarry Books, USA // *2011*, Drawn In, Quarry Books, USA // *2011*, Illustration Now! 4, TASCHEN, Germany // *2011*, Illustrators Unlimited, Gestalten, Germany

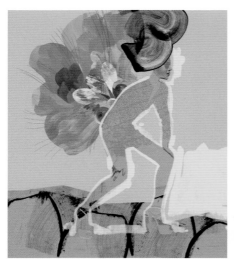 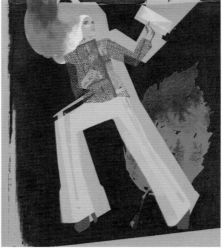

Women's Summer Fashion Single, 2012
Bankers Hall, Art Direction: Rick Thomas, acrylic, ink and digital

Snow White & Rose Red, 2013
Personal work, acrylic and oil on wood panel

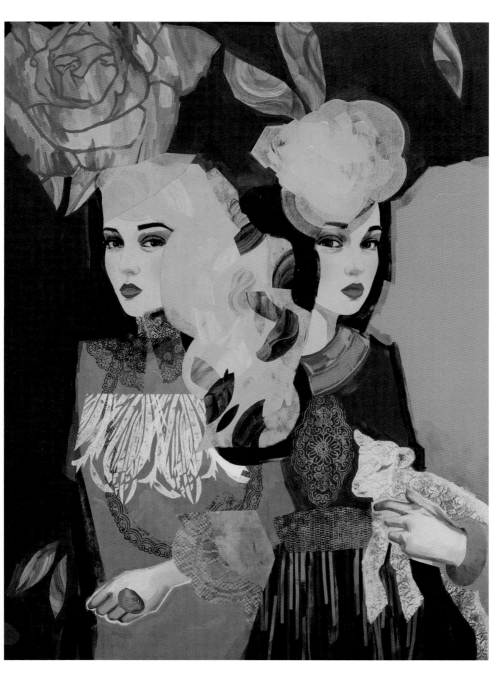

Take equal measures of realism, impressionism and expressionism, add a tincture of romanticism and blend in a Mixmaster, and Karen Klassen's light and dark illustrations will be the final result. Klassen's style is the sum of these parts and yet achieves a distinct visual voice of its own as well. She takes pleasure in using a variety of materials, "I skip from one to another quite frequently, whenever I start to feel a little bored," she told *The Flood* blog. "I also love to try and exploit the inherent qualities of a specific material. Right now I'm using printmaking techniques, acrylics, oils, fountain pens, gouache, and Photoshop."

Man nehme Realismus, Impressionismus und Expressionismus zu gleichen Teilen, füge eine Prise Romantik hinzu, gebe alles in einen Mixer, und heraus kommen Karen Klassens Hell-Dunkel-Illustrationen. Klassens Stil ist die Summe dieser Zutaten und findet dabei doch zu einem eigenen unverwechselbaren Ton. Sie hat eine Vorliebe dafür, mit unterschiedlichen Materialien zu arbeiten. „Ich wechsle gern von einem zum anderen, wenn mir ein wenig langweilig wird", sagte sie im Blog *The Flood*. „Ich probiere und nutze auch gern die spezifischen Eigenschaften eines bestimmten Materials. Zurzeit verwende ich Drucktechniken, Acrylfarben, Ölfarben, Füllfederhalter, Gouache und Photoshop."

Prenez une part de réalisme, d'impressionnisme et d'expressionnisme, ajoutez de la teinture de romantisme et passez le tout au robot mixeur, vous obtiendrez les illustrations claires et sombres de Karen Klassen. Son style est la somme de ces éléments, et atteint pourtant un ton visuel bien distinctif. Elle prend plaisir à utiliser des matériaux très variés. « Je passe de l'un à l'autre très fréquemment, dès que je commence à m'ennuyer un peu », a-t-elle déclaré au blog *The Flood*. « J'aime aussi essayer d'exploiter les qualités intrinsèques de chaque matériau. En ce moment, j'utilise des techniques de gravure, l'acrylique, la peinture à l'huile, des stylos plumes, la gouache et Photoshop. »

Henry, 2012
Personal work, acrylic
on wood panel

Lolita Series: Lola and
Chris, 2010
Personal work, acrylic
and oil on panel

Anita Kunz

1956 born in Toronto
Lives and works in Toronto
www.anitakunz.com
www.anitakunzart.com

"I am a witness to the world around me,
and my visual comments are reactions to these events.
In every case, there is a fluidity, a desired response,
though of course I cannot control that response;
in some ways, what I really do is try
and encourage thoughtful participation
in the cultural moment."

Cocoon, 2011
Personal work, Christmas
card 2011, acrylic

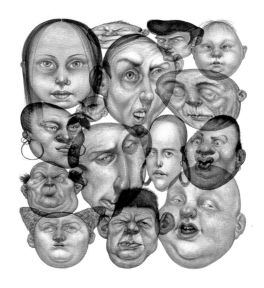

Little Monsters, 2012
Polaroid, Phillips de Pury
gallery, New York,
exhibition, Curation:
Lady Gaga, watercolor

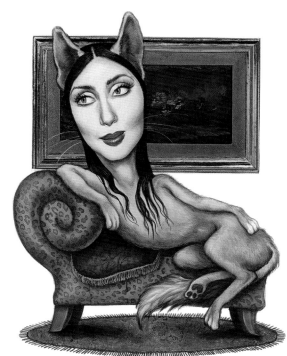

Elton John, 1998
The New Yorker,
watercolor and gouache

Cher, 1991
Entertainment Weekly
magazine, mixed media,
watercolor and collage

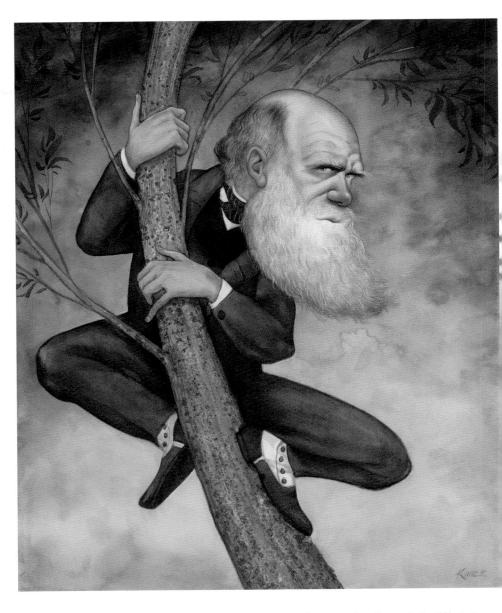

SELECTED EXHIBITIONS — 2016, *The Visual Narrative: Three Perspectives*, group show, Norman Rockwell Museum, Stockbridge // 2012, *Covers of The New Yorker*, group show, Martel Gallery, Paris // 2010, *The Naughty Show*, solo show, Gallery One800, Toronto // 2003, *Canadian Counterpoint*, solo show, Swann Gallery, Library of Congress, Washington DC // 2000, *Kunz: Mid-career Retrospective*, solo show, Museum of American Illustration, New York

SELECTED PUBLICATIONS — 2016, *The New Yorker* magazine, USA // 2012, *Lifestyles* magazine, Canada // 2002, *Nuvo* magazine, Canada // 1993, *Creation* magazine, Tokyo // 1984, *Communication Arts*, USA

To be accepted as a pioneer in illustration, one typically has to stand on the shoulders of those who have gone before. Anita Kunz's shoulders must be near collapsing from the weight put upon them, since she was one of a small band that pushed conceptual boundaries and helped break taboos by way of her sometimes caustic commentaries on gender, war and religion. She has explained, "I probably became an illustrator for the same reason that everyone else does… I always knew that I wanted to go to art school, and I was fortunate to have had an uncle who was a working illustrator, so it was never a choice for me whether to pursue a career in fine art or illustration."

Wenn man sich in der Kunst der Illustration einen Namen gemacht hat, steht man üblicherweise auf den Schultern derer, die vor einem kamen. Anita Kunz' Schultern dürften unter dem Gewicht, das sie zu tragen haben, fast zusammenbrechen, denn sie gehört mit ihren manchmal sarkastischen Kommentaren zu Geschlecht, Krieg und Religion zu einer kleinen Gruppe, die die konzeptuellen Grenzen erweiterte und Tabus brechen half. „Wahrscheinlich bin ich aus denselben Gründen Illustratorin geworden wie andere auch", hat sie einmal erklärt. „Ich wollte schon immer auf eine Kunstschule gehen und hatte glücklicherweise einen Onkel, der als Illustrator arbeitete. Daher war es für mich nie eine Frage, ob ich eine Laufbahn in der bildenden Kunst oder als Illustratorin einschlagen sollte."

Pour se faire accepter en tant que pionnier de l'illustration, il faut généralement se tenir debout sur les épaules de ses aînés. Les épaules d'Anita Kunz doivent crouler sous le poids qu'elles supportent, car elle a fait partie d'un petit groupe qui a repoussé les limites conceptuelles et a contribué à rompre les tabous avec ses commentaires parfois caustiques sur le sexe, la guerre et la religion. Elle a expliqué : « Je suis probablement devenue illustratrice pour la même raison que les autres … J'ai toujours su que je voulais faire des études artistiques, et j'ai eu la chance d'avoir un oncle qui était illustrateur professionnel, alors pour moi, faire carrière dans les beaux-arts ou l'illustration n'a jamais été un dilemme. »

Charles Darwin, 2009
The Illustration Academy,
video instruction and
demonstration, watercolor
and gouache

The Marked (diptych),
2010
Personal work, Gallery
House, promotional
cards, acrylic

Ronald Kurniawan

1979 born in Jakarta
Lives and works in Monrovia, USA
www.ronaldkurniawan.com

"Inspired by ideograms,
syllables, letterforms, beasts,
and heroic landscapes."

Revelations, 2012
The New Yorker, digital

SELECTED EXHIBITIONS — *2008*, Summer Solstice, group show, LACMA, Los Angeles // *2007*, Buffoon, group show, Roq La Rue, Seattle // *2006*, Bittersweet, group show, Gallery Nucleus, Alhambra // *2006*, LA Weekly, group show, Bergamot Station, Santa Monica

SELECTED PUBLICATIONS — *2012*, American Illustration 31, USA // *2011*, American Illustration 29, USA // *2010*, Communication Arts, USA // *2009*, Communication Arts, USA // *2008*, Metro.Pop, USA

It is likely that those looking at Ronald Kurniawan's densely phantasmagoric illustrations may find they succumb to a bout of vertigo. In his tableaux there is just so much to see and decipher that the eye and mind are unable to capture a full mental screenshot in one go. Symbols and signs are of course very important in our everyday lives, and duly inspired by ideograms and letterforms, as too the varieties of animal life and a sense for grand settings, Kurniawan has developed a meticulous visual language where "the wilderness and civilization could merge happily together."

Es ist nicht ausgeschlossen, dass Betrachter von Ronald Kurniawans vollgepackten fantasmagorischen Illustrationen einen Schwindelanfall erleiden. In seinen Tableaus gibt es einfach so viel zu sehen und zu dechiffrieren, dass Auge und Geist überfordert sind, ein komplettes geistiges Abbild davon auf Knopfdruck einzufangen. Symbole und Zeichen sind in unserem Alltag natürlich sehr wichtig, und so sind es Ideogramme und Buchstabenformen, die, zusammen mit der Vielfalt des Tierlebens und einem Gespür für großartige Kulissen, Kurniawan zu einer ausgefeilten Bildsprache animiert haben, in der „Wildnis und Zivilisation sich fröhlich vermischen" können.

Les illustrations densément fantasmagoriques de Ronald Kurniawan ont probablement été responsables de nombreuses crises de vertige. Il y a tant de choses à y voir et à y déchiffrer que les yeux et le cerveau sont incapables de saisir un cliché mental complet en une fois. Les symboles et les signes sont bien sûr très importants dans notre vie quotidienne, et dûment inspiré par les idéogrammes, les lettres et la diversité de la vie animale, et avec un sens des décors grandioses, Kurniawan a mis au point un langage visuel méticuleux où « la nature et la civilisation pourraient fusionner dans la joie ».

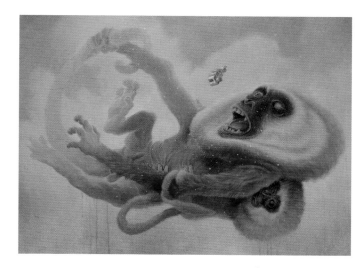

Treasure Hunt, 2007
LA Weekly newspaper,
acrylic and digital

Car Sick, 2008
Roq La Rue Gallery,
acrylic on birch

422 **Ronald Kurniawan**

Altered States, 2012
The New Yorker, pencil
and digital

Imagination Can Become
Reality, 2011
Cleveland Institute of Art,
pencil and digital

B Wary, 2006
Plansponsor magazine,
acrylic and digital

Michael Kutsche

1977 born in Berlin
Lives and works in Los Angeles
www.michaelkutsche.com

"Parallel realities, populated by
odd characters reminiscent of movies and comics,
but also Flemish Renaissance painting."

Boxer, 2008
Personal work, digital

The ferocity of some of the monsters Michael Kutsche unleashes through his illustration may not be intentionally threatening, but the impression his most demonic characters leaves behind is guaranteed to plant the seeds of nightmares. Kutsche's extremely lifelike work forces us to see what might otherwise be repulsive through the lens of beauty. As horrific as many of these images are, they have been rendered with such precision, attention to detail, and understanding of the human (or inhuman) form, that the viewer is lulled into a curiously hypnotic state. Kutsche calls himself a conceptual illustrator but qualifies this, saying: "I'm somewhere between movies, comics, fine arts, animation, architecture and design."

SELECTED EXHIBITIONS — 2010, Alice in Wonderland Exhibition, group show, Arludik Gallery, Paris // 2010, Curiouser and Curiouser, group show, Gallery Nucleus, Alhambra, California

SELECTED PUBLICATIONS — 2011, Illustration Now! 4, TASCHEN, Germany // 2010, Neo York, IdN, USA

China Doll, 2011
Disney Enterprises,
Oz the Great and Powerful,
character design,
Direction: Sam Raimi,
digital

Mad Hatter, 2008
Disney Enterprises,
Alice in Wonderland,
character design,
Direction: Tim Burton,
digital

Die Wildheit einiger der Ungeheuer, die Michael Kutsche in seinen Bildern loslässt, ist vielleicht nicht bedrohlich gemeint, aber der Eindruck, den seine besonders dämonischen Figuren hinterlassen, garantiert Albträume. Kutsches extrem lebensechte Darstellung zwingt uns, das, was sonst abstoßend wäre, durch die Brille der Schönheit zu betrachten. So schreckenerregend viele dieser Bilder sind, so sind sie doch mit so viel Genauigkeit, Liebe zum Detail und Verständnis für die menschliche (oder außermenschliche) Form ausgeführt, dass der Betrachter in einen seltsam hypnotischen Zustand gewiegt wird. Kutsche bezeichnet sich selbst als einen konzeptuellen Illustrator, differenziert aber: „Ich stehe irgendwo zwischen Film, Comics, den schönen Künsten, dem Zeichentrick, der Architektur und dem Design."

La férocité de certains des monstres de Michael Kutsche n'est peut-être pas menaçante de façon intentionnelle, mais l'impression que ses personnages les plus démoniaques laissent sur leur passage sera sans doute matière à nombre de cauchemars. Kutsche imite la vie à s'y méprendre, et nous force à regarder à travers la lorgnette de la beauté ce qui serait par ailleurs répugnant. Car aussi horribles que nombre de ses images soient, elles ont été travaillées avec tant de précision, de sens du détail et de compréhension de la forme humaine (et inhumaine) qu'elles bercent l'observateur et le mettent dans un état curieusement hypnotique. Kutsche se qualifie bien d'illustrateur, mais ajoute : « Je me situe quelque part entre le cinéma, la bande dessinée, les beaux-arts, l'animation, l'architecture et le design. »

River Fairy, 2011
Disney Enterprises,
Oz the Great and Powerful,
character design, Direction:
Sam Raimi, digital

Steambots, 2011
Disney Enterprises,
Oz the Great and Powerful,
character design, Direction:
Sam Raimi, digital

pp. 430/31
Cheshire Cat, 2008
Disney Enterprises,
Alice in Wonderland,
character design, Direction:
Tim Burton, digital

Zohar Lazar

1971 born in Tel Aviv
Lives and works in upstate New York
www.zoharlazar.com

"Get the job in on time.
Don't forget to send the invoice."

I Can't See Myself, 2012
Personal work, ink,
watercolor and gouache

Undine, 2012
Applibot, Legend of the
Cryptids, digital

New Girl, 2013
Personal work, digital

So Much of Nobody,
2002–2003
Personal work, Credits:
Alex Gross, Rob Clayton,
David Mocarski and
Richard Keyes, acrylic and
colored pencil on canvas

The voltage dial is turned up high to supply the ultraluminescence emitted from Daniel Lim's futuristic fantasies. Lim's portraits of gorgeous sirens from another dimension fit squarely into a science-fiction tradition that continues to hold its viewers entranced, not least by the sensuality and erotic intensity of these characters. As Fawn Fruits, he assumed an alias for the 1000 Drawings project, selling portraits for US$100 to pay the rent, describing himself as an "intuitive artist who doesn't sketch out an elaborate design, but relishes the spontaneity of the art and moves things as he goes with colored pencils and acrylics."

Daniel Lim dreht den Spannungsregler bis zum Anschlag, um die Ultraluminiszenz seiner futuristischen Fantasien unter Strom zu setzen. Seine Porträts verführerischer Sirenen aus einer anderen Dimension fügen sich nahtlos in eine Science-Fiction-Tradition ein, die ihre Betrachter nach wie vor in Bann schlägt, nicht zuletzt wegen der Sinnlichkeit und erotischen Intensität ihrer Figuren. Als „Fawn Fruits" nahm er unter Pseudonym am „1000 Drawings Project" teil, verkaufte Porträts für 100 Dollar das Stück, um sich die Miete zu verdienen, und beschreibt sich als einen „intuitiven Künstler, der keine ausgefeilten Entwürfe macht, sondern die Spontaneität der Kunst genießt und mit Buntstift und Acrylfarben leicht die Dinge in Bewegung bringt".

La tension électrique doit être au maximum pour fournir leur ultra-luminescence aux fantaisies futuristes de Daniel Lim. Ses portraits de superbes sirènes venues d'une autre dimension s'inscrivent directement dans une tradition de la science-fiction qui continue à ravir son public, notamment grâce à la sensualité et l'intensité érotique de ces personnages. Pour le projet 1000 Drawings, il a pris le pseudonyme de Fawn Fruits, et a vendu des portraits à 100 $ pour payer le loyer. Il se décrit comme un « artiste intuitif qui n'esquisse pas des compositions compliquées, mais se délecte de la spontanéité de l'art et suit le fil de son inspiration avec des crayons de couleur et de l'acrylique ».

Misty Misia, portrait of Misia, 2007
1000 Fawn Fruits Portraits, acrylic and colored pencil on canvas

GladysEye, portrait of Roxanne Kirigoe, 2007
1000 Fawn Fruits Portraits, acrylic and colored pencil on canvas

27th of May, portrait of Mitsuka in Harajuku, 2009
Sweet Streets, acrylic and colored pencil on canvas

Liz Lomax

1975 born in New York
Lives and works in New York
www.lizlomax.com

"I enjoy the challenge of short deadlines,
which allow me to completely immerse myself in
a subject for a short time to hold my attention
without losing interest in the project."

The Perfect Storm, portrait
of Steve Jobs, 2008
University of South
Carolina, magazine article,
polymer clay, oil paint,
insulation foam and digital
photography

There is an old chestnut that goes: "Dying is easy, comedy is hard." That could be modified in Liz Lomax's case to read: "Drawing is easy, 3D caricatures are hard." Of course, Lomax makes it look easy—she hits her targets' quintessential distinguishing expressions with a marksman's accuracy. But familiar humans are not her only prey, she molds virtually any creature with both accuracy and delight, while the genre's broad appeal was noted thus by Anna Richardson in *Design Week*: "With its delight in the grotesque and its echoes of childish play, 3D illustration in the digital era offers a sense of heightened reality that artists and advertisers alike find hard to resist."

Lomax uses tin foil, wire and clay to model her figures, then paints and photographs them before digitally processing the results. Her likenesses are humorous and satirical, though seldom vicious, capturing Amy Winehouse's cat-like eyes, Michael Jackson in the notorious baby-dangling incident, and the ubiquitous Steve Buscemi whose tired gaze and uneven teeth cannot be mistaken. If her work's appeal lies in this, there being nothing better than to visualize absurdity in three dimensions, she notes as well that "it's a very bizarre way of making a flat image."

Es gibt diese alte Binsenweisheit: „Sterben ist einfach, schwer ist das Lustige." Im Fall von Liz Lomax ließe sich das abwandeln zu: „Zeichnen ist einfach, schwer sind Karikaturen in 3D." Natürlich lässt Lomax es einfach aussehen – sie trifft die wesentlichen Merkmale ihres jeweiligen Ziels mit der Sicherheit eines Scharfschützen. Aber allbekannte Mitmenschen sind nicht ihre einzige Beute, sie formt praktisch jedes denkbare Geschöpf mit Genauigkeit und Genuss zugleich. Was dieses Genre allgemein so attraktiv macht, wurde von Anna Richardson in *Design Week* so formuliert: „Die 3D-Illustration im digitalen Zeitalter, mit ihrem Vergnügen am Grotesken und den Anklängen an kindliches Spiel, bietet eine Übersteigerung von Wirklichkeit, der Künstler wie Werbetreibende nur schwer widerstehen können."

Lomax benutzt Alufolie, Draht und Ton, um ihre Figuren zu modellieren, bemalt und fotografiert sie dann und bearbeitet das Ergebnis schließlich digital. Die Ebenbilder, die sie von Personen anfertigt, sind humoristisch und satirisch, aber selten gehässig – sie fängt Amy Winehouses Katzenaugen ein, ertappt Michael Jackson in dem berüchtigten Vorfall des Säugling-in-die-Luft-Haltens und zeigt den omnipräsenten Steve Buscemi mit dem unverwechselbaren müden Blick und den schiefen Zähnen. Wenn der Reiz ihrer Arbeiten eben darin liegt, dass es nichts Besseres gibt, als Absurdität in drei Dimensionen zu zeigen, so hat sie einen Einwand: „Eine ziemlich bizarre Methode, flache Bilder herzustellen, oder?"

Lil Wayne, 2011
Rolling Stone magazine,
Art Direction: Steven
Charny, polymer clay, oil
paint, insulation foam and
digital photography

p. 448 Tiger Woods, 2006
Golf Digest magazine,
polymer clay, oil paint,
insulation foam and digital
photography

p. 449 The Rolling Stones,
2004
Rolling Stone magazine,
polymer clay, oil paint,
insulation foam and digital
photography

D'après une vieille expression, «la mort est plus indulgente que la comédie». Dans le cas de Liz Lomax, on pourrait la détourner et lui faire dire : «Le dessin est plus indulgent que la caricature en 3D.» Bien sûr, Lomax donne l'impression que c'est facile. Elle épingle les expressions caractéristiques de ses sujets avec la précision d'un tireur d'élite. Mais les humains familiers ne sont pas son seul gibier, elle modèle pratiquement n'importe quelle créature avec précision et délice, et Anna Richardson a décrit dans *Design Week* l'attrait universel de ce genre en ces termes : «Avec son sérieux penchant pour le grotesque et ses échos de jeu d'enfant, l'illustration en 3D à l'époque numérique offre un sentiment de réalité augmentée à laquelle les artistes et les annonceurs ont du mal à résister.»

Lomax utilise du papier d'aluminium, du fil de fer et de l'argile pour modeler ses figurines, puis les peint et les photographie avant de passer au traitement numérique du résultat. Ses portraits sont humoristiques et satiriques, mais rarement méchants. Elle immortalise les yeux de chat d'Amy Winehouse, Michael Jackson dans le célèbre incident du bébé au balcon, ou encore l'omniprésent Steve Buscemi, avec son regard et sa dentition inimitables. Si l'attrait de son travail vient de ce qu'il n'y a rien de mieux que de visualiser l'absurdité en trois dimensions, elle remarque que «c'est une façon très étrange de fabriquer des images en deux dimensions».

SELECTED EXHIBITIONS — *2010, Earth: Fragile Planet, group show, The Society of Illustrators, New York // 2010, Lines of Attack: Conflicts in Caricature, group show, Nasher Museum of Art at Duke University, Durham // 2009, Flushing Cow Parade, group show, Crossing Art Gallery, New York // 2006, Dimensional Salon, group show, The Society of Illustrators, New York*

SELECTED PUBLICATIONS — *2011, Illustration Now! Portraits, TASCHEN, Germany // 2011, 200 Best Illustrators Worldwide, Lürzer's Archive, Austria // 2009, Illustration Annual 50, Communication Arts, USA // 2005, Illustration Now! 1, TASCHEN, Germany // 2004, The Art of Der Spiegel, teNeues, Germany*

Tara McPherson

1976 born in San Francisco
Lives and works in New York
www.taramcpherson.com

"Creating art about people
and their odd ways."

Wayob, 2012
1800 Essential Tequila,
bottle artwork, oil on linen

The characters Tara McPherson creates "seem to exude an idealized innocence with a glimpse of hard-earned wisdom in their eyes." McPherson recalls the myths and legends she absorbed during her childhood, along with the general by-products involved in growing up, which combine to inform her "thought-provoking and seductive" images. People and their relationships are central themes, and her output includes designing toys and games for Kidrobot, Dark Horse and Toy2R, comics and covers for DC and Vertigo, and advertising and editorial illustrations for Wieden + Kennedy, *Elle* and *Vanity Fair*, among several other publications.

Tara McPhersons Charaktere, „scheinen eine idealisierte Unschuld auszustrahlen, mit dem Schimmer erster mühsam erworbener Lebensweisheit im Blick". Sie erinnert sich an die Mythen und Legenden, die sie als Kind aufgesogen hat, zusammen mit den üblichen Nebenprodukten des Erwachsenwerdens, und alles gemeinsam prägt ihre „zum Nachdenken anregenden und verführerischen" Bilder. Menschen und ihre Beziehungen zueinander sind zentrale Themen, und sie hat Spielzeuge und Spiele für Kidrobot, Dark Horse und Toy2R entworfen, Comics und Umschläge für DC und Vertigo und Illustrationen für Werbung und Editorials für Wieden + Kennedy, *Elle* und *Vanity Fair* sowie eine Reihe anderer Publikationen.

Les personnages de Tara McPherson « semblent distiller une innocence idéalisée, assortie d'un regard où brille une étincelle de sagesse durement gagnée ». McPherson puise dans les mythes et légendes qu'elle a absorbés pendant son enfance, ainsi que dans les sous-produits du passage à l'âge adulte. Tout cela se combine pour alimenter ses images « qui stimulent l'esprit et séduisent les sens ». Les gens et leurs relations sont ses thèmes centraux, et elle crée aussi des jouets et jeux pour Kidrobot, Dark Horse et Toy2R, des bandes dessinées et des couvertures pour DC et Vertigo, et des publicités et des illustrations de presse pour Wieden + Kennedy, *Elle* et *Vanity Fair*, entre autres publications.

SELECTED EXHIBITIONS — *2016, Master Class and Artist Talk, solo show, Virginia Museum of Contemporary Art, Virginia Beach //* **2016***, "Point of Vision," group show, Museum of American Illustration, New York //* **2012***, New Works, group show, Merry Karnowsky Gallery, Los Angeles //* **2010***, Pop Surrealism, group show, Carandente Museum, Spoleto, Italy //* **2010***, The Bunny in the Moon, solo show, Jonathan LeVine Gallery, New York //* **2009***, We Will Rock You, solo show, Choque Cultural Gallery, São Paulo //* **2008***, Lost Constellations, solo show, Jonathan LeVine Gallery, New York*

SELECTED PUBLICATIONS — *2011, PBS Arts, USA //* **2010***, Maxim magazine, Mexico //* **2010***, The New York Times newspaper, USA //* **2009***, O Globo newspaper, Brazil //* **2008***, Elle magazine, USA*

p. 452 The Witching #1, 2004
DC Comics, acrylic

p. 453 Vicky Chicory and Audrey Aprihop, 2012
Dogfish Head Brewery, art prints, shirts, promotional material, Art Direction: Sam Calagione, oil on linen

Hey We All Die Sometimes, 2008
Personal work, Dorothy Circus Gallery, Rome, exhibition, art prints, phone and laptop skins, pillows, oil on birch panel

Faith No More, 2010
Poster, hand-drawn line art, digital and screen printing

455

Gildo Medina

1980 born in Mexico City
Lives and works in Mexico City and in New York
www.gildomedina.net

"I love to play with making photos and films,
but when I draw, it is the only way
to connect directly my brain, my eyes, my heart
and my hand through my pencil."

Fashion Victim, portrait
of Daul Kim, 2010
Next Libération magazine,
Paris, pencil and
watercolor on paper

SELECTED EXHIBITIONS — *2016*, NEC MERGITUR, solo show, Galerie Details, Paris // *2010*, Le Miroir de Dionysos, solo show, Galerie 13 Jeannette Mariani, Paris // *2010*, Welcome to Reality, solo show, Project Room Vice Gallery, Mexico City // *2008*, Beauty Knows No Pain, solo show, Galeria Sin Sitio, Madrid // *2007*, Eat My Handbag, Puta!, solo show, Galerie Chappe, Paris

SELECTED PUBLICATIONS — *2011*, Illustration Now! Portraits, TASCHEN, Germany // *2010*, American Dream, Art Department Illustration Division, USA // *2010*, The Beautiful, Gestalten, Germany // *2009*, Illustration Now! 3, TASCHEN, Germany // *2008*, Reel, Art Department Illustration Division, USA

No More Make-Up, 2010
Personal work, pencil,
pastel and watercolor
on paper

Happy Birthday Mr.
Ambassador, 2008
Personal work, pencil and
gold paint on paper

Last Tango in Paris, 2008
Art Department, pencil
and watercolor on paper

What is the difference between illustration and fine art? Don't even go there. Especially in Gildo Medina's case, where his installations and drawings blur the line into invisibility. As it says on his website, "an artistic trajectory of influence" permeates his work. "From his origins in pencil and a profound relationship with realism, he masters the art of transformation while maintaining a watermark signature." Medina came to illustration from an international background of cultural and academic diversity: "Mexico the surreal underlay, Florence the traditional techniques, Paris the sophistication, Berlin the vision, Hong Kong the complexity, New York the energy."

Wo liegt der Unterschied zwischen Illustration und Kunst? Versuchen Sie es gar nicht erst. Ganz besonders im Fall von Gildo Medina, dessen Installationen und Zeichnungen die feine Trennlinie ins Unkenntliche verschwinden lassen. Wie es auf seiner Webseite heißt, durchdringt „eine Trajektorie künstlerischer Einflüsse" sein Werk. „Von seinen Anfängen aus der Bleistiftzeichnung her und in einer tiefen Beziehung zum Realismus meistert er die Kunst der Umwandlung und bewahrt doch immer, wie ein Wasserzeichen, seine Eigenart." Kulturelle und akademische Vielfalt bilden den internationalen Hintergrund, von dem aus Medina zur Illustration kam: „Mexiko lieferte mir die surreale Grundlage, Florenz die traditionellen Techniken, Paris die Verfeinerung, Berlin die Vision, Hongkong die Komplexität, New York die Energie."

Quelle est la différence entre l'illustration et les beaux-arts ? N'essayez même pas de chercher. Particulièrement dans le cas de Gildo Medina, dont les installations et les dessins brouillent la limite jusqu'à la faire disparaître. Comme on peut le lire sur son site web, « une trajectoire artistique d'influence » imprègne son œuvre. « Il a débuté au crayon et entretient une relation profonde avec le réalisme, et maîtrise l'art de la transformation tout en conservant une identité caractéristique en filigrane. » Medina est arrivé à l'illustration en partant d'un environnement international de diversité culturelle et académique : « Mexico pour les renforts surréels, Florence pour les techniques traditionnelles, Paris pour la sophistication, Berlin pour la vision, Hong Kong pour la complexité, New York pour l'énergie ».

I'm Still Alive, 2009
Personal work, pencil and
watercolor on paper

Chair Electro-
ambassadeur, 2011
Personal work, acrylic and
ballpoint pen on Louis XV
chair (c. 19th century),
leather and silver leaf

Sergio Membrillas

1982 born in Valencia
Lives and works in Valencia
www.sergiomembrillas.com

"I would define my work as a mixture
of retro and naïve languages combining
in the pursuit of tenderness."

Old Man in the
Woods, 2011
Personal work, digital

The muted airbrushed colors in the work of Sergio Membrillas recall the art moderne style (related to art deco) of 1930s Spain, around the time of the civil war. Membrillas does this retro style so well, and has succeeded in reinventing it and making it his own. Some of his illustrations might seem more entrenched in the past than others, but as a whole the work has a very distinct signature. He credits his style to the influence of the great Saul Bass, along with Miroslav Sasek and his series of *This Is…* travel titles, and the Human Empire studio. He plans to continue with work on a children's coloring book as well as other illustrative projects.

Die gedämpften Airbrush-Farben im Werk von Sergio Membrillas erinnern an den Arte-moderne-Stil im Spanien der 1930er-Jahre, um die Zeit des Bürgerkriegs, der dem Art déco verwandt ist. Membrillas beherrscht diesen Retro-Stil so gut, dass es ihm gelungen ist, ihn neu zu erfinden und zu seinem eigenen zu machen. Manche seiner Arbeiten scheinen vielleicht von der Vergangenheit befangener als andere, aber im Ganzen besitzt sein Werk eine durchaus eigene Note. Er selbst führt seinen Stil auf den Einfluss des großen Saul Bass zurück, daneben auf Miroslav Saseks Illustrationen für die Reiseführerreihe *This Is…* und auf das Human Empire Studio. Derzeit plant er ein Malbuch für Kinder und weitere Illustrationsprojekte.

The Young Pianist, 2011
Personal work, digital

Economy Investments and
Sources of Money, 2012
Süddeutsche Zeitung,
newspaper article,
mixed media

Les couleurs sourdes et diffuses de Sergio Membrillas évoquent le style arte moderne (cousin de l'Art déco) des années 1930 en Espagne, à l'époque de la Guerre civile. Le talent qu'il possède pour ce style lui a permis de le réinventer et de se l'approprier. Certaines de ses illustrations peuvent sembler plus ancrées dans le passé que d'autres, mais dans l'ensemble son travail a une personnalité très caractéristique. Il attribue son style à l'influence du grand Saul Bass, ainsi qu'à Miroslav Sasek et à sa série de carnets de voyage *This Is…*, et au studio Human Empire. Entre autres projets professionnels d'illustration, il a l'intention de travailler sur un livre de coloriage pour enfants.

SELECTED PUBLICATIONS — 2012, Behind Illustrations, Index Books, Spain // 2012, Etapes, Spain // 2011, Illustration Now! 4, TASCHEN, Germany // 2011, Picnic, Promopress, Spain

Log Cabin, 2012
Smith Journal, mixed
media

Hide & Seek 1 and 2,
2012
Human Empire studio,
poster, mixed media

Christian Montenegro

1972 born in Buenos Aires
Lives and works in Villa Sarmiento, Argentina
www.christianmontenegro.com.ar

"An attempt to fuse personal
and commercial work into one."

Calaca, 2011
Museo Nacional de
Culturas Populares,
exhibition, Art Direction:
Jorge Alderete and Vértigo
Galería, digital

The tribal and religious iconography in Christian Montenegro's illustrations can be stunningly haunting, while his employment of decorative conceits (in his less haunting work) in a representational manner results in *tours de force* which are the envy of any illustrator. Montenegro earlier taught morphology in the department of Graphic Design at the University of Buenos Aires, which can be discerned in, among others, his illustrations for some of the more powerful tales from the Bible. As Dutch Uncle agency noted: "While Montenegro's illustrations and designs have a lot in common with the emotions of Expressionism and the texture of woodblock prints, they also impress with their unique and distinctly contemporary feel."

Christian Montenegros religiös und von Stammestraditionen geprägte Ikonografie kann eine überwältigende Eindringlichkeit entwickeln, während seine Verwendung dekorativer Konzepte figürlicher Art (in den weniger eindringlichen Arbeiten) auf eine Tour de force hinausläuft, die jeder Illustrator bewundert. Montenegro unterrichtete früher Morphologie in der Abteilung Grafikdesign der Universität Buenos Aires, was sich unter anderem in seinen Illustrationen jener biblischen Geschichten eher kraftvoller Natur niederschlägt. Wie die Agentur Dutch Uncle festhielt: „Während Montenegros Illustrationen und Designs viel mit dem emotionalen Ausdruck des Expressionismus und der Textur von Holzschnitten zu tun haben, beeindrucken sie doch mit ihrer einzigartigen und ausgesprochen zeitgenössischen Griffigkeit."

L'iconographie tribale et religieuse des illustrations de Christian Montenegro peut se révéler étonnamment envoûtante, et son emploi des techniques décoratives (dans ses œuvres moins envoûtantes) d'une façon figurative a pour résultat des tours de force que tout illustrateur pourrait lui envier. Montenegro a enseigné la morphologie au département de graphisme de l'Université de Buenos Aires, ce que trahissent par exemple ses illustrations pour quelques-unes des histoires les plus frappantes de la Bible. Comme l'agence Dutch Uncle l'a remarqué : « Les illustrations et dessins de Montenegro ont beaucoup en commun avec les émotions de l'expressionnisme et la texture des gravures sur bois, mais elles impressionnent également par leur esthétique originale et très contemporaine. »

SELECTED EXHIBITIONS — *2009*, 7 Deadly Sins, solo show, Johanssen Gallery, Berlin // *2008*, Illustrative 08, group show, Illustrative International Art Festival, Zurich // *2008*, When The Cows Fly, Off/Yes, Bologna Children's Book Fair, Bologna // *2006*, Christian Montenegro, solo show, Maxalot Gallery, Barcelona // *2006*, Montenegro-Turdera, group show, Centro Cultural Recoleta, Buenos Aires

SELECTED PUBLICATIONS — *2012*, Little Big Books, Gestalten, Germany // *2007*, Illustration Now! 2, TASCHEN, Germany // *2005*, Illusive, Gestalten, Germany // *2004*, The Creation, Gestalten, Germany // *2003*, Pictoplasma 2, Gestalten, Germany

Gallery Puzzle Oriental
Palace from Djeco, 2012
Djeco, puzzle, digital

↖ Red Panda and Malayan Sun Bear, 2012
Wellington Zoo, advertising campaign, Agency: Saatchi & Saatchi, Art Direction: Mariona Wesselo-Comas, Writer: JP Twaalfhoven, digital

← First Sorrow, 2011
Pehuén Editores, book, Author: Franz Kafka, digital

Hawking's Flexiverse, 2006
New Scientist magazine, digital

Gabriel Moreno

1973 born in Baena, Spain
Lives and works in Madrid
www.gabrielmoreno.com

"Everything influences my work,
I would say people and relations have a lot to do with it,
but more important is sensuality."

Carolina, 2012
Personal work, etching

Joe Morse

1960 born in Windsor, Canada
Lives and works in Toronto
www.joemorse.com

"My work flows from drawing and
the expressive collision of pigment and solvent.
In a gas mask and chemical gloves
I work with materials that form images
and inform my ideas."

Working Class Boy
to Man U, portrait of
David Beckham, 2007
Los Angeles Times, oil
and acrylic on paper

There is not just one Joe Morse, the illustrator we have here, but at least two: there is the conventional vignette artist, whose portraits of athletes, musicians and politicians are, in fact, anything but conventional, albeit carefully drawn and dramatically composed; then there is the anarchic storyteller whose sketchier journal pages belie the deliberate precision of this other Morse. The amalgam of these two illustrators studied Fine Arts at Ontario College of Art, and there found his métier in printmaking, even if most of the materials he worked with "were quite lethal." Nowadays, his powerful graphic images are still made with similar dangerous materials like solvents, oil and acrylic mix.

Es gibt nicht nur einen Joe Morse, den Illustrator, wie wir ihn hier vor uns haben, sondern mindestens zwei: Da ist der konventionelle Künstler, dessen Porträts von Sportlern, Musikern und Politikern eigentlich alles andere als konventionell sind, wenn auch sorgfältig gezeichnet und effektvoll komponiert; dann gibt es den anarchischen Geschichtenerzähler, dessen eher hingeworfene Blätter die absichtsvolle Genauigkeit jenes anderen Morse Lügen strafen. Das Amalgam dieser beiden studierte Kunst am Ontario College of Art und fand dort in der Drucktechnik seine Zukunft, wenn er auch mit Substanzen arbeitete, die „ziemlich töd-lich" waren. Auch heute noch stellt er seine ausdrucksstarken grafischen Bilder mit ähnlich gefährlichen Materialien her wie Lösungsmitteln, Öl und Acrylmischungen.

Il n'y a pas un seul Joe Morse, l'illustrateur que nous avons ici, mais au moins deux : il y a l'artiste de portrait classique, qui croque les athlètes, musiciens et personnalités politiques de façon tout sauf classique, quoique le trait soit soigné et la composition spectaculaire ; et puis il y a le conteur anarchique dont certaines pages de carnet démentent la précision délibérée de l'autre Morse. L'amalgame de ces deux illustrateurs a étudié les beaux-arts à l'Ontario College of Art, où il a trouvé sa vocation dans la gravure, même si la majorité des matériaux avec lesquels il a travaillé « étaient d'une toxicité relativement mortelle ». Aujourd'hui, ses images d'un graphisme puissant sont toujours fabriquées à l'aide de substances dangereuses, solvants, peintures à l'huile et mélanges à l'acrylique.

A Life of Reinvention, 2011
The Washington Post, book
review, Art Direction:
Christopher Meighan, oil,
acrylic and digital

Billy Cobham, 2009
Cut to the Drummer,
exhibition and drumming
event, oil, acrylic and
digital

Hoop Genius, 2013
Lerner Books, John Coy,
picture book, Art Direction:
Zach Marell, watercolor
and digital

SELECTED EXHIBITIONS — *2012, Fall Classic, group show, Smash Gallery, Toronto // **2011**, Rolling Stone: Art of the Record Review, group show, Museum of American Illustration, New York // **2009**, The Illustrated Book, group show, National Gallery of Canada, Ottawa // **2009**, Paint for Print: Contemporary Illustration, group show, C Gallery, Columbia College, Chicago // **2007**, Original Art Show: Children's Books Art, group show, Museum of American Illustration, New York*

SELECTED PUBLICATIONS — *2015, Beloved, The Folio Society, UK // **2012**, Commarts.com Insights Column, Communication Arts, USA // **2012**, 200 Best Illustrators Worldwide, Lürzer's Archive, Austria // **2011**, Illustration Now! Portraits, TASCHEN, Germany // **2007**, Drawing Power/News Front, The Windsor Star, Canada // **2001**, iM/ Identity Matters, Het Dozijn Uitgeefprojekten, The Netherlands*

In One Person, 2012
Los Angeles Times,
book review, watercolor
and digital

Ego Trippin, portrait
of Snoop Dogg, 2008
Rolling Stone magazine,
album review, oil and
acrylic on paper

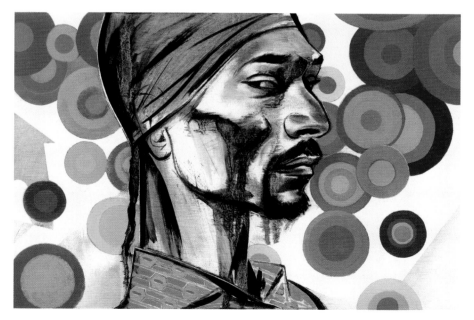

Barbara Nessim

1939 born in New York
Lives and works in New York
www.barbaranessim.com

"Releasing my creative potential
is about relaxing my conscious thought process,
paying attention to my peripheral vision,
and taking action."

Untitled, 2012
Personal work, collage,
pen, ink and watercolor

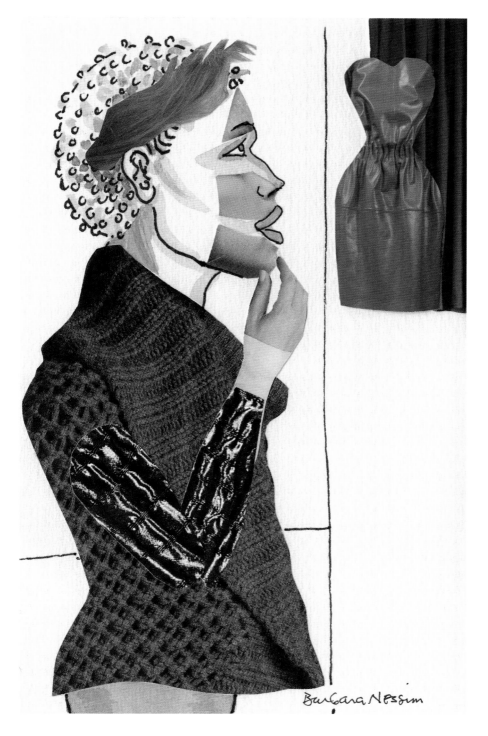

Barbara Nessim

SELECTED EXHIBITIONS — *2013, Barbara Nessim: An Artful Life, solo show, Victoria and Albert Museum, London // 2009, The Model Project, solo show, DFN Gallery, New York // 2004, Women in Illustration: Contemporary Visions & Voice, group show, Norman Rockwell Museum, Stockbridge // 2003, Black Truths/White Lies, solo show, Bitforms Gallery, New York // 1991, Random Access Memories, solo show, Rempire Fine Art and Gallery, New York*

SELECTED PUBLICATIONS — *2013, The Guardian newspaper, UK // 2012, Communication Arts magazine, USA // 2011, Illustration Voice magazine, USA // 1987, Innovators of American Illustration, Watson-Guptill, USA // 1984, Frankfurter Allgemeine Zeitung newspaper, Germany*

In the 1960s Barbara Nessim was one of the pioneers of conceptual editorial illustration, and among her distinctions was her successful entry into what was in effect an illustrators men's club. Nessim's metaphorical ideas and ethereal style hit the right chords during a period when art, design and illustration were in a state of redefinition and flux. "This may be hard to believe," she recalled, "but I had no idea there were so few women working as illustrators." In fact, as a freelance illustrator she was working on her own in a kind of vacuum. "I never thought that being a woman would be a hindrance."

In den 1960er-Jahren gehörte Barbara Nessim zu den Vorreiterinnen der konzeptuellen Illustration, und neben anderem war es ihr Verdienst, in eine Szene einzubrechen, die praktisch ausschließlich von männlichen Kollegen beherrscht war. Nessims metaphorische Einfälle und ihr ätherischer Stil trafen den Ton einer Zeit, zu der Kunst, Design und Illustration sich in einer Phase der Neudefinition und des Übergangs befanden. „Es ist vielleicht schwer zu glauben", erinnert sie sich, „aber ich hatte keine Ahnung, dass es so wenige Frauen gab, die illustrierten." Tatsächlich arbeitete sie freiberuflich ganz auf sich gestellt in einer Art Vakuum. „Ich glaubte nie, es wäre hinderlich, eine Frau zu sein."

Dans les années 1960, Barbara Nessim a été l'une des pionnières de l'illustration de presse conceptuelle, et entre autres distinctions on peut citer son entrée dans ce qui était de fait un club d'illustrateurs exclusivement masculin. Les métaphores de Nessim et son style éthéré ont fait mouche à une époque où l'art, le design et l'illustration étaient dans un état de redéfinition et de fluctuation. « C'est peut-être difficile à croire, se souvient-elle, mais je ne savais pas qu'il y avait si peu de femmes qui travaillaient dans l'illustration. » De fait, en tant qu'illustratrice freelance, elle travaillait toute seule dans une espèce de bulle. « Je n'ai jamais pensé qu'être une femme pouvait être un obstacle. »

Curious Secret, residential building lobby, 2004
Costas Kondylis Architects, commissioned by Philip Koether, Art Direction: Zach Marell, archival pigment applied on canvas digitally

Personal Number, residential building lobby, 2006
Perkins Eastman Architects, commissioned by Philip Koether, archival pigment applied on canvas digitally

Certain art directors, such as Henry Wolf at *Harper's Bazaar*, Robert Benton at *Esquire* and Stan Mack at the *New York Herald Tribune*'s magazine, appreciated Nessim's uniqueness and felt willing to take the chance. This period around the early 1970s was when her self-confidence really emerged. In the early '80s she was among the first to use digital media for making art—another pioneering feat—and today makes creative use of both analog and digital. A retrospective exhibition at the Victoria and Albert Museum in London in 2013, with the publication of her first monograph in conjunction with the show, fully endorses the stature she has earned through talent and hard work.

Eine Reihe von Artdirectors wie Henry Wolf von *Harper's Bazaar*, Robert Benton von *Esquire* oder Stan Mack vom Magazin des *New York Herald Tribune* erkannten Nessims Einzigartigkeit und waren bereit, es mit ihr zu versuchen. Zu dieser Zeit, Anfang der 1970er-Jahre, entwickelte sie echtes Selbstbewusstsein. In den frühen 80ern gehörte sie zu den Ersten, die digitale Medien in der Kunst einsetzten – eine weitere Vorreiterrolle –, und heute arbeitet sie gleichermaßen analog und digital. Eine Retrospektive im Londoner Victoria and Albert Museum 2013 und die damit verbundene Publikation einer ersten Monografie unterstreichen nachdrücklich den Rang, den sie sich durch Talent und harte Arbeit erobert hat.

Certains directeurs artistiques, comme Henry Wolf de *Harper's Bazaar*, Robert Benton d'*Esquire* et Stan Mack du magazine du *New York Herald Tribune* ont apprécié la personnalité unique de Nessim et lui ont fait confiance. C'est à cette époque, au début des années 1970, que sa confiance en elle s'est vraiment consolidée. Au début des années 1980, elle a été l'une des premières à utiliser des techniques numériques pour faire de l'art, et aujourd'hui elle utilise l'analogique et le numérique avec une grande créativité. Une rétrospective au Victoria and Albert Museum de Londres en 2013, assortie de la publication de sa première monographie, témoigne de l'envergure qu'elle a acquise grâce à son talent et son travail.

In Her Boudoir
Series, 2012
Personal work, collage,
pen, ink and watercolor

Far Away Places, 2012
Personal work, collage,
pen, ink and watercolor

A Current Past, 2010
Personal work, digital
and collage, printed
on aluminum

Christoph Niemann

1970 born in Waiblingen, Germany
Lives and works in Berlin
www.christophniemann.com

"Probably because of my education as
a graphic designer, my approach to illustration
focuses more on problem solving than
on artistic expression *per se*."

American Illustration, 2001
Digital

Christoph Niemann transcends the clichés of editorial illustration since he is uncannily prodigious in transforming the commonplace into the extraordinary by routinely coming up with the "aha" idea that so clearly summarizes a story. Niemann's economical linear (or instruction-manual) approach is fairly popular these days, but he doesn't simply mimic this dominant style, incorporating it instead into a wider ability to make unusual concepts come keenly alive. He uses minimalism as a styleless style, and even his more narrative images, where a sequential story unfolds, are brilliantly concise—indeed, his drawing is so boldly simple that each image is a veritable logo for the idea being conceptualized.

Christoph Niemann überschreitet jedes Klischee der Illustration. Er besitzt ein geradezu unheimliches Talent, aus dem Allgemeinplatz etwas Außergewöhnliches zu machen, indem er eine Geschichte immer wieder so auf den Punkt bringt, dass sie Aha-Erlebnisse auslöst. Niemanns sparsamer Strich, der an eine Bedienungsanleitung erinnert, ist heutzutage sehr beliebt, aber anstatt diesen vorherrschenden Stil einfach nur zu imitieren, nutzt er ihn, um ungewöhnliche Konzepte lebendig werden zu lassen. Minimalismus ist bei ihm stilloser Stil, und selbst seine eher narrativen Bilder, die eine Geschichte in Fortsetzung erzählen, sind außerordentlich prägnant – in seiner stark vereinfachten Art wird jedes Einzelbild zu einem wahren Logo, das die Idee repräsentiert.

Christoph Niemann transcende les clichés de l'illustration de presse, car il possède un talent prodigieux pour transformer le banal en extraordinaire. Il trouve toujours une idée de génie qui résume l'histoire avec une limpidité sans pareil. Sa démarche linéaire économe (qui pourrait évoquer un manuel d'instructions) est relativement populaire en ce moment, mais il ne se contente pas d'imiter ce style dominant, il l'incorpore plutôt à une capacité plus large consistant à insuffler de la vie aux concepts inhabituels. Chez lui, le minimalisme est un style dénué de style, et même ses images les plus narratives, où il déroule une séquence pour raconter une histoire, sont brillamment concises – de fait, son dessin est d'une telle simplicité que chaque image est un véritable logo de l'idée conceptualisée.

Frauen reden sich um Kopf und Kragen, 2004
Men's Health magazine, Germany, Art Direction: Andreas Schomberg, digital

I Lego N.Y., 2009
The New York Times, mixed media

SELECTED EXHIBITIONS — *2016*, Unterm Strich, solo show, Hamburger Museum für Kunst und Gewerbe, Hamburg // *2011*, It's about Time, group show, Broodwork, Ben Maltz Gallery, New York // *2010*, Hall of Fame Laureates, group show, Art Directors Club, New York // *2007*, Hansel and Gretel, New Yorker magazine Artists, group show, Arnold & Marie Schwartz Gallery Met, New York // *2005*, 1000 Spots, solo show, The New York Times, New York // *2003*, National Design Triennial: Inside Design Now, group show, Smithsonian Cooper-Hewitt, National Design Museum, New York

SELECTED PUBLICATIONS — *2016*, Words, Greenwillow Books, USA // *2011*, Abstract City, Abrams, USA // *2011*, That's How, HarperCollins, USA // *2010*, Subway, HarperCollins, USA // *2008*, The Pet Dragon, HarperCollins, USA // *2005*, 100% Evil, Princeton Architectural Press, USA

Master of the
Universe – Dart, 2009
The New York Times,
mixed media

Hand mit Karten, 2005
100% Evil, Princeton
Architectural Press, book,
mixed media

Niemann would not be capable of conceiving viable ideas at the rate he does if he were insulated from the world, and so it is that he keeps politically aware. At the same time, he's always searching for the Holy Grail of ideas. While he employs a range of styles in his work, his pared-down approach takes less time to render an image. With computer-generated clarity his work presents a refreshing wit and humor in vivid colors, and a decade back he was the quintessential New York illustrator, fully adopting the city's artistic attitudes and aesthetics. Despite a change of residence, Niemann is still today a "destination" for art directors and editors.

Niemann gelingt es, in rascher Folge neue, brauchbare Ideen zu entwickeln, weil er nicht isoliert von der Welt lebt, sondern ein waches politisches Bewusstsein besitzt. Zugleich ist er auch ständig auf der Suche nach dem heiligen Gral der Ideen. Die Vielfalt unterschiedlicher Stile in seinem Werk hindert ihn nicht daran, mit seinem reduktionistischen Ansatz ein Bild in relativ kurzer Zeit zu produzieren. Die Illustrationen, die er am Computer entwirft, zeichnen sich durch Klarheit sowie erfrischenden Witz und Humor in lebhaften Farben aus. Vor einem Jahrzehnt war er der Inbegriff des New Yorker Illustrators, der wie kein anderer die künstlerische Haltung und Ästhetik der Stadt zum Ausdruck brachte. Auch wenn er inzwischen umgezogen ist, gilt Niemann doch immer noch als Richtlinie für Artdirectors und Redakteure.

Niemann ne serait pas capable de concevoir autant d'idées viables s'il était isolé du monde, et il se tient au courant de la politique. Dans le même temps, il est toujours à la recherche du Saint Graal des idées. Il utilise différents styles dans son travail, mais sa démarche dépouillée accélère la production de l'image. Avec une netteté qui vient du traitement informatique, son travail affiche un humour vivifiant et des couleurs toniques, et, il y a une dizaine d'années, il était l'illustrateur new-yorkais par excellence, complètement en phase avec les attitudes artistiques et l'esthétique de la ville. Bien qu'il ait aujourd'hui déménagé, Niemann reste un incontournable pour les directeurs artistiques et les rédacteurs en chef.

Ich hab's gleich, 2012
ZEITmagazin, mixed media

Brooklyn Bridge, 2012
Abstract City, back cover,
mixed media

Christopher O'Leary

1966 born in Youngstown
Lives and works in Columbus
www.olearyillustration.com

"I try to create
simple images that intimate
the beginnings of a story."

Man & Dog, 2011
The Bark magazine,
watercolor and pastel

A blend of classic painting with a humorous twist is the essence of Chris O'Leary's storybook tableaux. Everything in O'Leary's portfolio was originally triggered by a few choice words, yet his pictures embody the proverbial 1,000. He began working as a freelance illustrator after a brief stint at a greeting-card company, and today says, "There's nothing I enjoy more than beginning work on a new assignment. I'm fascinated by the creative process and watching ideas emerge and take shape. I enjoy taking the constraints that any assignment brings and finding a solution that will push me creatively and intellectually. And then, with a new assignment, beginning all over again."

Eine Mischung aus klassischer Malerei, gewürzt mit einem Schuss Humor, das zeichnet Chris O'Learys Buchillustrationen aus. Am Anfang seiner künstlerischen Laufbahn standen ein paar wenige ausgewählte Wörter, aber seine Bilder verkörpern die buchstäblichen 1000. Nach einem kurzen Job bei einem Grußkartenverlag begann er als freiberuflicher Illustrator zu arbeiten, und heute sagt O'Leary: „Es gibt nichts, was mir größere Freude macht, als mit der Arbeit an einem neuen Auftrag zu beginnen. Mich fasziniert der Schaffensprozess als solcher, wenn ich sehe, wie Ideen entstehen und allmählich Gestalt annehmen. Die Zwänge, die jeder Auftrag mit sich bringt, nehme ich gerne auf mich, denn es macht mir Spaß, eine Lösung zu finden, die mich kreativ und intellektuell voranbringt. Und dann, mit einem neuen Auftrag, beginnt wieder alles von vorn."

Untitled, 2012
Personal work, watercolor
and gouache

Dog, 2011
The Bark magazine,
watercolor, gouache
and pastel

Un mélange de peinture classique et d'humour, voilà l'essence des compositions de Chris O'Leary, qui semblent sorties d'un livre d'histoires. Tout ce que contient son portfolio a été déclenché à l'origine par une poignée de mots choisis, et pourtant ses images en valent bien 1000. Il a commencé sa carrière comme illustrateur freelance après une brève incursion dans une société de cartes de vœux, et aujourd'hui il déclare : « Il n'y a rien que j'aime davantage que de commencer à travailler sur une nouvelle commande. Je suis fasciné par le processus de création et j'adore voir les idées émerger et prendre forme. J'aime trouver dans la limite des contraintes imposées une solution qui me stimule sur le plan créatif et intellectuel. Et ensuite, je recommence à zéro avec une autre commande. »

Untitled, 1998
Personal work, oil

Mr. Vertigo, 1994
Playboy magazine, oil

Thurber & Dog, 2012
Promotional bookmark,
watercolor, gouache and
pastel

Needled to Death, 2006
Penguin Putnam
Publishing, acrylic

Dan Page

1970 born in Toronto
Lives and works in Cambridge, Canada
www.danpage.net

"I love everything about illustration: always dealing with different subject matter on a daily basis, thinking of the ideas, bringing them to life in full color, fueled by the adrenaline rush of a deadline."

In Pursuit of Doped
Excellence, 2004
The New York Times
Magazine, Art Direction:
Nancy Harris, mixed
media and digital

Flatness is a means of creating a certain kind of drama, and it is this perspective and dynamic idea which Dan Page's work sets before us. Here, image and concept are inseparable, yet not in any heavy-handed manner: simplicity reigns. Page has been an illustrator for over 20 years and still recalls having studied with Jerzy Kolacz, a "conceptual illustrator" from Poland who spoke only a little English. "This was a major revelation to me, communicating with images or pictures that had opinions and clever ideas." Even so, balancing business with aesthetics is Page's goal, and he seeks to stay current, challenging himself, not settling for less or creative stagnation.

Planheit ist ein Mittel, um eine bestimmte Art von Dramatik zu erzeugen, und genau diese Perspektive und dynamische Idee haben wir in Dan Pages Werk vor uns. Bild und Konzept sind untrennbar miteinander verbunden, aber keineswegs auf plumpe Weise: Schlichtheit ist das vorherrschende Merkmal. Page, der seit über 20 Jahren als Illustrator arbeitet, studierte bei Jerzy Kolacz, einem „konzeptuellen Illustrator" aus Polen, der kaum Englisch sprach. „Mithlfe von Bildern Meinungen und kluge Ideen zu kommunizieren – das war für mich eine wesentliche Offenbarung." Dennoch versucht Page ein Gleichgewicht zwischen Geschäft und Ästhetik herzustellen. Sein Anspruch an sich selbst ist, aktuell zu bleiben, sich nicht mit weniger zu begnügen oder in kreativer Hinsicht zu stagnieren.

Pedestrian Death, 2010
Vancouver magazine, Art
Direction: Randy Watson,
hand-drawn and digital

Political Compromise,
2012
Harvard magazine, mixed
media and digital

Emerging Markets, 2011
The McKinsey Quarterly
magazine, Art Direction:
Delilah Zak, hand-drawn
and digital

L'absence de volume est une façon de créer un genre de théâtralité, et c'est cette perspective et cette idée dynamique que le travail de Dan Page nous propose. Ici, image et concept sont inséparables, mais sans lourdeur : la simplicité règne. Page est illustrateur depuis plus de 20 ans, et il se souvient encore d'avoir étudié avec Jerzy Kolacz, un « illustrateur conceptuel » polonais qui ne parlait que très peu d'anglais. « Cela a été une grande révélation pour moi, de communiquer avec des images qui exprimaient des opinions et des idées intelligentes. » L'objectif actuel de Page est de trouver un équilibre entre esthétique et commercial, et il cherche à rester en phase avec son époque, à se lancer des défis, et à éviter l'autosatisfaction ou la stagnation créative.

Mobile Security, 2012
Time magazine, Art
Direction: Nailee Lum,
hand-drawing and digital

How the Future Will
Judge Us, 2010
The Washington Post,
Art Direction: Kristin Lenz,
hand-drawn and digital

Roberto Parada

1969 born in Passaic
Lives and works in Arlington
www.robertoparada.com

"I bring a painterly approach
to my portraits and I'm always seeking to
capture the essence of the subject
in their likeness."

Adele, 2011
Entertainment Weekly
magazine, oil on linen

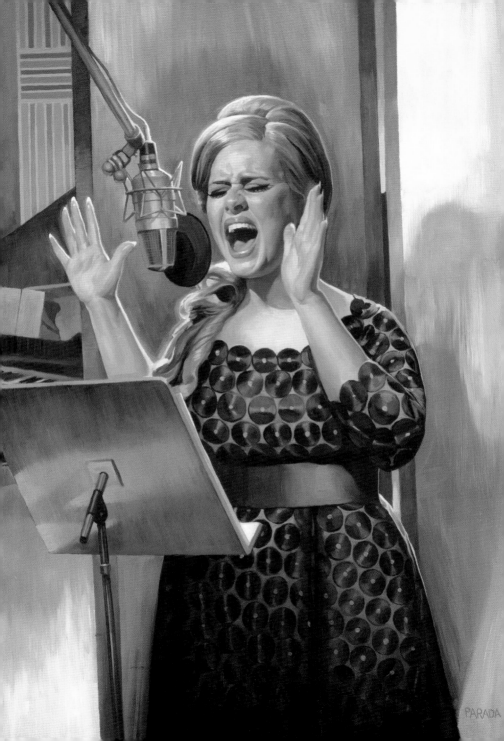

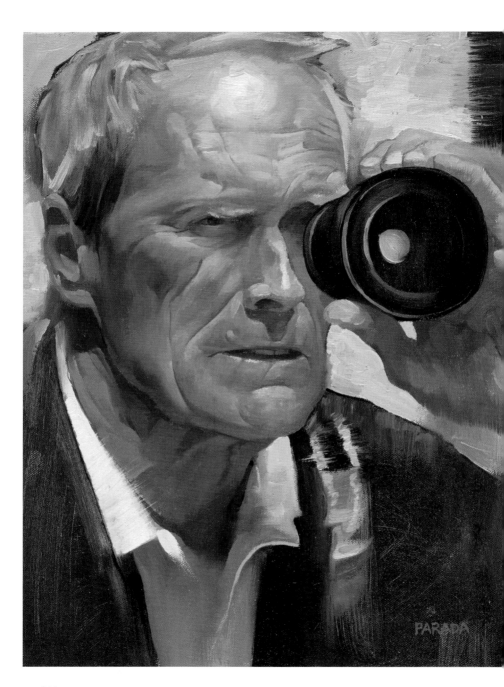

In September 2004, Roberto Parada underwent lengthy surgery for a bone marrow transplant in a bid to cure him of severe aplastic anemia (a bone marrow failure which is always fatal). The condition had come about as a result of certain tools Parada had been using in his work, and being then only in his mid-30s, this life-saving operation had a profound impact on his art in many ways. "My life in illustration now is dedicated to bringing about a greater conscious understanding of the dangers that exist in some of the materials we work with and still be able to create great artwork."

Im September 2004 unterzog sich Roberto Parada einer langwierigen Stammzell-transplantation, da er an aplastischer Anämie litt (einem gravierenden Knochenmarkver-sagen mit fast immer tödlichem Ausgang). Hervorgerufen worden war die Krankheit durch bestimmte Arbeitsmittel, die Parada verwendet hatte, und da er damals erst Mitte dreißig war, wirkte sich dieser lebensrettende Eingriff nachhaltig und in vielfältiger Weise auf sein weiteres Werk aus. „Mein Leben als Illustrator ist heute ganz darauf gerichtet, das Bewusstsein für die Gefährlichkeit mancher unserer Arbeitsmaterialien zu schärfen, mit denen wir immerhin große Kunst schaffen."

En septembre 2004, Roberto Parada a subi une longue intervention chirurgicale pour une greffe de moelle osseuse, une tentative pour le guérir d'une grave anémie aplasique (une affection de la moelle osseuse qui est toujours fatale). Sa maladie avait été causée par certains outils que Parada avait utilisés dans son travail. Il n'était alors qu'au milieu de la trentaine, et cette opération qui l'a sauvé a également eu un profond impact sur son œuvre, à plus d'un égard. « Aujourd'hui, je consacre ma vie dans l'illustration à sensibiliser sur les dangers de certains des matériaux avec lesquels nous travaillons, tout en continuant à créer de belles illustrations. »

Time's 100 Most
Influential People 2005,
portrait of Clint Eastwood,
2005
Time magazine, oil on linen

The Night Steve Jobs Met
Andy Warhol, 2012
Playboy magazine, Author:
David Sheff, oil on linen

Parada's illustration is not entirely produced to promote this better understanding, though his practice has altered in this respect since art materials, "especially the toxic variety, need to be approached with the utmost caution and safety," he warns. Today he works in oils, but now everything in his studio is non-toxic. With this new chance at life, portraits and caricatures pour out, including magazine covers for *Rolling Stone* (Eminem), or *Time*, where his bloody cross on the face of Saddam Hussein recalled the same magazine's use of this device, going back to Hitler's face in 1945 following his death.

Parada produziert seine Illustrationen nicht allein, um dieses bessere Verständnis zu fördern, allerdings hat sich seine Praxis in dieser Hinsicht geändert, denn mit Kunstmaterialien, so warnt er, „vor allem mit solchen toxischer Art, muss man äußerst vorsichtig und behutsam umgehen". Heute arbeitet er in Öl und umgibt sich in seinem Atelier ausschließlich mit ungiftigen Substanzen. Seit seiner „Wiedergeburt" ist er sehr produktiv: Porträts und Karikaturen erschienen unter anderem auf Titelblättern von Magazinen wie *Rolling Stone* (Eminem) oder *Time*, wo sein blutrotes Kreuz über dem Gesicht Saddam Husseins das Cover-Motiv der Zeitschrift aus dem Jahr 1945 zitierte, das nach dessen Tod Hitlers Gesicht darstellte.

Les illustrations de Parada ne sont pas créées uniquement dans ce but de sensibilisation, mais il a changé ses habitudes car les fournitures artistiques, « particulièrement celles qui sont toxiques, doivent être manipulées avec la plus grande précaution et dans un respect total de la sécurité », met-il en garde. Aujourd'hui, il travaille avec de la peinture à l'huile, mais maintenant tout dans son studio est non toxique. Avec cette nouvelle vie qui lui a été offerte, il ne cesse de produire des portraits et des caricatures, notamment des couvertures de magazine pour *Rolling Stone* (Eminem) ou *Time*, où la croix sanglante qu'il a plaquée sur le visage de Saddam Hussein évoquait ce que le même magazine avait fait avec l'image d'Hitler après sa mort en 1945.

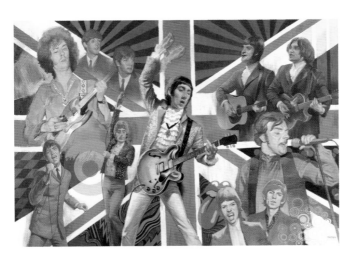

The British Invasion, 2012
Personal work, oil on linen

Obama Elect, 2012
Newsweek magazine/
The Daily Beast, cover, oil
on linen

C.F. Payne

1954 born in Cincinnati
Lives and works in Cincinnati
www.cfpayne.com

"Illustration is the art form
that tells a story."

Andrew Wyeth, 1998
Commissioned by Betsy
Wyeth, mixed media

There were two things C. F. (Chris) Payne loved to do as a kid—play baseball and drawing. "Considering the fact that I got one hit on a curve ball in my baseball life, I think it is safe to say focusing my energies on art was the wiser choice," he reckons. It wasn't until college that Payne entered the great debate about whether to practice illustration or fine art, with the outcome that in the end he found he had more in common with the illustrators. The decision resulted in a career creating his exquisite distorted portraits for every major magazine in the US.

Als Kind liebte C. F. (Chris) Payne zwei Dinge – Baseball und Zeichnen. „Angesichts der Tatsache, dass mir in meinem Baseballleben nur ein einziger Curveball gelungen ist, war es sicherlich die klügere Option, meine Energien auf die Kunst zu richten", lautet seine Bilanz. Erst auf dem College sah sich Payne mit der großen Frage konfrontiert, ob er Illustration oder Kunst machen solle, letzten Endes wurde ihm klar, dass ihn doch mehr mit den Illustratoren verband. Diese Entscheidung sollte sich als tragfähig erweisen, denn sie leitete eine Karriere ein, in deren Verlauf er seine exquisit verzerrten Porträts für alle größeren Zeitschriften in den USA anfertigte.

Il y a deux choses que C. F. (Chris) Payne aimait faire lorsqu'il était enfant : jouer au baseball et dessiner. « Si l'on tient compte du fait que j'ai réussi à toucher une balle courbe une seule fois dans ma vie, je pense qu'on peut dire que concentrer mon énergie sur l'art a été une sage décision », constate-t-il. Ce n'est qu'à l'université que Payne a dû choisir entre l'illustration et les beaux-arts, et il a fini par trouver qu'il avait plus en commun avec les illustrateurs. Cette décision a été le point de départ d'une carrière qu'il a passée à créer ses admirables portraits déformés pour tous les grands magazines des États-Unis.

The Aging Face of Germany, 2006
Der Spiegel magazine, mixed media

Love Notes, 2005
Reader's Digest magazine, back cover series, mixed media

524

Early in Payne's career he had a major insight: "There are two lines with illustrators looking for work," he said. "There are long lines and there are short lines. The long lines are looking for the annual report covers, the *Time* covers and all the similar, high-profile work. The short lines have lousy deadlines, lower paydays, but if you pick them wisely, these jobs have creative freedom." That aside, the hardest thing about being an illustrator, he continued, is proving to clients that "in illustration you can create your own individual look, make your own individual statement, communicate so directly to your audience and it is you that participates in the creative process."

Schon früh in seinem Schaffen gelangte Payne zu einer wichtigen Erkenntnis: „Für Illustratoren, die Arbeit suchen, gibt es zwei Alternativen", sagte er sich, „eine langfristige und eine kurzfristige. Entweder man setzt langfristig darauf, irgendwann mal den ganz großen Coup zu landen und das Titelblatt für den Jahresbericht einer Firma zu gestalten, das *Time*-Cover und all diese prestigeträchtigen Sachen. Oder man entscheidet sich kurzfristig für kleinere Jobs mit schlechterer Bezahlung, knapperen Terminen und so weiter. Aber wenn man die klug auswählt, hat man größere kreative Freiheiten." Abgesehen davon sei das Schwierigste am Beruf des Illustrators, die Erwartungen der Kunden zu befriedigen und ihnen klarzumachen, was alles möglich ist, nämlich dass man „der Illustration eine eigene individuelle Note verleihen und unmittelbar mit dem Publikum kommunizieren kann, sodass es das Gefühl bekommt, am kreativen Prozess teilzuhaben."

Tôt dans sa carrière, Payne a eu une grande révélation : « Il y a deux files d'attente pour les illustrateurs qui cherchent du travail. Les longues et les courtes. Les longues files d'attente sont pour les illustrateurs qui veulent faire la couverture du *Time* et ce genre de travail en vue et prisé. Les files d'attente courtes ont des délais impossibles et sont mal payées, mais si vous savez les choisir, ces projets vous laissent une grande liberté de création. » Ceci étant, le plus difficile dans l'illustration, selon lui, est de prouver aux clients que « dans l'illustration vous pouvez créer votre propre style, communiquer votre propre message directement au public, et que c'est vous qui participez au processus de création ».

SELECTED EXHIBITIONS — *2009*, Group show, Cincinnati Art Museum, Cincinnati // *2000*, Group show, Selby Gallery, Sarasota // *1999*, Group show, Norman Rockwell Museum, Stockbridge // *1998*, Group show, National Portrait Gallery, Washington, D.C. // *1995*, Hamilton King Award, group show, Society of Illustrators, Museum of American Illustration, New York

SELECTED PUBLICATIONS — *2012*, Totally MAD: 60 Years of Humor, Satire, Stupidity and Stupidity, Home Entertainment, USA // *2005*, The Art of Der Spiegel, teNeues, Germany // *2000*, Rolling Stone: The Illustrated Portraits, Chronicle Books, USA // *1998*, Face of Time: 75 Years of Time Magazine Cover Portraits, Bulfinch Press, USA // *1992*, The Savage Mirror, Watson-Guptill, USA

Joe Eszterhas's
Cleveland, 2012
Playboy magazine, oil,
acrylic, watercolor, colored
pencils and ink

World Choir Games,
Cincinnati, 2012
Vehr Communications,
poster, acrylic, watercolor,
colored pencils and ink

Jack Nicholson, 2004
Personal work, mixed
media

Hanoch Piven

1963 born in Montevideo
Lives and works in Tel Aviv and in Barcelona
www.pivenworld.com

"I like to think of my illustrations as puzzles that need to be solved within a certain amount of time."

Ellen DeGeneres, 2012
The Washington Post,
collage

Einstein, 2006
Time magazine, collage

The neurologist Oliver Sacks helped greatly in making people aware of visual agnosia, a brain dysfunction where those affected are literally unable to recognize the shapes of certain objects, as in the title of his famous book, *The Man Who Mistook His Wife For a Hat*. The exact opposite of this condition may be caricaturist Hanoch Piven's gift—he perceives things like microphones, tape reels, broccoli, bananas and matzos as perfectly human facial features, typically those of a recognizable public figure. While this keen ability to transform everyday objects into noses, mouths or eyes with distinct expressions and emotions might attract the attention of Dr. Sacks, Piven's collage-making skills are anything but neurologically impaired.

Over the past 20 years or so, his comical illustrations of politicians, dictators, entertainers and intellectuals have appeared in numerous American and European periodicals, including *Time*, *Rolling Stone*, *Newsweek*, *The Times* (UK) and Switzerland's *Die Weltwoche*. *Time* also featured Piven's *What Presidents Are Made Of* as one of its "10 Best Children's Books" for 2004. His work is held in the permanent collection of the Library of Congress, in the Prints and Photographs department, while his distinctive 3D image-making has been adopted in kindergartens in Israel to teach children different ways to make art.

Dem Neurologen Oliver Sacks ist maßgeblich das allgemeine Bewusstsein für visuelle Agnosie zu verdanken. Diese Funktionsstörung des Gehirns macht es unmöglich, Umrisse bestimmter Gegenstände zu erkennen, sodass es Betroffenen ergehen kann wie dem *Mann, der seine Frau mit einem Hut verwechselte* – so der Titel seines berühmten Buchs. Das Gegenteil dazu könnte die Gabe des Karikaturisten Hanoch Piven sein, der Dinge wie Mikrofone, Filmspulen, Brokkoli, Bananen oder Matzen als perfekte menschliche Gesichtszüge wahrnimmt, vor allem bei prominenten Persönlichkeiten. Seine Fähigkeit, alles in Nasen, Münder oder Augen mit typischen Zügen zu verwandeln, könnte Dr. Sacks interessiert haben, allerdings sind Pivens Collagen alles andere als neurologisch bedingte Krankheiten.

Seit gut 20 Jahren erscheinen seine komischen Illustrationen von Politikern, Diktatoren, Entertainern und Intellektuellen in zahlreichen amerikanischen und europäischen Medien, unter anderem in *Time, Rolling Stone, Newsweek, The Times* (GB) und der Schweizer *Weltwoche*. Pivens Titel *What Presidents Are Made Of* gehörte 2004 zur jährlichen Auswahl der „10 Best Children's Books" von *Time*. Sein Werk ist in der ständigen Sammlung der Abteilung Druckgrafik und Fotografie der Library of Congress vertreten, und in israelischen Kindergärten wird Pivens charakteristische 3D-Bildtechnik als Lehrmittel in der Kunsterziehung eingesetzt.

SELECTED EXHIBITIONS — 2012, Family Matters, solo show, Beth Hatefutsot, Tel Aviv // **2011**, Making Faces, solo show, The Czech Centre, Prague // **2010**, Making Faces, solo show, The Skirball Cultural Center, Los Angeles // **2008**, Hanoch Piven, solo show, Sixth and I Synagogue, Washington, D.C.

SELECTED PUBLICATIONS — 2012, El País – Paula, Uruguay // **2012**, InPrint magazine, USA // **2012**, La Vanguardia newspaper, Spain // **2011**, Haaretz newspaper, Israel

Stephen Hawking, 2006
Die Weltwoche magazine,
collage

Le neurologue Oliver Sacks a beaucoup contribué à informer le public sur l'agnosie visuelle, une dysfonction cérébrale qui empêche les personnes qui en sont atteintes de reconnaître la forme de certains objets, comme dans le titre de son célèbre livre, *L'Homme qui prenait sa femme pour un chapeau*. Le caricaturiste Hanoch Piven est atteint de la maladie inverse : il perçoit dans des objets tels que des micros, des bobines de film, des brocolis, des bananes ou du pain azyme des traits de visage tout à fait humains, et en général ceux de personnalités bien connues du public. Cette capacité à transformer des objets quotidiens en nez, bouches ou yeux transmettant des expressions ou des émotions pourrait attirer l'attention du Dr Sachs, mais les talents de Piven sont tout sauf une maladie neurologique.

Au cours des vingt dernières années, ses illustrations comiques de personnalités politiques, dictateurs, gens de spectacle et intellectuels sont apparues dans de nombreuses publications américaines et européennes, notamment *Time*, *Rolling Stone*, *Newsweek*, *The Times* (Grande-Bretagne) et le journal suisse *Die Weltwoche*. *Time* a également cité son livre *What Presidents Are Made Of* dans sa liste des dix meilleurs livres pour enfants de 2004. Il a des œuvres dans la collection permanente de la Bibliothèque du Congrès, dans la section Tirages et photographies, et sa technique de création d'image en 3D a été adoptée dans les écoles maternelles israéliennes pour apprendre aux enfants une façon différente de faire de l'art.

Sacha Baron Cohen
as Borat, 2007
Village Voice newspaper,
collage

Karl Marx, 2009
Foreign Report magazine,
collage

Sigmund Freud, 2002
Haaretz newspaper,
collage

Edel Rodriguez

1971 born in Havana
Lives and works in Mt. Tabor
www.edelrodriguez.co

"Much of my illustration work evolves
from my sketchbooks or personal work.
They are drawings about loss,
oppression, joy, death, or whatever happens
to be in my head at the time."

Osama Bin Laden, 2011
Newsweek magazine,
paint, printmaking and
digital

Graham Samuels

1975 born in Southend, UK
Lives and works in Stockholm
www.grahamsamuels.com

"My illustrations are bold and colorful,
yet detailed and nuanced, and always hand-drawn.
I am inspired by vintage paperbacks,
LPs and film posters."

This Is Your Life, 2013
Modern Psykologi
magazine, cover, acrylic

Xtabay!, 2011
Personal work, pencil
and acrylic

Cry Bear, 2010
Naturskyddsföreningen,
advertisement, pencil
and acrylic on board

pp. 544/45
The Personalized
Auction, 2010
Plaza Deco magazine,
pencil and digital

Graham Samuels stalks the world of comics and creates illustrations that revive the classic comic-book aesthetic. Samuels's narratives are entirely in the present, but his imagery recalls the days when draftsmanship was a divine skill and every comic-book artist had Rembrandt in his genes. Illustration was set to be a part of his future "ever since I could hold a crayon," he said. He attended Kingston University in London and Konstfack in Stockholm, and particularly enjoys designing illustrations for album and book covers—examples of both include Peter Bjorn and John's *Writer's Block* and Stuart Murdoch's *The Celestial Café*.

Auf seiner Jagd durch die Welt der Comics schafft Graham Samuels Illustrationen, die die klassische Comic-Buch-Ästhetik neu beleben. Seine Geschichten spielen ausschließlich in der Gegenwart, aber seine Bilder erinnern an die Tage, als zeichnerisches Können noch eine Gottesgabe war und jeder Comic-Künstler über Rembrandt-Gene verfügte. Dass er eines Tages Illustrator werden würde, war ihm klar, „seitdem ich einen Buntstift halten konnte", wie er sagt. Er studierte an der Kingston University in London und an der Konstfack in Stockholm, und besonders gern illustriert er Musikalben und Buchumschläge – beispielsweise für *Writer's Block* der schwedischen Popband Peter Bjorn and John oder für *The Celestial Café* von Stuart Murdoch.

Graham Samuels traque le monde du neuvième art et crée des illustrations qui raniment l'esthétique de la bande dessinée classique. Les histoires qu'il raconte sont entièrement dans le présent, mais ses images évoquent l'époque où le talent de dessinateur était d'essence divine et chaque auteur de bande dessinée avait un peu de Rembrandt dans ses gènes. L'illustration a toujours été destinée à faire partie de son avenir, « depuis que j'ai pu tenir un crayon », a-t-il déclaré. Il a étudié à l'Université de Kingston à Londres et à Konstfack à Stockholm, et aime particulièrement créer des illustrations pour des couvertures d'albums et de livres, par exemple *Writer's Block* de Peter Bjorn and John et *The Celestial Café* de Stuart Murdoch.

SELECTED EXHIBITIONS — 2012, Agent Bauer + Sven-Harrys, group show, Sven-Harrys Konstmuseum, Stockholm // *2011*, C/O Illustration, group show, Stockholm // *2008 and 2010*, Kolla! Grafisk Design & Illustration, group show, Svenska Tecknare, Stockholm // *2006*, Degree Exhibition, group show, Konstfack, Stockholm

SELECTED PUBLICATIONS — 2011, Illustration Now! 4, TASCHEN, Germany // *2010*, CAP & Design, Sweden // *2010*, Creative Review magazine, UK // *2009*, Tusen Svenska Klassiker, Norstedts, Sweden // *2009*, 200 Best Illustrators Worldwide, Lürzer's Archive, Austria

Yuko Shimizu

born in Tokyo
Lives and works in New York
www.yukoart.com

"Some people say, 'Illustration is dead.'
Is that true? I believe it is the illustrator's job now
to show how exciting and powerful
illustration can be, to show the possibilities
outside the regular boundaries
of what people would think it can do."

Battle Hymn of
Tiger Mother, 2011
Time magazine, cover,
unpublished, ink and
digital

After graduating from the MFA Illustration Program at the School of Visual Arts in New York, Yuko Shimizu became a proverbial overnight sensation on the international illustration scene. Shimizu's distinct mixture of East and West, old and new sensibilities, detailed linear style and playful imagination appeals on many levels, and being at the same time fantastical and comprehensible her work lets viewers in while still retaining a few degrees of mystery. Illustration is actually her second career, having first chosen to study advertising and marketing as the more practical path, which led to a job in corporate PR in Tokyo.

Nachdem Yuko Shimizu das MFA (Master of Fine Arts) Program an der School of Visual Arts in New York absolviert hatte, wurde sie buchstäblich über Nacht zu einer Sensation in der internationalen Illustratorenszene. Ihre charakteristische Mischung aus Ost und West, aus alten und neuen Sensibilitäten, detailliertem linearem Stil und spielerischer Imagination wirkt auf vielfältige Weise reizvoll, und da ihr Werk gleichzeitig fantastisch und verständlich ist, erschließt es sich dem Betrachter einerseits, während es andererseits bis zu einem gewissen Grade geheimnisvoll bleibt. Zur Illustration fand Shimizu übrigens erst auf Umwegen, denn ursprünglich hatte sie sich für ein eher praktisches Metier entschieden und Werbung und Marketing studiert, was ihr zu einem Job in der PR-Abteilung einer Firma in Tokio verhalf.

Après avoir obtenu son diplôme du programme d'illustration MFA de la School of Visual Arts de New York, Yuko Shimizu a fait sensation sur la scène internationale de l'illustration. Son mélange distinctif de sensibilités orientales et occidentales, d'ancien et de nouveau, son style linéaire détaillé et son imagination espiègle séduisent sur plusieurs plans. Son travail est à la fois fantastique et compréhensible, et laisse la porte ouverte au public tout en conservant quelques degrés de mystère. L'illustration est en fait sa seconde carrière, car elle a d'abord choisi d'étudier la publicité et le marketing, une voie plus pragmatique, qui l'a menée à un poste dans les relations publiques à Tokyo.

Panda Girl – The First Asian American Superheroine, 2005
Murphy Design, USA, Artistic Utopia, artists' calendar 2005, ink and digital

Blow Up 3, 2010
Personal work, Society of Illustrators, New Work, group show, with Tomer Hanuka and Sam Weber, ink and digital

Untitled, 2006
Walrus magazine,
Canada, unpublished
cover, ink and digital

Miyamoto Musashi, 2012
Personal work, ink
and digital

Shimizu speaks of herself at this time that it "never quite made her happy. At age 22, she was in mid-life crisis." She stuck out the corporate job for 11 years before taking her biggest gamble and moving to New York in 1999. Since then her explosive work (her images really do seem to explode off page and screen) has featured on Gap T-shirts and Pepsi cans, in ads for Target and Microsoft, as well as for *Time*, *The New York Times*, *Rolling Stone*, Penguin books and DC Comics. She was nominated as one of the "100 Japanese People the World Respects" in 2009 by *Newsweek Japan*.

Über diese Zeit sagt Shimizu selbst, sie habe sie „nie wirklich glücklich gemacht" und sie „schon mit 22 in eine Midlife-Crisis gestürzt". Den Job in der Firma hielt sie elf Jahre lang durch, dann nahm sie „das größte Wagnis ihres Lebens" auf sich und ging 1999 nach New York. Seitdem waren ihre explosiven Motive (die den Betrachter wirklich unmittelbar anzuspringen scheinen) auf T-Shirts von Gap und Pepsi-Dosen zu sehen sowie in Anzeigen von Target und Microsoft; außerdem erschienen sie in Medien wie *Time*, *The New York Times*, *Rolling Stone* sowie bei Penguin und DC Comics. 2009 wurde sie für die Liste „100 Japanese People The World Respects" der japanischen Ausgabe von *Newsweek* nominiert.

Parlant d'elle-même à cette époque, Shimizu se souvient que cela « ne l'avait jamais vraiment rendue heureuse. À 22 ans, elle faisait sa crise de la quarantaine ». Elle supporta son travail en entreprise pendant 11 ans avant de prendre le pari de déménager à New York en 1999. Depuis, son travail explosif (ses images semblent vraiment exploser sur la page et sur l'écran) a été vu sur des t-shirts Gap et des canettes de Pepsi, dans des publicités pour Target et Microsoft, ainsi que dans *Time*, le *New York Times*, *Rolling Stone*, les livres Penguin et DC Comics. Elle a été nommée l'une des « 100 personnalités japonaises que le monde respecte » par *Newsweek Japan* en 2009.

SELECTED EXHIBITIONS — *2013, Sketchtravel, group show, Kyoto International Manga Museum, Kyoto // 2011, Annual Summer Invitational, group show, Jonathan LeVine Gallery, New York // 2011, Rolling Stone and the Art of the Record Review, group show, The Society of Illustrators, New York // 2009, Embedded Art: Art in the Name of Security, group show, Akademie der Künste, Berlin // 2008, Yuko Shimizu, solo show, The University of the Arts, Philadelphia*

SELECTED PUBLICATIONS — *2011, Sketchtravel, Éditions du Chêne, France // 2011, Yuko Shimizu, Gestalten, Germany // 2008, How to Be an Illustrator, Laurence King, UK // 2008, Things I Have Learned in My Life So Far, Abrams, USA // 2005, Illustration Now! 1, TASCHEN, Germany*

Unwritten #44, 2012
DC Comics Vertigo,
The Unwritten, monthly
cover, ink and digital

Shout

aka Alessandro Gottardo
1977 born in Pordenone, Italy
Lives and works in Milan
www.alessandrogottardo.com

"I try to eliminate
as many details as possible to get to
an image's core essence."

Swimming Pool, 2010
SEAC, advertising
campaign, mixed media
and digital

There is considerable irony with Alessandro Gottardo's *nom de crayon* being "Shout" since no word could be further from describing the impression his art gives at first glance. Shout's illustration speaks softly but then shows it carries a graphic wallop. His precise minimalist detailing whispers rather than yells, grabbing the viewer's eye through ingenious ideas and generous use of negative space. This reductive style is at once soothing yet challenging, serious yet witty, and while it employs the tropes of cartoon illustration the results are not slapstick—this is observational commentary. The noise being made here is a contemplative white noise.

Dass sich Alessandro Gottardo den Künstlernamen „Shout" zugelegt hat, verrät einen beträchtlichen Sinn für Ironie: Kein Wort wäre weniger geeignet den Eindruck zu beschreiben, den seine Kunst – zumindest auf den ersten Blick – vermittelt. Shouts Illustration spricht eine sanfte Sprache, die aber grafische Schlagkraft besitzt. Seine präzisen, minimalistischen Details flüstern eher, als dass sie schreien, sie fesseln den Blick durch raffinierte Ideen und eine üppige Verwendung von Leerflächen. Dieser reduktive Stil ist angenehm und fordernd zugleich, seriös und doch witzig, und obwohl er auf Elemente der Cartoon-Illustration zurückgreift, hat er nichts Slapstickartiges – vielmehr handelt es sich um Kommentare, die aus der Beobachtung resultieren. Der Krach, der hier gemacht wird, ist ein kontemplatives weißes Rauschen.

Black Swan, 2007
The New York Times, Art
Direction: Nicholas
Blechman, mixed media
and digital

Picking the Best, 2006
Plansponsor magazine, Art
Direction: SooJin Buzelli,
mixed media and digital

Danger You Are Not Aware,
2006
Plansponsor magazine,
Art Direction: SooJin
Buzelli, mixed media and
digital

Le fait que le nom de crayon d'Alessandro Gottardo soit « Shout » (« cri ») est d'une considérable ironie, car aucun autre mot ne pourrait être plus éloigné de l'effet que ses illustrations impressionnistes produisent au premier regard. Elles commencent tout en douceur, puis envoient un crochet du droit visuel. Les détails minimalistes précis murmurent plus qu'ils ne crient, et attirent le regard grâce à des idées ingénieuses et une utilisation généreuse de l'espace négatif. Ce style qui élimine le superflu est à la fois apaisant et stimulant, sérieux mais spirituel, et bien qu'il emploie les recours usuels de l'illustration humoristique, le résultat n'est pas comique. Il s'agit d'observer et de commenter. Le bruit produit ici est un bruit blanc contemplatif.

SELECTED EXHIBITIONS — *2012*, Drawings, group show, Alessandro de March, Milan // *2012*, Little Circus, solo show, Galleria Colombo, Milan // *2012*, Shout, solo show, Pan, Naples // *2011*, Dazed, solo show, Known Gallery, Los Angeles

SELECTED PUBLICATIONS — *2012*, Fifty Years of Contemporary Illustration, Laurence King, UK // *2011*, Japan Illustration magazine #187, Japan // *2011*, 3x3 magazine #17, USA // *2008*, Style and Substance, a Visual History, Abrams, USA // *2007*, New Visual Artist // *2007*, Print magazine, USA

Alone Together, 2009
The New York Times
Magazine, mixed media
and digital

October, 2012
Internazionale, calendar,
mixed media and digital

Peter Sís

1949 born in Brno, Czech Republic
Lives and works in New York
www.petersis.com

"I express most of myself through
my art and hope that others may enjoy
how I convey feelings and ideas through my work.
I would like to enlighten people and
show them how the world is fascinating,
and complex and inspiring."

Map of Tibet, 1998
Tibet Through the Red Box,
FSG Books, pen and ink

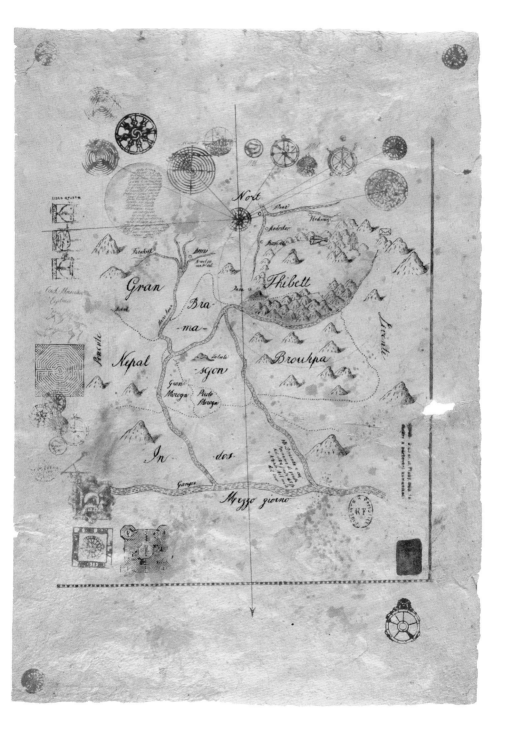

Peter Sís is one of only five children's book authors to have won the prestigious MacArthur Fellowship, the so-called "genius prize" which is a "no strings attached" award in support of creative individuals rather than specific projects. That Sís was given the award is testament to his prodigious output since emigrating to the US in 1983, having left his homeland because "I just wanted to be creative, which was impossible in my home country at that time. My father brought me up with a desire to be an artist and to be successful. But he never explained what might be waiting at the end of the road."

Peter Sís ist einer von lediglich fünf Kinderbuchautoren, die die renommierte MacArthur Fellowship gewonnen haben, eine „bedingungslose" Auszeichnung, die zur Unterstützung kreativer Einzelpersonen und nicht für spezifische Projekte verliehen wird. Den sogenannten „Genie-Preis" bekam Sís in Anerkennung des erstaunlichen Outputs seit seiner Emigration in die USA. Im Jahr 1983 war er aus der ehemaligen ČSSR ausgewandert, weil „ich einfach nur kreativ sein wollte, was in meinem Heimatland damals nicht möglich war. Nach dem Wunsch meines Vaters sollte ich ein erfolgreicher Künstler werden, aber er hat mir nie erklärt, was mich am Ende des Wegs vielleicht erwarten würde."

← The Dreamer, 2011
Book, Author: Pam Muñoz
Ryan, Scholastic, pen
and ink

Vaclav Havel, 2012
HN magazine, Prague,
cover, watercolor

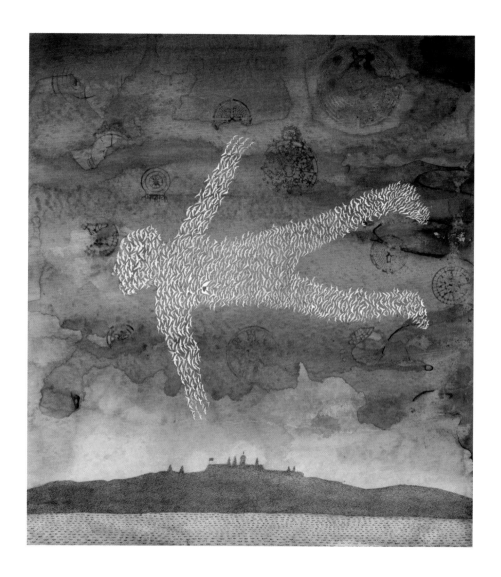

Peter Sís fait partie du club très fermé des cinq illustrateurs de livres pour enfants qui ont remporté le prestigieux prix MacArthur, surnommé le « prix des génies ». C'est une bourse complètement indépendante dont la vocation est de soutenir le travail d'individus créatifs, plutôt que des projets spécifiques. Le fait que Sís en ait été lauréat témoigne de sa prodigieuse production depuis qu'il a émigré aux États-Unis en 1983. Il a quitté son pays d'origine parce que « je voulais juste être créatif, ce qui était impossible dans mon pays à l'époque. Mon père m'a élevé dans le désir d'être artiste et de réussir dans la vie. Mais il ne m'a jamais expliqué ce qui pouvait m'attendre au bout du chemin ».

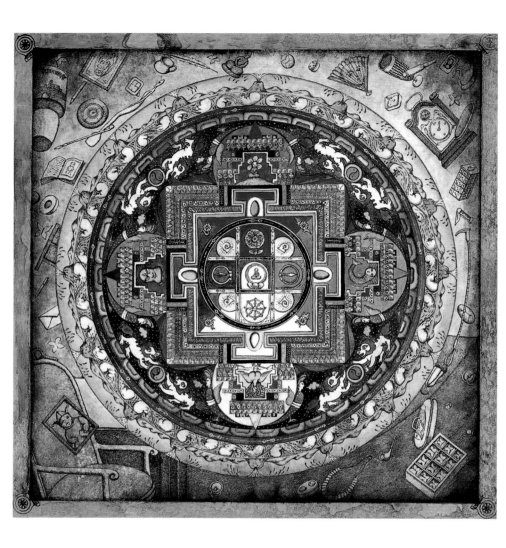

Sís was taken under the wing of then book editor at Doubleday, Jacqueline Kennedy Onassis, and went on to create a number of books about grand themes, both daring in scope and with detailed illustration, such as about Prague or Tibet, Christopher Columbus, even Komodo dragons. He won major awards and became a highly respected and sought-after author (regularly touring the globe to promote titles), putting out at least one major illustrated book a year, as well as providing designs for several other authors' works. "I've finally liberated myself from the European/Central European formula, and I can appreciate and understand many more things in the US."

Unter der Obhut von Jacqueline Kennedy Onassis, der damaligen Lektorin bei Doubleday, publizierte Sís eine Reihe umfangreicher Bücher mit detaillierten Illustrationen zu großen Themen wie Prag oder Tibet, Christoph Kolumbus und sogar Komodowarane. Er erhielt bedeutende Auszeichnungen und wurde zu einem hoch angesehenen und sehr gefragten Autor (mit ständigen Promotiontouren um die ganze Welt), der pro Jahr mindestens einen größeren Illustrationsband herausbringt und daneben immer wieder für Bücher anderer Autoren zeichnet. „Inzwischen habe ich mich von dem europäischen/mitteleuropäischen Schema völlig befreit und kann sehr viel mehr Dinge in den USA schätzen und verstehen."

Jacqueline Kennedy Onassis, alors éditrice chez Doubleday, prit Sís sous son aile. Il créa de nombreux livres sur des sujets ambitieux, avec des illustrations détaillées, comme Prague ou le Tibet, Christophe Colomb ou encore les dragons de Komodo. Il a remporté des récompenses prestigieuses et est devenu un auteur très respecté et recherché (qui a régulièrement parcouru le globe pour promouvoir ses titres), et a produit au moins un grand livre illustré par an, ainsi que des dessins pour les projets de plusieurs autres auteurs. « Je me suis enfin libéré de la formule type d'Europe et d'Europe centrale, et je peux apprécier et comprendre beaucoup plus de choses aux États-Unis. »

SELECTED EXHIBITIONS — 2014, Cartography of the Mind, solo show, Brooklyn Museum, New York // 2013, Bologna Illustrators, group show, Bologna Children's Book Fair, Bologna // 2011, The Conference of the Birds, solo show, Mary Ryan Gallery, New York // 2007, Growing Up Behind the Iron Curtain, solo show, traveling // 2003, Exploring the World with Peter Sís, solo show, Art Institute of Chicago // 1998, Follow Your Dream, solo show, Pražský hrad, Prague

SELECTED PUBLICATIONS — 2011, The Conference of the Birds, Penguin, USA // 2007, The Wall, Farrar, Straus & Giroux, USA // 1998, Tibet Through the Red Box, Farrar, Straus & Giroux, USA // 1996, Starry Messenger, Farrar, Straus & Giroux, USA // 1994, The Three Golden Keys, Doubleday, USA

Mandala, 2011
Tibet Through the Red Box,
FSG Books, watercolor,
pen and ink

40 character studies for
the animated short You
Gotta Serve Somebody
based on Bob Dylan's
song, 1984
Fine Arts, Los Angeles,
oil pastel on gesso

pp. 566/67 Conference
of the Birds, 2011
Penguin Books, pen,
ink and watercolor

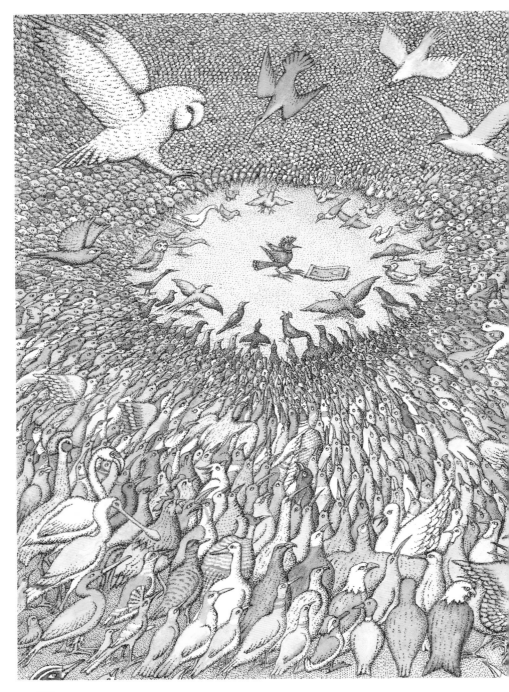

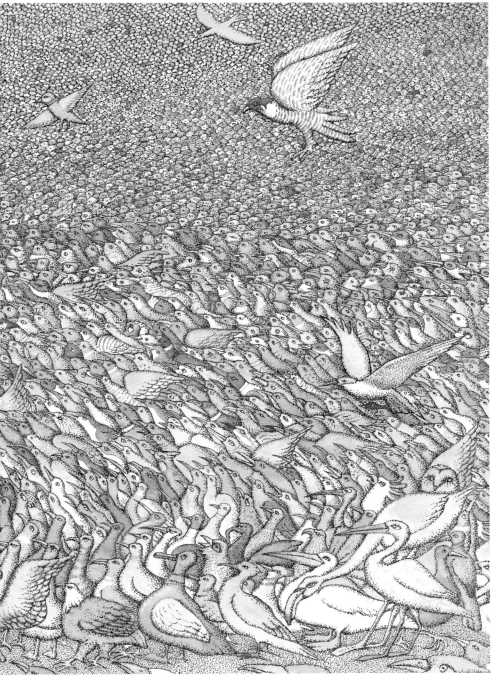

Owen Smith

1964 born in Fremont
Lives and works in Alameda
www.owensmithart.com

"My paintings reflect my interest
in figure painting from 1900 to 1950.
I tend to exaggerate proportions and emphasize
volume and movement. The figures crowd
the frame and overlap each other in angular
or swirling compositions."

Brigid, 2008
San Francisco Arts
Commission, the Market
Street Poster Project,
poster, oil on wood

A throwback to the days of early 20th-century American urban and regional art, Owen Smith has channeled pulp illustrators along with Ashcan and WPA-era painters like Reginald Marsh, George Bellows, Thomas Hart Benton and Grant Wood, and made the style his own. The work is not copied nor simply revived—instead it is as if Smith were possessed by the spiritual shades of these venerable artists. He is an accomplished painter, muralist, mosaic artist and sculptor, while his illustration work has illuminated endless magazines, editorials, as well as CD covers. In the words of the *Eclectix* blog, Smith has been "permeating pop culture for at least the last 20 years," his illustrations having "a vibrant, lusty feel to them, conjuring up 1940s Los Angeles, vintage detective stories and film noir." The detail in his work speaks of a deep interest in the human form and its environment, although it is not intended to be wholly realistic; within the representational style that is his forte, each image is designed to evoke a mood or emotion and draw the interested eye into a two-dimensional melodrama. He is an artist of noir, but one working in color—dark, vivid colors.

Bei Owen Smith fühlt man sich in die Zeit der urbanen und regionalen US-Kunst Anfang des 20. Jahrhunderts zurückversetzt: Inspiriert von Groschenheft-Illustratoren, aber auch von Malern der Ashcan School und der Works Progress Administration wie Reginald Marsh, George Bellows, Thomas Hart Benton oder Grant Wood, hat er sich deren Stil zu eigen gemacht. Dabei kopiert er nicht einfach und unternimmt auch keine Wiederbelebungs-versuche – vielmehr ist es so, als würde er von den spirituellen Schatten dieser altehrwürdi-gen Künstler heimgesucht. Smith, der auch ein vollendeter Maler, Bildhauer, Mosaik-Künstler und Wandmaler ist, hat endlose Magazine, Leitartikel und CD-Cover illustriert. Smiths Illustrationen haben, so heißt es im *Eclectix Blog*, „seit mindestens 20 Jahren die Popkultur durchdrungen. Von ihnen geht etwas Schwungvolles, Robustes aus, sie beschwören das Los Angeles der 1940er-Jahre, klassische Detektivgeschichten und den Film noir". Die Details in seinem Werk lassen ein starkes Interesse an der menschlichen Form und ihrer Umgebung erkennen, auch wenn nicht die vollends realistische Abbildung beabsichtigt war. Seine große Stärke ist die Gegenständlichkeit, aber jedes Bild soll auch eine Stimmung oder Emotion hervorrufen und den neugierigen Blick auf ein zweidimensionales Melodrama lenken. Er ist ein Künstler des Noir, aber einer, der in Farbe arbeitet – dunklen, lebhaften Farben.

Combatant, 2008
Society of Illustrators, New York, Artists Against the War, exhibition and book, Curation: Steve Brodner, oil on wood

K.O., 2008
Long Gone, Billy Shire Fine Arts, exhibition, oil on wood

Effectuant un retour à l'époque de l'art américain urbain et régional du début du XX^e siècle, Owen Smith a repris le style des illustrateurs pulp et des peintres de l'école Ashcan et WPA tels que Reginald Marsh, George Bellows, Thomas Hart Benton et Grant Wood et l'a fait sien. Il ne s'agit pas de copier, ni même de ressusciter, c'est plutôt comme si Smith était possédé par les ombres spirituelles de ces vénérables artistes. C'est un peintre, muraliste, créateur de mosaïques et sculpteur accompli, et ses illustrations ont enluminé d'innombrables magazines, journaux et couvertures de CD. D'après le blog *Eclectix*, Smith « s'est frayé un chemin dans la culture populaire au fil des 20 dernières années au moins », et ses illustrations « donnent une impression de vie et de vigueur, et évoquent le Los Angeles des années 1940, les histoires de détectives et les films noirs ». Les détails de ses œuvres expriment un profond intérêt pour le corps humain et son environnement, bien que l'intention ne soit pas d'être tout à fait réaliste. Dans le cadre du style figuratif qui est son point fort, chaque image est conçue pour évoquer une humeur ou une émotion et attirer le regard intéressé dans un mélodrame en deux dimensions. Smith est un artiste du noir qui travaille en couleur, dans des teintes foncées et vives.

SELECTED EXHIBITIONS — *2012*, Owen Smith, solo show, SFMOMA Caffé Museo, San Francisco // *2010*, Long Gone, solo show, Billy Shire Fine Arts, Los Angeles // *2010*, The Art of Owen Smith, solo show, Nelson Gallery, Davis // *2008*, Artists Against the War, group show, Museum of American Illustration, New York // *2007*, Hansel and Gretel, group show, Schwartz Gallery Met, Lincoln Center, New York

SELECTED PUBLICATIONS — *2011*, This Is the Game, HarperCollins, USA // *2008*, Illustration: A Visual History, Abrams, USA // *2007*, Illustration Now! 2, TASCHEN, Germany // *2003*, Front Page: Covers of the Twentieth Century, Orion Publishing, UK // *2000*, Rolling Stone: The Illustrated Portraits, Chronicle Books, USA

A Day's Work, 2002
The New Yorker, Art
Direction: Françoise Mouly,
oil on canvas

Trash, 2002
Phoenix magazine, Art
Direction: Sharon Seidl
Vargas, oil on board

Simon Spilsbury

1963 born in Yeovil, UK
Lives and works in Bath
www.spilsbury.co.uk

"Spontaneous and investigative graphic
image-making. Solving visual problems via
a drawing-based style that adapts
to the individual demands
of each brief, from a regular newspaper
column to a 96 sheet."

Gunangel, 2012
Personal work, War and
Celebrity, series, ink
and digital

Call it expressive or chaotic or both of these things, but Simon Spilsbury's line is the high-speed engine that pulls his drawing along at a frenetic pace. Indeed, he describes himself as "an exponent of line." When Spilsbury is not drawing he is teaching drawing at Bath Spa University, but most often he is in full drawing mode and over the past couple of decades has done work for Cobra beer, Martell, Nike, Virgin, the London Election, *The Sunday Times* and *The Independent*.

Man mag ihn expressiv oder chaotisch nennen oder beides zugleich, aber der Strich von Simon Spilsbury ist eine Hochgeschwindigkeitsmaschine, die seine Zeichnung in atemberaubendem Tempo vorantreibt. Er selbst bezeichnet sich sogar als „Strich-exponenten". Wenn er nicht gerade selbst zeichnet, unterrichtet Spilsbury Zeichnen an der Bath Spa University, doch die meiste Zeit befindet er sich ohnehin im vollen Arbeitsmodus und hat in den letzten Jahrzehnten sowohl für Firmen wie Cobra Beer, Martell, Nike und Virgin gearbeitet als auch für die Londoner Bürgermeisterwahlen sowie für *The Sunday Times* und *The Independent*.

On peut le qualifier d'expressif ou de chaotique, ou des deux à la fois, mais le trait de Simon Spilsbury est un moteur surpuissant qui tracte ses dessins à un rythme frénétique. De fait, il se décrit lui-même comme « un représentant de la ligne ». Lorsque Spilsbury ne dessine pas, il enseigne le dessin à l'Université Bath Spa, mais il passe la majeure partie de son temps en mode dessinateur. Au cours des deux dernières décennies il a travaillé pour la bière Cobra, Martell, Nike, Virgin, l'élection du maire de Londres, *The Sunday Times* et *The Independent*.

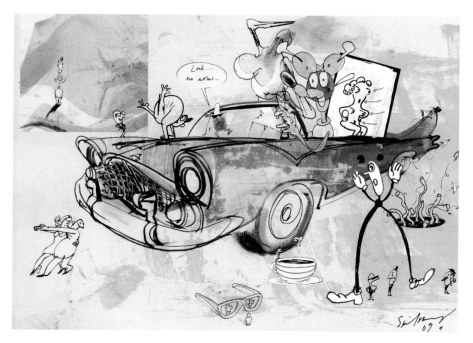

SELECTED EXHIBITIONS — *2012*, American Illustration, group show, New York // *2011*, American Illustration, group show, New York // *2011*, AOI Images 35, group show, Somerset House, London // *2011*, Working Drawings, group show, Sheffield Institute of Arts, Sheffield // *2009*, AOI Images 33, group show, LCC, London

SELECTED PUBLICATIONS — *2016*, Playboy magazine, USA // *2011*, Images 35, AOI Publications, UK // *2009*, Images 33, AOI Publications, UK // *2009*, Sketchbooks: The Hidden Art Of Designers, Laurence King, UK // *2007*, Illustration Now! 2, TASCHEN, Germany // *1995*, D&AD magazine, UK

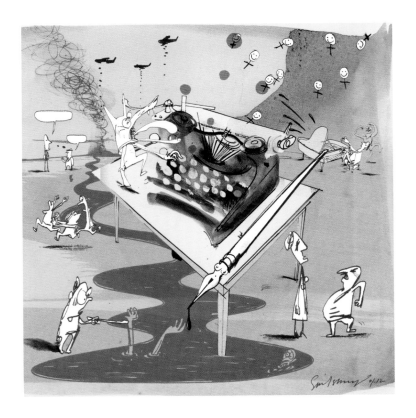

p. 576 Snakedollar, 2011
The Drawbridge, ink

p. 577 V8 Rave, 2012
Personal work, War and
Celebrity, series, paint,
ink and digital

The Writer, 2012
CHI, Virginia Woolf, live art
evening, ink and digital

Cityhell 2, 2001
Personal work, exhibition,
ink, graphite, paint and
digital

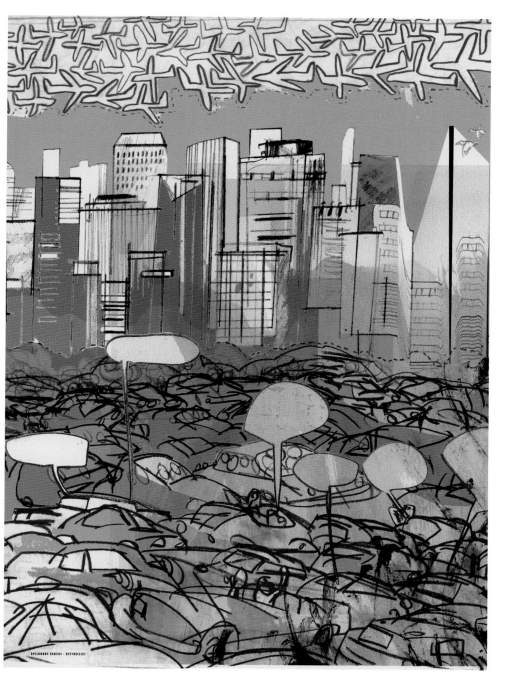

Mark Summers

1955 born in Burlington, Canada
Lives and works in Waterdown, Canada
www.marksummers.prosite.com

"Mark Summers takes the illustrator's
art back a century by enlisting the
wood engraver's craft to the scratchboard medium.
He gives it a thoroughly contemporary flavor,
however, in the power of his imagery."

Moby Dick, 1994
Barnes and Noble, book,
scratchboard

The faces he draws are very well known and as a portraitist with an eye for slight exaggeration, Mark Summers is well known too. He has inherited a cartoonist's wit and acquired the taste for elegant graphics, while his unmistakable style is evidence of other converging influences—the intelligence of John Tenniel and poise of David Levine. Summers's pristine scratchboard renderings are thus a curious blend of 19th- and 21st-century sensibilities, though unlike his partisan forebears, his stated aim is to make well-done pictures, rather than acerbic satire. In consequence, the caricatures of characters from the arts for which he is known are formally striking, without the distortion of political cartoons.

Mark Summers zeichnet bekannte Gesichter, und als Porträtist mit Hang zu leichter Überzeichnung ist er ebenfalls bekannt. Neben seinem angeborenen Witz des Karikaturisten entwickelte er eine Vorliebe für elegante Darstellungen, aber sein unverkennbarer Stil lässt auch andere Einflüsse erkennen – etwa die Intelligenz eines John Tenniel und die Sicherheit eines David Levine. Das heißt, in Summers' brillanten Scratchboard-Zeichnungen vermischen sich Befindlichkeiten des 19. und des 21. Jahrhunderts auf merkwürdige Weise. Doch im Unterschied zu seinen Vorbildern geht es ihm eher um gut gemachte Bilder als um ätzende Satire. Folglich bestechen seine historischen Gestalten, für die er bekannt ist, vor allem in formaler Hinsicht, während ihnen das Verzerrende der politischen Karikatur fehlt.

Les visages qu'il dessine sont très connus, et en tant que portraitiste doté du sens de l'exagération légère, Mark Summers est également très connu. Il a hérité de l'esprit d'un humoriste et a acquis le goût du graphisme élégant. Son style inimitable porte les signes de la convergence d'autres influences – l'intelligence de John Tenniel et l'élégance de David Levine. Les dessins immaculés sur carte à gratter de Summers sont un curieux mélange de sensibilités du XIXᵉ et du XXIᵉ siècle, bien que, contrairement à ses ancêtres partisans, son but déclaré soit de créer des images bien faites, plutôt qu'une satire acerbe. Les caricatures des personnages culturels pour lesquelles il est célèbre sont donc d'une beauté formelle saisissante, sans la distorsion des dessins politiques humoristiques.

Pirate, 2012
Pirates at the Plate,
Creative Editions, book,
scratchboard

Napoleon, 2008
Wicked, Scholastic, book,
scratchboard

It was an interest in literature and literary caricature that attracted Summers to Levine's work for *The New York Review of Books*, and indeed many of his early pictures when he worked freelance could be said to be Levine-like. Spying this talent, regional newspaper *The Spectator* secured his services, assigning him to the "graveyard" shift. "If someone important died, like John Lennon, for example, I would be given the assignment at 10:00 p.m. to do a full-color, airbrushed portrait to be delivered to the platemaker by 6:30 a.m. the next morning." He never missed a deadline, and received all of $75 for each commission.

Aufgrund seines Interesses für Literatur und literarische Karikatur fühlte sich Summers von Levines Arbeiten für *The New York Review of Books* besonders angesprochen, und nicht von ungefähr erinnern seine frühen Bilder als Freiberufler in gewisser Hinsicht an Levine. Dieses Talent wurde von der Regionalzeitung *The Spectator* entdeckt, die ihn daraufhin engagierte und der „Friedhofs"-Schicht zuteilte. „War eine bekannte Persönlichkeit verstorben, wie zum Beispiel John Lennon, bekam ich um 22:00 Uhr die Anweisung, ein farbiges Airbrush-Porträt anzufertigen, das bis zum nächsten Morgen um 6:30 Uhr beim Layouter sein musste." Er hielt immer alle seine Termine ein und bekam für jeden Auftrag ganze 75 Dollar.

C'est son intérêt pour la littérature et la caricature littéraire qui ont attiré Summers vers le travail de Levine pour *New York Review of Books*, et, de fait, nombre des images produites au début de sa carrière lorsqu'il était freelance ressemblaient beaucoup à celles de Levine. Le journal régional *The Spectator* a repéré son talent et l'a embauché pour ses nécrologies. « Si quelqu'un d'important décédait, par exemple John Lennon, on me demandait à 10 heures du soir de faire un portrait ultra-détaillé en couleur, qui devait être livré au photograveur à 6 h 30 le lendemain matin. » Il n'a jamais été en retard, et a touché une enveloppe royale de 75 $ pour chaque commande.

Aviator Amelia
Earhart, 2005
Vherses: A Celebration
of Outstanding Women,
Creative Editions, book,
scratchboard

Edvard Grieg, 1996
Caldey Island, charity
calendar, scratchboard

Sharon Tancredi

1959 born in Chicago
Lives and works in Brighton, UK
www.sharontancredi.com

"Inspirations are many, from 15th-century
Christian altarpieces to 1950s packaging
and design, American and Latin American folk art,
street graphics, and all things kitsch!"

The Magic Soup, 2012
Watkins Publishing, book,
Art Direction: Suzanne
Tuhrim, digital

Mysteriously and innocently sensual is how Sharon Tancredi's work appears to the naked eye — Nabokov's Lolita couldn't be better portrayed than by her doe-eyed, nubile nymphets. Yet it is the technical precision Tancredi brings to her images which set hers apart from others working in the fantasy genre. She creates digital work that ranges from her stylized nymphets to quirky and fanciful animals and fantasy landscapes. She is equally at home with advertising, editorial, packaging and children's book illustration, and not surprisingly she enjoys reading and illustrating fairy tales, with examples of her book covers including *Tempest Rising* and *The Rescue Princesses* series.

Mysteriös und auf unschuldige Weise sinnlich sind Sharon Tancredis Bilder – Nabokovs Lolita könnte nicht besser porträtiert werden als durch ihre attraktiven, rehäugigen Nymphchen. Was Tancredi jedoch von anderen Fantasy-Illustratoren unterscheidet, ist die technische Präzision ihrer Arbeiten. Ihre digital gestalteten Motive reichen von den stilisierten Nymphchen bis zu schrulligen Tieren und Fantasy-Landschaften. Sie ist in unterschiedlichen Gebieten zu Hause – Werbung, Verpackung, Text- und Kinderbuch-Illustration –, und es versteht sich fast von selbst, dass sie auch gerne Märchen liest und bebildert: Zu den Buchumschlägen, die sie entworfen hat, gehören beispielsweise *Tempest Rising* und die Serie *The Rescue Princesses*.

Mystérieusement et innocemment sensuel, c'est ainsi que se présente le travail de Sharon Tancredi. La Lolita de Nabokov ne pourrait pas être mieux représentée que par ses nymphettes nubiles aux yeux humides. Et pourtant, c'est la précision technique de Tancredi qui la distingue des autres illustrateurs qui travaillent dans le genre du fantastique. Elle crée des images numériques peuplées de ses nymphettes stylisées, d'animaux étranges et de paysages rêvés. Elle se sent aussi à l'aise dans la publicité, la presse ou l'emballage que dans les livres pour enfants, et on ne s'étonne pas qu'elle aime lire et illustrer des contes de fées, avec par exemple ses couvertures de livres, notamment *Tempest Rising* et la série *The Rescue Princesses*.

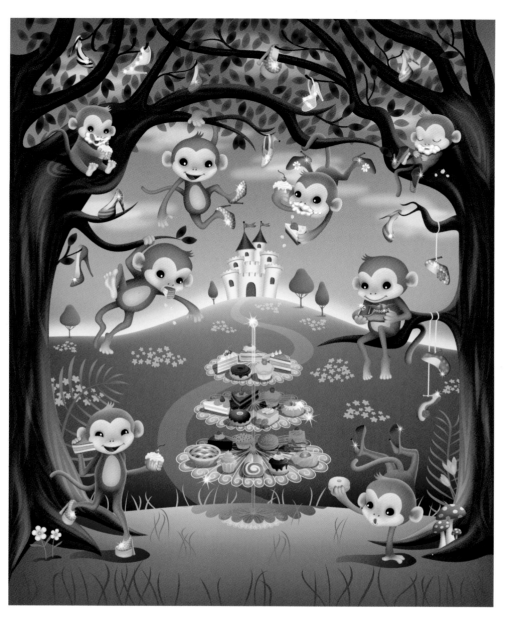

The Rescue Princesses
– Moonlight Mystery & The
Snow Jewel, 2012

Nosy Crow Publishing,
book, Art Direction: Nicola
Theobald, digital

The Monkey
Thieves, 2012
Watkins Publishing, book,
Art Direction: Suzanne
Tuhrim, digital

Mary of the Block, 2007
Personal work, digital

Mother Nature, 2008
Delta Sky magazine,
Art Direction: Ann Harvey,
digital

Green Machine, 2005
Intelligent Life magazine,
Penny Garrett, digital

SELECTED EXHIBITIONS — 2010, *AOI Images, group show, Mall Galleries, London // **2009**, Brighton Festival, group show, Artists Open House, Brighton*

*SELECTED PUBLICATIONS — **2012**, Computer Arts magazine, UK // **2012**, Dark Faeries, Online Urban Fantasy Blog, USA // **2009**, Dynamic Graphics + Create magazine, USA // **2008**, Idea Illustrator magazine, Taiwan // **2004**, Pixelsurgeon, Online Design & Culture magazine, UK*

Gary Taxali

1968 born in Chandigarh, India
Lives and works in Toronto
www.garytaxali.com

"I think about mood,
attitude and state of mind,
and go from there."

Poof, Qeedrophonic
Doll, 2004
Personal work, mixed
media

SELECTED EXHIBITIONS — 2015, *Here and Now: The Art of Gary Taxali, solo show, Design at Riverside, Cambridge, Canada* // *2012*, *My Feelings Like You, solo show, The Outsiders (Lazarides), London* // *2012*, *Selected Works, solo show, Antonio Colombo Gallery, Milan* // *2012*, *Serigraph Assemblages, solo show, Soho House, Toronto* // *2009*, *Hindi Love Song, solo show, Jonathan LeVine Gallery, New York*

SELECTED PUBLICATIONS — 2012, *Blab World 2, Last Gasp, USA* // *2012*, *Selected Works: Gary Taxali, Antonio Colombo Arte Contemporanea, Italy* // *2011*, *I Love You, OK?, teNeues, Germany* // *2011*, *Mono Taxali, 279 Editions, Italy* // *2010*, *This Is Silly!, Scholastic, USA*

Contradiction, 2004
Converse, advertisement,
Agency: Butler, Shine,
Stern and Partners, Art
Direction: John Butler,
mixed media

Detail from "Good
Husband / Good Lover,"
2005
Personal work, mixed
media

Then and Now, 2012
Playboy magazine, Art
Direction: Bruce Hansen,
mixed media

Whew, Friends, 2012
The Outsiders (Lazarides)
Gallery, giclée print,
alkyd oil on plywood

Bella Vita, 2012
Cinelli, catalog cover, Art
Direction/Editor: Antonio
Colombo, mixed media

Gary Taxali's work recalls a past when goofy, bulbous, amiable characters roamed the pages of newspapers and comic books. Taxali has resurrected the somewhat innocent-faced types immortalized by Sluggo in the 1930s in a manner once called "Pop Art" and now termed retro—a homage transformed. He has cornered the market for his brand of retro-recollection, tapping into the memories of a generation that would give anything for a time-machine ride back to places never lived. Apart from these neverlands, his most important influences, he said—when I forced him to pick only three—are typography, film and banal manuals or text books.

Gary Taxalis Werk erinnert an eine Vergangenheit, als leicht vertrottelte, liebenswerte Figuren mit Knollennasen die Seiten von Zeitungen und Comic-Büchern bevölkerten. Taxali hat die etwas unschuldig dreinschauenden Typen, wie Sluggo sie in den 1930er-Jahren verewigte, auf eine Weise wiederbelebt, die früher einmal als „Pop Art" bezeichnet wurde und heute „Retro" heißt – eine anachronistische Hommage, die ihm auch ein Marktmonopol sicherte: Mit seinem Markenzeichen der Retro-Erinnerung spricht er die nostalgischen Gefühle einer Generation an, die alles dafür geben würde, sich mit einer Zeitmaschine an Orte zurückversetzen zu lassen, die es nie gegeben hat. Auf meine Frage, welche – außer diesen Traumwelten – seine drei wichtigsten Einflüsse seien, nannte er Typografie, Film und banale Hand- oder Lehrbücher.

Le travail de Gary Taxali rappelle un passé où des personnages comiques affables, tout en rondeurs et un peu gauches peuplaient les pages des bandes dessinées et des journaux. Taxali a ressuscité ces visages innocents immortalisés par Sluggo dans les années 1930 dans un style que l'on a à l'époque appelé «Pop art» et que l'on qualifie aujourd'hui de rétro – un hommage transformé. Il a accaparé le marché de ces souvenirs rétro en puisant dans les souvenirs d'une génération qui donnerait n'importe quoi pour un petit voyage en machine à remonter le temps. Outre ces territoires d'un passé fantasmé, ses influences les plus importantes sont d'après lui la typographie, le cinéma et de banals manuels et livres de classe.

Ode to a Twinkie, 2012
The New York Times,
Art Direction: Alexandra
Zsigmond, screen printing
and mixed media

Mike Thompson

1968 born in Kaiserslautern, Germany
Lives and works in Beltsville, USA
www.miketartworks.com

"I spend a lot of time crafting
each painting. I won't step away from it
till I feel it's right. You are only as good as
your last piece, that's just real."

→ Nick Fury, Agent
of Shield, 2012
Wacom, digital

pp. 600/01 The Four
Elements of Hip Hop, 2012
Aria Multimedia
Entertainment, digital

Why so Serious?, 2009
Warner Bros., digital

I Love Rock and Roll!,
2012
Hard Rock Hotel / Corel
Painter, digital

Eric Tranchefeux

1969 born in Paris
Lives and works in Paris
www.tranchefeux-arts.com

"This feeling of being close
to the great masters of the past, the seeking
of philosophical contents, the moments of
reflection and the pleasure of suppressing
the reality that surrounds us, all this influences
the very true realization of his work."

Little M, 2012
Painting, oil on canvas

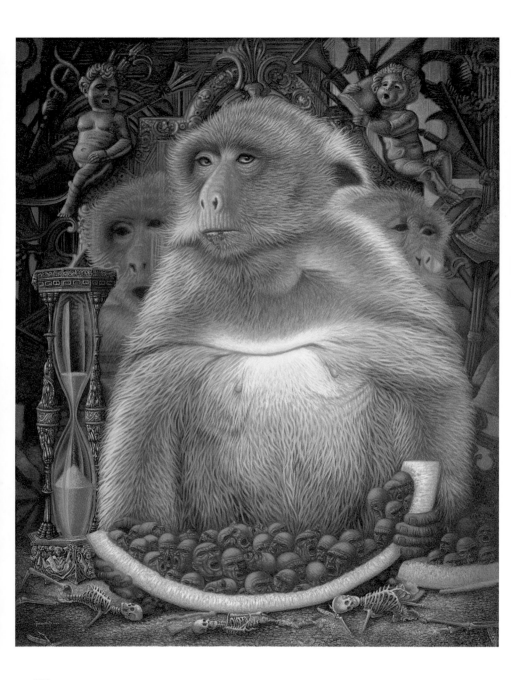

SELECTED EXHIBITIONS — 2014, Art Capital, group show, Grand Palais, Paris // 2006, French Artists Exhibition, group show, Grand Palais, Paris // 2002, Salon d'Automne, group show, Société du Salon d'Automne, Paris

SELECTED PUBLICATIONS — 2012, 3DVF (interview), France // 2009, Computer Arts magazine, France // 2009, Imagine FX #38, USA // 2009, Magazine Série Créatives #1, France // 2004, CG TALK: Cat Project, Computer Graphics Society, Australia

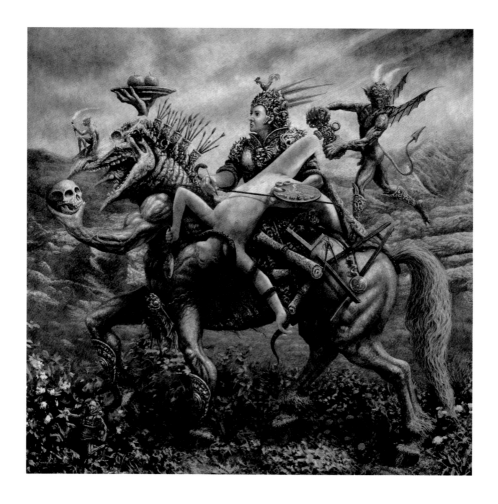

Nourriture de l'Homme, 2002
Personal work, oil on wood

Artist Painting His Model, 2007
Personal work, digital

Eric Tranchefeux does not just do extraordinary landscapes of the imagination, he can focus his hands and eyes sympathetically on human beings as well. In a magic-realist manner, Tranchefeux's nudes shimmer on the page yet are quite beyond reproach, while his historical figures are so real they might well be in the same room as the viewer. These incredibly detailed tableaux, created for science-fiction and fantasy genres, are rendered with a kind of Renaissance majesty and a symbolic profundity that simply takes the viewer's breath away. His themes, aside from the fantasy most apparent, involve people and animals, landscapes and architecture, and range from conceptual designs to surrealistic, dreamlike scenes.

Eric Tranchefeux zeichnet nicht nur außergewöhnliche Fantasielandschaften, sondern er hat auch einen mitfühlenden Blick für das Menschliche. Seine Akte, die in magisch-realistischer Manier auf dem Papier schimmern, sind über jeden Tadel erhaben, während seine historischen Gestalten so real wirken, als befänden sie sich im selben Raum wie der Betrachter. Diese unglaublich detaillierten Science-Fiction- und Fantasy-Tableaus sind mit geradezu renaissanceartiger Grandeur gestaltet und besitzen so viel symbolische Tiefe, dass es dem Betrachter einfach den Atem verschlägt. Zu Tranchefeux' Themen gehören – neben dem besonders präsenten Fantasy-Genre – Menschen und Tiere, Landschaften und Architektur, und ihre Bandbreite reicht von konzeptuellen Designs bis zu surrealistischen Traumszenen.

Eric Tranchefeux ne fait pas seulement des paysages imaginaires extraordinaires, il peut aussi concentrer l'énergie empathique de ses yeux et de ses mains sur les êtres humains. Dans un style magique-réaliste, les nus de Tranchefeux chatoient sur la page et sont au-delà de tout reproche. Ses personnages historiques sont si réels qu'on a l'impression de pouvoir les toucher. Ces compositions incroyablement détaillées, créées pour les genres de la science-fiction et du fantastique, sont travaillées avec une sorte de majesté typique de la Renaissance et une profondeur symbolique qui coupent le souffle. Ses sujets de prédilection, outre le fantastique, sont les personnes et les animaux, les paysages et l'architecture, et il en fait des dessins conceptuels ou des scènes oniriques surréalistes.

L'Equipartition, 2000
Personal work, oil on
canvas

Pirate, 2011
Personal work, digital

Jeremy Traum

1978 born in Edison
Lives and works in Portland

"I am a firm believer that content
should always dictate style.
Style is a peripheral element in one's work
that comes naturally from working hard.
Content will always resonate with
the viewer no matter what package
it comes in."

Progress, 2005
Personal work, digital

After studying at Parsons School of Design in New York with the social activist artist Sue Coe, Jeremy Traum realized there was more to illustration than illustrating and more to expression than simply espousing a popular style. That is not, of course, to say Traum does not illustrate or have his own style, but that Coe's advocacy of issues and causes, including animal rights and AIDS prevention, influenced him to walk the tightrope between self-expression and client-expectation. His balancing act is pretty successful, employing a visual voice rooted in classic representational drawing that borders on abstract expressionism.

Nachdem Jeremy Traum an der Parsons School of Design in New York bei der sozial engagierten Künstlerin Sue Coe studiert hatte, wurde ihm klar, dass Illustration mehr bedeutet als, zu illustrieren, und dass zum Ausdruck mehr gehört, als einfach einen populären Stil zu übernehmen. Natürlich illustriert er und natürlich hat er auch seinen eigenen Stil entwickelt, doch Coes Engagement für gesellschaftliche Themen wie Tierschutz und Aids-Prävention wirkte sich dahingehend aus, dass ihm die Gratwanderung zwischen Selbstausdruck und Kundenerwartung gelingt. Diesen Drahtseilakt vollführt er mit ziemlichem Erfolg, wobei er sich einer visuellen Sprache bedient, die – in der klassischen gegenständlichen Zeichnung wurzelnd – an den abstrakten Expressionismus grenzt.

Après ses études à la Parsons School of Design de New York avec l'artiste-activiste sociale Sue Coe, Jeremy Traum a réalisé qu'il y avait plus que de l'illustration dans l'illustration et que l'expression signifiait davantage qu'épouser un style populaire. Cela ne veut bien sûr pas dire que Traum ne fasse pas d'illustration, mais que le militantisme de Coe pour des causes telles que les droits des animaux et la prévention du SIDA l'ont incité à marcher sur la corde raide entre l'expression de soi et les attentes du client. Son numéro de funambule est assez réussi, et il emploie un ton visuel qui prend ses racines dans le dessin figuratif classique mais tend vers l'expressionnisme abstrait.

Friends, 2012
Personal work, marker

Cowmachine, 2004
Personal work, digital

Joy 2, 2012
Boston Globe, ink

San Diego, 2012
Personal work, oil

China #1, 2006
Personal work, pencil
and digital

Japan, 2012
Personal work, acrylic

Yury Ustsinau

1979 born in Vitebsk, Belarus
Lives and works in Frankfurt am Main
www.ustsinau.com

"The combination of
the two extremes of the color spectrum:
black for absorption of all light,
and white for reflection of all light."

Kosik, 2011
Personal work, plywood,
acrylic and hand-drawn

Perhaps being born in the hometown of Marc Chagall gave Yury Ustsinau a reason for being an artist, if not a spiritual connection to expressive surrealism. Alternatively it was the skills learned at the Vitebsk State Technological University, where Ustsinau studied for a degree in Product Design, that shaped his future career. His illustrations certainly echo Chagall's sense of absurdity, but given their three-dimensional look and feel, they likewise suggest the hand of a technical illustrator. From early work spent making traditional illustrations he soon evolved to wanting to create "his own special world."

Der Tatsache, in der Heimatstadt Marc Chagalls geboren zu sein, mag Yury Ustsinau seine Raison d'être als Künstler, vielleicht sogar eine spirituelle Verbindung zum expressiven Surrealismus verdanken. Andererseits war es die Ausbildung zum Produktdesigner an der Staatlichen Technologischen Universität Witebsk und das damit erworbene handwerkliche Können, das seine spätere Karriere bestimmen sollte. Seine Illustrationen haben fraglos etwas vom chagallschen Sinn für Absurdität, doch ihre dreidimensionale Erscheinung und Anmutung verrät genauso die Hand eines technischen Zeichners. Nachdem er anfänglich traditionelle Illustrationen angefertigt hatte, entwickelte er sehr bald den Wunsch, sich „seine eigene, besondere Welt" zu erschaffen.

Le fait d'être né dans la ville d'origine de Marc Chagall a peut-être donné à Yury Ustsinau une raison de devenir artiste, voire une connexion spirituelle avec le surréalisme expression-niste. C'est aussi son diplôme en conception de produit obtenu à l'Université technologique d'État de Vitebsk qui a déterminé sa future carrière. Ses illustrations font sans aucun doute écho au sens de l'absurde de Chagall, mais leur tridimensionnalité suggère également la main d'un illustrateur technique. Il a fait des illustrations traditionnelles au début de sa carrière, mais a vite décidé qu'il voulait créer son « propre monde ».

SELECTED EXHIBITIONS — *2013*, The Black World of Yury Ustsinau, solo show, Maximillian Gallery, Darmstadt *// 2012*, Black and White, solo show, Siemens AG, Frankfurt am Main *// 2012*, Parallax Art Fair, group show, Chelsea Town Hall, London *// 2011*, Collection, group show, Absolute Art Gallery, Bruges *// 2009*, Artists for Dalai Lama, group show, European Parliament, Strasbourg

SELECTED PUBLICATIONS — *2011*, ArtBox magazine, UK *// 2011*, Hi Fructose magazine, USA *// 2011*, Illustration Now! 4, TASCHEN, Germany *// 2010*, Bang Art magazine, Italy *// 2010*, Dark Inspiration, Victionary, China

Alphaface K, 2011
Personal work, mixed
media

Buldo, 2010
Personal work, plywood,
acrylic and hand-drawn

Plaksova, 2012
Personal work, mixed
media

Smithplue, 2012
Personal work, mixed
media

Mayke, 2012
Personal work, mixed
media

Raphaël Vicenzi

aka Mydeadpony
1972 born in Charleroi, Belgium
Lives and works in Brussels
www.mydeadpony.com

"I view my works as a blend
of fashion models, symbolism,
street art, melancholia, typography
and social critique."

Terror Zero, 2012
Personal work, watercolor,
textures and digital

La vie rêvée des autres,
2012
Personal work, watercolor,
textures and digital

Feeling Blue, 2012
Personal work, watercolor,
blue bic, textures and
digital

Mydeadpony, the *nom de crayon* of Raphaël Vicenzi, mixes digital media with sketching, drawing and watercolors, adding certain splotches and textures to create immensely detailed images that are meticulous but also ethereal. His ideas derive from a mood or emotion which is then represented in visual form. "The idea has to matter to me so I can spend time with it and turn it around." His work is similarly inspired by his place in society, but with a certain distance: "I try to make it less personal to allow other people to refer to it as well with their own experiences."

Mydeadpony, der Künstlername Raphaël Vicenzis, kombiniert digitale Medien mit Skizzen, Zeichnungen und Aquarellen, die er um gewisse Farbtupfer und Texturen ergänzt, und so entstehen Bilder von unendlichem Detailreichtum, die akribisch und zugleich ätherisch sind. Seine Ideen ergeben sich aus einer Stimmung oder Emotion, die dann in visueller Form dargestellt wird. „Die Idee muss mir wichtig sein, dann kann ich mich ihr widmen und sie hin- und herwenden." Sein Werk ist auch von seinem Platz in der Gesellschaft inspiriert, allerdings mit einer gewissen Distanz: „Es soll nicht allzu persönlich sein, damit auch andere Menschen mit ihren eigenen Erfahrungen Zugang zu ihm finden können."

Mydeadpony, le nom de crayon de Raphaël Vicenzi, mélange le numérique et le croquis, le dessin et les aquarelles, et ajoute des taches et des textures pour créer des images immensément détaillées, méticuleuses mais également très éthérées. Ses idées dérivent d'une humeur ou d'une émotion qu'il représente sous forme visuelle. « L'idée doit être importante pour moi, pour que je puisse passer du temps dessus et la retourner. » Son travail est aussi inspiré par sa place dans la société, mais avec une certaine distance : « J'essaie de rendre tout cela moins personnel, afin que d'autres puissent s'y identifier à partir de leurs propres expériences. »

SELECTED PUBLICATIONS — 2015, *Living With: My Dead Pony, Roads Publishing, Ireland //*
2012, *New Illustrators File, Art Box, Japan //* **2011**, *Illustration Now! Portraits, TASCHEN, Germany //*
2010, *The Beautiful, Gestalten, Germany*

Morbid Fashion, 2008
Personal work, watercolor
and digital

Oh the Slavery, 2008
Personal work, watercolor
and digital

Flesh Casket, 2008
Personal work, watercolor
and digital

Amanda Visell

1978 born in Puyallup
Lives and works in Los Angeles
www.amandavisell.com

"I paint what I find in the sock drawer
of my brain. Sometimes you find a sock with
no match, sometimes you find 20 bucks."

Wonder Woman, 2012
DC Comics, cel-vinyl
acrylic on board

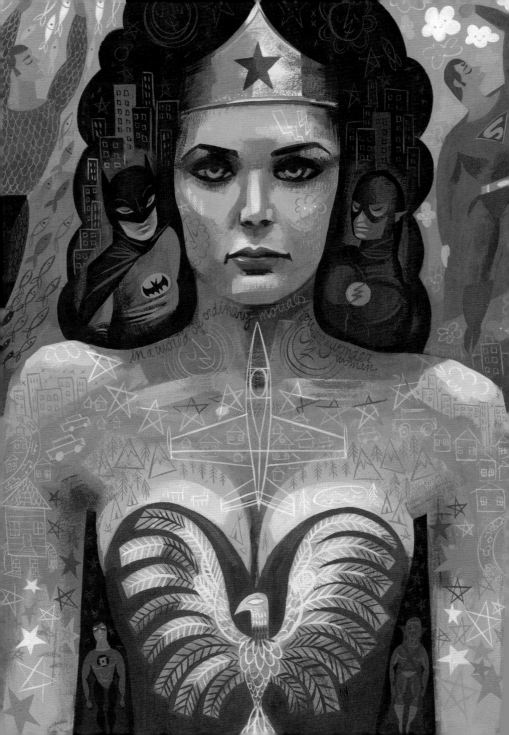

i can save myself.

Vintage Disney is the inspiration that filled Amanda Visell's imagination and likewise her art. Visell grew up in the Pacific Northwest as the Riot Grrrl movement was kicking off and found it a cathartic time, with the exciting surge of independent artists and particularly "their overall message of equality." Moving to Los Angeles she worked in animation, specializing in design and contributing stop-motion sequences for shows like *The Simpsons*. In 2005 she began showing her own work which led not only to exhibitions and workshops but also commissions for brands and in turn the development of her own design brand, Switcheroo.

Vintage-Disney ist die Quelle, von der sich Amanda Visell in ihrer visuellen Fantasie ebenso anregen ließ wie in ihrer Kunst. Sie wuchs an der nordwestlichen Pazifikküste der USA zu einer Zeit auf, als die Riot-Grrrl-Bewegung so richtig in Schwung kam, und das sollte sie nachhaltig prägen – sie fand es aufregend, wie plötzlich überall unabhängige Künstlerinnen mit „ihrer Forderung nach Gleichheit" auftauchten. Später ging Visell nach Los Angeles, um im Trickfilmbereich zu arbeiten, wobei sie sich auf Design spezialisierte und Zeitraffer-sequenzen für Serien wie *The Simpsons* machte. Ab 2005 zeigte sie ihre eigenen Arbeiten in Ausstellungen und Workshops, übernahm Aufträge von Firmen und entwickelte ihr eigenes Designlabel Switcheroo.

Le Disney à l'ancienne est l'inspiration qui a nourri l'imagination d'Amanda Visell. Elle a grandi dans le Nord-Ouest Pacifique, à l'époque où le mouvement Riot Grrrl donnait des coups de pied dans la fourmilière, et y a trouvé une libération intellectuelle, avec l'essor des artistes indépendants et plus particulièrement « leur message global d'égalité ». Elle a déménagé à Los Angeles, où elle a travaillé dans l'animation, s'est spécialisée dans la conception et a participé à des séquences d'animation image par image pour des séries telles que *The Simpsons*. En 2005, elle a commencé à montrer son travail personnel, ce qui lui a apporté des expositions, des commandes pour des marques et la naissance de sa propre marque de design, Switcheroo.

I Can Save Myself, 2010
Personal work, Girls,
poster series, cel-vinyl
acrylic on board

Tell a Friend, 2011
Personal work, cel-vinyl
acrylic on board

pp. 632/33 Bayou-hoo,
2007
Personal work, cel-vinyl
acrylic on board

SELECTED EXHIBITIONS — 2011, Everything Dies, solo show, Guru Galeria, Mexico City // 2010, Primeval Love, solo show, Natural History Museum, Los Angeles // 2009, Enchanted Tiki Room 45th Anniversary, solo show, Disneyland, Anaheim // 2008, Tic Toc Apocalypse, solo show, M Modern Gallery, Palm Springs // 2007, Pirates of the Caribbean 40th anniversary, solo show, Disneyland, Anaheim

SELECTED PUBLICATIONS — 2016, Clutter magazine, USA // 2012, d.p.i. magazine, Taiwan // 2012, Hello Kitty Hello Art, Abrams, USA // 2012, Pictoplasma, Germany // 2010, I Am Plastic, Too, Abrams, USA // 2008, Swindle magazine, USA

Pegaphunt, 2008
Personal work, cel-vinyl
acrylic on board

I Should Have Written That
Book, 2012
Personal work, cel-vinyl
acrylic on board

I'm a Tiger in Any Hat,
2011
Personal work, cel-vinyl
acrylic on board

Marco Wagner

1982 born in Würzburg, Germany
Lives and works in Veitshöchheim, Germany, and in Prague
www.marcowagner.blogspot.de

"As a child, I often felt uneasy about
older people in my family,
with their wrinkles, warts and thick glasses.
I utilize this fear in my paintings."

Tea, 2011
TUSH magazine, Art
Direction: Emrah Seckin,
mixed media and digital

SELECTED EXHIBITIONS — *2016, Don't Wake Daddy XI, group show, Feinkunst Krüger, Hamburg // 2012, Domov, solo show, Feinkunst Krüger, Hamburg // 2012, Domov, solo show, Galerie Neongolden, Wiesbaden // 2012, Don't Wake Daddy, group show, Feinkunst Krüger, Hamburg // 2012, End of the Summer, group show, MOHS Exhibit, Copenhagen // 2011, Lucid Dreams, group show, Noel-Baza Fine Art Gallery, San Diego*

SELECTED PUBLICATIONS — *2014, The Book of Hearts, Laurence King Publishing, UK // 2012, Rooms magazine, UK // 2011, American Illustration 29, USA // 2011, Illustration Now! Portraits, TASCHEN, Germany // 2011, Illustrators Unlimited, Gestalten, Germany // 2011, 200 Best Illustrators Worldwide, Lürzer's Archive, Austria*

Akkurat, 2011
Slanted magazine,
Fontnames Illustrated,
mixed media
and digital

Bojovníci #1, portrait of
Muhammad Ali, 2009
19 Karen Exhibition
Space, acrylic and collage
on cardboard

There is a hint of Francis Bacon in Marco Wagner's surreal distortions, yet they don't look like Bacon's works at all. Wagner's images are not as doggedly intense, and there is a certain matter-of-fact quality about his visual dislocations. They are also, at times, more photographic, and a suspicious stillness—the quiet before the storm—is a hallmark of his image-making. He studied design at the University of Applied Sciences in Würzburg, with a focus on book illustration, and has since had several exhibitions of his work throughout Germany and the rest of Europe.

Marco Wagners surreale Verzerrungen lassen an Francis Bacon denken, sehen aber überhaupt nicht wie Gemälde von Bacon aus. Wagners Bildern fehlt diese verbissene Intensität, und seine visuellen Verschiebungen haben fast etwas Prosaisches an sich. Gelegentlich sind sie auch eher fotografisch, wie überhaupt eine verdächtige Reglosigkeit – die Ruhe vor dem Sturm – für seine Art der Bildgestaltung charakteristisch ist. Er studierte Design an der Hochschule für angewandte Wissenschaften in Würzburg mit dem Schwerpunkt Buchillustration, und seitdem waren seine Arbeiten in verschiedenen Ausstellungen in Deutschland und anderen europäischen Ländern zu sehen.

Il y a une touche de Francis Bacon dans les distorsions surréalistes de Marco Wagner, et pourtant elles ne ressemblent pas du tout aux œuvres de Bacon. Les images de Wagner ne sont pas aussi obstinément intenses, et ses déconstructions visuelles ont une certaine nonchalance. Elles sont aussi, parfois, plus photographiques, et une immobilité suspecte – le calme avant la tempête – est sa marque de fabrique. Il a étudié le design à l'Université des sciences appliquées de Würzburg, avec une spécialisation en illustration de livre, et a depuis exposé son travail dans toute l'Allemagne et dans le reste de l'Europe.

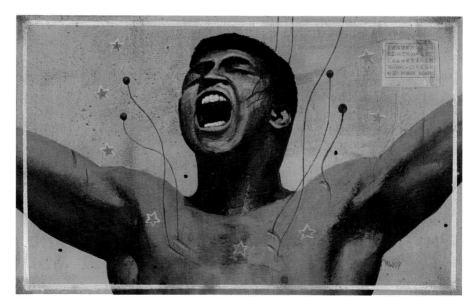

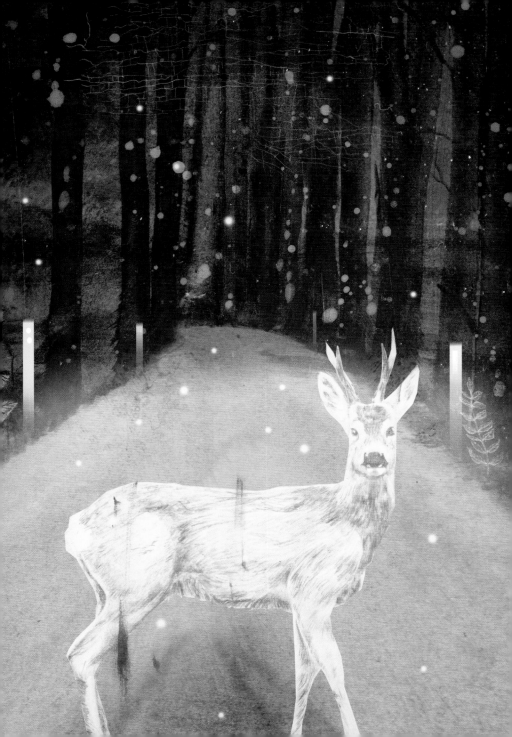

Wagner's art is also autobiographical to an extent, and a place for "facing the fears and discomfort from his childhood, while the main focus is on people's vulnerability in an assumed protective environment. Religion, nature and tradition represent the biggest threat for figures in his works, though they flaunt their wounds with strange pride," as the text from a recent group show he participated in puts it. In an interview with the *COWard33&sNEEze15* blog he described his working process: "I don't do scribbles. [...] Sitting in front of a whiteboard or paper makes me uninspired. [...] When I work on a personal series everything is a little bit different. I spend much time in thinking, reading and trial and error."

Wagners Kunst ist bis zu einem gewissen Grad auch autobiografisch und stark geprägt von Kindheitserinnerungen: In seinen Bildern kämpft er „mit diesen bleibenden Eindrücken, die die Verletzlichkeit des Menschen in einem vermeintlich sicheren Umfeld zeigen. Tiere, Natur, Religion, Rituale und der Mensch wirken wie eine Bedrohung für sich selbst", wie es im Katalogtext einer kürzlichen Gruppenausstellung heißt, an der er sich beteiligte. In einem Interview mit dem Blog *COWard33&sNEEze15* beschrieb er seinen Arbeitsprozess folgender- maßen: „Ich mache keine Kritzeleien [...] Vor einer Weißwandtafel oder einem leeren Blatt Papier verlässt mich die Inspiration [...] Wenn ich an einer persönlichen Serie sitze, ist alles ein bisschen anders. Ich denke lange nach, lese und experimentiere mit Trial and Error."

L'œuvre de Wagner est également autobiographique dans une certaine mesure. C'est pour lui une façon de « se confronter aux peurs et à l'inconfort de son enfance, tandis que le centre de l'attention est la vulnérabilité des personnes dans un environnement qu'elles croient protecteur. La religion, la nature et la tradition représentent les plus grandes menaces pour ses personnages, mais ils exhibent leurs blessures avec une étrange fierté », comme l'indique le texte d'une exposition de groupe récente. Dans un entretien avec le blog *COWard33&sNEEze15*, il décrit son processus de travail : « Je n'aime pas gribouiller. [...] Si je m'assieds devant un tableau blanc ou une feuille de papier, je perds mon inspiration. [...] Lorsque je travaille sur une série personnelle, tout est un peu différent. Je passe beaucoup de temps à réfléchir, à lire, et à faire des essais. »

Augenblick, 2012
Psychologie Heute
magazine, Art Direction:
Heiko Ernst, mixed media
and digital

The Magician King, 2011
The New York Times,
Art Direction: Catherine
Gilmore-Barnes, mixed
media and digital

Alice Wellinger

1962 born in Lustenau, Austria
Lives and works in Lustenau
www.alice-wellinger.com

"As a matter of fact I am totally different
but rarely get round to it."

Torso, 2012
Personal work, acrylic
on board

When my grandma died, she left behind a small, sad coat. It was the kind of coat that makes elderly women invisible. I unbuttoned the coat and the lining showed me grandma's wonderful, complicated life.

SELECTED EXHIBITIONS — *2016*, Global Network Illustration Fair, group show, Seoul // *2012*, Society of Illustrators, group show, New York

SELECTED PUBLICATIONS — *2016*, 3x3 Illustration Annual, USA // *2012*, Creative Quarterly magazine, USA // *2012*, Society of Illustrators Annual 54, USA // *2012*, 3x3 Illustration Annual, USA // *2011*, Communication Arts Annual 2011, USA // *2011*, Illustration Now! 4, TASCHEN, Germany

Grandmother's Coat,
2010
Personal work, acrylic on
board, pen and digital

The Enigmatic Advent
Calendar, 2012
Personal work, acrylic
on board

The stories Alice Wellinger tells through her art are at the same time lyrical and mysterious. Wellinger's palette is dark, her characters are often solemn and her messages are layered with many meanings. "My illustrations are short stories," she explained. In telling (or rather rendering) her pictorial narratives, she works mostly for editorial for magazines, including *Der Spiegel* and *Cosmopolitan*, as well as Residenz publishers. Concerning her personal work, she added: "Ideas ambush me, they appear in my dreams or when browsing the Internet. It's a sort of 'internal commission' that I have to carry out before the excitement vanishes."

There are two sides to Wellinger's work, and two quite different points of departure: "In the case of commissioned and especially editorial illustration, the challenge for an image is to catch the eye, support as well as complement the text in a humorous and ambiguous way. A picture editor or art director commissions me to illustrate a specific item. After I have read the article, I conceive several ideas for images and concepts regarding the subject. The excitement lies in playing with different clichés and associations, in convincing the reader as well as the client, and at the same time coming up with one's own expectations."

Die Geschichten, die Alice Wellinger mit ihrer Kunst erzählt, sind zugleich lyrisch und geheimnisvoll. Ihre Palette ist dunkel, ihren Figuren eignet oft etwas Feierliches, und ihre Botschaften haben vielschichtige Bedeutungen. „Meine Illustrationen sind Kurzgeschichten", erklärt sie. Ihre malerisch gestalteten Erzählungen kreiert sie hauptsächlich für Zeitschriften wie *Der Spiegel* oder *Cosmopolitan*, aber auch für Buchverlage wie Residenz. Bei ihren persönlichen Arbeiten, so Wellinger weiter, „überfallen mich die Ideen, erscheinen mir im Traum oder beim Surfen durchs Internet. Es ist eine Art ‚interner Auftrag', den ich dann schnell erledigen muss, bevor der Reiz verfliegt."

In ihrem künstlerischen Schaffen gibt es für Wellinger „zwei grundverschiedene Ausgangssituationen: Was die Auftragsillustration – im Speziellen die Editorialillustration – betrifft, hat ein Bild die Aufgabe, das Auge zu fangen, den Text zu unterstützen und ihn auf humorvolle oder hintersinnige Art zu ergänzen. Ich bekomme von einer Bildredakteurin oder einem Artdirector den Auftrag, einen konkreten Artikel zu illustrieren. Nachdem ich den Artikel gelesen habe, überlege ich mir ein paar verschiedene Bildideen und Konzepte zum Thema. Der Reiz dabei ist, mit Klischees und Assoziationen zu spielen, den Leser und den Auftraggeber zu überzeugen und gleichzeitig den eigenen Ansprüchen gerecht zu werden".

Les histoires qu'Alice Wellinger raconte à travers son art sont à la fois lyriques et mystérieuses. Sa palette est sombre, ses personnages sont souvent graves et ses messages contiennent plusieurs significations superposées. « Mes illustrations sont des nouvelles », explique-t-elle. Elle narre ses récits visuels principalement pour des magazines, notamment *Der Spiegel* et *Cosmopolitan*, ainsi que la maison d'édition Residenz. En ce qui concerne son travail personnel, elle a ajouté : « Les idées me prennent en embuscade, elles apparaissent dans mes rêves ou lorsque je surfe sur Internet. C'est une sorte de commande interne que je dois satisfaire avant que l'excitation ne disparaisse. »

Le travail de Wellinger a deux versants, et deux points de départ bien distincts : « Dans le cas de l'illustration sur commande, particulièrement pour la presse, l'image doit attirer le regard et soutenir et compléter le texte avec humour et ambiguïté. Le directeur artistique me demande d'illustrer un élément spécifique. Après avoir lu l'article, je prépare plusieurs idées d'image et de concept sur le sujet. Ce qui est intéressant, c'est de jouer avec différents clichés et associations, de convaincre le lecteur et le client, et aussi d'être à la hauteur de mes propres attentes. »

SELECTED EXHIBITIONS — *2013*, Ladies and Gentlemen, group show, Tim Olsen Gallery, Sydney // *2008*, Eponymous, group show, Kinz Tillou Gallery, New York // *2006*, Feigen Contemporary, group show, Pulse, Art Basel, Miami // *2005*, Across and Down, group show, Gigantic Artspace, New York // *1998*, 52 Pick Up, group show, Level Gallery, Sydney

SELECTED PUBLICATIONS — *2012*, Illustration Annual, Communication Arts magazine, USA // *2009*, Illustration Now! 3, TASCHEN, Germany // *2006*, Fashion Illustrator, Laurence King, UK // *2005*, NY ARTS, New York // *2003*, Hand to Eye, Angus Hyland, Pentagram, UK

Wild Hare, 2013
Good Weekend magazine,
pencil, paint and digital

The Minimalist, 2006
Personal work, exhibition,
pencil, acrylic and ink
on old paper

The Way the Wind
Blows, 2011
Personal work, exhibition,
pencil, acrylic and ink
on old paper

Alleluia, 2007
Personal work, exhibition,
painting on book cover

Playful but spooky, the faux-innocent art brut method preferred by Edwina White not only makes for compelling images, but also invites the viewer to "search" them for hidden meanings. White revels in being swept up by the challenge of making her ideas concrete. She works freelance as an illustrator, painter, writer and performer, and says: "To feed constantly from a collection of experiences and feelings is therapeutic." Nowadays she tries to make sure that life and work are symbiotic, and adds: "Whether it be a series, a poster, a likeness, an animation, it's a lovely chance to make anew — it's an adventure every time."

Mit dem verspielten, dabei gespenstischen Stil, wie Edwina White ihn bevorzugt, gelingen ihr nicht nur unwiderstehliche Bilder, sondern sie lädt den Betrachter auch ein, diese nach verborgenen Bedeutungen zu „durchsuchen". Sie hat großen Spaß an der Herausforderung, ihre Ideen konkret werden zu lassen. White, die als Illustratorin, Malerin, Autorin und Performerin arbeitet, findet es „therapeutisch, ständig auf einen Fundus von Erfahrungen und Gefühlen zurückzugreifen". Inzwischen wird es ihr zunehmend wichtig, dass Leben und Arbeit eine Einheit bilden, und sie fügt hinzu: „Ob eine Serie, ein Poster, ein Porträt, oder ein Trickfilm – es ist wunderbar, immer wieder etwas Neues zu machen, das ist jedes Mal ein Abenteuer."

Ludique mais effrayante, la méthode « art brut » faussement innocente qu'Edwina White privilégie produit des images irrésistibles, mais invite également l'observateur à y « chercher » des significations cachées. White aime se laisser emporter par le défi de la concrétisation de ses idées. Elle travaille en freelance comme illustratrice, peintre, auteure et artiste de scène, et elle déclare : « Me nourrir constamment d'une collection d'expériences et de sentiments est très thérapeutique. » En ce moment, elle essaie d'assurer la symbiose entre sa vie et son travail, et elle ajoute : « Qu'il s'agisse d'une série, d'une affiche, d'un portrait ou d'une animation, c'est une excellente occasion de faire quelque chose de nouveau – chaque fois c'est une aventure. »

A Foodies Tour, 2006
Financial Review magazine,
pencil, watercolor on old
paper

Spring, 2011
Personal work, exhibition,
pencil, ink and collage
on paper

Autumn Whitehurst

1973 born in Providence
Lives and works in Brooklyn

"My work is a clean combination
of vector graphics and detailed rendering.
I'm partial to 'less-is-more,' though
only in my work."

Genomics, 2007
The Telegraph, digital

In fashion illustration the artist injects personality into certain details of a picture, and for Autumn Whitehurst the focal point tends to be the eyes. Whitehurst has mastered the intensity of a stare and the coyness of a glance, and even if all else is perfection, the eyes still carry her pictures. She now works as a full-time illustrator for clients which include American Eagle Outfitters, Ecko Red, British and American *Elle*, *Nylon* magazine, Penguin Books, Ogilvy & Mather, DDB and Crush Design, among others.

In der Modeillustration lässt der Künstler seine Persönlichkeit in bestimmte Details eines Bildes einfließen, und Autumn Whitehurst ist dabei tendenziell auf die Augen fixiert. Die Intensität eines starren Blicks beherrscht sie ebenso wie die Schüchternheit eines leichten Augenaufschlags, und auch wenn alles andere reinste Perfektion ist, so haben die Augen doch immer einen ganz individuellen Touch. Heute arbeitet Whitehurst als Vollzeit-Illustratorin für Kunden wie American Eagle Outfitters, Ecko Red, für die britische und amerikanische Ausgabe von *Elle*, das Magazin *Nylon*, Penguin Books, Ogilvy & Mather, DDB, Crush Design und andere.

Dans l'illustration de mode, l'artiste injecte de la personnalité à certains détails de l'image, et pour Autumn Whitehurst, le centre de l'attention est souvent les yeux. Elle sait maîtriser l'intensité ou la coquetterie d'un regard, et même si tout le reste est parfait, ce sont tout de même les yeux qui forment l'épine dorsale de ses images. Elle travaille maintenant comme illustratrice à plein temps pour des clients qui comprennent American Eagle Outfitters, Ecko Red, les éditions britannique et américaine de *Elle*, le magazine *Nylon*, Penguin Books, Ogilvy & Mather, DDB et Crush Design, entre autres.

Rihanna, 2013
The New Yorker, digital

Whitney Houston, 2011
Bartle Bogle Hegarty,
digital

SELECTED PUBLICATIONS — **2013**, *New Icons of Fashion Illustration, Laurence King, UK //* **2010**, *The Beautiful, Gestalten, Germany //* **2009**, *Illustration Now! 3, TASCHEN, Germany //* **2007**, *100 Years of Fashion Illustration, Laurence King, UK //* **2006**, *New Fashion Illustration, Anova Books, UK*

Wish You Were Here, 2004 Action Baths, 2008
Art Department, digital The Telegraph, digital

Olimpia Zagnoli

1984 born in Reggio Emilia, Italy
Lives and works in Milan
www.olimpiazagnoli.com

"I like to work with graphical
and clean illustrations with a retro feel.
I like to play with shapes and lines and
make them do a little dance before
creating the final piece."

Page Turner, 2012
The New Yorker, digital

Olimpia Zagnoli's personal logo is an echo, and possibly an homage, of Paul Rand's own self-portrait. It makes sense too, since Zagnoli's work is both mid-century and twenty-first-century Modern. Working with economical, geometric and abstract forms, a limited color palette, and playful graphic puns is one way to define Rand, Ladislav Sutnar, Saul Bass, or Alvin Lustig. Zagnoli embraces them all and goes to the next evolutionary level. She adds that while studying in New York, "I found a more dynamic and fresher working environment than that in Italy, and without a doubt this was very useful for me." One of her projects involved designing the icons for *The Scoop*, a guide to New York for the iPhone.

Wenn Olimpia Zagnoli in ihrem persönlichen Logo das Selbstporträt von Paul Rand zitiert, so ist dies möglicherweise auch als Hommage zu verstehen. Was insofern Sinn ergibt, als sich in ihrem Werk das Grafikdesign der Nachkriegszeit mit der Moderne des 21. Jahrhunderts verbindet. Mit ihren sparsamen geometrischen und abstrakten Formen, einer reduzierten Farbpalette und zeichnerischem Sprachwitz orientiert sich Zagnoli an Künstlern wie Rand, Ladislav Sutnar, Saul Bass oder Alvin Lustig, geht aber einen Schritt weiter. In New York, wo sie eine Zeit lang studierte, „erlebte ich eine Arbeitsatmosphäre, die dynamischer und erfrischender war als die in Italien, und das war fraglos sehr nützlich für mich". Unter anderem entwarf sie hier die Icons für *The Scoop*, einen New-York-Führer für das iPhone.

Le logo personnel d'Olimpia Zagnoli est un écho de l'autoportrait de Paul Rand, voire un hommage. Et c'est bien logique, car le travail de Zagnoli appartient à la fois aux années 1950 et aux modernes du XXIᵉ siècle. Elle travaille avec des formes géométriques abstraites économes, une palette de couleurs limitée et des calembours visuels, tout comme Paul Rand, Ladislav Sutnar, Saul Bass ou Alvin Lustig. Elle les absorbe tous et passe à l'étape suivante sur l'échelle de l'évolution. Elle ajoute que, lorsqu'elle étudiait à New York, «j'ai trouvé un environnement de travail plus dynamique et plus original qu'en Italie, et cela m'a sans aucun doute été très utile». L'un de ses projets a été de dessiner les icônes pour *The Scoop*, un guide de New York pour l'iPhone.

Cut Your Tongue, 2012
La Repubblica, digital

Opus Pistorum,
Tropic of Cancer, Tropic
of Capricorn, 2012
Feltrinelli, book covers,
digital

Censor a Zebra, 2012
La Repubblica, digital

Protecting Our Children,
2011
Internazionale, digital

Naked in the Jungle,
2013
Clodomiro, silk scarf,
digital

AGENTS INDEX

2Agenten
Schwarz & Wendt GbR
Bergstrasse 20
DE – 10115 Berlin
+49 30 41 71 46 74
mail@2agenten.com
www.2agenten.com

→ Olaf Hajek, 310

Agency Rush
68a Clyde Road
GB – Brighton BN1 4NP
+44 1273 675 122
info@agencyrush.com
www.agencyrush.com

→ Billie Jean, 74

Agent 002
13, rue Bouchardon
FR – 75010 Paris
+33 1 40 21 03 48
sophie@agent002.com
www.agent002.com

→ John Jay Cabuay, 130
→ Daniel Egnéus, 248
→ Gianluca Folì, 262
→ Stéphane Goddard, 298
→ Antoine Helbert, 342

Agent Bauer
Drottninggatan 81A
SE – 111 60 Stockholm
+46 8 545 710 10
nicole@agentbauer.com
www.agentbauer.com

→ Cecilia Carlstedt, 152
→ Graham Samuels, 540

**Anna Goodson
Management**
38 – 11, Place du Commerce
Suite 611
CA – Verdun QC H3E 1T8
+1 514 482 0488
info@agoodson.com
www.agoodson.com

→ Tony Healey, 336

Bang-Bang Studio
ul. Pokrovka, 30
Building 2
RU – 105064 Moscow
+7 495 668 37 03
bang@bangbangstudio.ru
www.bangbangstudio.ru

→ Gabriel Moreno, 474

Bernstein & Andriulli
58 West 40th Street
6th Floor
US – New York NY 10018
+1 212 682 1490
info@ba-reps.com
www.ba-reps.com

BA reps Asia
amanacliq Shanghai Ltd
+86 138 186 72735
edie.zhang@amanacliq.com
www.amanacliq.com

→ Gary Baseman, 66

→ Josh Cochran, 192
→ Olaf Hajek, 310
→ Jeremyville, 386
→ Yuko Shimizu, 546,

Caroline Maréchal
8, rue Saint Marc
FR – 75002 Paris
+ 33 1 42 61 43 34
caroline@caroline-
marechal.fr
www.caroline-marechal.fr

→ Sophie Griotto, 304

Central Illustration Agency
17b Perseverance Works
38 Kingsland Road
GB – London E2 8DD
+44 (0) 203 222 0007
info@centralillustration.com
www.centralillustration.com

32 Place Saint Georges
FR – 75009 Paris
+33 47 419 19 019
morten@centralillustration.
com

→ Simon Spilsbury, 574

**Colagene
Illustration Clinic**
304, Notre-Dame Est, #401
CA – Montreal QC H2Y 1C7
+1 514 845 4730
montreal@colagene.com
www.colagene.com

→ David Despau, 224
→ Raphaël Vicenzi aka
mydeadpony, 622

Creative Syndicate
29, rue des Petites Ecuries
FR – 75010 Paris
+33 (1) 452 343 46
info@creative-syndicate.com
www.creative-syndicate.com

→ Gildo Medina, 456

Début Art
420 West 14th Street
Suite 5 SE
US – New York NY 10014
+1 212 995 50 44
info@debutart.com
www.debutart.com

30 Tottenham Street
GB – London W1T 4RJ
+ 44 20 7636 1064
info@debutart.com

Tokyo, Japan
info@debutart.jp

→ Istvan Banyai, 52
→ Ronald Kurniawan, 418
→ Gabriel Moreno, 474

Dutch Uncle Agency
42 West 24th Street
US – New York NY 10010
+1 212 710 1326
nyc@dutchuncle.co.uk
www.dutchuncle.co.uk

First Floor East
1-5 Clerkenwell Rd
GB – London EC1M 5PA
+ 44 20 7336 7696
info@dutchuncle.co.uk
www.dutchuncle.co.uk

403 17-20 Samoncho
Shinjuku-Ku
JP – 160-0017 Tokyo
+ 81 80 96 51 0808
jpn@dutchuncle.co.uk
www.visiontrack.jp

→ Tavis Coburn, 186
→ Christian Montenegro,
468

Edebé Licensing
Paseo San Juan Bosco 62
ES – 08017 Barcelona
+ 34 932 037 408
audiovisual@edebe.net
www.edebeaudiovisual.com

→ Catalina Estrada, 256

Folio
10 Gate Street
Lincoln's Inn Fields
GB – London WC2A 3HP
+ 44 20 7242 9562
info@folioart.co.uk
www.folioart.co.uk

→ Gez Fry, 274
→ Sharon Tancredi, 586

Friend + Johnson
37 West 26th Street, #313
US – New York NY 10010
+ 1 212 337 0055
rsaxon@friendandjohnson.
com
www.friendandjohnson.com

870 Market Street, #1017
US – San Francisco CA
94102
+ 1 415 927 4500
bjohnson@friendandjohnson.
com

901 West Madison Street,
#918
US – Chicago IL 60607
+ 1 312 435 0055
sfriend@friendandjohnson.
com

→ Brian Cairns, 138
→ Patrick Hruby, 372

Gerald & Cullen Rapp
420 Lexington Ave
US – New York NY 10170
+ 1 212 889 3337
info@rappart.com
www.rappart.com

→ Nigel Buchanan, 118
→ Dan Page, 508

Good Illustration
11 – 15 Betterton Street
Covent Garden
GB – London WC2H 9BP
+ 44 20 8123 0243
draw@goodillustration.com
www.goodillustration.com

→ Daniel Egnéus, 248

Heflinreps Inc
10 Linden Terrace
US – Leonia NJ 07605
+ 1 201 944 6058
sally@heflinreps.com
www.heflinreps.com

→ Joe Morse, 480
→ Hanoch Piven, 528

Herman Agency
350 Central Park West
US – New York NY 10025
+ 1 212 749 4907
ronnie@hermanagencyinc.
com
www.hermanagencyinc.com

→ Seymour Chwast, 172

Illustopia
Praça Coronel Pacheco, 2
PT – 4450-453 Porto
+ 351 91 6472121
info@illustopia.com
www.illustopia.com

→ Daniel Bueno, 124

Illustration Division
420 West 24 Street,
Suite 1F
US – New York NY 10011
+ 1 212 243 2103
illustration@art-dept.com
www.illustrationdivision.com

→ Cecilia Carlstedt, 152
→ Daniel Egnéus, 248
→ Gildo Medina, 456
→ Graham Samuels, 540
→ Autumn Whitehurst, 654

Illustrissimo
13, rue Bouchardon
FR – 75010 Paris
+ 33 1 42 02 50 85
michel@illustrissimo.com
www.illustrissimo.fr

→ Olimpia Zagnoli, 660

Jed Root
333 Seventh Ave.
US – New York NY 10001
+1 212 226 6600
illustration@jedroot.com
www.jedroot.com

9220 West Sunset Blvd
Suite 315
US – West Hollywood CA
90069
+ 1 310 385 0685

3rd Floor 118-120 Great
Titchfield Street
GB – London W1W 6SR
+ 44 20 7151 1000

10, rue du Mont Thabor
FR – 75001 Paris
+ 33 1 44 54 30 80
christine@jedroot.com

→ Jean-Philippe Delhomme,
212

**Jennifer Vaughn
Artist Agency**
289 North Sunset Way
US – Palm Springs CA 92262
+ 1 760 808 2462
jen@jenvaughnart.com
www.jenvaughnart.com

→ Marco Wagner, 636

Margarethe Hubauer
Im Winkel 3
DE – 23820 Pronstorf
+ 49 4 55 64 14
mhubauer@margarethe.de
www.margarethe-illustration.
com

→ Guy Billout, 80
→ Brad Holland, 360

Marlena Agency Inc.
278 Hamilton Ave
US – Princeton NJ 08540
+ 1 609 252 9405
marlena@marlenaagency.
com
www.marlenaagency.com

→ Olimpia Zagnoli, 660

Morgan Gaynin Inc
194 Third Avenue #3
US – New York NY 10003
+ 1 212 475 0440
info@morgangaynin.com
www.morgangaynin.com

→ Dave Calver, 144

Kate Larkworthy
Artist Representation
325 First Street, #5
US – Jersey City NJ 07302
+ 1 718 857 1150
kate@larkworthy.com
www.larkworthy.com

→ Edwina White, 648

Killington Arts
11 Cross Rd
GB – Bromley BR2 8PH
+ 44 20 8462 9820
kit@killingtonarts.com
www.killingtonarts.com

→ Joe Morse, 480

Levy Creative Management
245 East 63rd Street
Suite 1622
US – New York NY 10065
+ 1 212 687 6463
info@levycreative.com
www.levycreative.com

→ Kako, 392

Lindgren & Smith
Eighth Avenue, #329
US – New York NY 10019
+ 1 212 397 7330
pat@lindgrensmith.com
www.lindgrensmith.com

→ Christopher O'Leary, 500

Pekka
Nervanderinkatu 5
DFI – 00100 Helsinki
+ 358 50 363 5252
pekka@agentpekka.com
www.agentpekka.com

Korsjespoortsteeg 16
NL – 1015 AR Amsterdam
+ 31 6 4629 0589

→ Minni Havas, 330

Pencil Ilustradores
Paseo de Zorrilla 42
Bajo Izquierda
ES – 47006 Valladolid
+ 34 983 336 440
pencil@pencil-ilustradores.
com
www.pencil-ilustradores.
com

→ Gianluca Folì, 262

Peppercookies
287 Victoria Dock Road
GB – London E16 3BY
+44 (0)7597 835 986
kajsa@peppercookies.com
www.peppercookies.com
→ Christina Drejenstam,
236

**Richard Solomon
Artists Representative**
110E 30th Street, Ste 501
US – New York NY 10016
+ 1 212 223 9545
richard@richardsolomon.
com
www.richardsolomon.com

→ Chris Gall, 280
→ C. F. Payne, 520
→ Mark Summers, 580

Shannon Associates
333 West 57th Street
Suite 809
US – New York NY 10019
+ 1 212 333 2551
simon@shannonassociates.
com
www.shannonassociates.
com

→ Stéphane Goddard, 298

Studio Goodwin Sturges
255 Promenade St
US – Providence RI 02908
+ 1 401 861 2775
info@studiogoodwinsturges.
com
www.studiogoodwinsturges.
com

→ Nicoletta Ceccoli, 166

The Jackie Winter Group
101A Sackville St
AUS – Collingwood VIC 3066
+61(0)3.8060.9745
info@jackywinter.com
www.jackywinter.com

→ Nigel Buchanan, 118

The Loud Cloud
US – San Francisco CA
+ 1 510 325 0559
contact@theloudcloud.com
www.theloudcloud.com

→ Lisel Ashlock, 46

The Mushroom Company
Pasaje de Collado de
Villaba, 4.
ESP – 28002 Madrid
+34 619 382 054
info@mushroom.es
www.mushroom.es

→ Carmen García Huerta,
286

The Wylie Agency
250 West 57th Street
Suite 2114
US – New York NY 10107
+ 1 212 246 0069
mail@wylieagency.com
www.wylieagency.com

17 Bedford Square
GB – London WC1B 3JA
+ 44 20 7908 5900

→ Peter Sís, 560

100 Illustrators

Illustration Now!
Portraits

Illustration Now!
Fashion

100 Manga Artists

Logo Design

Fritz Kahn.
Infographics Pioneer

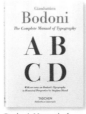
Bodoni. Manual of
Typography

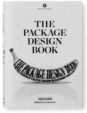
The Package Design
Book

D&AD.
The Copy Book

Menu Design
in America

1000 Tattoos

Bookworm's delight:
never bore, always excite!

TASCHEN
Bibliotheca Universalis

The Circus.
1870s–1950s

Mid-Century Ads

1000 Pin-Up Girls

20th Century Fashion

20th Century Travel

20th Century
Classic Cars

1000 Record Covers

Funk & Soul Covers

Jazz Covers

Extraordinary
Records

Steinweiss

Film Noir

Film Posters of the Russian Avant-Garde

A History of Photography

20th Century Photography

100 Contemporary Houses

100 Interiors Around the World

Interiors Now!

The Grand Tour

Burton Holmes. Travelogues

Living in Japan

Living in Morocco

Living in Bali

Living in Mexico

Living in Provence

Living in Tuscany

Tree Houses

Scandinavian Design

Industrial Design A-Z

domus 1950s

domus 1960s

Design of the 20th Century

1000 Chairs

1000 Lights

Decorative Art 60s

Decorative Art 70s

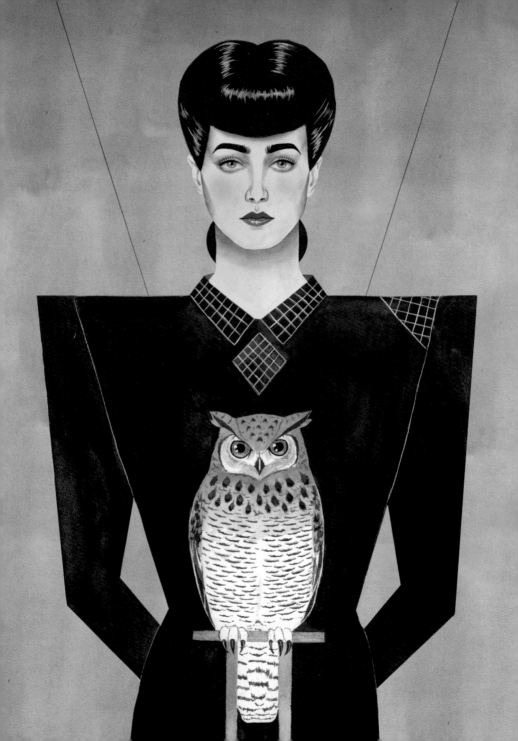

Perfect likeness

Portraiture today, from caricature to realism

The field of illustration has flourished over the last decade, with professionals working both on computers and by hand. In illustration, the single most challenging and captivating subject has been the portrait, frequently used in editorials, advertising, products, and most recently, being the subject of major exhibitions. With an introduction from Steven Heller, this collection gathers the portrait work of more than 80 illustrators including André Carrilho, Jody Hewgill, Anita Kunz, and Dugald Stermer.

"This is a multicultural selection, and hence a book of very beautiful, diverse signatures."
— *Design Week*, London

Illustration Now! Portraits
Julius Wiedeman, Steven Heller
576 pages

TRILINGUAL EDITIONS IN:
ENGLISH / DEUTSCH / FRANÇAIS &
ESPAÑOL / ITALIANO / PORTUGUÊS

Manga-nificent

From Astro Boy to Akira, the superstars of the manga scene

Since the original TASCHEN edition of *Manga Design,* Japan's comic phenomenon has produced yet more captivating characters and a whole host of hot new talents. This revised and updated edition delivers the lowdown on the latest and the greatest makers and shapers of the manga scene. Through its A–Z directory we discover the superstars—both human and fictional—of what is now a vast global industry. From classic maestros—such as Osamu Tezuka (creator of Astro Boy) and Katsuhiro Otomo (creator of Akira)—to newcomers such as Hajime Isayama, each entry includes biographical and bibliographical information, descriptions of main characters, and of course plenty of examples of the artist's finest manga spreads and covers.

"This eye-popping survey of hundreds of Manga artists hurtles from *Sailor Moon* to stylish homoerotic porn, showing how Manga has influenced everything from advertising to movies like *Kill Bill.* Zap, wow, take that, Western literature!"

— *The Globe and Mail*, Toronto

100 Manga Artists
Julius Wiedemann
672 pages

TRILINGUAL EDITION IN:
ENGLISH / DEUTSCH / FRANÇAIS

2194

2195

2196

2198

2199

2200

2202

2203

2204

2206

2207

2208

Sure signs

Diverse logos from around the world

A good logo can glamorize just about anything. Now available in our popular *Bibliotheca Universalis* series, this sweeping compendium gathers diverse brand markers from around the world to explore the irrepressible power of graphic representation. Organized into chapters by theme, the catalog explores how text, image, and ideas distil into a logo across events, fashion, media, music, and retailers. Featuring work from both star names and lesser-known mavericks, this is an excellent reference for students and professionals in design and marketing, as well as for anyone interested in the visuals and philosophy behind brand identity.

"An excellent visual reference…"

—*Curve Magazine*, Sydney

Logo Design
Julius Wiedemann
664 pages
TRILINGUAL EDITION IN:
ENGLISH / DEUTSCH / FRANÇAIS

YOU CAN FIND TASCHEN STORES IN

Berlin
Schlüterstr. 39

Beverly Hills
354 N. Beverly Drive

Brussels
Place du Grand Sablon /
Grote Zavel 35

Cologne
Neumarkt 3

Hollywood
Farmers Market,
6333 W. 3rd Street, CT-10

Hong Kong
Shop 01-G02 Tai Kwun,
10 Hollywood Road,
Central

London
12 Duke of York Square

London Claridge's
49 Brook Street

Madrid
Calle del Barquillo, 30

Miami
1111 Lincoln Rd.

"If browsing is considered an art form, the TASCHEN store is a masterpiece."
— *Dwell*

Milan
Via Meravigli 17

Paris
2 rue de Buci

**EACH AND EVERY TASCHEN BOOK
PLANTS A SEED!**
TASCHEN is a carbon neutral publisher.
Each year, we offset our annual carbon
emissions with carbon credits at the
Instituto Terra, a reforestation program in
Minas Gerais, Brazil, founded by Lélia and
Sebastião Salgado. To find out more about
this ecological partnership, please check:
www.taschen.com/zerocarbon
Inspiration: unlimited.
Carbon footprint: zero.

To stay informed about TASCHEN and our
upcoming titles, please subscribe to
our free magazine at www.taschen.com/
magazine, follow us on Instagram and
Facebook, or e-mail your questions to
contact@taschen.com.

© **2021 TASCHEN GmbH**
Hohenzollernring 53, 50672 Köln
www.taschen.com

ORIGINAL EDITION
© 2013 TASCHEN GmbH

ENGLISH TRANSLATION
Daniela Thoma

GERMAN TRANSLATION
Matthias Wolf and Ursula Wulfekamp for
Grapevine Publishing Services, London;
Heike Lohneis, Ronit Jariv, Jürgen Dubau

FRENCH TRANSLATION
Aurélie Daniel for Delivering iBooks
& Design, Barcelona; Anna Guillerm,
Valérie Lavoyer, Martine Joulia

p. 1 Portrait of Steven Heller, 2000,
Christoph Niemann, personal work, digital

p. 2 Lost Paradise, 2012, Olaf Hajek,
Strange Flowers, Whatiftheworld gallery,
Caper Town, exhibition, acrylic on wood

Printed in Singapore
ISBN 978–3–8365–2222–9

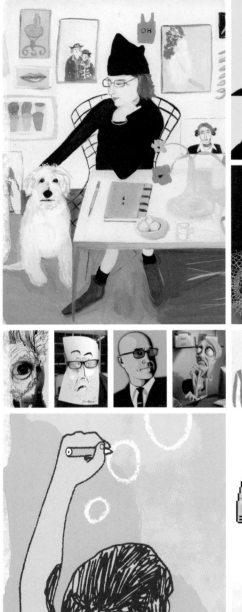

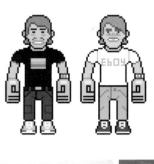